SELECTED
ERRORS

'The intelligence of millions of creators
provides something infinitely superior
to the most gifted individual insights.'
LENIN

'Art is a terribly complex thing,
and it would not do merely to say
that in order to actualize its concept
art must transcend it;
for if in doing so
art assimilates itself to real things
and conforms to reification
despite its protest against it,
then it may be a good political commitment,
but it is also bad art.'
ADORNO

SELECTED ERRORS

Writings on Art and Politics
1981–90

John Roberts

PLUTO PRESS
LONDON • BOULDER, COLORADO

First published 1992 by Pluto Press
345 Archway Road, London N6 5AA
and 5500 Central Avenue,
Boulder, Colorado 80301, USA

British Library Cataloguing in Publication Data
Roberts, John
 Selected errors.
 1. General essays in English
 I. Title
 082

 ISBN 0–7453–0498–2
 ISBN 0–7453–0497–4 pbk

Library of Congress Cataloging-in-Publication Data
Roberts, John, 1955–
 Selected errors : writings on art and politics, 1981–90 / John
 Roberts
 p. cm.
 Includes bibliographical references and index.
 ISBN 0–7453–0498–2. — ISBN 0–7453–0497–4 (pbk.)
 1. Art—Political aspects—United States. 2. Art—Political
 aspects—Great Britain. I. Title.
 N72.P6R63 1991
 701'.03—dc20 91–29037
 CIP

Designed and produced for Pluto Press by
Chase Production Services, Chipping Norton.
Typeset in 10/12pt Palatino by
Stanford DTP Services, Milton Keynes.
Printed and bound in Great Britain
by T.J. Press, Padstow.

CONTENTS

ART AND THE 'MARGINS':
REPRESENTING IRELAND

RECLAIMING THE REAL

ILLUSTRATIONS

For Sarah

ACKNOWLEDGEMENTS

We are grateful to the Metro Gallery, New York, for permission to reproduce Cindy Sherman's *Untitled*, 1981; to the Saatchi Collection, London, for permission to reproduce David Salle's *Zeitgeist Painting No. 4*, 1982; to the Pace Gallery, New York for Julian Schnabel's *Vita*, 1983, and to the Whitechapel Art Gallery, London, for providing the print; to Peter Halley for *Two Cells with Circulating Conduit*; to the Anthony d'Offay Gallery and Prudence Cuming Associates Limited, London, for *The Singing Sculpture* by Gilbert and George; to Klaus Staeck for his *Zero Option*, 1983; to the Mary Boone Gallery for Barbara Kruger's *Untitled*, 1983; to the Lisson Gallery for *Opening Spiral* by Tony Cragg; to Robin Klassnik of Matt's Gallery for Willie Doherty's *Closed Circuit*. Thanks also to the following for permission to reproduce their work: Stuart Brisley, Jo Spence/Terry Dennett, Leon Golub, Ian McKeever, Art & Language, Mark Wallinger, Susan Hiller, David Mabb, Sonia Boyce, Locky Morris, Terry Atkinson, John Stezaker and John Wilkins. We are grateful to the ICA, London, for their assistance and cooperation. While every effort has been made to trace copyright holders, the publishers would be glad to hear of any omissions.

PREFACE

Selected Errors consists of essays and interviews written during the 1980s. Some of the essays have been rewritten or extended, some have been re-edited. With the exception of the interview with Jo Spence, and the essays 'Eleven Theses on the Situationist International' and 'Realism and Pictorial Competence: Nelson Goodman and Flint Schier', all the pieces have been published before.

I would like to thank Anne Beech at Pluto for her enthusiastic support for the project. I would also like to thank Dave Evans, Dave Beech and Mark Hutchinson, and Sue Kelly for the typing and editorial advice.

'Masks and Mirrors: Simulation and Appropriation in recent American and British Art' was published under the title 'Masks and Mirrors' in *Art Monthly*, Number 63, February 1983. 'Interview with John Stezaker' was published in *Aspects*, Number 22, Spring 1983. 'Interview with David Salle' was published in *Art Monthly*, Number 64, March 1983. 'The Success and Failure of Schnabel' was published in *Alba*, Number 3, Spring 1987. 'Lost in Space: Peter Halley' was published under the title of 'Lost in Space', *Art Monthly*, Number 124, March 1989. 'Entangled in Imagery: Tony Cragg' was published under the title of 'Entangled in Imagery' in English and Portuguese in *Transformations: New Sculpture in Britain*, XVII Bienal de Sao Paulo 1983, British Council, 1983. 'Beyond the Arches: Gilbert and George' was published in *Artscribe International*, Number 66, November/December 1987. 'The Poster and the Counterpublic' was published in *Art Monthly*, Number 98, July/August 1986. 'Interview with Barbara Kruger' was published in *Art Monthly*, Number 72, December/January 1983/4. 'The Performance of Stuart Brisley' was published under the title of 'Stuart Brisley' in *Stuart Brisley*, ICA, 1981. '"Directions Out": A Critique' was published as 'Directions Out' in *Artscribe International*, Number 65, September/October 1987. 'Three

xi

Irish Artists' was published in *Art Monthly*, Number 118, July/August 1988. 'Representing Ireland: An Interview with Terry Atkinson' was published under the title of 'Ireland and Representation: Terry Atkinson Interview' in *Mute 2*, Orchard Gallery, Derry, 1989. 'Sinn Fein and Video: Notes on a Political Pedagogy' was published in *Screen*, Volume 29, Number 2, Spring 1988. 'Approaches to Realism' was published as a brochure by the Bluecoat Gallery, Liverpool, 1990. 'Zones of Exclusion: Leon Golub's "Other America"' was published in *Leon Golub: Selected Paintings 1967–1986*, Orchard Gallery, Derry, 1987. 'Art and Value: A Philosophical Dialogue' was published in *Art Monthly*, Number 103, February 1987. 'Masculinity, Politics and Art' was published in *The Invisible Man*, Goldsmiths' Gallery, London, 1988. 'Blindness and Light: Science and Nature in the Painting of Ian McKeever' was published in German under the title of 'Blindheit und Licht', Daad Galerie, Berlin, 1990.

INDEXES, METAPHORS AND ALLEGORIES: NOTES ON THE REMAPPING OF ART AND POLITICS

Selected Errors needs to be read as a kind of companion text to my *Postmodernism, Politics and Art* (1990)[1] (hereafter *PPA*). But whereas *PPA* deals with the modernist / realist debate from within the confines of an analysis of postmodernism, *Selected Errors* concentrates specifically on the modernist / realist legacy itself. *Selected Errors* fills in the historical gaps so to speak.

What were the dominant changes that characterised art in the West during the 1980s? The 'return' to painting, the strengthening of the market and museum culture, the theorisation of postmodernism? All could easily fit the bill. In fact we might speak of the 1980s as that period when the market and museum reclaimed certain kinds of nostalgically inflected painting under the rubric of a 'post-historical' definition of the modern. The rush to line up the crisis of the avant-garde with conservative accounts of painting's past and future is obvious enough. This all may well be true, but it is also superficial. The kinds of managerial discourse that have dominated the international artworld in the 1980s have resorted to crude sociology and formalistic pattern recognition as a means of drawing out the implications of the new art. The resultant remapping has been skewed and partial to say the least. The 'end' of this and the 'end' of that, the glorious continuation of this, the ignominious death of that, droned on through the 1980s. As Marx acknowledged through the very complexities of his method in *Capital*, bourgeois and liberal thought heaves to and fro in a slovenly way between facile evolutionism and intemperate discontinuism; the hypertrophic guardianship of tradition cohabits with a fetishism of the new. The international artworld has had its fair share of heaving in the 1980s.

The underlabour of the materialist critic then is always determined by two responsibilities: the fashioning and defence of reputations and

1

histories that have been marginalised by dominant managerial interests, and the reclamation of reputations and histories from the clutches of such interests. The idea therefore that there is a straight counter-cultural fight on between the margins and the centre needs to be quickly dispensed with; the work of understanding is not to be mollified by what people say they are doing or what other people say they are doing. *Selected Errors* is a product of this division of responsibilities, which is why its structure and interests are marked by a set of thresholds and oppositions rather than by evolutionistic formulas or stylistic compendiums. By offsetting the legacy of productivism (an historical and revolutionary commitment to art's collective and shared powers of intervention into working-class lives) and a defence of art's 'relative autonomy' (a commitment to the specialist interests of the aesthetic as it is grounded in the legacy of modern painting), the determining structural realities of what it means to produce art at the latter part of the twentieth century, with all its distortions of production and effect, is given an open and contradictory exposition. Likewise, my defence of realism in painting against the grain of the resemblance-model dominated social realist tradition ('Approaches to Realism'), does not seek to dismiss the role of resemblance in art as against the role of 'seeing-as', but rather to put the realist debate on its proper footing by reclaiming its earlier modernist imperatives. The historical split between figuration and abstraction, grounded as it was in Stalinist and cold war realities, severed the realist debate from an understanding of representation's full complexities. This is why the early modernist–realist insistence on the realist effects of fragmentation is so important in both placing realism in its proper historical context and countering the contemporary aesthetic view that fragmentation is the product solely of the destruction of meaning and the obliteration of the social referent. Benjamin's insightful defence of the aesthetic fragment as 'non-mimetic' correspondence still has much to teach us about resemblance being necessary but *non-sufficient* for representation.

In fact it is this basic philosophical insight about how representation works that is the touchstone of the book. For not only does this allow us to defend realism without recourse to the figuration / abstraction divide, but it also provides us with the conceptual coordinates to construct another kind of critical map for contemporary practice. What has characterised some of the most compelling and vivid of contemporary work is the use of what might be called 'indirect speech': indexicality, metaphor and allegory. Indexicality (the

aesthetic artefact or pictorial fragment as indicator of a larger reality or set of relations, or physical trace of an object), metaphor (figurative meaning based on literal correspondence), and allegory (the standing in of one thing for another) have all of course played parts in the development of modernist and pre-modernist art (Courbet, Duchamp and Surrealism to mention the most obvious examples).[2] Today, however, they exhibit a self-consciousness and coherence in their use that is unprecedented. In the best contemporary work there has been a move to clear away the debris of the prevailing aesthetic dichotomies. The use of 'indirect speech' forms has clearly sought to break with the complementary opposition of 'expression' and 'reflection' that has underpinned the abstraction / figuration, modernism / realism split. Art becomes situated contingently *in* and *across* the workings of representation, and not at the conjuncture of reified formal or stylistic categories and the artist's 'sensitivity' or 'intuition'. Julian Schnabel, lauded by the cultural right and attacked by the cultural left has put it, surprisingly, very well ('The Success and Failure of Schnabel'):

> A lot of Americans still don't understand that it was Beuys who instigated the current shift in art. They think it came from reductivism and minimalism and painting being dead and resurrected – but I'm talking about an involvement with materials. The issue of whether it's sculpture or a painting is obsolete, as well as the difference between abstraction and figuration.[3]

This hasn't prevented Schnabel, ironically, from saying 'in each work, you must be able to forget who you are';[4] but the point is well taken. The motivations of works cannot be reduced to their formal insertion into reified categories like neo-Expressionism. Schnabel's work itself in fact is a good example of those artists who need to be read against the grain of their dominant interpreters in order to put in place an adequately synchronic analysis of contemporary practice. For, the issue isn't whether Schnabel uses indexicality, metaphor and allegory to say interestingly radical things about the world – he doesn't – but the fact that he uses such resources to make certain claims about painting not being able to go on in the same old ways.

Essentially what is at stake is an expanded sense of denotation in art across media; the dominant forms of criticism in the 1980s, rooted as they have been in caricatures of modernism and realism, have largely been unable to recognise or register this complexity. Schnabel

is certainly right to cite the 'social sculpture' of Beuys as a contribu-
tory influence; a more important figure though, and another influence
on Schnabel, has been Robert Rauschenberg. Rauschenberg's use of
collage in his paintings in the 1950s as a means to blur both the
distinctions between the autographic and mechanical and the flat
surface of the painting and illusionistic depth sharpened up the
possibilities for painters seeking to mobilise their resources across the
increasingly moribund figuration / abstraction divide. His much
commented use of the painting's surface as a bed for signifying
material opened up the non-illusionistic potential of painted space
post-Pollock, to new modernist combinatory effects. In effect Beuys
in Europe and Rauschenberg in America re-employed early modernist
techniques in order to renegotiate the widening gap, post-war,
between media.

 The expanded sense of denotation I discuss in recent sculpture
(Tony Cragg), performance (Stuart Brisley), photography (Barbara
Kruger, Jo Spence) and painting (Terry Atkinson, Leon Golub, Ian
McKeever) clearly owes something to this latter-day modernist de-
hierarchicising of forms and genres; 'bricolage' though is only half
the story. Indexicality, metaphor and allegory presuppose the work
of perception as the work of *reading*. The textuality of visualisation
has now generated a massive literature and became something of a
commonplace in the 1980s. I do not claim any novelty for reasserting
the claims here. However, the analysis of the expanded sense of
denotation in contemporary art under the theorisation of textuality
of vision has on the whole been an anti-realist move. 'Seeing-as' has
been employed – mainly through the auspices of post-structuralism
– to question the referential relationship between pictures and the
world of events and objects. The writings of Peter Halley are a good
example here ('Lost in Space: Peter Halley'). Echoing Paul de Man on
allegory,[5] another American writer has referred to the doubling of
meaning in allegory as a space of *unreadability*.[6] *Selected Errors* seeks
to challenge this. The section 'Reclaiming the Real' presents a defence
of art's denotative resources from a realist position. But it does this,
to complicate matters, without lining up with recent attacks on
reportage. For if we are to talk about resemblance being necessary but
non-sufficient for representation, then this does not mean it does not
play *any* role. Reportage, illustration, documentation, iconicity, are
not monologic *in themselves*.

 Despite their own denotative moves both Terry Atkinson and Jo
Spence recognise this:

resources of illustration cannot be dismissed since they also might be aberrant or anomalous resources vis-a-vis the canons of a modernist and transatlantic orthodoxy. ('Representing Ireland: An Interview with Terry Atkinson')[7]

The vocabulary that comes out of the discussion [of documentary photographs] would be grounded in their own experience of oppression which would overthrow the idea of naturalism as we know it by bringing up contradictory readings. ('Interview with Jo Spence')[8]

Documentary or reportorial images do not merely objectify, they also answer back as a form of 'reported speech' ('Realism and Pictorial Competence: Nelson Goodman and Flint Schier'). Documentary or reportorial images then can take on second-order critical or realist effects subject to their textual use or articulation.

Using the coordinates mass culture / modernism, productivism / 'relative autonomy', denotation / resemblance, *Selected Errors* presents a dialectical overview of the problems and contradictions that face contemporary practice. As such it provides an excursion across· historical divisions and critical categories in order to put in place the anomalies and discrepancies that give shape to art's present unfolding. Despite the prevailing consensus, art still proceeds by its *dark* side.

Notes

1. John Roberts *Postmodernism, Politics and Art* (Manchester University Press 1990)
2. For a discussion of indexicality in relation to Duchamp, for instance, see Rosalind Krauss, 'Notes on the Index: Seventies Art in America', *October* 3, Summer 1977.
3. *Selected Errors* p 57
4. Ibid p 58
5. Paul de Man *Allegories of Reading* (Yale University Press, 1979)
6. Craig Owens 'The Allegorical Impulse: Toward a Theory of Postmodernism Part 2' *October* 13, Summer 1980
7. *Selected Errors* p 176
8. Ibid p 141

MASS CULTURE AND MODERNISM:
THE DIFFICULT DIALOGUE

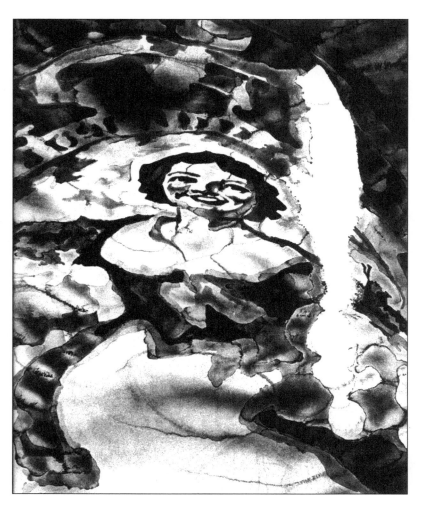

1. John Wilkins, *Still Life, (Ovaltinies No. 8)*, 1980–2.

1

MASKS AND MIRRORS: SIMULATION AND APPROPRIATION IN RECENT AMERICAN AND BRITISH ART

In recent painting and drawing which addresses the mass media, what has become of conspicuous importance is not simply the fact that the mass media distorts our relationship to the real, but that misinformation is a structural effect of the media itself. Jean Baudrillard, whose writing has come to exert an enormous influence on thinking on the image in America and Europe, has called this grandly the 'implosion of the social',[1] a closing down between the medium and the real. We are faced, he says, 'with the circularity of all media-effects',[2] a mirroring back and forth, or equivalence between signs.

The contention that we are entering a new epoch of image sanctification as images and information proliferate and neutralise difference, discrimination and analysis is not something that is peculiar to the 1980s. Marshall McLuhan was saying very similar things in the 1950s; so was Guy Debord in the 1960s. However, in Jean Baudrillard's writing the stakes are upped considerably. Rejecting Debord's essentially classical Marxist view of the capitalist communications industry as disguising reality, he argues that 'truth, reference and objective causes have ceased to exist'[3] under current media conditions. Images have usurped the real to such an extent that the symbolic violence of the media is indistinguishable from the real itself. In fact in common with a number of other post-structuralist writers he argues that we have entered a new social order: that under such an order the domination of the subject can no longer be based upon the primary analysis of economic relations at the point of production. We can no longer assume that under 'informational' capitalism the alienations of waged labour are the principal form of domination. This view of course is not peculiar to post-structuralism, but has characterised a

9

great deal of Western post-war Marxism. As Marcuse argued in 1969 in the wake of the failure of May 1968:

> The modifications in the structure of capitalism alter the basis for the development and organisation of potentially revolutionary forces. Where the traditional labouring classes cease to be the 'grave-diggers' of capitalism, this function remains, as it were, suspended, and the political efforts towards change remain 'tentative', preparatory not only in a temporal but also in a structural sense. This means that the 'addressees' as well as the immediate goals and occasions of action will be determined by the shifting situation rather than by a theoretically well-founded and elaborated strategy. This determinism, direct consequence of the strength of the system and the diffusion of the opposition, also implies a shift of emphasis towards 'subjective factors': the development of awareness and needs assume primary importance. Under total capitalist administration and introjection, the social determination of consciousness is all but complete and immediate: direct implantation of the latter into the former. Under these circumstances, radical change in consciousness is the beginning, the first step in changing social existence: emergence of the new Subject.[4]

For Baudrillard though all possibility of a new Subject – collective or otherwise – has been vanquished by 'total capitalist administration'. Frankfurt school pessimism has become *fin de siècle* diabolism. Thus for Baudrillard the residual humanism of a Marcuse fails to face up to the overriding structural reality of total capitalist administration: the foreclosing of the gap between the economic and the ideological. 'All through the 19th and 20th centuries political and economic practice merge increasingly into the same time of discourse. Propaganda and advertising fuse in the same marketing and merchandising of objects and ideologies.'[5] Advertising, and capitalist communications generally then, Baudrillard argues, institute an operational simulacrum over the political spectrum of public life; a simulacrum of democracy that cannot be challenged openly because of the way the system is designed to regulate all opposition as equivalent to bourgeois rule. Capitalist rationality cannot be forged in the image of a new Subject, it has to be rejected altogether. Thus in a predictable Romanticist, Heideggerian-type inversion, Baudrillard transforms the would-be passivity of the oppressed and subordinated into a positive

language of refusal. If the real is unable to be reclaimed for historical reason, then let us march away from all reason, and mock capitalism by simulating its most alienating forms.

The notion that our relationship to the real has somehow disappeared or become highly attenuated has become one of the major concerns of vanguard art in Britain and the USA. Two exhibitions staged in London in 1982 – 'Urban Kisses' at the Institute of Contemporary Arts (ICA)[6] and 'Simulacra' at Riverside Studios[7] – are exemplary in this respect; both invoke a world of confinement and closure, in which the real is made within the code. Although it would be superficial to say both shows were illustrations of Baudrillard's thinking, nevertheless they are clearly products of the pessimistic 'culture of negation' he represents. As such the two exhibitions offer an ideal opportunity to discuss and assess the new media-based art and the post-structuralist theory that has come to shape and direct it.

Central to Baudrillard's theory of ideology is the impossibility of recovering a critical space for art outside of the vastly technologically transformed conditions of bourgeois culture. There are no spaces where art might compete ideologically on open terms. Out Frankfurt-schooling the Frankfurt school then, he locates the function of art in the wake of the end of the avant-garde not within any formal resistance to bourgeois ideology, but from within the spaces of bourgeois ideology itself. Faced with the power of bourgeois commodity relations, and the exhaustion of art as negation in either its formalist or didactic variants, the artist enters the world of bourgeois relations in order internally to stage their phantasmagor-ical qualities. Although there is a residue of Benjaminesque allegory here, Baudrillard's aesthetic commitments are crucially to a vehement anti-humanism – the end of the avant-garde is the end of the myth of the originary creative subject – and to a Kierkegaardian sense of dread about the world. Kierkegaard's view that 'in the hidden recesses of happiness, there dwells also the anxious dread which is despair',[8] might be changed into 'in the hidden recesses of the commodity form there dwells the anxious dread which is despair.' In fact the aesthetics of dread and the commitment to a post-expres-sivist art practice are structurally linked, for both converge under the heading of an art of 'purloining' and 'stealing', an art of appropria-tion comparable in form to the economic appropriations of the bourgeoisie. Roland Barthes, whose own aesthetic predilections in the 1970s followed a similar path, summed up this position in

Sade/Fourier/Loyola (1977) as follows: in a world where counter-aesthetics have become impotent 'the only possible rejoinder is neither confrontation nor destruction, but only theft.'[9] Appropriation of found images, copying, mimicry becomes a means of defining, or adequating, the 'homelessness' of art under capitalism's 'equivalence of signs'.

More specifically though such homelessness locates the crisis of the avant-garde as a crisis of *expression*. If the avant-garde is exhausted this is because the modernist artist has increasingly had a weak sense of the exteriorised nature of the conditions of artistic production: the fact that the artwork is the divided and heterogeneous manipulation of extant signifiers before it is ever 'self-expression'. In Barthes, the conversion of images into *texts* plumped full of unconscious signifying processes is used in Baudrillard's writing as a locus for identifying a two-fold crisis: the crisis of the avant-garde as a crisis of *expression as negation*, and concomitantly, the crisis of the self-identical subject, subjugated as it is under late capitalism to a massive 'labour of signification'.[10] Thus, if the production of artworks are the *re*production of textual signifiers, and this process in turn is an *inter*textual one – 'any text is a new tissue of past citations. Bits of codes, formulae, rhythmic models, fragments of languages, etc' (Barthes)[11] – and the subject itself is a textualised construction, the post-avant-gardist artist must declare a commitment to foregrounding the very absurdity of free creativity and the exigencies of capitalism's 'labour of signification'. However if Baudrillard is made to sound here like a redoubtable defender of a new kind of deconstructive political art this couldn't be further from the truth. Art cannot impede or disturb this labour of signification; for Baudrillard it can only replicate it. Drained of a determining subjectivity and cognitive value art is quite simply semiotically *collusive* with the world, the exhausted product of an internalised game of intertextual differencing. The question of art locating or contesting the real then is unrealisable on two counts for Baudrillard: first there can be no question of the reclamation of the real when the labour of signification traps the subject in a process of abstract manipulation without escape; and second even if art could lay claim to the reclamation and contestation of the real, the real would be doomed to radical disinvestment of meaning by the logic of the system anyway. The real therefore, as for Althusser, is ideological from the very beginning.

'Urban Kisses' and 'Simulacra' differ quite substantially though in their commitment to an appropriative, anti-humanist aesthetic,

revealing the different conditions under which post-structuralist thinking has been absorbed in the artworlds of Britain and the USA. On the whole the American work at the ICA (Robert Longo, Cindy Sherman, Mike Glier, Judy Rifka, John Ahearn, Keith Haring) reveals a much closer affective relationship to the culture that sustains it. By this I don't mean the work glorifies mass culture, but rather sees it as a source of undeniable – if ambivalent – pleasure. Placing itself firmly within the post-avant-gardist camp, the high-modernist disdain for mass culture is absent; being part of the very culture it seeks to mediate the question of overestimating its significance, and power doesn't arise. Generally then 'Urban Kisses' colludes with the dominant culture as a means of signifying how late modernism drained the modern in art of urban content, which is why the profusion of found images in the show offers itself tendentiously as the re-conquest of the signs of the street over an anti-demotic late modernism. Furthermore the profusion of purloined public imagery functions as a simulacrum of the city itself: a mirror, a mythic panoscope, of the motion and heterogeneity of metropolitan life.

'Simulacra' (John Stezaker, Jonathan Miles, John Wilkins, Jan Wandja) on the other hand, is not so much concerned with the pressures and ubiquity of mass culture and the mass media, but with something far more meditative. If 'Urban Kisses' busies itself with the circulation of images, 'Simulacra' adopts the vantage point of fascination in front of the consumer image, opening up the ambivalent pleasures of mass culture to those Kierkegaardian feelings of dread. As Michael Newman, the organiser of the exhibition, argues in his accompanying essay:

> The rapid scan to which such images are normally subject is replaced by another kind of attention, an intenser scrutiny, under which they are revealed as void of the promise they offered or else resonant with unintended meanings. These found, stilled images, already mediated and consumed, are the starting point for works of art in which they are recycled and transformed through painting, drawing and screenprinting … [The artists] go beyond the passivity of the aesthetic of pure appropriation, the distancing of irony and the closure of the caption to explore the life and death of the image in our culture.[12]

With this, the work moves close to Baudrillardian notions of 'silent resistance'. Like Susan Sontag, in *On Photography*,[13] calling for an

ecology of the sign, the 'Simulacra' artists subject the stereotype or
commercialised image to an enigmatic distancing. The 'hot' world of
media desire is given a 'cool' ministration. Thus despite the polemical
anti-modernist tone that has accompanied the majority of this new
art, what largely distinguishes 'Simulacra' from 'Urban Kisses' is its
continuing commitment to some modernist notion of the image as a
space of imaginative investment outside, or athwart, the mass cultural.
This is why we should be clear that although the 'Simulacra' artists
like the American artists in 'Urban Kisses' seek new forms of
negotiation between high-art and mass culture, for the 'Simulacra'
artists this is not of value in itself. What counts is how a new kind of
imagery might be *won from* the mass cultural. Modernist aspirations
then for the vivid, contemplative image are being conducted within
that very sphere of relations from which modernism sought to sever
art.

If the 'Simulacra' show pursues a more 'contemplative' image
than 'Urban Kisses' this has much to do with the conditions under
which the work was made. It is impossible not to see some causal
connection between the lively and vertiginous sense of place and
custom in much of the American work, and the strong urban self-
image of a great deal of the USA's post-war culture. Addressing the
manipulative power of mass culture cannot be separated from the
whole post-war experience of United States mass culture as a globally
hegemonic one. The power of the United States media and its
imperialist extensions is experienced as a palpably real form of social
control. The violence of the city streets is matched by the symbolic
violence of a thousand and one mythologised urban signs. This kind
of density of imagery and media control – the nearest perhaps we get
in the world to Baudrillard's simulacrum of democracy – has just not
been historically available, in the same way at least, to British artists;
which is not to say that the same power relationships do not apply
to the circulation of information under British capitalism, but that the
urban experience in the USA has brought the USA's national self-
identity under the sway of powerful and self-regulating collective
urban images. The very title of the American show acknowledges this:
'Urban Kisses'. This is the USA as the mythologised urban experience:
throwaway, unpredictable, dangerous. 'Consider the United States'
says Barthes in *Camera Lucida*, 'where everything is turned into
images: only images exist.'[14] Hardly, we might say, but the point is
well taken. As Hal Foster declares in his catalogue essay for the
show, the United States urban experience, in particular New York,

takes on the quality of a 'projection'.[15] And this is what 'Urban Kisses' wants to invoke above all else: New York and the USA are made of electronic chimera. 'Urban Kisses' in fact is a perfect example of modern art management's continued symbolic and cultural investment in New York as the heart of the Western art experience; the crucible of capitalist expansion and artistic innovation; a spectacle of dreams and degradation. The perfected bourgeois antithesis – the greatest riches and the most appalling poverty – becomes the perfected heroic background for the modern urban artist.

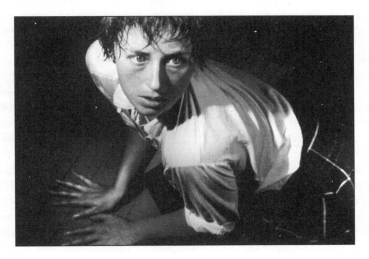

2. Cindy Sherman, *Untitled*, 1981.

As a spectacle of dreams 'Urban Kisses' is very much about the power of late capitalism's 'labour of signification' to organise subjectivity. In this the representation of the self in the exhibition is tied umbilically to the power of the media stereotype. The stereotype is viewed as that which holds the capitalist imaginary together, the expression of deep controlling structures which we think through, and collude with, unconsciously and consciously. Consequently much of the work (Robert Longo, Cindy Sherman, Mike Glier, Ken Goodman) sees sexual division starkly as the *management* of subjectivity. Longo's drawings of male and female executives grappling with each other, Sherman's staged photographs of herself taking on various female identities, Glier's portrait drawings of American male executives, and Goodman's drawings of anxious young men,

map out a range of modern role models (in Goodman's case breakdown of role models) that are the products of anonymous technocratic control. Which is why although there is an implicit critique of such roles in the process of their staging, a certain social determinism accompanies the celebration of urban diversity: it is impossible for the modern subject to grasp the world as the product of his or her own activity. Longo's, Sherman's, Glier's and Goodman's figures are Foucault's 'docile bodies' or André Gorz's individuals trapped within the functional legitimacy of capitalist consumption.

Post-structuralism's taxonomies of confinement then have certainly provided new scope for the imaging of alienation. However what has occurred is that a new apocalypticism has descended on contemporary art. This is not so much the old 1950s dystopianism renewed – technology as the suppressor of subjectivity – than the collapse of subject into the commodity as such. As in Sherman's fatalistic staging of femininity, the show locates subjectivity as the internalised self-surveillancing of commodity relations. Capitalist relations of technological control are so enmeshed with the everyday – in Baudrillard's words the media refracts itself 'into the real'[16] – that the subject–object relation has reached a petrified 'end state'. For Baudrillard this process signifies the 'end of the social', for Gorz, like Baudrillard, deeply antagonistic to industrial culture, it reveals we have 'arrived at the threshold which plus turns into minus.'[17] 'Urban Kisses' and 'Simulacra' are 'end state shows'. They seek to present an aesthetic that is adequate to the felt perceptions of the crisis of what seems like an increased reliance by Western capitalism on both consensual and coercive control. The mediation of this 'crisis culture' however takes on a very different quality in 'Simulacra'. For if the 'Simulacra' artists emphasise the 'contemplative' side of spectatorship it is because the subject is seen to inherit a world in which the 'equivalence of signs' implies a *highly* phantasmagoric relationship between subject and object. The representation of late capitalism here is less to do with mapping out the construction of our subjectivities through the intercessions of the 'labour of signification' than the desiring power of that labour itself. The representation of our cultural crisis then becomes the representation / acknowledgement of our *seduction* by, and *fascination* for, the image, for its fetishistic power to render the same different and different same without interruption. The 'Simulacra' artists use the iconic and repeated image to metaphor these would-be closures more self-consciously than the Americans. To paraphrase Maurice Blanchot – whose writing has had some influence on the

'Simulacra' artists – the images in the exhibition render our fascination and desire for the image a mute and passive experience. To be fascinated by the image is to be 'taken by it'.[18] The sexual analogy is obvious.

'Simulacra' consists of four artists who have in various ways been associated with the British magazine ZG, which has done much to introduce the application of the new French post-structuralist writing to visual culture in Britain. Overall this was very much a ZG show put together under the aegis of John Stezaker, whose own work, long associated with these ideas, has done much to lay the ground for this type of media-oriented art. Wandja and Wilkins are ex-students of Stezaker at St Martin's art college. Miles and Stezaker were close associates through the 1970s – in 1975 they collaborated on work together. The closeness of concerns gives the show an aesthetic coherence that the New York show lacks, despite sharing a common intellectual ground.

This was a vivid show. It was vivid on three counts: first it draws into view a continuing – if relatively hidden – area of work in Britain which uses found mass cultural imagery; second it addresses the marginal place of the graphic / iconic image and illustration within the fine arts; and third it sees an engagement with consumerism and the mass media as central to critical practice today. The latter two points are no different of course from a good deal of the new work in the USA, but what differentiates their application in the British work is the position the artists take up in relation to modernism and its Romanticist heritage. Mixing post-structuralist theory and Romantic poetics the recycled images in 'Simulacra' attempt to *hold* the gaze, to wrench some extended space of reflection against the grain of the modern loss of duration in the image. To resist the visual fluctuations and transitoriness of 'common experience' was a position modernist abstraction inherited from late Romanticism. In seeking the contemplative, the artist sought some point of 'transcendence' outside of commodity relations. In 'Simulacra' this idealism is given a kind of bathetic twist. Holding the gaze, wrenching some extended space of reflection, some mystery if you like, is not the move of the artist disclosing the sublime in the familiar, but the opposite: severed by commodification from any 'depth model' of apperception, the 'sublimity' of the iconically transformed product-image, or mythic film still is rendered a fake. There is no reclaimable beyond here, only the emptiness of the consumer image itself. Behind the fascination then is the emptiness that Kierkegaard saw as the seat of dread.

Engaging complicitly with the consumer / media image (that is by dropping contextualising captions or not breaking up the picture space) they heighten its ghostliness. Deferring to our fascination (desire) for the consumer / media image, they at the same time lock into its emptiness (its superfluity). There is no pretence at ideological critique (overt displacement of the sign, ironic or otherwise). That is the work's challenge. It acknowledges our pleasure in the perception and memory of desire, whilst simultaneously holding up a mirror to its faithlessness, its inauthenticity.

Stezaker's work remains the most accomplished work in the show and the most compelling he has produced to date. Superficially the work looks as if it has undergone enormous change. In the early 1980s he switched from photo-collage to painting (silkscreened images on canvas) and veils (silkscreened nudes – headless – taken from a 1950s *Health and Efficiency* magazine, printed as a frieze). His concerns though remain constant: the visualisation of the repressed contents of public images. For Stezaker the found public image contains a kind of 'secret writing' that passes us subliminally by. By reclaiming and isolating the images, trapping what has passed out of circulation at the point of greatest potential for meaning, he offers the viewer, as he said in 1979, the 'opportunity to stop and see and ask questions.'[19] But what are these repressed contents? What meanings lie in wait to be summoned? First and foremost the spectre of death. Like the Romantics' valorisation of the ruin as a stereotyped sign of mortality, Stezaker's meditation on the dreadfulness and faithlessness of the consumer image is a meditation on mass culture as a graveyard of desire. Hovering in a black void like a late-Romantic death-head, his kissing couple (*Kiss* 1979–80) and man looking out of a window (Anthony Perkins in *Psycho*) allegorise their own presence – fascination, mysteriousness – as an absence, as faked sublimity and depth. They are Janus-faced then like the consumer image itself: they elicit our fascination, but do so only at the level of surface appearances. And this is fundamentally where the aesthetics of appropriation register their politics. For appropriation – copying, borrowing, mimicry – reduces the original to silence and ephemerality, in effect to a kind of death's-head: appropriation *hollows out* the appropriated image. By copying, borrowing and mimicking – processes that in a sense absorb without return – Stezaker and the other 'Simulacra' artists literally metaphor the death-in-life life-in-death existence of the image under commodity culture.

Stezaker borrows images and reproduces them by mechanical means; the other artists in the show copy images by hand. In the work of Jonathan Miles and John Wilkins drawing and water-colour painting are used respectively as a means to focus on the superfluity and faithlessness of the advertising image. Miles reproduces this emptiness by copying and juxtaposing (in felt-tip pen) colour supplement ads. In *See yourself as a legend* (in which poor, faded colours strike an additional level of ghostliness) he pairs an image of a Chinese peasant waving/beckoning, behind which is seated a group of musicians, with the image of a female model striding through the centre of an unidentifiable ancient city. Wrapped around the model's head and trailing behind her is a long scarf. Her posture is quite theatrical, made more spectacular by our vantage point as viewers. As in the case of the peasant poster we are looking up at the image, creating a dynamic and emancipatory sense of space. Like the peasant the woman is executing a gesture of goodwill or welcome. The coding of these two gestures is ostensibly very different, opposed in fact. The peasant's gesture and smile signal communality, the model's gesture, a distant, carefree, sophisticated independence. But without captions, without colour and scale differentiation the content of the images is equalised, rendered banal. Appropriation for Miles thus works as a form of enclosure around the image: the identity of each image is hollowed out.

Wilkins's transformation of the advertising images is taken to even greater lengths of condensation. His images are the most mediated in the exhibition, reaching, in their self-reflexive spiral, a space of visual implosion. Wilkins though is somewhat different from the other artists in that he builds up his images painstakingly slowly. The contemplativeness that I have stressed as being fundamental to the treatment of the consumer image in 'Simulacra' is the product here of what in other circumstances would be called conventional painting skills. Over a period of a year Wilkins has worked on a series of water-colours based on one image.

From the colour reproduction of the farm girl on the label of the Ovaltine tins he produced a series of black and white photographs, 'varying the camera angle, focus and lighting.'[20] Working flat on the floor he then painted in black a water-colour copy of each photograph, building up the images slowly by forming pools of paint which were left to dry to form rings. The final image – her features distorted into benign idiocy – is a painting of a photograph of a reproduction of a painting. Very ingenious one might say; and one could imagine

the process going on indefinitely, copies of copies of copies. The circularity of the process though displays more than its own conceit; it shows us a consumer image literally dying, its fascination for us crumbling like a burning piece of paper. Like Stezaker, Wilkins is concerned to metaphor how death is locked into the heart of the image. What makes Wilkins's paintings so compelling is that this is secured in the process itself. The Ovaltine girl is gradually reduced – dematerialised if you like – to the point of blackness. The body dissolves into the abstract, into the void. Loss of meaning is enacted step by step before our eyes.

Something common to all the work in 'Simulacra' is this paradox of absence and presence. Stezaker achieves this by fragmenting the body, Miles by juxtaposing opposites as similarities, Wilkins by the serial abstracting of the image. Jan Wandja on the other hand employs superimposition. Superimposition for Wandja means a simple form of image overlap, of a figure – usually a portrait – over a crowd scene or a symbol; private over public. In the large drawings of the athlete Sebastian Coe, Coe's tortured, exhausted face is superimposed over a Union Jack. Of all the work in the show Wandja's use of the stereotype (the sports hero) is the most dramatic in its coding. It is also the most overt in its identification of the sacralisation of the modern media image. Her choice of sportsmen as the most valorised of public figures (Joe Bugner, Coe, Bjorn Borg) is obviously a recognition that it is in the world of sport where the most strongly held emotions – those religious emotions of fascination and absorption – are staged today. In this her art is closest of all the 'Simulacra' artists to the work of the Americans (Longo, Sherman, Glier, Goodman) in that it shows us the peak of experience, the heightened mask of the stereotype. Wandja's sportsmen are figures of fanaticism and devotion. Here in fact is the phantasmagoric theme of 'Simulacra' at its most explicit: the investiture, on the terrain of mass culture, of the sacred in the demotic. With the extension of the commodity form the mass media captures those passive experiences of absorption and fascination that were once solely the province of the devotional. In short, what 'Simulacra' argues through its espousal of a modern Romanticism, is that we live in a global and *perfected* world of devotion to the faithless consumer image.

The neatness of this argument has appeal. Yet, the empirical evidence points to a very different reality. The reproduction of ideology through the media is not monolithic but fractured and contradictory, the result of changing social forces to which the media

responds and adapts. This is not to say that capitalist control of the media is somehow vulnerable at its major centres of power, but that this Baudrillard-influenced vision of a hegemonic, media subsuming and pacifying all it touches, simply over-inflates the powers of ideology to discipline the subject to bourgeois rule, and as a consequence ignores the *material* circumstances that compel people to contest and change their circumstances and therefore their consciousness. We perhaps need to be clear then about the conditions under which mass culture and art operate under late capitalism. For we need to be clear about what is interesting and what is preposterous about the intellectual claims for this new work if we are to set the critical relationship between art and mass culture in its proper context and avoid the twin pitfalls of either univocally celebrating or cynically denouncing the work.

The development of the notion of mass culture clearly has both negative and positive connotations. It conjures up on the one hand notions of vulgarity and kitsch, a levelling process if you like, and on the other a potentially emancipatory social force and space for class solidarity – the masses. This contradictory usage became available in the middle of the nineteenth century with the birth of modern class society emerging from the womb of Western European industrialisation. As such, theories of mass culture are by definition ways of talking about class and politics. The emergence of the Western urban proletariat and the working-class movement as a whole began therefore, to determine modern definitions of the mass. The rejection or affective celebration of mass culture has been that dialectic which has underwritten the development of the avant-garde in this and the last century. We can in fact see in the conflict between mass culture and high culture the very development of modern art this century.

This relationship, as historians such as T J Clark have argued, goes back to Manet's *Olympia*, which superimposed the popular sign, a pose borrowed from contemporary pornography, over Titian's *Venus of Urbino*. Similarly the Impressionists' defence of painting as a diffused play of forms is inseparable from the new spaces of commercial leisure created by the emergence of mass consumption in the latter part of the nineteenth century and so memorably encapsulated by Baudelaire in the figure of the *flâneur*. After the failed revolution of 1848 and the breakdown of classical bourgeois political culture, a reconstruction of traditional ideas of individual autonomy in spaces outside of the dominant institutions of society was developed, spaces where conspicuous styles of freedom were made

available (the beach, parks, the music hall, the promenade, the café). This shift was bound up with the increasingly advanced development of mass consumption; the internal conquest of markets required for continuous economic expansion.

The socialisation of new pleasures, the creation of a consumerist mass culture, was thus seen initially as a spur to the creation of a new independent identity for the urban-based early modern artist. By the use of illicit popular signs within the space of the high cultural, artists like Manet sought to carve out a new set of *commercial* pleasures for painting. High-art was revivified in the name of the contingent, unstable and ugly. This search for the demotic then can be read as the crisis of an autarkic, classical academy-based culture in the face of an emergent market economy and its contradictory forces – the increasing marginalisation of the artist under the weakening of his role as an official state functionary, and a demand for the representation of the new that could match the aspirations of the bourgeoisie. In effect the artist was being pulled apart, which is why the initial 'heroism' of early modernism with its grand public themes soon passed into alienation and retreat as economic necessity drove artists into the hands of the bourgeoisie – that umbilical cord of gold as Clement Greenberg was later to call it – and away from the audience that gave form to their pursuit of the demotic: the masses. The history of modernism this century is essentially a history of, or changing perceptions of, this dialectic, as artists have accommodated to mass culture, in the name of 'popularity' or 'access', or resisted it in the name of 'critical autonomy'. The development of modernism out of Cubism and Dada in fact is the gradual development by artists of the recognition that modern art is now by definition the negative of mass culture despite the incursions and bridging operations of individual artists. Manet's 'balancing act' has been impossible to sustain in a culture where the 'mass' no longer means simply art's mediation of collective pleasures but structures of economic and ideological control that isolate and fragment the production and reception of art irrespective of its contents. It is perhaps with Pop art that we finally get a recognition of this. For Pop art was, above all else, an attempt to bridge the mass cultural / high cultural divide by pushing art sympathetically and uncompromisingly into the spaces of the mass cultural. Negation was exchanged for a wry celebration, as artists in response to the great second expansion of mass consumption sought new images of the modern. In many ways Pop art reflected the final crisis of art's affective negotiation with capitalist

culture, just as Abstract Expressionism represented the final crisis of its negation as 'other'.

Crucially what I am arguing here is that with Pop art and the victory of mass culture over the negative dialectic of modernism, the mass cultural / high cultural dialectic was inutterably altered. For in rejecting the productive tension of this dialogue in favour of an adaption to commodity culture, it brought into view the breakdown of the pursuit of the commercial in art as a *democratising* move. In reality the demotic aspirations of Pop art were shown to be as politically marginal as the negating impulses of Abstract Expressionism. For what Pop art showed was that art, irrespective of its would-be popular contents, had been overtaken by those very social relations it claimed to be participating equitably within. Art, in short, was now structurally subordinate to a hegemonic, electronic mass culture, that, in consort with the style and fashion industries, was constantly mediating and commemorating its own pleasures. The idea of art mediating these new pleasures as a challenge to art's marginalisation was just bathetic.

Which is where we came in, for Baudrillard's rejection of the avant-garde's negative dialectic is also accompanied by a rejection of its conventional alternative: populism. What is at stake therefore is a changed conception of art's position within capitalist culture beyond avant-gardism and populism. Baudrillard though fails to define and elaborate on this because of his highly deterministic model. By implication he may be arguing that art needs to be seen as participating *in* the culture and not simply mediating it, but this is never translated into a projective and transformatory relation where meanings might be contested.

'Urban Kisses' and 'Simulacra' are thus very much contradictory in their approach to the mass culture / high culture dialectic. Recognising that a post-avant-garde art must immerse itself in those 'real cultural forces which affect our lives and mould our perceptions',[21] they nevertheless hold back (though less so in the case of 'Urban Kisses') from arguing for practices which openly contest the culture at the level of the sign. This result, particularly in 'Simulacra' is a view of the function of art within the spaces of mass culture as strangely akin to that of Pop, though without the sanguinity of that art. Art's function under consumer capitalism is not so much about the mediation or deconstruction of capitalism's world of desires and fantasies, but a site where these might be given independent corporeal form. The 'Simulacra' exhibition therefore

wants something more from the commercial found image than a reflection of our alienation or a celebration of 'shared values'. In effect it wants a loss of 'guilt' in front of mass culture if its entry into that culture is not to be grounded in moralism. By replicating what is in itself empty it seeks an authenticity – a recognition of the desiring powers of mass culture – within the inauthentic. It ventures into mass culture not in order to praise it or settle scores, but to confront it as something that shapes and determines our collective experience. Hence, talk of the 'Simulacra' show being a renegotiation with mass culture is in a way both true and false: true in that the world of popular capitalist culture is the dominant culture we inhabit, false in that, unlike Pop art, it does not seek any hypothetical unification of interests between fine art and mass culture as a whole. Unification implies a distance to be overcome that the work refuses to recognise. The problem though with this erosion of the distinction between high culture and mass culture is that questions of art's critical autonomy become formulistic. What is gained in terms of acknowledging the reality of the pleasures of commercial culture as the bounded place of art's production of popular meanings, is lost in terms of being subordinate to those meanings. Because 'Simulacra''s entry into the spaces of mass culture is predicated on the notion of the equivalence of all signs under late capitalism, it sees its job principally in terms of archeological retrieval. That is why in contrast to 'Urban Kisses' there is something almost funereal about 'Simulacra'. In seeking to preserve the sublime, the ineluctable, the mysterious, in that which has passed out of circulation, the art communicates a morbid feeling of renunciation, as if the only viable model or metaphor for the contemporary artist were the museum, of which he or she were the passive curator. 'Urban Kisses' may endorse a similar cultural pessimism at the level of capitalist rationality, but there the intercessions of language and irony at least render the reading of such identifications more unstable. However, this is not to say that the better art is in the 'Urban Kisses' show. On the contrary the paradox of a show such as 'Simulacra', which bases its aesthetic model on an exaggerated view of capitalist relations, is that it provides a stronger grasp on the ideological introjections of commodity culture. Adorno recognised a similar kind of problem some time ago; the problem still remains. Value cannot be read straight off from intention.

Notes

1. Jean Baudrillard 'The Implosion of Meaning in the Media' in *The Shadow of the Silent Majorities* (New York: Semiotext(e) 1983) p 103
2. Ibid p 142
3. Jean Baudrillard 'The Precession of Simulacra' *Art & Text* 11, Spring 1983 p 6
4. H Marcuse *An Essay on Liberation* (Penguin Books 1972) pp 58–9
5. Jean Baudrillard *Simulations* (New York: Semiotext(e) 1983) p 128
6. 14 October – 21 November 1982; Bluecoat Gallery 2 December – 7 January 1983
7. 23 November – 19 December 1982
8. Kierkegaard *Fear and Trembling and The Sickness unto Death* (New York 1954) p 158
9. R Barthes *Sade/Fourier/Loyola* (Hill and Wang 1977) p 10
10. Jean Baudrillard *For a Critique of the Political Economy of the Sign* (St Louis, Missouri: Telos Press 1981) p 93
11. R Barthes 'Theory of the Text' in ed. Robert Young *Untying the Text: A Poststructuralist Reader* (RKP 1981) p 39
12. Michael Newman 'Simulacra: A New Art from Britain', photocopied essay pp 2–3. Essay later published in *Flash Art* December 1982
13. 'If there can be a better way for the real world to include the one of images, it will require an ecology not only of real things but of images as well.' Susan Sontag *On Photography* (Penguin Books 1979) p 180
14. R Barthes *Camera Lucida* (Jonathan Cape 1982) p 118
15. Hal Foster 'New York: Seven Types of Ambiguity' *Brand New York* (ICA/Literary Review 1982) p 24
16. Baudrillard 'Precession' p 00
17. André Gorz *Farewell to the Working Class, An Essay on Post-Industrial Socialism* (Pluto 1982)
18. M Blanchot 'Two Versions of the Imaginary' *The Gaze of Orpheus* (Station Hill Press 1981) p 87
19. John Stezaker *Fragments* (Photographers' Gallery 1978) p 42
20. Newman 'Simulacra' p 8
21. 'John Stezaker interviewed by Ian Kirkwood and Brandon Taylor' *Artlog* (1979) p 14

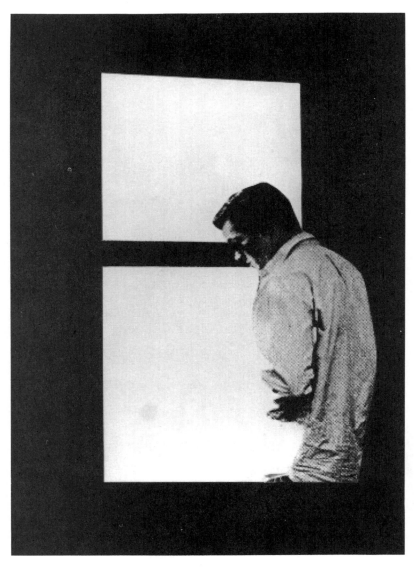

3. John Stezaker, *Window I*, 1979.

2

INTERVIEW WITH
JOHN STEZAKER

JR You have regularly used the modernist device of the colour field as an absence, a void if you like, but reclaimed it for representation. In the portraits we are presented with an absence against an absence, a moment of greatest potential for meaning, an ambiguous threshold of desire. You use the image to *capture* the spectator, but that capture is delayed, made mysterious.

JS I suppose in the end that is what I'm looking for in the trap for the gaze, something that is slightly more permanent than the passing poignancy of the source material that I'm scanning. I suppose in a way I'm trying to constitute a point of stoppage within the scan, to posit a point of contemplation in the image, but on the ground of what is passing away, beyond.

JR What kind of beyond are you talking about? Is this a sublime beyond? The beyond of the object that Maurice Blanchot claims the image follows?

JS I suppose I'm thinking more of a kind of beyond that is associated with something slightly less elevated; perhaps the other-world of the image and the culture of images. A certain kind of dread that I would associate with Blanchot – yes, a feeling of dread about the image. I think in the end that is what I look for. I like these threshold images. By cutting out the central object the void envelops the subject in some way. It's not a sublime void like Barnett Newman. You mentioned colour-field painting. In fact I have for years been influenced by Barnett Newman; I find him the most compelling of that generation of painters. There is something about the unsettling nature of his interests, something that makes you keep going back to look at them. I get the same feeling with Cornell. The Whitechapel

show of Cornell's felt like lots of little voids, there was nothing there to look at, you had to keep going back to make sure that there was nothing to see.

JR So you would see Barnett Newman and Joseph Cornell at opposite extremes of your investigations?

JS Yes, it's quite nice, the idea of merging the two though. Newman believed in the absoluteness of sublimity; for Cornell it was like a small cage.

JR Domestic and obsessive.

JS There is nothing beyond the image. In Cornell you get an uncomfortable sense of the form the imagination takes in its accommodation within the ready made. Barnett Newman tries to liberate you from that form. I suppose I feel as if I have the same aspirations as Barnett Newman, but in the end I don't believe that one can surrender oneself to the sublime in that sense.

JR Do you see your use of the sublime, your use of the colour field, as being ironic in any way?

JS Actually no. People could read it like that. I know one person in particular who thinks they are hysterically funny. I find that response odd, but I do acknowledge it. It is strange to see a silkscreened photographic head gazing at a gap between two canvasses. It could seem like a comment. But I don't feel as if I came about the image in that way. The allusion to irony suggests that I am bracketing my response, putting it in quotation marks. I don't think I am. I'm interested much more in the idea that the painting is a threshold of some kind, an image, and at the same time what interests me is the edge that separates that image from the real world. Barnett Newman wanted to engulf you in the picture space rather than draw too much attention to the edge. The subjective exchanges take place on the edge; I can't imagine exploring them in the absence of the image, because the image both places me in the painting and also excludes me from it. This is what concerns me rather than a sense of sublime unity between artwork and spectator. That abandonment is unreal to me at any rate. The contemplative halting I'm after confronts the stream of representation occurring around the image and through it.

In other words what I'm saying is – even Barnett Newman is mediated in the end. I don't think you can have those aspirations any longer, or rather you can have those aspirations but they have to enter into some relationship with our experience of the real world and of images generally.

JR This takes me on to the question of the addressee which is central to your work. Your early work was very much concerned with the *production* of the imaginary. In the captioned work and the photomontages you made the reading of the images difficult. To borrow a word from film theory, the collages and fragments addressed the spectator as a 'suturing' subject, the subject as the interpellator of the imaginary. In the new work this has taken a back seat, the fragment has taken on a more submissive, and as you say, contemplative role. The role of the spectator has changed accordingly. We are in a sense not asked to do so much 'work', we are both distanced from and compelled by the image.

JS You are linking two spheres of work and making a division. You are putting the new paintings and veils in a separate category from the rest and suggesting that there is something common in both, whereas I feel the moment of transition for me was actually in the mid-seventies when I stopped using captions. That is the one big shift that I feel has happened. I don't feel any real shift has taken place between the collage work on a small scale and the large-scale presentation of these through the paintings. The early caption work I was doing was the result of a practice that emerged in about '73. What it consisted of essentially was me collecting images.

JR Brian Hatton used the word deconstruction in his discussion of that work in his catalogue for the Luzern show.[1] What I'm getting at, was this part of your thinking in the caption work and collages?

JS No, because I have never believed in any position of objectivity, from which one could deconstruct. The captioned work generally tended to consist of collections of a particular image – 'The Pursuit' is the best known. This consisted of a series of ten travel and motor car ads. The one thing in common about the ten images was that they involved an individual dwarfed by a huge space. The intention at the time was that they should be billboard size enlargements, so that they could go all round the gallery, but I never realised them in this form.

I realised them instead in magazine space with a commentary which ran below. What interested me at the time was issues about individuality. What I used in the text below was my only way of representing a particular kind of attitude towards the individual which was emerging in my thinking. I was searching for what I considered – at the time I was reading Mercea Eliade – to be the imbedded mythology of everyday life, to use his own phrase. Around mid-1975 I went through a crisis in the work. I had been collecting a whole lot of images which seemed to me to need no captions at all – the captioning was becoming repressive to the ambiguities of the images I was looking for. So that's when I dropped captions completely. That to me was an important moment because that was an abandonment to the image, without saying I was going to dominate it, without there being any suggestion of commentary or deconstruction. Eliade said of the image that to reduce it to any one of its frames of reference (in other words captioning) was to do worse than mutilate it; it was to annihilate it as an instrument of cognition. The abandonment to the image was not though an intellectual realisation; it was a liberation from intellectual constructs. This, in the end, meant an abandonment of working in series for the particularity of the single found image.

JR I was thinking in particular of the *Vanishing Point / Vantage Point* series. At the time you talked about 'decentring' dominant forms of representation.[2]

JS Yes, *Vanishing Point / Vantage Point* was the moment of transition for me. I started getting interested in the idea of breaking up the picture space, which led into the collage work. I was becoming interested in the way the third person of narrative, of cinematic convention and of all kinds of pictorial imagery is a sort of centring mechanism, the sense that one's vantage point is locked into the vantage point of an idea or abstract impossibility of breaking with it. But this was much closer to Rilke. Rilke talked of the ghost of the third person.

JR And Brecht?

JS Yes Brecht was important for me at the time. But I didn't go along with Brecht on the production of a revolutionary art. I don't think I believed in that at any point. Or rather, I don't think I believed in the idea of a people's art. I still find that an extraordinary idea. In the end

I feel my work is apolitical. I can't imagine art changing a thing. I think art is more about a resignation to certain things.

JR But there is a world of difference between work being non-didactic and being non-political. It's strange to hear you say your work is apolitical.

JS Politics to me is to do with an equivalent kind of representation to that of pictorial representation. I am as sceptical of making a revolutionary break within society as I am of modernism's break with pictorial representation. I feel that there is probably a much more fundamental coercion, as occurs in looking at pictures; you essentially do the same thing which means you are not engaged in the image, you are not engaged in the action. Any form of political representation I find extremely dubious.

JR But hasn't your work been concerned with that coercion, with trying to break it down?

JS That's what you believe. I am not denying that my work has been concerned with these forms of coercion, but I don't think I've ever reflected a belief that one can break them. It sounds very pessimistic, well yes it is very pessimistic.

JR Jean Baudrillard has talked pessimistically of an 'implosion of the social'. The feeling I got from viewing the 'Simulacra' show was of a culture and of a politics turning in on itself, a closed world of signs. The show seemed to be lining up with Baudrillard in arguing that we can only talk about authenticity in art today in terms of the *inauthentic*. How do you see this?

JS It's very interesting for you to see the 'Simulacra' show in those terms. I can understand that, especially Jonathan's [Miles] work, but I never really looked at it in those terms, so it is difficult to put myself in your shoes. Baudrillard was talking about a *loss* of meaning; maybe the work is about the possible loss of meaning. Consumer culture does produce a disjunction from the past. Perhaps the 'Simulacra' work produces that shock of recognition by suggesting the reverse symbolic continuities with the past in consumerism. Continuity comes over as mis-reading – it exaggerates loss of meaning.

JR So, if we talk about this loss in terms of inauthenticity, are you arguing that the only site of the authentic today is in the inauthentic?

JS That was the realisation I had when I started out on this kind of work.

JR To go back to the original question, do you think by this you are making a political statement?

JS Perhaps it can be seen in that way.

JR Through that negation. Because I had the feeling that was the objection of a number of people to the show – that it was too negative.

JS Well, what can I say? It probably is too negative for somebody who is interested in some kind of solution to things. I just can't see art operating in those terms, in providing solutions to things or changing the world. I don't think it ever has and I don't think it can. I think what art does is more profound. It confronts realities which go beyond current possibilities, wished for realities. Hopefully it challenges one's perception of the world and one's being in the world. This is more fundamental than any kind of conceptual thinking that goes into, in quotes, politics. It can have political ramifications – sure – but it's very difficult for me as an artist actually to envisage those things; they are things that happen to the work or to me, and maybe they change my perceptions of it. The reaction in what one might call political circles to the veil pieces is irrelevant to me, because it is irrelevant to the concerns of the work. The work attempts to challenge those aspects of our relationship with our bodies, our relationship with other people's bodies, on the level of the image. Art must be a suspension of these relations which are the basis of everyday existence. I may be challenging things but I don't believe that I will actually change them, because I am engaging with certain structures which are perhaps inescapable. One always must push one's work closer and closer to what one thinks is the heart of things, and increasingly it has become a sphere so way beyond anything which could be affected by politicians that it is irrelevant even to think of it in the same sphere. It sounds like an art for art's sake argument but not in the formalist sense of professional autonomy. More than that art is nothing – its value is a punctuation of nothingness.

JR Why did you chose a female nude for the veil pieces?

JS I don't know what the reason was.

JR That it was provocative.

JS No, that was in fact what prevented it being produced much earlier. That is precisely what I want to avoid in my work. I don't want my work to be provocative or controversial on that conceptual level. To me that prevents people seeing things – they approach it within certain categories. I would much rather catch people unawares with my work. This is the way the work has to work on me in the first place. When I first started working on the things which eventually became the veils – the images were from a collection of nudist photographs in which I'd cut the heads off, which I started in '77 to '78 – quite a few people were very deeply offended, so I stopped showing them. I realised the works were offensive; they offended me in a way because they were rather *dreadful*. That is what interested me in them in a way, you could take an image that was used for pleasurable purposes – an image designed for a strong bodily connection (a masturbation aid) – and by isolating the object of pleasure – the body – and removing the head you could achieve the opposite. Cut adrift from the cultural references which are centred on the head (facial gestures etc) the bodies become like specimens. They were very shocking images, they shocked me, that is why I held on to them.

JR After you beheaded them did that draw you to the classical references?

JS No, that only struck me later – that we encounter classical sculptures as beheaded torsos. Initially the headless torsos seemed dreadful in their particularity. I had completely forgotten about them until this summer. Then I started playing about with one of the veil images by feeding it through a Xerox machine, using superimposition. It was through repetition that the torsos started to take on the abstraction of classicism. It wasn't classicism that initiated the series though. I had been impressed by Tiepolo in Venice. I wanted that over-fullness of the image, not a sense of classical proportion. It was still to do with the eye, but instead of the edge as a site of loss I wanted an overflowing of the image, in the way that Tiepolo's

ceilings overflow into the environment around them; I wanted them to completely envelop you.

JR Had this overflow anything to do with the photodynamism of the Futurists?

JS That is what really interested me that summer too. I became interested in Balla. But I think he is rather atypical as a Futurist. I find his work very interesting because of a strangely static quality. Very often in the late work – which nobody ever seems to look at – there is this double thing of stillness and dynamism. Obviously he is concerned with images on the move but I don't associate him with the rest of the Futurists and their more declamatory aims. He is a much more meditative painter than he is ever given credit for.

JR So what was your interest in movement in the motif in the veils?

JS I don't know whether it is an interest in movement. In the earlier work I emphasised stasis within the moving cinematic image. In the new work I have been taking something static and making it move. I recognised similar concerns in Balla but it happened after the fact – I came across a Balla illustration and I thought, my God, that looks just like the veils. This led me to look at Marey, who of course was an influence on the Futurists. I find some of the photographs amazing but all that is a bit tangential to the direction the work has taken since.

JR The Futurists were actually very down on Marey because he never showed those imperceptible movements between actions.

JS I didn't know that, I thought they were straightforwardly influenced by him. Marey interests me because he is that point at which the still photograph moves. My work has conventionally been about the reverse – the point at which the moving photograph becomes still. And it seems a similar connecting point, one which is concerned with the unity of the image and its fragmentation, its multi-faceted aspect. But the Futurists' view was obviously optimistic, a belief that out of this was going to emerge a new pictorial form or space. It was a vision of progress. My vantage point is much more terminal. The shifting reality that cinema has created is precisely the ground – the shifting sands – upon which I am trying to restore a point of stillness or contemplation.

JR This takes me on to the question of Romanticism. I've always felt – particularly in the recent canvasses – that you were recasting the symbolist image. In fact if I was to put your work into a category I would argue that it was symbolist, in that your work attempts to resist explication, that it's emblematic, meditative, deathly.

JS I've looked at a lot of Redon. I don't know about the Symbolists though. I'm curious what you mean by emblematic.

JR I was thinking in formal terms of the centred, isolated image. The Symbolists were very much concerned with the concrete image, with the exclusion of insignificant detail.

JS I've never really understood what Symbolism means though. I can't see what connects Redon and Moreau for example. That sounds like a good analogy. I felt a particular point of empathy with Redon in the late seventies when I moved from using exclusively black and white to colour. It was actually through looking at Redon's work – suddenly in old age he began to use colour – that I felt I needed a burst of colour. I was also looking at a lot of Munch earlier on, particularly the kiss pieces. I tend to find it increasingly difficult to think in terms of isms. I think they felt that they were at the end of something, a symbolic universe, in the way that I feel that we are at the end of something. Maybe what we are at the end of is consumerism; what they recognised was the end of a shared symbolic order. They were at the end of a particular relationship with the image, they were just encountering photography and the possibilities of mechanical reproduction. Certainly they were very aware of leaving a world in which the image could bear a symbolic / allegorical, as well as objective relation, to reality. I suppose what I'm trying to do in a way is revive that possible unity in terms of consumerism itself.

JR So you're recasting Romantic aesthetics within the scan of consumerism?

JS Yes, a recognition that mass culture is the destination of Romantic inspirations.

JR The connection between the image and death which was so central to the Romantics is important to your work and important to a great deal of recent painting and drawing in America, particularly

David Salle. It is interesting talking to David Salle that he refused to divulge the sources of his images. This desire for mystery, for foreclosure, this desire for self-protection, if you like, seems to be so characteristic of this view of the image being a kind of living death. Earlier you argued that images cannot be expressed in concepts.

JS Yes, our culture is an image culture and yet nowhere is the power of images allowed. Images are contextually forced into the linearity of reading. To de-contextualise images is to restore their essential ambiguity. This is perhaps the only freedom left to us. I find I can only use an image when its original use has been forgotten. The image then betrays something uncomfortable. Its strangeness is what you see. It is freed of use and can take you by surprise. But this isn't the freedom the Romantics saw in images – as spaces for the free individual imagination. These are the spaces of limitation. A restoration of freedom to these images is a recognition of a collective desire – this is the *beyond* of the images.

JR How do you think this projected freedom relates to the so-called renegotiation between the fine arts and mass culture? What place do you see these images as having in popular terms? What place do you want for them?

JS I don't have any neat answer to that question. I don't see my images as flowing back into the sphere from which they came but I recognise that the reality of mediation of any kind is an equivalent contextualisation, a channelling of images. What I'm searching for is more precarious. I don't recognise the dualism of high-art / popular art in the first place. That's what I'm trying to suspend in my work. My work puts me on that edge between the vantage point of the producer and consumer of images. Perhaps this can avoid the complacency of high art. But on the other hand I don't necessarily see the work occupying an equivalent edge culturally. In other words the works are not interventions in mass culture. Hopefully they are points at which these contexts of seeing are beside the point. Yet, of course they are contextualised – in galleries.

JR Do you think that this renegotiation between high culture and mass culture – admittedly more in American art than here – bodes for any fundamental reorientation of commitments? This takes us back

to this troubling notion of implosion. Are the fine arts literally imploding into mass culture?

JS I don't know. Perhaps we are approaching a point where such distinctions (between high and low art) will cease to be essential contexts for our encounter with culture. But this is speculation and I am producing art now. I am trying simply to open up a part of myself, as formed within this culture, which conventional modernist art training tries to repress. I am trying to open up my work to the horizons of images in general as they impinge on my life without separating them by the conventional reflexes of taste and distance. I may have put myself in the position where I'm parasitic on the media.

JR How much of this is a kind of hit and run tactic?

JS Not at all; on the contrary my relationship with popular culture is my relationship with my past, my upbringing, my way of seeing the world, it is absolutely everything to do with what I am.

JR It's indivisible from that?

JS That's its primary function for me if I had to ascribe a function to something which seems beyond functionality.

JR Right, that's what I was getting at. Mass culture is not something external to our lives.

JS But you seem to be interested in whether or not what I'm doing is something which is going to perpetuate that culture.

JR No, not perpetuate it, reorientate it.

JS I feel as though I am simply watching its decline. I am aware of this in terms of the images I choose. Once I've started collecting them they become very difficult to find. A permanent frustration I have with my work is that I am often following up images' sources which are dying out: photo romans, nudist magazines. They are no longer with us, no longer available. Maybe in some way I intuit that in my collecting activities. I can speculate wildly and conceptually on what I think the future might hold with a different form of mediation but I can only deal with what is given. That really is the vantage point of what I am doing.

JR You feel dread in front of mass culture?

JS Yes, and also that the image is a source of pleasure. The quality in the images which I pursue is difficult to define – perhaps it is the point where repulsion and attraction are unified. Maybe the dread is already implied in those containers of pleasure. Perhaps it's a sense of containment that dread creeps in. But it's not just dread it's also attraction, a desire to become engaged with an image for a long period of time, to allow the container to spill over, to overcome its limitations and actually become a part of one's life.

JR It is this living with images, getting to know images that perhaps separates the 'Simulacra' show from the current American work. Your images are far more considered, far less to do with a celebration of what it's like to live in a large city in the latter part of the twentieth century. Would you agree with that?

JS I always thought of my rather slow meditative relation to these images of turnover as being a perverse misuse of images designed for instant consumption. The American work certainly came up a lot faster, appeared much quicker and seems to be consumed in much the same way. I was excited by the work initially. It reassured me that my own wasn't completely out on a limb. But it hasn't developed that much. New York doesn't seem to allow that. You make your hit and that's it – from then on you have to repeat yourself. The English work has certainly evolved over a longer period. Though that's no recommendation in itself. Our work has been more marginal. This has in a way had its advantages – it's meant constant re-evaluation, though I envy the sense of flow which American production allows. In the end the English works reflect a different take on things. I think its tone is more pessimistic. There is more of a sense of the perversity in the English use of found images and perhaps of representing a terminal vantage point on consumerism. We've been out of it. The Americans from the first stirrings of the work seem to have been in the swim of the culture which they are addressing.

JR Circumstances are obviously different. Mass culture in the United States – particularly New York – appears indissociable from the everyday.

JS Yes. As artists we are remarkably cut off from the mass media. For example the only TV viewing that I do is watching films, and I usually cut the sound off so I can see the images better. In each case we [the artists in 'Simulacra'] take a strange and specialised attitude towards media images. John Wilkins spent a year and a half painting one tiny fragment of an image. It seems that the Americans work on a much faster production of images; they also use more of an admix of images. I think one of the dangers though is that a lot of that work seems to repeat itself, which is one of the things that it should be addressing.

Notes

1. Brian Hatton 'John Stezaker's Photomontage: The Image and the Cut' in *John Stezaker (Works 1973–78)* (Kunstmuseum Luzern 1979)
2. See *Vanishing Point / Vantage Points* (1976) in *Aspects* no. 2 (Feb–April 1978) pp 6–9

4. David Salle, *Zeitgeist Painting No. 4*, 1982.

3

INTERVIEW WITH
DAVID SALLE

JR What were you doing between 1979 – the time of your *Cover* article on your painting – and 1981, the year your work came to a wider audience through Tom Lawson's *Artforum* article 'Last Exit: Painting'?

DS At the time I was working on a series of paintings which, as far as I know, have never been shown. The paintings were a canvas stained a single colour with various images drawn on top in charcoal. The images tended to be a fairly consistent grouping of things, more or less hovering near each other, but not touching or overlapping.

JR This was after a period of minimalist / conceptual work?

DS Well, that's what often is assumed. Conceptual work has the ring of a specific kind of investigation and a specific historical time-frame and it is something I don't feel I shared or participated in. I feel in a sense that it was all over by the time I started to make my work. I don't feel my concerns were those concerns; my interests have always been imagistic. And that didn't seem to me to be the concern of Conceptualism at all. As far as Minimalism is concerned I have even a more remote connection. I see Minimalism and Conceptualism obviously as very closely linked – maybe one is just a further point on an evolutionary scale of a primarily American formalist way of thinking about art – but this was not only something I was not sympathetic to, historically it was not of my time. It was a completely different generation, a completely different set of *a priori*s of rules and desires. The kind of journalistic assumption is that first he was a Conceptual artist then he started to paint.

JR But all the same there was a certain conceptual input into the work.

DS Painting is not monolithic; there has always been in my frame of reference a kind of painting that has a self-reflexive nature, which Conceptualism shared. There is a way in which painting embodied or projected a kind of questioning, first of all the identity of the object itself and second, more interestingly, of the relationship between the viewer and the object, how that relationship could be changed, making visible the inherent subversiveness of the act of looking at a picture and having a picture look back. This was something I was thinking about from the time I started thinking seriously about art. The other thing I was thinking about was the idea of a presentational mode of address and the way images become visible. I think the thing I've always been concerned with is visibility, how a thing requires visibility. Which is perhaps another way of saying, why is it that we notice what we notice? Whether the work took the form of a video or a set of photographs, this is what interested me. In 1974 I started making very large works on paper – images were painted with a brush on flat rectilinear surfaces. The orientation was always to painting space, pictorial space, as opposed to sculptural space or purely mental space. Actually this so-called mental space turned out to be another kind of formalism. So I don't feel as if any break or shift has taken place in the work – it ranged around, tried out different guises, meandered for a while. Around 1976 I started making the first works on canvas that physically resembled paintings.

JR Where were you making these?

DS In New York. It wasn't necessarily my intention, to quote, start painting again, unquote, or to continue to avoid painting again. But I had been making these works on paper, they were getting destroyed because I was moving around a lot – every time you put them up on the wall they got ripped – so I made works on canvas, and then thought making works on canvas without stretching them made a statement about materiality which wasn't really interesting to me. When I stretched them I realised almost by default that I had in fact made a painting; I had almost 'backed' into it. They were paintings in a very provisional way, which was a way of thinking about what a painting is or isn't. Now I would think that really isn't what makes a painting anyway, and yet at the same time that *is* an essential ingredient, it is the kind of thing I've always tried to keep in focus even if it's sometimes in the background; the simple fact of the thing's existence as a thing was inherently mysterious to me or

inherently problematic or self-reflexive. But to me that was not theoretically different from my earlier works which involved tearing pages out of a magazine and putting them on the wall, somehow that alone had resonance.

JR Did the fact that these objects didn't look like paintings present a problem for you?

DS The non-paintings?

JR Yes.

DS No. There was no possibility of the work being confused with so-called 'painting concerns' about immateriality or surface or gesture. You have to understand this was all taking place in the context of mid-seventies New York in which what passed for art was primarily an exercise in craft or an exercise in private mythology or hero worship or all three combined. There was nothing in that which was holding my attention.

JR Who were you associating with at the time? Did you consider yourself as part of an emergent group then?

DS I was close with people who I went to Cal Arts with, most of whom had either individually or in small bands migrated by 1976 to New York. It wasn't such a homogeneous group, people were doing different things because they were different and distinct personalities. At that time I met Julian Schnabel whose work was probably about as far from mine as anybody I was close with at the time. His concerns were largely material, mythological, heroic, mine just weren't. People that I was intellectually closer to were James Welling, Sherrie Levine, Tom Lawson, Ross Bleckner, Barbara Kruger, Matt Mulligan. I think everybody was pretty depressed at that moment. There was very little recognition that anything that we were thinking about even existed. The stuff that we thought was real and interesting and provocative truly just did not exist for anybody else; it was like making invisible art. What is funny, what is interesting is how certain things have become highly visible, whilst other things have persisted in being largely invisible. Well, actually none of that stuff has *persisted* in being invisible – even the most stubbornly invisible art, Sherrie Levine's, has in fact become quite visibly controversial, at least in New

York. However, I feel that something essential about our work, including Julian's, is still largely invisible.

JR How equivocal are you about your images? You have referred to them simply as 'presentations'. Is this as neutral as it sounds in view of what you said in the *Cover* magazine article: 'I am interested in infiltration'? Tom Lawson emphasised this line in his article 'Last Exit: Painting', placing you, albeit tentatively, in the 'deconstructionist' bracket. On the other hand Donald Kuspit wrote recently: 'Salle's message is that there is no longer any inner necessity for criticality.' Has something happened along the way or are things as deterministic as Kuspit makes out?

DS Neither what I said in 1977 nor what Tom said a year ago nor what Kuspit said six months ago, sums it up, I hope. I don't feel any particular allegiance to something I might have published that was clearly, deliberately polemical. So, I'm not sure what you're asking me. Are you asking me has something in the work changed to allow people to be able to use different metaphors about it?

JR I'm asking you have your strategies changed?

DS I don't think I ever had any strategies and I don't think I have any now. It depends on what you mean by strategy. I have nine million little strategies, but you might substitute for the word 'strategies' the word 'ideas' or 'desires' to use a certain thing or do a certain thing. If that is what you mean by strategies then those change constantly.

JR But when you use the word 'infiltration' it implies a certain didacticism, a certain aggression.

DS Yes, but all of those statements, and particularly that one, are really to be understood in the most metaphoric way. I think this applies not just to my writing but to most writing produced by artists in the history of modern art. Usually the statements exist in advance of the work; they are much more shrill than the work itself. The Futurist manifestos don't have a lot to do with the painting, the same is true of Sol Le Witt's statements about Conceptual art. It's a kind of tradition. That is something to keep in mind. Now more specifically has the idea of infiltration changed? Don't think so. I could

still make that statement today, that I'm interested in usurpation and beating people at their own game, because what I mean by that is what happens when you look at pictures, which to me is fairly constant and part of my life, and has nothing to do with market acceptance or market rejection. That just doesn't apply. What has been implied in certain criticism is that market acceptance and the kind of criticality which the idea of usurpation implies are mutually exclusive, and I don't think that is true at all. I think that is really presumptuous. And anyway that is not what usurpation means, for two reasons: first it's not terribly interesting to usurp the power of the art market to begin with, because who wants it and what would you do with it if you had it? Secondly, the usurpation I'm talking about is really psychological. That's not so easily done anyway, and if it is done it is probably done for about six people at a time. It is the beauty of that which interests me and not the polemics of that. Disappointingly to some people my usefulness as a political critique of things doesn't go very far. My meanings are primarily aesthetic, which is to me not in any way having to settle for something. It's one thing to talk about the relationship between the political and the aesthetic; but it's not political in the sense that Dada was. My ideas aren't as simple as *épater* the bourgeoisie – it never was about that in my mind and if other people wanted to make it into that it's their prerogative but then they shouldn't be disappointed if it turns out it didn't fulfil any programme. I feel that my work contrives to deal with ideas of authority or agency in ways that most art doesn't and couldn't. It's quite complicated and not un-spiritual.

JR Your references are pan-cultural, anything and everything is worth taking and re-contextualising. But these moves are not indiscriminate. You enjoy manipulating certain codes, genres. What process of deliberation goes on?

DS The pictures may give an illusion of being pan-cultural, but in fact I think they are quite culture-specific in terms of most of the material. I've used Japanese calligraphy in my painting – I've gone totally Oriental – but that's just Orientalism as it appears in the West in 1982. It is the way things appear in reproduction, the way things appear through various forms of presentation, that's what is interesting to me. What I've recently refused to do is to identify all the different sources; the point is all the images come from somewhere, sometimes they come directly from things I've drawn or observed,

some of them are drawn from life and some of them are invented images – so-called imaginary images, which is a hilarious term in so far as what it discriminates against. It's not the case that they come from anywhere; to focus on *where* they come from is, I think, to make at this point a distortion about what it is they are all doing together. Basically, I am attracted to images which are either self-effacing or self-conscious or both. The way I used to experience it was: images which seem to understand us.

JR They're not surreal, they bear little relation to Lautreamont's umbrella on a dissecting table.

DS They are not cathectic in that hocus-pocusy sense. But it is interesting, just as an aside, that I've started to become very attracted to Surrealist imagery; the most recent painting has some quotations from Surrealist imagery. Ultimately I am not sure how I can answer the original question because even though the collecting or filtering of the images isn't automatic writing it is primarily intuitive.

JR But all the same there is a recurrence of certain sets of images: figures in bed, female nudes, consumer goods, animals.

DS Actually there are very few animals in the pictures. There is sometimes cartooning in the pictures. And cartooning takes as its subject almost always animals, because cartooning is about person-ification, it's about making personification visible. That interests me, so cartooning interests me. So sometimes there are animal images in the paintings, but that doesn't have much to do with animals, it has a lot to do with characterisation, personification. Anyway, I think the consistent ingredient about the selection of images and what to do with them once selected is a certain kind of erotic poetry. That's probably the only consistent thing I can focus on. Now what I mean by erotic has a direct relationship with the presentational. That probably is what makes my work my work.

JR So the images are not as cold as some commentators have made out.

DS Not in my mind. I'm not saying they don't appear that way, that the paintings ultimately don't have that attitude, but that's not the way the images appear for me to want to use them. The images are

about empathy. A lot of people are horrified to hear that. Because the images sometimes have a public source they consider them to be *a priori* debased or banal. I wish people could stop using that word. Probably one of the reasons why some people have difficulty with my work is because of that assumption which doesn't exist for me. It may exist for other images I don't use but it seems for a lot of people to exist for *any* image that doesn't spring full blown from the so-called imagination, or an image which is derived from what might be loosely called observation. But I'm not using images from either of those sources. I'm using images that exist on some level already and other images that exist already. That is not so different from what artists have done for a long time.

JR It has taken on a polemical force, whether you call it postmodernism or not.

DS Not just because of its use for the postmodernist but because of this other thing that you touched on which is that people see it as cool or detached or distanced. Which is not a contradiction – I'm not saying it couldn't be both, or couldn't be somewhere in between the two, or couldn't be about those things being the flip side of the same coin. But in my mind it is about the process by which something transforms itself from a point of empathy to a point of detachment and vice versa. It's that kind of reciprocity in one's emotional life which I am interested in. I'm not interested in making a statement about alienation, or any of that nonsense. What is interesting about that is that empathy by nature is very humble and very *humbling* and yet the depiction and presentation of it is somewhat arrogant. That is another polarity between which the work seems to run back and forth. I don't think it is something one would be even momentarily puzzled by in poetry. Yet in painting it is seen as something very unpainterly, almost unmanly. The reaction to it is very revealing in itself.

JR What you borrow, what you contextualise, functions *imaginatively*, it becomes a product of the creative mind.

DS That is certainly one of the ideas the work insists on. Yes, that's true. I think that too much emphasis – and it might be a fault of the work that this has occurred – is placed on the fact that these images have sources outside of the painting. As you say, ultimately it is

imaginative; the other thing to say though is that when something is drawn naturalistically it also has a source outside its own existence. The desire to do that is cultural; and more importantly, the way the patterns of meaning and communication that it will almost inevitably fall into are totally cultural. Anyway it is always the imagination that activates something – whether it's found in this pile or that.

JR It's a false distinction.

DS Yes, but it is not a totally false distinction; the distinction is only useful in a stylistic sense, not in a philosophical sense and yet somehow the distinction has been made philosophically and not even stylistically – and that's the point.

JR It is interesting that a critic like Craig Owens has got a lot of mileage out of this, but he's never written about your work.

DS He isn't smart enough to think about my work or anybody else's work. He doesn't really write about art in a very convincing way.

JR Your relationship with mass culture seems to be highly ambiguous. You neither celebrate it nor criticise it. It appears ubiquitous, unavoidable, simply there.

DS Consider someone who paints landscapes. Somebody who had recently been to Kiefer's studio told me that the view outside of his studio window actually looks like one of his pictures. He's basically painting what he sees outside of his window.

JR That implies a certain passivity in relation to your material.

DS I'm not sure that my relationship with things isn't in part passive. I think that a starting point is a certain passivity. We tend to use the work pejoratively, but I don't think that has to be the case. But the other thing I was going to say, which is actually the opposite, is that in a seemingly passive landscape there is a heavy amount of interpretation going on. Then again the interpretation is largely painterly, aesthetic information – what's left out, what's included, what's emphasised – which my work also does. It's interesting – an artist interprets a classical theme like landscape but is either passive or manipulative. This is a very old controversy. It is

easy to look at Edward Hopper's painting and say: look at those bleak desolate American landscapes. But maybe Hopper found them very beautiful, very moving. Is that passive? Is that highly interpretive? Is it both?

JR Your work has been accused of being solipsistic. How would you react to that?

DS I have no objections. The thinking in my work in some ways might be a meditation on solipsism. I'm not going to sit here and say solipsism is the issue of our time. The notion of solipsism does have a hard bitten resonance, just as the idea of inevitability appeals to me intellectually and emotionally.

JR Isn't that a very New York credo?

DS Well, isn't it very European to want to make it into an ideological issue? But you meant something else I think? What was it you were saying about my relationship with popular culture? It was ambiguous?

JR Well, that despite your immersion in it, you didn't have that much room for it; that it didn't really impinge upon you – it was there, obviously, but you could take it or leave it.

DS I don't have much relationship to it really. I'm seldom sure what people mean when they talk about it, which perhaps says something about my relationship with it.

JR I now have a long question, which hopefully will put into perspective some of the things we have been talking about. I have always felt the determinism and pessimism of recent American art has much to do with the power of the American mass media, a sense of estrangement that because of very different cultural conditions in Britain hasn't really taken root here. You once said you never watch television. Cindy Sherman reputedly watches television all the time. That polarity in response by artists has no real equivalent in Britain. There was a show recently at Riverside Studios of the work of John Stezaker, John Wilkins, Jan Wandja and Jonathan Miles, four artists who have been closely associated with the magazine *ZG*. As a British response to the found image, popular culture and the mass media,

it is quite different from recent American work. The interaction with the city, its energy, its disorder, is less marked, if present at all. The artists in a sense live with their found images longer. There isn't the same sense of pressure, of pushing, of profligacy. What I'm getting at here is this question of the artist's productivity, of finding a language and mode of address adequate to the density and variegation of forms and identities in contemporary culture. Like most young American artists using found images from media sources you use what is essentially a 'democratic' process – no matter how indifferent you are to them in the end. Images are transferred from source with the minimum amount of fuss. The painting is done quickly as if to replicate the speed of the modern absorption of images. This may have once been motivated by a desire for a disposable urban art, but now the market has stepped in – and you are a conspicuous success – how has this affected the terms of your productivity?

DS Why push *and* profligacy? They contain very different implications. There is enormous push in Barnett Newman and enormous profligacy in Ellsworth Kelly. You could say these are two qualities of American painting.

JR What I'm getting at is, do you find any conflict between your methods – the 'quick' painting – and the increasing demands of the market?

DS The way my work is used culturally – that is to say what it will come to mean for any given generation, and this needs to be said in response to the last question and the question before – bears directly on the conflict between this generation and the generation of Conceptualists and political literalists like Craig Owens. I don't feel necessarily that the life of my work in my mind is how it's going to be used in the culture. It goes without saying that I don't feel like a sloganeer or a pamphleteer, I feel that there is something about making art which is more complex and interesting than that. If you want to say that [places box of matches on the table] then the chances are the way to say that is not to put that there, maybe the way to say that is to put that there [puts cigarette packet on the table]. All kinds of other meanings enter the work than the one originally intended. What I attempt to do in my work is *really* control what it means and not just having it mean nothing in particular. You do not solve the question

of what is the nature of art by going up to art and asking 'what is your nature?' That is a category mistake that has generated an enormous amount of bad art and bad criticism. If I had to get up in the morning and define my relationship with contemporary culture – because I thought that was what my work was about – I wouldn't be an artist. And it doesn't matter if it is a slow plodding British artist or a fast, productive American artist. I don't think artists go about representing their culture by necessarily intending to do so. Culture doesn't submit to critique quite so passively anyway. If culture is anything worth thinking about it doesn't even hold still long enough for you to subject it to the tools of criticality such as they have been developed in the Graduate Centre of City University, New York. By the time they have applied their critical tools to it, it's not even there any more, it's further down the road. The confusion is a misapplication of means to ends, because of a confusion about what the ends are. The other thing is that the ends aren't the ends anyway.

JR What are your ends? Would you accept the label that others have given you that because of your essential scepticism about picture-making that you aren't strictly a painter?

DS Well, if those people would also accept that neither is Frank Stella, if they would say that about *him* then I would accept them saying that about me. Stella never really painted a picture, although he covered a lot of surfaces with paint. He just changed the terms of what painting he wanted to make.

JR Do you see yourself painting over the next five years? Because the feeling I get from following your work over the last two years is that you may stop altogether.

DS The idea of stopping has had a functional seductiveness to it for a long time. It lies within a certain idea of making art. The last picture – not needing or being able to do that anymore – has fueled some great work. But what we feel in our heads, in terms of possibility and potential, is sometimes a way of thinking about the variety of life, wishing your life had more variety. If I sit here and fantasise I can imagine doing a lot of different things, one of which would be making paintings in a naturalistic mode; it's something I think about all the time – painting what I see, which I did as a kid. And I also think about drying up and not having any creative impulses left anymore

and just trying to have a nice life or being a libertine. But in reality the work is probably going to continue along the trajectory that it has been continuing along for some time, to work in a relatively two-dimensional way with the complex juxtaposition of images. It depends on how you want to talk about yourself to yourself. You can say, starting tomorrow I'm going to turn over a new leaf and be a good person, although chances are when you get up tomorrow you are going to continue being the way you were today.

4

THE SUCCESS AND FAILURE OF SCHNABEL

The single and ineluctable question that faces criticism today is: do we interpret artworks on the grounds of the author's intentions and their institutional ratification or on the basis of some *causal* analysis of their conditions of production? Is criticism purely about piling up 'readings-in' or is it about asking why things look the way they do and the reasons behind how they got there? The choice would seem to be obvious: without a historical materialist analysis of the economic and ideological determinations of cultural production we are left simply with surface appearances and self-justifications. Moreover, this is not just an academic Marxian nicety, but an absolute imperative in an art culture increasingly given over to self-promotion and egregious art-talk. The troublesome counter-question though is of course: is such causal analysis enough? Does our 'laying bare' of the economic conditions and beliefs that underpin the modish claims of market *wunderkinder* indefatigably undermine or remove the work's aesthetic value? Can we be satisfied simply with the knowledge that the market has inflated a reputation? Can ideological critique historically remainder what we take to be unpalatable works of art?

It is these real and substantive questions of art criticism that hang like a pall over Julian Schnabel's work and career. In fact, it is *because* of such contradictions (the work's simultaneous invitation to reductive economic critique and the intractibility of its aesthetic interests) that has generated the massive furore around his painting. For despite the fact that the painting is the celebrated and high-prestige product of a regressive, hyper-capitalist American art culture, its visual novelties and transgressions remain genuinely engaging. This is why there has been such a polarisation in opinion over his work: nobody knows what to do with him. The trappings of mercantilism and promotional hyperbole have abrogated discussion of much of the work itself. However, this is not to say there aren't problems with the paintings,

. but that Schnabel's *succès de scandale* and undeniable fascination for many, point to qualities in the art that are more than just residual. In the light of his 1986 Whitechapel retrospective show[1] therefore, I want to look at Schnabel as a kind of vivid problem or test-case for criticism.

Schnabel was born in 1951. After a period of travel in Europe in the mid-1970s he had his first one-man show in Germany in 1978. The following year he had his first one-man show in New York at Mary Boone's. The rest is history. A meteoric rise in companion with the new European painting placed him at the centre of Europe and America's refocus on painting. His media-catching bravura – imposed as much as courted – created an instant point of critical reference against which this emergent culture of painting, and its detractors, could measure itself. Everybody had an opinion on Schnabel. As a consequence Schnabel became something of an ideological football. Valorised by the defenders of a heroic modernist legacy (Picasso, Pollock) and vehemently denounced by the theorists of a critical post-conceptualist postmodernism respectively, he came to figure Janus-like as both a figure of painterly redemption and the last-ditch guardian of a masculinised, Romantic expressivism. The brickbats and plaudits from the early 1980s make interesting reading. Tom Lawson accused him of 'bombast'.[2] The Holy Ghost Writers (the pseudonym of four women art critics and curators) dubbed him 'Julian-the-hero-of-Male-Creation' in an article that compared his variegated appropriation of sources to the Counter-Reformation.[3]

> The counter-reformation began in XVI Century following the Council of Trent, which was called by the Pope to develop strategies to prevent the expanding stronghold of Protestantism. One of its main forms of persuasion was the use of the emotional religious images which characterized the Baroque – ecstasy, maternity, martyrdom – to counteract the Protestant prohibition of imagery and idolatry ... Schnabel's [painting] is to Modernist practice what the counter-reformation was to Protestant iconoclasm.[4]

Schnabel as capitalist idolator – strong stuff! Likewise Peter Fuller in one of his splenetic moods makes no bones about how morally reprehensible Schnabelism is. Schnabel's imagination is 'acned and adolescent: at best, it is John W Hinckley Jnr stuff, sick, immature, sexually unsavoury, strung up on a few improbable, external cultural hooks'.[5] Moreover, Fuller goes on, he has the aesthetic touch of an 'incompetent washer-upper'.[6]

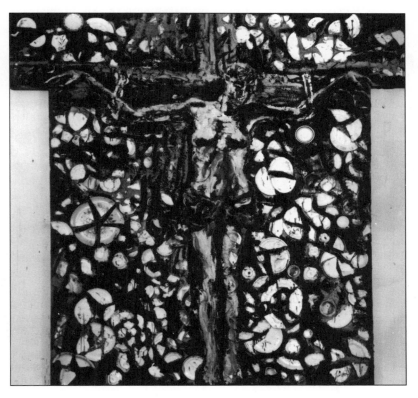

5. Julian Schnabel, *Vita*, 1983.

If Schnabel is an amoral high priest of boyish virility and adolescent self-aggrandisement for these writers, to his supporters he is a figure that has 're-invented the artworld',[7] a figure whose 'Promethean hubris',[8] to quote Stuart Morgan, is just 'what we need'[9] in the wake of the dulled and rational sensibilities of Conceptualism's legacy. 'If Julian Schnabel hadn't existed it would have been necessary to invent him'.[10] Such sharp division in opinion and eagerness to rhetoricise clearly points to the view that here is an artist whose motivations and works have powerfully focused the conflicts between a retheorised and confident painting and the emergence of a new-media critical postmodernism.

Now that all the self-interested noise over such arguments has died down what is first and foremost interesting about the Whitechapel exhibition is that our picture of Schnabel can no longer be reducible to the stereotypes of the neo-Expressionist painting versus deconstructionist photography debate. In fact, in contrast to a number of his American peers and European *blut bruders* Schnabel's work in the interim period stands up surprisingly well. In a space of a few years, as his painting has taken on a greater variety of modes, the original context in which the work was received and debated – the marketing of artistic alienation – appears increasingly impoverished. Far from looking like the product of an overweening self-regard the painting actually foregrounds some of the problems and contradictions of making large-scale, ambitious painting in the West in the latter part of the twentieth century. The prodigiousness, the protean use of materials and images, in a sense 'sort out' – or attempt to 'sort out' as I will discuss later – the resources available to serious painting today. As such, Schnabel's work *looks* remarkably modern, a view that Schnabel himself has been at pains to emphasise recently in the face of the 'painting as Counter-Reformation' critique. 'I don't think about neo-Expressionism, it doesn't exist. I'm a modern artist.'[11] And it is very much on these terms that the recent Whitechapel show has been organised; an attempt to recontextualise Schnabel as a figure who is at the centre of discussion on the modern *in* painting and not some unreconstructible revisionist or maverick. It is at least gratifying therefore to see a painting show that sets up a strong sense of painting as a *transitive* medium, as a medium open potentially to new content spaces.

But on what terms can we speak of Schnabel's work as modern? And on what grounds might such terms be said to be acceptable or adequate?

Schnabel's formal success as a painter undoubtably lies in his extravagant and inventive intertextuality. His energetic adoption of a post-Rauschenbergian combinatory aesthetic in which diverse materials and images are fused clearly marks out a kind of watershed for what constitutes successful image making in painting today. As with many other intertextual painters, albeit ideologically combative in a way Schnabel is not (Art & Language, Terry Atkinson, for example), there is no going back to a purely *descriptive* narrative realism or reasserting the autonomy of the expressive mark. Painting today under *post*-late-modernism's post-avant-gardist negation of the myth of the 'vigorously original image', and the necessity for painting to reclaim some expressive mobility faced with the sheer supplementarity of visual material in our culture, is an incontrovertibly impure and self-conscious business. The artist in a sense if he or she is to participate in the life of images, has to render painting a place of creative incursion and instability. Schnabel says as much in an interview in 1986:

A lot of Americans still don't understand that it was Beuys who instigated the current shift in art. They think it came from reductivism and minimalism and painting being dead and resurrected – but I'm talking about an involvement with materials. The issue of whether it's sculpture or a painting is obsolete, as well as the difference between abstraction and figuration.[12]

As such, it can be argued that Schnabel's art is at the centre of an extended modernist or postmodernist problematic that has located a deep uncomfortableness with representation as a stable or transparent source of meaning. In so far as appearances have no sufficient link to the real and in so far as the interpretations of images are open to a supplementarity of readings, representations of the world are held to be merely rhetorical; we cannot *know* the world through picturing it, we can only imagine it, it is argued. Schnabel's combinatory aesthetic is a high-tension treatment of this familiar 'crisis of representation'. In this sense although we are confronted by a prodigious maker of images – an 'omnivorous maw'[13] to quote the American poet René Ricard – the unsettled, oblique and indeterminate nature of the process qualifies the art as a product of loss and failure: Schnabel the vertiginous maker of follies. In connection with this, in the early 1980s Schnabel referred to painting as a 'bouquet of mistakes';[14] recently he has referred to painting as a process of abandonment.

In each work, you must be able to forget who you are. You have
to *forget* that when you make a work of art. Now that sounds like
bullshit but if you can't forget all the stuff that you knew ... I mean
you take everything with you to the point where you're equipped
for a task but you must let go all that stuff of who you are ...[15]
People *do* make paintings of ideas, and I think you know who the
painters are ... There are limits to that because at a certain point
what you're doing with your body and what you're doing with
your head doesn't gel, and it's inertia.[16]

Intertextuality for Schnabel therefore is an appropriative process
which is very much a hit and miss affair; what 'works' is down to the
frisson produced by the meeting and superimposition of disparate
images and materials. That this is not a *wholly* ad hoc process or
expressionist *élan vital* is of course self-evident when we begin to trace
the recurrence of certain motifs (bodily fragments for example),
formats (the doubling of the picture space *pace* Rauschenberg as a
metaphorical bed) and images (broken classical columns). The
collision of images and materials is clearly a collision of cultures. But
nonetheless the semiotic exchanges of intertextuality for Schnabel have
little to do with transcribing an external and knowable world; the only
'story' Schnabel tells is the sceptical one of a continual failure of 'fit'
between representation and reality, artwork and cultural effectivity.
And this of course is where Schnabel's modernism has been secured:
in an equation between representation as loss and the modern sense
of history as a piling up of ruins and fragments. It is this conserva-
tive-postmodernist theme – history as inchoate – that is extensively
elaborated upon in the Whitechapel catalogue by Thomas McEvilly.
Schnabel's aesthetic discontinuity and fragmentation – broken
columns, bodiless heads and shards of crockery – reveals history as
an 'archeological rubbish dump',[17] invoking the 'brokenness of
cultural norms in the late modern world.'[18] 'Time is present as an
ocean of ruins falling away from the past upon the present.'[19]
However, if the paintings allegorise history and Western culture as
junk heaps of fragments, for McEvilly Schnabel is not concerned to
present this (as in de Chirico and recently Kounellis) as a loss of vision
and faith in the evolutionism of the Enlightenment project, but as the
record of an historical process that has always and *ever will be* without
reason. For Schnabel 'there is no past state in particular to lament or
any future state to bend one's effort to attaining.'[20] Thus, taking up
the central anti-progressivist leitmotif of post-structuralism McEvilly

sees Schnabel's aesthetic of discontinuity as involving us in a world of unregularisable difference in which human identity is seen as 'lacking essence and coherence'.[21]

Whether Schnabel agrees or disagrees with such an interpretation such a meeting between the familiar idealism of American criticism and the indeterminacy of Schnabel's intertextuality as a inward looking response to the lacunas and tragedies of modern history produces a vivid sense of the modern in Schnabel as a distinctively American phenomenon. For the sense of formal ingenuity in Schnabel's work may be real enough, but its epistemological under-pinnings remain firmly entrenched within a post-war modernist tradition whose vaunted materialism has been, on the whole, largely contemplative in its relation to the question of the place of knowledge in art. Thus even though Schnabel's work aspires to a historical vividness it is not difficult to see the continuity between his aesthetic of abandonment and the agnosticism over political meaning in the work of Rauschenberg, Cage and Johns. The aleatory, anti-expres-sionist character of post-1950s American modernism was very much a moral position, in so far as the pursuit of the adventitious and arbitrary approximated the heteroclite nature of reality far closer than any form of figurative representation. Schnabel inherits these moves and upgrades them, if you like, to the level of an anti-historical history painting. In fact he pushes such moves firmly back into the space of high-art and high culture. In Rauschenberg, Cage and Johns the art object was always produced with a degree of scepticism, the unwarranted but unavoidable result of artistic sensibility and technique. For Schnabel, firmly committed to extending *painting's* resources, there is little embarrassment about the status of the object; which is why Schnabel's art also looks to that other side of post-1950s American modernism to embolden his expansionist aesthetic: the use of scale and novelty of material to carry a degree of cultural authority. Schnabel's appropriation of a vast array of exotic cross-cultural and art-historical images, and eccentric use of 'non-art' materials (crockery, tarpaulin, animal hides, velvet) are projected as 'advanced' materials in much the same fashion that the new industrial materials used by Robert Morris and other sculptors in the 1960s were claimed to be 'advanced'. Schnabel uses found images and eccentric materials as an extension of painting in the same way Morris used the new industrial materials to extend the affective range of sculpture: to defamiliarise the object–body relationship. Schnabel's painting then is clearly about unlocking painting from a set of rationalistic or expressionist

conformities that are no longer able to compel or enthrall the spectator in the same way. Schnabel's blurring of conventional distinctions between painting / sculpture, figuration / abstraction is about wresting a new diction from object / image relations.

And this is where we might speak of the success and failure of Schnabel. For although Schnabel does generate a great deal of novel detail and effect we are being given a variation on a familiar American modernist theme; the artist as the 'free floating' consumer and 'mouldbreaker'. Thus despite the debt to Beuys and the acknowledgement of Brecht's foregrounding techniques (the crockery strikingly dramatises painting as a fictive act) the singular characteristic of Schnabel's art is a refusal to place the spectator in a determinate relation to the social world. We are given history but no historical circumstances, as if a recognition of determinate historical place or detail would loosen the mythologising powers of the artist to create a coherent imaginative world. The artist's powers of imaginative reconstruction must be given their 'captivating' say; history must be at the *artist's* disposal if that history is to remain vivid. Now this is not to say that Schnabel is an arch-formalist – on the contrary Schnabel has insisted that the juxtaposition of materials and images is made in the hope of the transcendence of their facticity – but the images and meanings are destined to serve a constituency which is cynical, apolitical and anti-rational. For who does the work's sense of a past without reason and a future without reason actually address? Whose interests are in the best position to use and internalise such a 'falling away from the future'? A metropolitan New York art audience of course, fed on a conservative American intelligentsia's conflation between the fragmented life-world of late capitalism with the end of reason in history. As Raymond Williams has said, this link has become the routine, adaptive modern aesthetic of the late capitalist world:

> The originally precarious and often desperate images – typically of fragmentation, loss of identity, loss of the very grounds of human communication – have been transferred from the dynamic compositions of artists who had been, in majority, literally exiles, having little or no common ground with the societies, in which they were stranded, to become at an effective surface, a 'modernist' and 'postmodernist' establishment. This near the centres of corporate power, takes human inadequacy, self-deception, role playing, the confusion and substitution of individuals in temporary relationships, and even

the lying paradox of the fact of non-communication as self-evident routine data.[22]

Is this a fair estimation of Julian Schnabel though? Is Schnabel's work that detached and cynical, that in thrall to the pessimistic diversions and confirmations of paranational commodity exchange? Well in one sense yes, for Schnabel's painting with its valorisation of aesthetic abandonment, points to a freedom from any social justification that is the product of a white, male, middle-class metropolitan American milieu that is extraordinarily *protected* through wealth and power. But in another, eventually more rewarding sense, no. The work clearly is not to be remaindered that easily through ideological critique. For despite the adaptation to a particularly conservative world view this world view is in no sense nostalgic. In its indeterminacy it seeks no refuge in the past; Schnabel cannot be compared to the recent Italian neo-classicists with their vulgar pastiches of styles. Schnabel is not a languid stylist, or Arcadian dreamer; we are not being given some uptempo American version of *Brideshead Revisited*. On the contrary there is something unquestioningly striking about Schnabel's 'irresponsibility' that taps into our collective uncertainty about the intractabilities of the historical process, and it has to be said the place of high-art in the culture as a whole. There is something genuinely compelling about how the churned surfaces and palimpsests visualise the theme of homelessness. As images without refuge they adhere to a certain realism, a realism that no doubt artists like Rauschenberg, Cage and Johns would say was part of their tradition. And this is why in the final analysis his images continually recall us to historical realities, because there is a point where the indeterminacy passes over from the cynical to the redemptive and to the communication of human *vulnerability* (rather than human inadequacy). Schnabel dramatises and indulges the pleasures of melancholy.

Notes

1. 'Paintings 1975–1986' 19 September – 26 October 1986
2. Tom Lawson 'Sandro Chia' *Artforum* (Summer 1981) p 91
3. Holy Ghost Writers 'Condensation and Dish-Placement' *Real Life* magazine, no. 9 (Winter 1982/3) p 12
4. Ibid p 13

5. Peter Fuller 'Plus ça change ... ' *Art Monthly* no. 59 (September 1982) p 8

6. Ibid p 8

7. René Ricard 'Not About Julian Schnabel' *Artforum* (Summer 1981) p 80

8. Stuart Morgan 'Misunderstanding Schnabel' *Artscribe* no. 36 (August 1982) p 49

9. Ibid p 49

10. Ibid p 45

11. 'Julian Schnabel in conversation with Matthew Collings' *Julian Schnabel: Paintings 1975–1986* (Whitechapel 1986) p 90

12. Ibid p 92

13. Ricard 'Not About' p 77

14. Schnabel quoted in Ted Castle 'A Bouquet of Mistakes' *Flash Art* (Summer 1982)

15. 'Julian Schnabel interviewed by Stuart Morgan' *Artscribe* no. 44 (December 1983) p 16

16. Ibid p 17

17. Thomas McEvilly 'The Case of Julian Schnabel' *Julian Schnabel: Paintings 1975–1986* (Whitechapel 1986) p 15

18. Ibid p 15

19. Ibid p 15

20. Ibid p 16

21. Ibid p 17

22. Raymond Williams 'Culture and Technology' in *Towards 2000* (Chatto & Windus 1983) p 141

5

LOST IN SPACE:
PETER HALLEY

Peter Halley currently has something of a 'radical chic' reputation in New York. As perhaps the most 'politicised' of that group of neo-geometricists[1] who have emerged in the wake of the market success of Salle, Schnabel and Kruger, he has established himself as a defender of the continuing critical possibilities of abstract painting. Central to his defence has been an attack on recent reductions of modernism to idealist readings of post-war abstract painting. In contrast to conventional formalist accounts of modernist development he offers a semiotic interpretation of the history of abstraction in terms of allegories of social control. Disaffirmation or analogue of technological control this century, abstract art indexes what he calls in his *Collected Essays, 1981–87* a 'real progression of the social';[2] the changing relationship between art and technological space, the self and mass culture.

These ideas are expressed in their most extended form in his *Collected Essays* in 'The Crisis of Geometry'. Thus, he argues, the 'transcendentalist' abstractions of Malevich, Mondrian, Rothko and Newman were essentially attempts to 'normalise' the omnipresence of the geometric in Western technological culture; geometry became vague utopian prefiguration of social unity; signs of modernity's would-be reconciliation of object and subject. Op art likewise celebrated modernity, in its adoption and transformation of the visual codes of modern production. It is with Minimalism, though, that we begin to see a breakdown in this trajectory; modern art's relationship to modern technology is no longer seen as a relationship of imagined or potential sublimity but of a realm of 'mundane' facts: the uniformity and seriality of modern industrial production. Sixties counter-culture and the burden of consumerism opened up a *non*-transcendental engagement with technology. The key figure in this change for Halley is the late Robert Smithson, whose work offered

an anomalous meeting between the 'idealised geometries'[3] of high modernism and the coercive realities of late capitalist culture. It is Smithson's land installations that expose the point where geometry in art moves from the status of social projection to that of social threat. Today geometry in art is no longer so 'innocent'[4] he contends, no longer filled with that affective progressivist spirit.

The crisis of geometry for Halley therefore is a crisis of its powers of signification in the face of the growing strength of systems of 'social control',[5] of 'technologies of surveillance, normalization, and categorization' ('Nature and Culture').[6] In fact, 'Now that we are enraptured by geometry, geometric art has disappeared' ('Deployment of the Geometric').[7] The geometric has come to invoke a world of disenchantment and powerlessness, spaces through which action and behaviour can be channelled and controlled.

This reading of technological development in terms of social constraint is of course hardly novel; contrary to Halley's very elided history it has been a commonplace of bourgeois opinion and sociology from the beginning of the nineteenth century onwards. The development of capitalist relations, as Marx was the first to notice, has been structurally accompanied by a Romanticist view of science and technology as the suppressors of subjectivity. For Halley, however, something *qualitatively* different has taken place in our relationship to technology over the last 20 years or so; the increased 'geometricization of the social'[8] (urban planning, electronic digital-isation) has displaced our relationship to nature and the real. With the growth of mass communications and the extended employment of microtechnology at work and at home, the geometries of techno-logical power and speed have come to assert a dominant imaginary relation over the social, signifying the final loss of immediacy between subject and object, the public sphere and human intimacy. In this sense the post-war search for the 'primitive' through art (Art Brut, Tachisme, Abstract Expressionism) and its extension into the 'tribal experience of real-live art'[9] in the 1960s and 1970s (Conceptualism, performance, body art) can be read principally as a symptomatic response to this loss. Contemporary critical practice therefore for Halley, if it is to be an adequate index of the culture, should visually register the force of these geometries. He describes his own work as follows:

> In my work, space is considered as just such a digital field in which are situated 'cells' with simulated stucco textures from

which flow irradiated 'conduits'. This space is akin to the simulated space of the videogame, of the microchip.[10]

6. Peter Halley, *Two Cells With Circulating Conduit*, 1986.

Halley's writing, as should now be clear, is greatly indebted to the carceral metaphors and analyses of post-structuralism's critique of Enlightenment thinking. His *Collected Essays* is mostly a top-down application of the critical categories of Foucault and Baudrillard to the history of geometric art. If this leads him to a crude functionalist view of social relations, it also leads him to a crude functionalist view of art history. In line with post-structuralism's historical nominalism and discontinuism, he constructs a grossly stagist view of art history in which one aesthetic paradigm subverts another. Thus in the 1930s we had Marxism–realism, in the 1960s phenomenology–expressionist abstraction and in the 1980s post-structuralism-simulation. The main plank of this discontinuism, consequently, is its insistence on a qualitative change in the function of representation. Under conditions of extended social control and the 'collapse' of the Enlightenment project, the artist 'stresses the manipulation of what already exists.'[11] But more of this in a moment.

In essence Halley's writing is characteristically American in its idealist analytic claims. Like many American cultural critics and artist-theorists his writing and art is predicated upon the theory of

reification and commodity fetishism; with the expansion of the commodity form it is the ideological power of capitalism that secures the domination and subordination of the subject. It is no surprise therefore that Foucault and Baudrillard play such a large part in Halley's writing and have had such a large influence on culture and art in the USA in the 1980s, for their diabolistic theories of social control seem to verify the extended alienation of the subject under an image-saturated late capitalist USA. The received framework from this perspective is of a particular hegemonic form of capitalism in which all social identities are mediated and articulated through consumption. As one leftist American social scientist has put it: 'Domination cannot be theorized from the point of view of the labour activity, of the subject acting on matter to produce things'.[12] Post-structuralism's view of the post-1960s West as the epoch of image-domination, simulation and the 'end of the industrial', have therefore found a ready audience in the USA where the heritage of the Frankfurt school has maintained a sizeable hold on the left and found a sympathetic hearing from the intellectual right.

Beginning from a theory of reification Halley's writing presents a familiar kind of technological determinist tragedarianism. Faced with the power of systems of ideological control and technological dominance all that is left to the artist after the 'protests' of transcendentalist abstraction and the anti-commodity politics of the late 1960s and early 1970s is to simulate and stage the mechanisms and structures of control. Talking about the painter Ross Bleckner, he asserts that the 'reality of disillusionment may also offer the possibility of transcendence' ('Ross Bleckner: Painting at the End of History').[13] The question of resistance becomes an ironic fall from the pretence of resistance. Or rather, ideological critique, unable to move beyond bourgeois horizons, presents the object of negation without commentary. Ironic detachment in effect, as Adorno says in *Minima Moralia* 'resigns itself to a confirmation of reality by its mere duplication.'[14] Art becomes a reflection of the dominant order and gainsays nothing beyond it. This is ostensibly the basis of Baudrillard's aesthetics: bourgeois ironism. In Halley's writing then, as in Baudrillard, ironic detachment takes on a specific historical role as a post-avant-garde mode of address. However, in Halley this is attached to a broader and more open estimation of the demotic side of this detachment.[15] For Halley the fall from resistance is also a positive falling away from any overburdened historical role for art.

Thus it was the loss of scepticism in modern art that led the way to idealist readings of modernism, to the over-rehearsed claims of Greenberg's defence of abstraction in terms of 'quality' and 'taste'. The final collapse of modernism into the canons of the high cultural in Greenberg made the link between the demotic and Modernism a memory. As such Halley turns to the sceptical Modernism of Ortega as the basis for his semiotic reading of abstraction. It is Ortega's argument that art has 'no transcending consequence[s]'[16] that has been lost to the high culturalist turn of modernism. But has it? Halley's use of Ortega just seems arbitrary. What of T J Clark, John Willett, Art & Language and a host of other writers who have sought to make explicit the historical relationship between scepticism and modernism, not just in terms of an Ortegan liberal, elitist distanciation, or bourgeois irony, but as an essentially *critical* and *transformative* relationship? One gets the impression that Halley stumbled across Ortega and said: 'that'll do!'.

But of course we ask too much. To acknowledge the historical depth of this *counter*-modernist tradition is to step over from crude theories of reification and social evolutionism into the complexities of *social formations*. Ortega in fact serves him very well. Quite simply, any reading of cultural production that begins from a theory of reification inevitably collapses different and contradictory relations into a given social formation; relations are derived from a pre-given whole rather than in terms of antagonistic ones forming a complex structured unity. Halley would no doubt be surprised to hear his methodology described as Lukácsian / Hegelian (in formal terms at least), but that is exactly what his totalising link between cultural artefact and social formation is. The detail comes to express the whole. In fact so strong is his Hegelian capsizal of agency into structure – for Halley artistic production follows on changes in the superstructure which follow on changes in the base – that there is even no space given in his history to those artists with whom his position might have some common interest: the ideological deconstructors.

Why should the pull of a theory of reification and sub-Hegelian notions of the 'expressive totality' be so attractive to American artists and theorists? For some writers such as Donald Kuspit (who ironically is no stranger to the theory of reification himself), the attraction is seen in terms of the putative seriousness it promotes: 'Baudrillard's notions have been heard before, if not in such elegant formulaic form. They probably have such appeal in the artworld because they promise the artist great significance with little effort.'[17]

This cynicism may be widespread, but the pessimistic lure of a 'total system' view of capitalism covers more general material considerations. As a number of writers on American culture and politics have pointed out, one of the principal reasons that the theory of reification, or the 'dominant ideology thesis' in its contemporary form, has such a hold, is the general weakness of independent organisations of the American working class, which Mike Davis has referred to as the product of the extreme fragmentation and 'disorganisation'[18] of the American working class, and the consequent distance of intellectuals from the labour movement as a whole. As Terry Eagleton has argued, discussing Fredric Jameson (another victim of reification theory), American intellectuals have not had the 'consolation of a militant working class movement'.[19] 'That political absence leaves its scar.'[20] And that scar precisely is an inflation of commodification at the expense of history and politics.

> The unusual popularity of the various Hegelian inflections of Marxism in the US is surely to be seen, not only as a particularly appropriate 'answer' to a thoroughly commodified society, but as part of the problem – the reflex of a condition in which the commodity bulks so large that it threatens to obfuscate, not only bourgeois social relations, but a specifically political and institutional understanding in areas of the left.[21]

However, this is not to say that there is an easily available organic link between intellectuals and artists and the labour movement in other Western countries, but that the specific circumstances of the development of the USA's working class, its increasing privatisation in consumption, has led a large number of intellectuals, writers and artists to short-cut the political by linking the ideological directly to the experiential. In this sense Kuspit is at least right: what metaphors of closure provide is a ready made theoretical armature for a politics without politics.

Is there anything worth retaining then from Halley's essays? Well in a kind of subfusc way there is; this requires us to return to the question of representation. As with many writers working within the terrain of post-late-modernism, Halley's response to the crisis of modernism is framed by a 'second-order' definition of artistic practice today. This, it might be argued untendentiously, remains the consensual theoretical basis of any progressive practice today. There can be no return to unproblematic defences of 'reflection' and 'free-

expression', the twin shibboleths of the social realist / American modernism axis. Halley's sense of the crisis of authenticity, originality and the real acknowledges this. Yet, because of his stagism and weak sense of social formations as subject to contradictory forces, he cannot move such insights beyond the most fixed and pre-ordered of concepts. Thus, rather than locating this new critical agenda in the mobile terms of the critical transformation / reworking of signs or a politics of parody / allegory, he refers to it, following Baudrillard, in the most static of language as a process of hyperrealisation. 'Each era becomes a hyperrealization of the preceding era, which in turn is assigned the value of reality.'[22] 'One may see Cubism as a hyperrealization of Cézanne, or Cézanne for that matter as a hyperrealization of Courbet.'[23] The moves open to artists are judged solely in terms of the recasting of received conventions of the Western avant-garde; criticality remains essentially an inter-art concept. Which is why his own art looks so narcissistic and bathetic. Hard edge abstraction is reclaimed to trivially signify confinement and normalisation.[24]

The price of this approach of course is a fundamental contradiction. Because Halley's theorisation of the social subject is so attenuated, the question of a 'second-order' practice looks no less 'autonomous' and 'idealist' than the modernist and realist thinking he criticises. By simply substituting the high-modernist ideology of 'free-expression' for a version of expression 'beyond the historical will of the artist'[25] he merely exchanges one formalism for another. But this Manichean opposition between subject and structure is all of a piece in Halley's determinism. Consequently it is no surprise that Halley's hyperrealisation is defended as a paradigm that claims to break with a notion of representation as intentioned critical transformative activity altogether, because if our systems of social control *are* so powerful then clearly a relational definition of the sign as without 'truth or falsehood'[26] would seem to be the best opportunity for matching the world. The artist, locked into art history and the commodity structures of late capitalism, must find his or her aesthetic resources from within the codification of exhaustion and closure. There must be no incursion of signifying material that might render such a self-confirming circle unstable, if the viability of the reality of the paradigm is to be retained. In a strange inversion of history what Halley presents is a mimicking of Mondrian from a dystopian position. Mondrian looked towards an anti-expressionist abstraction as a utopian prefiguration of the death of representation. Halley courts the death of representation as the death of the social itself.

Nevertheless, despite this cretinism Halley's general turn to abstraction as a source for art's 'second-order' renewal does at least need to be acknowledged as important in recognising how signification actually works. If meaning is determined by understanding use and not just an act of recognition, as Voloshinov and Wittgenstein put it, then the conventions of abstraction are as available for political 'recoding' as is figuration. The supposed necessary connection between politics in art and figurative resemblance is wholly spurious (as the modernists recognised). Halley doesn't actually phrase it like that, but the implications of his writing would point in that direction. Thus despite my reservations about his painting, I don't want to identify the projective aspects of his allegorisation of abstraction completely with his reactionary sociology and idealist historiography. On the contrary there remains interesting work to be done in this area. The idea of 'abstraction' as an index of social relations is highly suggestive.

In summary though, the weaknesses of Halley's writing, as with all hermeneutically centred writing like post-structuralism, is that cause and effect and the cognitive constraints of the 'better argument' get turned over for the free-floating realm of metaphor and analogy. Setting out to remap geometric art, Halley ends up looking *lost* in space.

Notes

1. Peter Schuyff, Philip Taaffe
2. Peter Halley *Collected Essays, 1981–87* (Bruno Bischofberger Gallery, Zurich 1988) p 195
3. Halley 'Statement' in *Collected Essays* p 25
4. Halley 'The Crisis in Geometry' in *Collected Essays*
5. Ibid
6. Halley 'Nature and Culture' in *Collected Essays* p 72
7. Halley 'Deployment of the Geometric' in *Collected Essays* p 130
8. Halley 'The Crisis in Geometry' p 102
9. Halley 'Nature and Culture' p 64
10. Halley 'The Crisis in Geometry' p 102
11. Halley 'Nature and Culture' p 69
12. Mark Poster *Foucault, Marxism & History: Mode of Production versus Mode of Information* (Polity Press 1984) p 53
13. Halley 'Ross Bleckner: Painting at the End of History' in *Collected Essays* p 60
14. T Adorno *Minima Moralia* (NLB 1974) p 211

15. 'Intuitive Sensitivity', Meyer Vaisman and Peter Halley interviewed by Claudia Hart *Artscribe International* no. 66 (November/December 1987). 'Other people should be doing what we do. Not necessarily making art, but thinking about culture in this way. It should not remain restricted only to a few specialists, but should become more and more opened up. This can happen when the artist does something that is accessible, that's involved with thinking and reflecting on things. I believe this approach has its roots in Duchamp.' (p 39)
16. Halley 'Against Post-modernism: Reconsidering Ortega' p 36
17. Donald Kuspit 'Barbara Kruger at Mary Boone' *Artscribe International* no. 65 (September/October 1987) p 76
18. Mike Davis *Prisoners of the American Dream* (Verso 1986) p 8
19. Terry Eagleton 'The Idealism of American Criticism' in *Against the Grain: Selected Essays* (Verso 1986) p 63
20. Ibid p 63
21. Eagleton 'Fredric Jameson: The Politics of Style' in *Against the Grain* p 75
22. Halley 'Notes on Abstraction' in *Collected Essays* p 177
23. Ibid p 178
24. See Donald Kuspit 'Young Necrophiliacs, Old Narcissists: Art About the Death of Art' *Artscribe International* no. 57 (April/May 1986)
25. Halley 'Notes on Abstraction' p 179
26. Halley 'After Art' in *Collected Essays* p 115

6

ENTANGLED IN IMAGERY:
TONY CRAGG

Through the 1960s and 1970s it was sculpture on the whole which gained prestige for British art abroad: Moore, Hepworth, Caro, King, Long. A vigorous post-war modernist mainstream, and a long line of individual achievement, had established a strong base-line against which new sculpture could measure itself. Therefore it is perhaps no surprise that British sculpture continues to be in such a strong international position today, though this mainstream is now very much in disarray. During the seventies the final collapse of New Generation abstraction (part to part construction) under the competing claims of the new 'humanism' and 'post-object' work, ushered in a number of different 'schools': mimetic figuration, process work, symbolic / allegorical tableaux, rustic totems, and of course trans-category work, performance and installation. However weak the current formalist doxa was in terms of numbers, it had assumed a level of professionalism (technical capability) that refused – in the face of what it saw as literary or pseudo sculpture – to submit to self-criticism. The contradictions of this position became insurmountable. If much of the avant-garde work at the time (Bruce McLean, Gilbert and George) was playing on the pomposity of its teachers – and little else – today its fundamental scepticism could be said to be paying dividends.

Richard Long of course remains a seminal figure in this process of transformation. Extra-studio based, site-specific, non-hierarchical in its use of materials, Long's sculpture operated – like a good deal of American sculpture at the time – in the face of conventional notions of craft and aesthetic unity. The performative, diagnostic nature of the work though, was somewhat different from the prevailing materialism. For Long, Carl Andre's dictum that 'the work must be experienced in terms of its material presence',[1] was always a way of speaking about other things. His forays into the

landscape were, and continue to remain, greatly indebted to ecological thinking: the recollection of 'unspoilt' pleasures.

In the late 1970s in Britain Long's pastoralism came to represent everything that had gone wrong with British sculpture. It became the apotheosis of institutionalised modernism: blank, aloof, repetitive. The emergence of a neo-primitive figuration and a kind of anthropomorphised object began to gain ascendancy. Advanced sculpture began to look back to go forward – a return to 'universal themes' (the mother and child), the strong profile, and the pedestal. On the basis of a return to 'first principles' this work sought to rescue some sense of corporeality for sculpture through the revival of traditional modes of sculptural production (casting and carving).[2]

In other recent work though, the re-engagement with the object has taken on a more critical, less defensive line. Instead of rejecting the legacies of Minimalism and Conceptualism it has re-negotiated their terms. What Minimalism and Conceptualism opened out for sculpture in the 1960s and 1970s, and what the new figuration and anthropomorphism has determinedly tried to close down – discredit as 'decadent' to borrow a familiar epithet of Peter Fuller[3] – was an expanded or contextual space. Even though the new British sculpture stands in direct antithesis to the terms of this given in Minimalism (it completely rejects the visual implacability of the late modernist object) it sees the interdependence of spectator, site and sculpture as fundamental to any adequate deconstructive interrogation of the status and functions of objects. This was what was at stake in St Martin's art school in the late sixties when Bruce McLean, Richard Long and Gilbert and George were there, and is what remains at stake today.

Although the strategies of Long and the material self-sufficiency of the new sculpture tends to get overemphasised, the new sculpture has the same geographical or extra-gallery impulse, in that it openly creates or introduces a world beyond itself by introducing 'alien' material into the familiar context of the gallery. The terms of this reclamation though have completely changed. In the new sculpture the high critical status accorded to process in Long's sculpture – the collecting and arranging of materials – is not adopted as a means of 'communion' with a 'non-alienated' reality, but as a meditation on the conditions of alienation itself: on consumption. Reclamation from the natural world has been exchanged for urban recycling, the city for the landscape.

'Pillaging' of the urban environment of course played a large part in the language of Pop sculpture, and in many respects the new sculpture acknowledges this tradition, but it takes no part in its conventional Expressionism or Symbolism. The new sculpture reintroduces us to the industrial artefacts and materials of our culture not as *symbols* of alienated consumption – as if capitalist culture was in some sense external to human needs, rather than a distortion of them – but as the signifying material of a shared culture that for better or worse we are a part of. Found objects and materials are re-presented as collective *signs*. Moreover, in contrast to Long's Romanticism, the discarded consumer object is displayed as that which has reached the universality of the natural itself.

Like the recent American critical postmodernists using mass cultural sources, the new British sculpture could be said to be working out of a convergence between Conceptualism and the popular image. And it is in the predominance of one over the other (or rather the extent to which popular images and signs serve concepts) that the new work diverges. For, although there is a tacit agreement that they are working in a similar area, have similar interests and have left similar things behind, the work is in no sense a movement or homogeneous in style or ideas. Tony Cragg's emblems and figures and Bill Woodrow's cutouts have a strong, in a way ethical commitment to process. Jean-Luc Vilmouth and Kate Blacker veer more over to Surrealism and illusionism respectively. Cragg and Woodrow are engaged with a politics of the object, Vilmouth and Blacker with the playful transformation of found materials and objects into anecdotal or humorous 'set-pieces'. (Though this is not to say that Cragg and Woodrow are not also involved with the playful manipulation of materials and objects.) On the whole what unites the work is the recycling of materials and objects and general use of metaphor and metonymy. Just as British poetry in the late 1970s and early 1980s has reacted against the 'clear, plain rigorous language of the Americans',[4] recent British sculpture has begun to secure a high level of imagism. But just as there are important differences in outlook between, for example, the 'Martian' vision of Craig Raine and the decorous word play of Christopher Reid, so there remains crucial distinctions between the way Cragg and Woodrow and Vilmouth and Blacker approach the image. In many respects it is on the critical strength of Cragg's work that the others have found their feet. It is on this basis that I want to look at Tony Cragg's work in detail.

By virtue of its emphasis upon *placing* rather than *fabricating*, Tony Cragg's work is much more indebted to the deconstructive impulse of 1970s avant-garde sculpture than the other new British sculptors. As with work which owes its aesthetic allegiance to the anti-illusionism and site-specificity of Minimalism and Conceptualism, Cragg's technical absence from the production of the work – his reliance on the discrete prefabricated unit – sets the terms of discussion. 'Cragg-the-scavenger' is not a theatrical conceit or a decorative aside, but the very basis of his commitment to a sculpture which operates across categories. What is important is not so much that the fragments once on the wall or floor represent chaos transformed into order, but that they mark a passage from one network of production and consumption to another.

Michael Thompson in his book *Rubbish Theory*,[5] in which he sets out to examine the social determinations of what we call rubbish, divides the possessable object into three categories: transient, rubbish and durable. Artworks are the only class of objects which pass from the category of transient to the category of durable. Once designated durable, they never slip back into the categories transient or rubbish. Cragg foregrounds this process by conferring, on transient objects that have dropped into the category of rubbish, durable status. In effect we see these three stages simultaneously. This process though is not foregrounded in classic modernist terms to confront the power of the art-context or subvert the boundaries of 'good taste' (the work doesn't titillate by declaring itself anti-art), but in order to address the social and cultural determinations of those object-categories. The very act of recycling becomes a means of interrogating – not aestheticising – these distinctions. But what is to be gained from breaking down these distinctions? Primarily a sense that just as rubbish in the right place, or wrong place (in the middle of someone's lounge) serves to define what is socially acceptable or unacceptable, the re-presentation of found materials and objects in a gallery can serve to redefine the boundaries of what we take to be the social and political meanings of sculpture. Cragg asks some fundamental questions. How much less real are the artefacts of mass culture than the high cultural ones that seek to render them transient? What is the relation between the artificial and the 'authentic'? What is the relation between the transient and the durable? Cragg is basically concerned with the 'social malleability'[6] of objects, with their passage as signs from one social category – one network of production and

consumption – to another. What happens in the process is where the interrogation takes place and the political readings begin.

The view of the artwork as a process or the residue of an event has been basic to avant-garde initiatives throughout the 1960s and 1970s. When Jacques Derrida set the terms for deconstruction in 1967 by declaring, in his critique of anthropology and the human sciences, that 'the centre had no natural site, that it was not a fixed locus but a function',[7] he could well have been laying the ground for contemporary sculpture. Disruption, heterogeneity, fragmentation, in essence a movement back and forth across the possibility of some 'centred structure', has been the condition of sculpture since Minimalism: a sculpture which has posited the residue of an event – be it relatively small scale in the work of Richard Serra or large scale as in the land art of Robert Smithson and Michael Heizer – as the inescapable and powerful source of a new expanded sculptural language; a language that is materialist in expression, extra-studio in vision and anti-humanist in ideology. Tony Cragg's work takes its place within this tradition.

In so far as deconstruction was an attack on anthropomorphism, sculpture at the time emphasised texture, weight and volume at the expense of representation. But this diagnosticism soon found its natural limits. Despite the liberation of sculpture from the ethnocentric bias of the monument, the radical fragmentation of form led to a radical *depopularising* of sculpture. The regulation and repetition of discrete elements became prohibitive, an end game, a set of terminal moves which finally descended into decorum and neutrality – what Carl André has called assertively in connection with his own work, 'significant blankness'. Tony Cragg's work has managed to break through that decorum and neutrality without breaking with the materialism of Minimalism. In other words Cragg has brought the deconstructive initiatives of Minimalist sculpture and Conceptualism back into a social and representative mode without resorting to conventional notions of 'skill' and 'good form'. But how has Cragg achieved this? By subordinating the event not to the 'natural' language of lines and configurations as in André or Long but to images – popular images. Cragg recycles objects as components of a system of three-dimensional image making. In effect he 'draws' with objects.

In the early work though Cragg is still very much working under the constraints of late modernism. Nonetheless we begin to see the framework for this breakthrough being built. The stacking pieces, *Untitled*, 1975, and *Untitled*, 1976 (organic and natural refuse piled into

large 'sandwiches'), are 'borderline' sculptures; they emphasise formal values while at the same time deconstructing the idea of the autonomous object. What is happening here, as in Cragg's subsequent work, is a meeting between structure and process. In this instance though the result is not pictorial but volumetric. It is not until Cragg disperses his materials and objects on the floor that the work takes on its familiar pictorial form. There are three stages to this development. First, Cragg disperses the materials and objects into gestalts on the floor (*New Stones – Newton's Tones*, 1978). He then develops these into images on the floor (*Redskin*, 1979) and finally images on to walls (*Blue Moon*, 1980). An aspect of this shift from volumetric form to pictorialism is Cragg's increasing use of plastics and other synthetic material. Not only has Cragg shifted deconstructive sculpture into a representational mode, but he has introduced a new set of terms and context for its elaboration; the production of a sculpture which is based on the preconsumed unit.

What Cragg has done, if we accept this deconstructive reading, is to explode one of the key critical categories to dominate sculptural thinking over the last 15 years: the nature–culture opposition. The move outside the gallery into the landscape during the sixties and seventies (Long, André, Heizer, Robert Smithson) was a bid to secure a new home and new set of critical contrasts for art, an attempt to arrest the so-called split in our culture between feeling (perception) and intellect (cognition). Hence the determination of many artists to produce works or events in nature which symbolically addressed this split in sensibility – even André, who despite his anti-Romanticism nonetheless saw his materialism as rooted in the natural world.[8] Cragg is working from the opposite direction. His re-presentation of artefacts from the urban landscape is not directly concerned with our emotional and physical exclusion from nature, but an acknow-ledgement that our relationship to the freedoms nature supposedly holds out are increasingly mediated ones. No longer a Primordial Wilderness or Garden of the World, as its boundaries are pushed further and further back by urbanisation and capitalist competition, nature has become a spectacular backdrop for tourism and the voyeurism of advertising. As Cragg says in his statement for the Documenta 7 catalogue in 1982:

THE IMAGES. CELLULOID WILDLIFE, VIDEO LANDSCAPES, PHOTO-GRAPHIC WARS, POLAROID FAMILIES, OFFSET POLITICS. QUICK CHANGE,

SOMETHING NEW ON ALL CHANNELS. ALWAYS A CHOICE OF SECOND-IMAGES. REALITY CAN HARDLY KEEP UP WITH ITS MARKETING IMAGE.[9]

Cragg has embraced a 'second-order' means for sculpture to deal with the integration of nature and culture. Instead of concentrating on the nature–culture opposition as something to be transcended or modified by ordering the natural world, Cragg elides the opposition by ordering the artificial as if it represented the natural. Cragg presents us with a fait accompli: *perception is always already cognition*; nature is consumed *as* culture, and vice versa.

Thus, it could be said that Cragg's reclamation of found materials is at least in one respect similar to the reclamations of Long. The extension of the environment into the gallery becomes a form of nature study. But of course in Cragg's case the idea of 'nature study' is reversed. Cragg's nature is synthetic. It offers nothing beyond its own materiality, no intimations of sublimity or transcendental freedom, no place where we might be free of the mediations of representation.

These ideas are first explored in a coherent way in the piece *New Stones – Newton's Tones.* By extending the idea of selecting found objects into sets, first presented in the *Beach Object* pieces of 1970, Cragg confers on various coloured plastic objects the semblance of naturalisation. In fact, as the title puts it emphatically, the idea of 'order in nature' which art has traditionally mimicked, is here cancelled out by a new language and conception of the aesthetic: the artificial. This is directly related to all those modernist initiatives this century, from Schwitters' bus ticket collages to John Chamberlain's crushed automobile sculptures, which have stressed the need to examine what we take to be unaesthetic. But Cragg is telling us more than that there is beauty to be found in detritus. The distribution of plastic objects and shards into the colour modulations of the rainbow changes their disparate and incurious consumption into the universal and assertive pattern of a new aesthetic and cognitive relationship with the material world. Hence Cragg's use of the mass-produced unit as something that – like nature in the manner of its operation – abounds in copies.

Cragg's break with pure-deconstruction (Serra, André, Long) thus rests precisely on the construction of a set of terms for sculpture which operate within the 'inauthentic', within the culturally pre-constrained and conceived. In this his work echoes, as I mentioned earlier, the appropriative and deconstructive turn of recent American and British

painting, photography and drawing. Cragg's work is clearly part of this emergent culture of the recycled image and sign. However, as a sculptor, as a gatherer, arranger and sorter of found *materials*, Cragg's appropriative aesthetic should perhaps be best seen as specifically a form of bricolage, given the term's emphasis in Lévi-Strauss's well-known definition – defined incidentally, against the analytic operations of engineering – on the manipulation of objects and materials that have been previously been used or consumed.[10] Bricolage of course also played a large part in the Pop-influenced assemblages of the 1960s, but it served very different ends. The assemblages of Eduardo Paolozzi and John Chamberlain for example recycled junk material as monuments of the heroic pleasures the new technology and mass consumption afforded. These artists looked to the manipulation of industrial waste as an indicator of surplus – even if they presented it in a grotesque form. Technology, under conditions of the post-war boom (1950–73) seemed to hold out so much for the rational control of the world. As an artist excavating the technological advancements of this period, Cragg's approach is more critical. By presenting technology in a fragmented state, by not recycling its products into what might be called industrial statuary, Cragg has closed down those heroic vistas of crisis-free growth. In fact as a British artist who has produced his work in a country whose economy, because of its particular history and place within the world market, has suffered through the early 1980s recession more than most, it could be argued that Cragg's art is given an extended profile by the continuing retraction of Britain's manufacturing base. However although it is important not to lose sight of this national context, the value of Cragg's engagement with technology and its products lies on a more general terrain: a recognition of the way technology continues, despite its distortion under capitalist relations, to change our awareness and expectations of the world. Thus the idea that we have lost a 'community through nature', or some other state of well-being through our over-reliance on technology – something which is fundamental not only to Richard Long's and Carl André's interventions into the landscape, but to much of the recent appropriation-based art – is not an issue in Cragg's work. Cragg's mediated images may denote a loss of immediacy in perception, but this is always a consequence of the material at hand and never a source of nostalgic longing for a world before modern technology. We never feel that the past is dominating the present. As the artist declared in the catalogue for Documenta 7: 'I AM NOT INTERESTED IN ROMANTICISING AN EPOCH

IN THE DISTANT PAST.'[11] Cragg's forays into the urban landscape may continue the image of the artist as a doomed mediator between the world and the gallery, but this cannot be separated from the transforming nature of the process itself. By reworking the discarded products of our industrial culture he metaphors the very transformation of our industrial culture as such.

If a Romanticism of the past has nothing to do with Cragg's archeology of the object, Cragg's work nonetheless possesses a self-conscious primitivism – a sense of things set within given limits. For what distinguishes Cragg's bricolage from other new urban-based sculpture is its adherence to pre-set limits. Lévi-Strauss defined the methods of the bricoleur as follows:

> His universe of instruments is closed and the rules of the game are always to make do with 'whatever is at hand', that is to say with a set of tools and materials which is finite and is also heterogenous because what it contains bears no relation to the current project, or indeed to any particular project, but is the contingent result of all the occasions there have been to renew or enrich the stock or to maintain it with the remains of previous constructions and destructions.[12]

Cragg exaggerates these restrictions into a system. Because the current project remains the same throughout Cragg's work, the means employed to achieve this remain the same also. The materials are always applied in the same way, with the same end in view. Although he carefully selects his material (with regard to colour, size, shape, condition, etc) their individual *sign value* does not redefine the completed piece. All the material is interchangeable. This is not the case with the bricolage of Bill Woodrow, Kate Blacker and Jean-Luc Vilmouth. All manipulate materials (albeit perfunctorily), all use found objects and materials for their particular visual qualities. There is a far greater sense of making do with 'whatever is at hand'. In contrast by working within such strict limits, Cragg is focusing on the notion, to follow Lévi-Strauss, that the self-definitions and models of bricolage are essentially mythological, pre-scientific. Lévi-Strauss sees bricolage, like mythical thought, as 'imprisoned in the events and experiences which it never tries of ordering the re-ordering in its search to find them a meaning.'[13] In Cragg's methods there is a corresponding conformity. If we take the idea of the primitive totem

or sculpture as our model, Cragg's system of building from the 'remains and debris of events'[14] embraces a similar mythological dimension. By building up primitive sets (emblems, figures) from the pre-consumed artefacts of mass production, Cragg projects a world of meaning constructed on correspondingly reduced lines: a world of copies and phantasms. But of course in Cragg's case these pre-constrained messages are the result of advanced technology: the media of television and film. This is most evident in a series of large-scale wall pieces completed in 1981: *Postcard Union Jack*, *Soldier* and *Submarine*, the most overtly political images Cragg has used. These images close down meaning to the exchange of clichés; politics are reduced to the manipulation of crude signs.[15]

Cragg's basic sculptural conceit then is to use the 'primitive' intuition of bricolage, the collection of 'oddments left over from human endeavours',[16] to construct a primitive mythology of signs. Thus the idea that these remains are also ideological debris is absolutely central. We stand in front of these figures and emblems in much the same way the Celts stood in front of their hill figures (Cerne Abbas for example) or the Trobriand islanders in front of their totems. We are addressed as captive spectators. In these terms the passage from production (the gathering and sorting of the objects and materials) to consumption (the scale and seductiveness of the images) establishes Cragg's bricolage as a commentary on a world in which objects are defined not by their use value but by their exchange value. Cragg's restriction of his sculpture to the recycling of found plastic objects should therefore be seen not simply as a critique of over-consumption, but more especially of the reification of the object under prevailing social relations. Cragg becomes the anthropologist of the late capitalist primitive.

Extra-studio, non-anthropomorphic, anthropological, Cragg's work is a rich confluence of ideas both inside and outside the land-art tradition. His use of the cultural fragment – its re-presentation as social commentary – owes a good deal to work outside of sculpture. But Cragg is one of the few sculptors to give this direct and accessible form. The use of plastics, as something both colourful and demotic, has given Cragg's work its vivid aspect. Generally if one was to identify where the success of Cragg's work lay, and that of the other urban-based British sculpture, particularly Bill Woodrow's, it would have to be in the promotion of a ludic sensibility. What is important about all the new urban-based work is that it has taken on the imperatives of play: openness, humour and simplicity. The belief that

humour could say serious things in sculpture has rarely been seen with such surety in Britain (with the possible exception of early Barry Flanagan). However, as a manipulator rather than a constructor of objects, Cragg's moves in this area remain far less exaggerated.

His project of 'search and find' has very little to do with the 'visual ruptures' of the other work: their manipulation of the banal and commonplace as a source of the mysterious and unexpected. His sense of playfulness is far more strategic. In Cragg's sculpture the sense of discovery-through-materials – and here we can now assimilate playfulness to Cragg's bricolage – is limited rather to the pleasures afforded by the regularised distribution of elements through space, in much the same way a child would compose a simple structure or image from building blocks. The parameters of the project determine the limits within which the imagination can transform materials. It is therefore perhaps more accurate to describe Cragg's playfulness / bricolage as a kind of mapping. It is important though to distinguish between mapping in a general sense – the mapping of areas of the gallery through the distribution of objects – and mapping in a conceptual sense, a movement out from the fragment or detail, to the whole.

Mapping of course was essential to land-art. By working in the landscape the artist overlaid the terrain with his or her 'signature'. The artist-as-designator though has nothing to do with Cragg's extra-studio pursuits. His object-placements are not 'place-memories', imagined or otherwise (unlike say Bill Woodrow's), they don't recall a site or location. On the contrary they are abstractions, in the sense that the mapping out of discarded consumer objects and plastic shards into images becomes part of a larger map; ideology, politics, economics, society itself. By using the mass replicable unit as the basis for the production of large-scale mass replicable images, Cragg extends our awareness of the work from a microscopic, or local event, to a macroscopic one. As with the Celtic hill figures, there is a deliberate intention on the artist's part to use scale as a means of mapping out the power of the image beyond its physical limits. Just as the hill figures were supposed to be seen aerially, extra-terrestrially by a deity, Cragg's figures and emblems acknowledge global systems of control. As ubiquitous and universal as the materials from which they are made, Cragg's shorthand images belong to the satellite and cable TV of an expanded world communications market.

This conceptual extension of space is given a specific geographical dimension in some of the recent work. In *Spiral*, 1982 and *S*, 1982,

7. Tony Cragg, *Opening Spiral*, 1982.

the arrangement of large boxes, containers and pieces of wood into a set of descending size mimics a city skyline, whereas the works which use plastic fragments assert their presence through their reproducibility – the fragment serves a more stable function: as a specific commentary on the ad-hocness of modern urban planning as a kind of anarchy. The image of the city becomes a metaphor of the free market. All the same, whether Cragg's mapping of space is local or global, what is important is the emphasis this conceptualism places on the critical, interpretative act. The spatial metaphors of the work address the spatialising act of perception. To see is thus at the same time a process of 'filling in' and 'opening out'. This opening out of conceptual space is perhaps at its most emphatic in a recent series of works which, like *Spiral* and *S*, are topographical. In the floor pieces *Axe*, 1982 and *Canoe*, 1982, the objects are set within a 'primitive' image. If we are aware of a general sense of the past in *Spiral* and *S*, a general sense that the objects don't match the image which contains them, then in *Axe* and *Canoe* this is opened right out: present and past

are polarised. These works represent Cragg at his most direct in his critique of prevailing technological relations: the image of a 'primitive' object acts as a container for a number of wooden objects, as if to set the history of technological development within a corrective non-historicist space.

Mapping thus works in two fundamental ways in Cragg's sculpture: in a general way as a registration of the limits of current production relations, and, more specifically, as a movement across territories, topographical and ideological: nature and culture, the environment and the gallery, mass culture and modernism, the object and the image, sculpture and 'non-sculpture'; the two-way passage of a classic deconstructive project.

Notes

1. Carl Andre quoted in the catalogue *Anti-Illusion: Procedures/Materials* (Whitney Museum of American Art 1969) p 36
2. For example the Wimbledon school of figurative carving. See also the welded modernist sculpture of Katherine Gili and Tony Smart: both return to a figuration based on Rodin and Degas.
3. Fuller was a vociferous critic of the new British sculpture in the 1980s, in particular Cragg and Bill Woodrow, accusing them fatuously of a lack of skill. For his defence of the Wimbledon school of figuration see 'Lee Grandjean and Glynn Williams', *Art Monthly* no. 51 (November 1981). Talking about their work in the Yorkshire Sculpture Park, he asserts 'I am confident that they point towards the emergence of sculpture from the stultifying decadence of the last quarter of a century.' (p 15)
4. John Bayley *London Review of Books* vol. 4 no. 17 (16 September – 6 October 1982). See also the 'Introduction' to *Contemporary British Poetry* edited by Blake Morrison and Andrew Motion (Penguin 1982). Morrison and Motion use the term 'post-modernism' (p 20) to categorise recent changes in British poetry: 'a preference for metaphor and poetic bizzarrerie'. (p 12)
5. Michael Thompson *Rubbish Theory* (Oxford University Press 1979)
6. Ibid
7. Jacques Derrida 'Structure, Sign and Play' in *Writing and Difference* (RKP 1978) p 280
8. 'One of the great influences on the course of my own development was the English countryside ... which is one vast earthwork. Apart from the explicit earthworks of various cultures ... the English countryside has been literally cultivated ... [and] moulded very slowly over at least three thousand years.' Interview with Carl Andre, *Avalanche* (1970)

quoted in Andrew Causey 'Space and Time in British Land Art' *Studio International* no. 986 (March/April 1977) p 126

9. Reprinted on the invitation to his Lisson Gallery exhibition 2–24 December 1982
10. C Lévi-Strauss *The Savage Mind* (Weidenfeld and Nicholson 1966)
11. Tony Cragg, statement in Documenta 7 catalogue, 1982
12. Lévi-Strauss *The Savage Mind* p 17
13. Ibid p 22
14. Ibid p 22
15. Brian Hatton 'Junk Culture: The Uses of Affluence' ZG ('Breakdown' issue, 1983) 'the recycling of object-products into image-stereotypes seems to metaphor a contemporary political foreshortening.' (p 11)
16. Lévi-Strauss *The Savage Mind* p 19

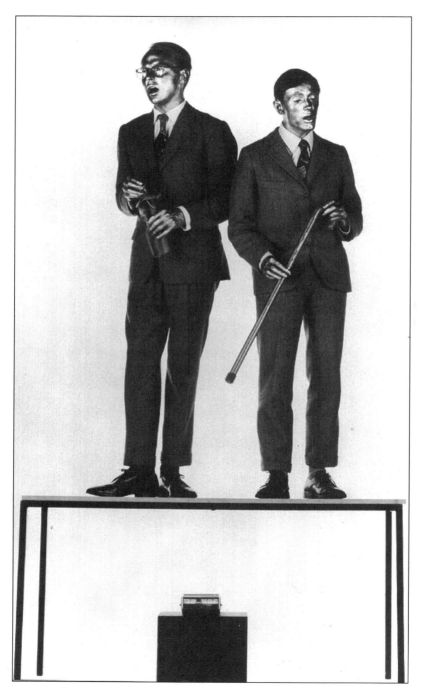

8. Gilbert and George, *The Singing Sculpture*, 1972.

7

BEYOND THE ARCHES:
GILBERT AND GEORGE

Emerging at the end of the sixties on the crest of that decade's post-object optimism and irreverence, Gilbert and George took performance and lifestyle as their way of 'worrying' art, making friends and influencing people. As they said in their 'Laws of Sculptors', published in *Studio International* in 1969: 'Make the world believe in you and pay heavily for the privilege'.[1] Closer to the iden-tifications of popular art than the majority of their generation of conceptual 'delegitimationists' they framed their distaste for the *artistic* in openly ironic terms, hence the 'responsibility suits'[2] and celebration of the English Pastoral. Conformism of dress, lifestyle and subject matter confronted 'text-book' modernism from the position of what modernism had been most determined to leave behind: good manners, national sentiment and personal smartness. Gilbert and George's adoption of conservative dress and persona at the height of the counter-cultural politics and student activism in the art schools would seem either to be a very self-conscious act of non-conformism, the *ne plus ultra* of conformism itself, or bloody-minded reaction. In fact it was neither; rather it was a way of licensing – quite literally – as an identifiable image, their public status as artists. What better way of making 'the world believe in you' than inverting the conventional modernist image of the artist as bohemian or flâneur into that of a proprietous bank manager, but *at the same time* making such a conversion the basis for similar claims upon the artist's 'specialness'. Their miming to Flanagan and Allan's 'Underneath the Arches', their faces painted gold, was straightforwardly a clash of the non-conformist and popular.

As 'serious' and 'disciplined', Gilbert and George would like us to believe that they are defenders of truth and beauty in a corrupt and uncaring world. The artist must put personal comfort aside and devote *him*self to the pain and anguish that is Art. In the prose piece

To be with Art is all we ask written in 1970, they address art as if they were entering the priesthood. 'We would honestly like to say to you, Art, how happy we are to be your sculptors.'[3] In praising Art for its 'all meaning',[4] they pay homage to its greatness and their unworthiness. Entering the priesthood then is a grave and righteous business. If the artist is to be 'high-minded'[5] and dutiful he should *look* the part.

The self-dramatisation of the artist's 'specialness' is our common and moribund modernist / Romantic heritage. What Gilbert and George have done, though, in revocalising its tendentious heroics, is to celebrate not the power of a would-be unbounded subjectivity, but the authority of a uniform ideal. By taking on a univocal identity (by behaving and dressing as one) they subordinate their individuality to a generalisable notion of Artistic conscientiousness and emotional control. The notion of masquerade has recently been adopted by feminist treatments of psychoanalysis as an assertion that the construction of femininity is a form of 'lying'. Gilbert and George's adoption of an image of stereotypical masculinity invokes a similar kind of disingenuousness. However, in this instance such 'lying' doesn't state identity as a problem, but as a form of psychic control behind which Gilbert and George's artistic masculine fantasies might operate freely and securely. Playing out the role of alienated artist in our culture then is one thing, self-consciously adopting an *antithetically* stereotypical self as the subject and public front of one's art is another; the voice of the ironist becomes the voice of the hysteric, in so far as the Gilbert and George we see in the work becomes the Gilbert and George we meet on the street in Spitalfields. There is no distinction; no dissemblance of the dissemblance itself.

What in fact Gilbert and George are doing is reworking those allegorical forces and themes that have been central to the Romanticism of the Western tradition: the pursuit of extremes of experience and the superimposition of the ideal over type as a way of opposing the loss of the self in a profane and inhospitable world. That this places them within a tradition and a problematic that has been largely discredited – the artist as transgressor of the conformities of bourgeois ideology – in a sense explains their hypertrophic compulsion to repeat themselves. For if their work stands against some imagined loss of (male) identity in a fallen, inauthentic world, then the need to bridge this loss inevitably becomes one in which the repetition of convention plays a redemptive or, more accurately, revanchist role. This was candidly revealed in an interview in 1987

in *Artscribe International*, which sees them having a go at their adversaries in the British art world: 'It will take years before the profession understands. One day they will.'[6] We'll show you, we'll show you, just wait and see!

In the early photo-pieces (the 'Modern Fears' series of the early 1980s) Gilbert and George present themselves as 'outsiders' by juxtaposing images of themselves alongside images of the marginal and dispossessed. Vaguely authoritarian in posture and lack of expression, they are shown either sitting or standing or disembodied, aloof and contemplative. They are as distanced from the real world of social relations – the world of communality and struggle – as the poor and destitute they depict. The use of male types from the British urban 'picturesque' – drunk, tramp, rasta – represents a key change in their self-dramatisation as Artists. Entering the social world as 'participants' for the first time – after a period of narcissistic self-possession in their studio – they survey the dead landscapes of late capitalism for signs of their own ill-feeling. Like Baudelaire in his role as flâneur, everything troubled returns them to their self-conscious role as artists. Thus they depict only males, for it is the social construction of masculinity in terms of a real or imagined freedom from *petit* social constraint (domestic responsibilities etc) that provides the material for their melancholic and, recently, heroic self-identifications (the use of young working-class boys as celebrants of non-bourgeois vigour).

Now, in one sense, the reference to Baudelaire can be seen, in this light, to be grossly misleading, since far from fixing the self, Baudelaire's self-consciousness as an artist actually split and multiplied it – in fact deliberately divided the ego *against* itself. 'My fantastic fencing'[7] he called it. Rather, what marks Gilbert and George's *métier* as particularly Baudelairian is the appeal to the self-approbation of such self-consciousness, or more explicitly, to quote Walter Benjamin on Baudelaire, to the 'metaphysics of the provocateur'.[8] Baudelaire's violation of conventional morality in his prose poem *'Let's Beat Up the Poor'*,[9] for example (he beats up a beggar and is in turn beaten up by the beggar – his 'equal', as if to suggest that charity is humiliating and oppressive) is an *exaggerated* response to the world. Gilbert and George's masquerading and theatrics, the candid dramaturgy of gay sexuality, violence, patriotism and Gothic religiosity, appeals to a similar confrontational anti-bourgeois reflex, but – and here's the distinction – from within the very world of bourgeois reaction itself. As wanderers through the

Manichean – for their shock value to lay seige to the world, the world must be built upon opposites: order / chaos, light / dark, good / evil – they 'touch' degradation, alienation, bigotry, in order to redeem the fabric of our fallen experience for Art and Beauty. The mode then is not just Baudelairian but Nietzschean – 'daring to be immoral like nature'.[10]

It is surprising how little Nietzsche has been mentioned in writing on the couple. For Nietzsche the pursuit of art was linked to the pursuit of human sovereignty. Which is why his theory of the Ubermensch was expressly a theory of artistic-hood. The Ubermensch, like the artist delights in risk and narcissistic self-display as a transgression of all received social *mores*. We must be – or rather men must be – poets of our lives. This poetry naturally means taking on and transmuting the dirt of the world, as the work of self-transformation and self-realisation. 'Daring to be immoral like nature' therefore is the very ground of the aesthetic because then art is assumed to mirror the chaos of the universe. As 'artist heroes' dancing on the grave of artistic pomposity, Gilbert and George occupy a similar kind of world, in which the duty of the artist is, as they declare, to 'be wanting: brutal: never diplomatic.'[11] But 'daring to be immoral like nature', brings problems. In fact it brings calumny, silliness, morbidity and self-aggrandisement.

Over the years Gilbert and George's use of a Nietzschean-Romanticism in the service of an anti-modernist irony has taken on the unyielding and authoritarian airs of official Kultur itself. Here more than anywhere, are the limits to such 'counter-cultural' tactics. 'Art for All' has become art *for* all, as the early affirmations of the democratic potential of photography have become subject to a grandiosity and self-importance that dictates *to* the viewer the 'wonderful world of Gilbert and George'. The claims for art as a form of moral decoration, as in the early William Morris inspired definitions of 'Art for All',[12] have capsized into a kind of corporatism, where scale and productivity regulate the terms of public access. 'Art for All' divested of its gentle and teasing ironies has become a thundering discourse on why Gilbert and George are right. And this is why the dissemblance is now more than revanchism, for their world has congealed around them in the form of their own spectacularisation. It is revealing, therefore, that the same modernist stereotyping should be employed by the pair as the means by which their 'subversiveness' should continue to be played out. Thus in the *Artscribe International* interview it is Gilbert and George who are held to be holding the day

against those modern art johnnies who muck around with 'funny shapes'.[13] The idea that the world is still populated by text-book modernists who are doing some 'funny squiggles'[14] needs to be maintained, in order that their confrontation with bourgeois convention can be tuned up and cranked out.

Notes

1. Gilbert and George 'Laws of Sculptors' written to accompany *Shit and Cunt*, magazine sculpture, *Studio International* vol. 179 no. 922 (May 1970) pp 218–21
2. *A Day in the Life of George & Gilbert*, first published as a booklet (Autumn 1971) reprinted in *Gilbert & George 1968–1980* (Van Abbemuseum, Eindhoven, 1980) p 98
3. Gilbert and George 'To be with Art is all we ask' (1970) reprinted in *The New Art* (Hayward Gallery, 1972) p 36
4. Ibid p 36
5. Ibid p 36
6. 'Sad and Blue', Gilbert and George interviewed by Gray Watson, *Artscribe International* no. 65 (September/October 1987) p 37
7. Charles Baudelaire *Art in Paris 1845–1862: Salons and other Exhibitions*, translated and edited by Jonathan Mayne (Phaidon 1965)
8. Walter Benjamin *Charles Baudelaire: A Lyric Poet In The Era Of High Capitalism* (NLB 1973) p 14
9. Charles Baudelaire *Twenty Prose Poems* (Cape 1968)
10. F Nietzsche *The Will To Power* ed. Walter Kaufmann (Vintage 1968) p 73
11. 'Sad and Blue' p 37
12. The aestheticisation of their lives and surroundings echoes the prescriptions of Morris. It is interesting to note the interior of their Huguenot house in Spitalfields. No furnishings, no pictures, just bare wooden floors and wainscotting, with the odd piece of original Arts and Crafts furniture. 'Believe me, if we want art to begin at home, as it must, we must clear our houses of troublesome superfluities that are for ever in our way: conventional comforts that are no real comforts, and do but make work for servants and doctors. If you want a golden rule that will fit everybody, this is it: *Have nothing in your houses that you do not know to be useful, or believe to be beautiful.*' William Morris *The Beauty of Life* (Brentham Press 1974) p 21. First published as *Labour and Pleasure versus Labour and Sorrow* (Cund Bros, Birmingham 1880)
13. 'Sad and Blue' p 35
14. Ibid p 35

ART AND THE
PUBLIC SPHERE

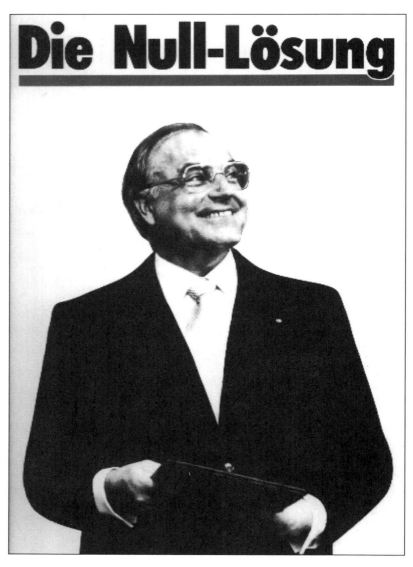

9. Klaus Staeck, *Die Null-Lösung (The Zero Option)*, 1983.

8

THE POSTER AND
THE COUNTERPUBLIC

Although agitational posters date back to the Commune their first effective and extensive use was during the Russian revolution and after and during the post-Weimar period in Germany, when photomontage techniques began to find their way out of the mass-circulation illustrated magazines and on to the streets. John Heartfield's work during this period of course remains something of an aesthetic guide and political model for subsequent agitational poster-work. His work for the German Communist Party (KPD) in the pages of *Arbeiter-Illustrierte-Zeitung* (*AIZ*) and on the streets of Berlin (in 1933 he was hounded out of Germany by the Nazis) has come to symbolise an exemplary form of revolutionary practice: an art that by dint of its reproducibility and portability could circumvent the bourgeois art institution. Heartfield never explicitly entered into the theoretical debates around photography in the 1930s, but nevertheless he began to assume for writers such as Sergei Tretiakoff and Walter Benjamin a key role in the construction of a new public art. Heartfield's political use of montage in the pages of *AIZ* and in poster form was to open up the possibility of an art that not only intervened directly into reality, but in the process transformed the status of the artist as such. Tretiakoff described the possibilities of this productivist model as follows:

> Each boy with his camera is a soldier in the war against the easel painters, and each little reporter is objectively stabbing *belles-lettres* to death with the point of his pen.[1]

Walter Benjamin in his well-known essay 'The Author as Producer',[2] which borrowed extensively from Tretiakoff, put the productivist model on a firmer theoretical footing by arguing that it represented a radical change in the conditions of production and consumption of

art which spoke from the left. Criticising those artists and writers who were content simply to display their political credentials, artists who, he argued, committed themselves *in mind* to political struggle, he defended an art whose methods and process of reception put in train the transformation of artist and spectator alike. In short for Benjamin the question of class allegiance lay not in the political authority of the message or content but in the quality of the work as a learning model, a model that could provide both the conditions for artistic self-criticism in front of the world and that allowed consumers to become producers with a modicum of training. This essentially is what Tretiakoff envisages by putting the camera into the hands of a boy. As Benjamin says in 'The Author as Producer', the producer

> will never be concerned with products alone, but always, at the same time, with the means of production, in other words, his products must possess an organising function besides and before the finished character as finished works.[3]

Principally what traditional forms of political art did (specifically gallery-based socialist realist painting, and privately consumed socialist realist literature) was to reduce the spectator or reader to the passive consumer of political messages. Photomontage and Tretiakoff's theory of the 'operational' writer – the writer working with workers in the factory or community on particular projects – produced the opposite: they empowered people in so far as they demythologised the creative process and created the conditions for the *self*-representation of workers. Benjamin's productivism in fact owes a great deal to Valentin Voloshinov's critique of monologic forms of discourse. For Voloshinov, writing in the Soviet Union in the early 1920s, the monologic likewise represented the bureaucratisation and conventionalisation of artistic expression.[4] His defence of dialogism was in actuality a code word for the kind of practice and conditions of artistic reception that Benjamin was later to defend. Dialogism for Voloshinov, based as it was on a critique of Ferdinand de Saussure and Russian formalism, was a defence of language and sign making as a process of reciprocal and mutual understanding determined by the 'immediate conditions of their interaction'.[5] Language and sign making was at root a social process that was in creative development and change, albeit subject to given conditions. The political key then for Voloshinov and Benjamin was that meaning is not embedded *in* the sign, waiting to be passively internalised, but rather is dependent

upon its active production in exchange between people. Meaning becomes an active process of interrogation, which is why Benjamin is concerned to emphasise the notion of 'organisation' in relation to the effects of photomontage; for what the notion of 'organisation' asserts is a framework through which dialogism might be given political space.

The dialogism of the productivist model has retained a great deal of prestige in left cultural theory since the 1930s. In many ways, with John Heartfield as its leading figure, it represented that continuing point of contact with a post-market practice. With the 'stabilisation' of the post-war bourgeois democracies and the Stalinisation of the Russian revolution though, its practicality as a model for artists has waxed and waned enormously, depending generally upon political circumstances. The marginalisation and disappearance of these debates was to a great extent broken only with the recrudescence of Marxism in the West in the wake of May 1968. May 1968 in fact was a key moment for the whole of the productivist tradition and in particular the public political poster, for it represented that point where a cultural politics not based on dominant forms of monologism (American modernism, and its continuing countertradition social realism) could once again find its voice. With the massed presence of the French working class and students on the streets of Paris, and the spontaneous explosion of a new radical poster art, the link between art and the public sphere seemed a real possibility again. The exclamations of Pouvoir Populaire, the graffiti, and general carnivalesque manifestations, galvanised a whole generation of artists to ask questions once again about the status of the art object and the conditions of its reception. Now this is not to claim that the counter-cultural revolution of May 1968 was the sole cause of artists' re-examination of productivist models, but rather that it provided a direct and popular impetus to their reassessment.

With May 1968 still fresh in many artists' minds the poster became a favoured resource for a substantial number of artists in the early 1970s. In fact the early to mid seventies perhaps represented the height of post-war art's theoretical retreat from the market and the 'auratic' object. One only has to read *Studio International*'s 1976 issue on 'Art and Social Purpose'[6] to see the extent to which mechanical reproduction plus 'work out doors' was the natural horizon of so much political practice at the time. As the British artist Jonathan Miles, then a member of the Poster Collective, wrote in that issue:

The development of organisational relations with political groups enables us to reach a mass audience without the mediation of art situations. The particular form this work must take is centrally through the production of posters, which become directly linked to the ongoing agitation and propaganda of political organisation.[7]

The confidence with which this was said reflected a left-culture that was to a large extent in the ascendancy in Britain at the time. Although Denis Healey and James Callaghan were to introduce swingeing public expenditure cuts in 1976, it was a period of relative state-funded prosperity for a whole layer of artists working outside of the market. The Arts Council, determined to hold to some commitment to 'public access' supported, directly or indirectly a large amount of new work. Moreover, there was a relatively confident labour movement, after the collapse of the Heath government in 1974, which pulled significant numbers of people to the left. Although it would be wrong to idealise these conditions – most of this work was produced determinedly and polemically in the face of the Labourist cultural politics of most of the left – nevertheless a sense of optimism was abroad about the formation of new organisational networks for the production and consumption of art. Today though, these aspirations and possibilities seem a long way away: cuts in state funding of the arts under Thatcherism, and the generalised attack on cultural modernity by both the left and right, has broken the back of a huge amount of this work, particularly poster art. As a consequence many artists drawn back into the orbit of the market through economic necessity, have severed themselves from these aspirations altogether. Let us not shy away from the fact that Thatcherism largely achieved what it set out to do culturally: to break the tacit link between state funding and a nominal left-culture.

But can economic changes be held solely responsible for these transformations? Isn't the crisis of this culture the product of more complex determinations? Essentially the crisis of an emboldened productivist tradition, in Britain at least, was not simply due to the growth of the right, but the product of an internal crisis of the model itself, which, when faced with the rise of the market capitulated to the right. One of the weaknesses of Benjamin's productivist model, produced as it was in a period of high political combatancy against fascism in Europe in the 1930s, was its incipient voluntarism and technological determinism: the idea that a revolutionised apparatus in itself can guarantee political effectivity and democratise art for the public sphere. Although Benjamin's organisation model was unquestionably

a learning model, it still *assumed* accessibility, and a high level of accessibility at that. Perhaps the poster artists in the 1960s and 1970s never *strictly* believed in the democratising power of mechanical reproduction, but nonetheless the validity of their arguments rested on a concept of political intervention that clearly valorised mechanical reproduction as an apparatus capable of disenfranchising art from bourgeois forms of consumption and exchange. The poster had a head's start in establishing an organic link between art and the working class.

The past ten years have exploded these mythologies. Intervention poster / photographic work in communities, poster work on the street, have come to appear not as the cutting edge of a new organisational framework for the democratisation of art, but the tired remnants of social functionalism. Benjamin's productivism may at the time have been tactical, given his need to counter the chronic sentiment of 1930s Popular Frontism, but the consequence was that for influential sections of the cultural left, it seeded the view that work which bypassed bourgeois institutions somehow allowed the working class to participate automatically, irrespective of political and economic circumstances, in the creation of a socialist culture. Under late capitalist conditions, particularly in Britain, where there are no mass parties of the left committed to the mobilisation of a sizeable minority of the political advanced sector of the working class, the production of a culture of *reception* for left-modernist practice is attenuated to say the least. Social democracy, allied to an insurgent mass media, has made the productivist model something of a paternalistic luxury.

However, if the claims of the productivist model need to be reassessed on the grounds of its incipient voluntarism, the dialogical core of the tradition remains up for grabs. Dialogism is not in fact reducible to voluntarism. On the contrary, it renders such idealism subject to critique by emphasising the possible conditions of access and exchange given a realistic recognition of prevailing social and economic conditions. Thus as far as the political poster goes today, we might say, yes, it is in retreat because of current economic conditions and the internal crisis of the productivist model itself, but this does not mean losing sight of what the poster *is* capable of doing: disseminating counter-information that in words of Klaus Staeck might be 'irrational'.[8]

My defence of dialogism though is not a defence of recent post-structuralist critiques of photographic voluntarism. This critique to

a large extent has given a great deal of succour to the right in attacking the productivist legacy. For if images only mean what they mean in a given context, then what is the point of producing public imagery that seeks to mobilise or address people beyond their own subject position or 'constituency'? We have to differentiate clearly between how post-structuralism has used an autonomous politics of gender and race to attack the idea of the public pedagogic poster and the need for a new politics of representation through which dialogic practices can ground themselves. The women's movement's focus on the gender-specific character of looking has obviously made the relationship between the representation of politics and its audience a more differentiated one than could even be secured by John Heartfield's ideological mobility.

In summary, we need to see the functional crisis of the public poster in the following terms: its idealised role as serving a mass audience came into conflict with the break up of any stable and generalised relationship between politics and representation (as for example during the post-Weimar period). This was in turn reinforced by a widespread return to painting and object making, which far from being a reactionary move back into high-cultural norms, actually sought to relativise the claims of the productivist tradition. It can be argued that the reassessment of painting and sculpture as practices subject to the contradictory forces of capitalist relations, sought to establish a critical distance from the revolutionary *romanticism* of much productivist discourse.

It seems vital therefore to debate the function of the poster again without the impediments of voluntarism and technological determinism. The poster needs to be re-examined as one possible aesthetic resource for political practice amongst many, subject to certain constraints and limits given its aims and field of operation. If we are to establish a realistically dialogic understanding of the poster we need to stress that it is subject to the same bourgeois relations of control as other practices, though in different ways and with a larger degree of flexibility.

From the above it would seem as if there has been no substantial political poster activity since the 1970s. This of course couldn't be further from the truth. The productivist culture that supported poster-work may have collapsed but individuals have continued to produce important work in the area. The British artist Peter Kennard and the German Klaus Staeck, both working out of the Heartfield tradition, the Situationist-influenced American Barbara Kruger, and

the Tretiakoff-inspired community-based posters of the British artists Peter Dunn and Lorraine Leeson, all offer evidence of continuing vitality in the field. In their respective way, they all have enlarged the poster's semiotic range.

Kennard's vivid iconic work for CND (Campaign for Nuclear Disarmament) and for the GLC (Greater London Council) when it was under left Labour control, have brought a modernising influence to the mediations of mass political campaigning that has generally been rare on the left. The retrogressive language of British Labourist culture has been subject to sharp critique by Kennard's photomontage. As Stuart Hall has said:

> Working class culture is still depicted like a Jarrow March, which it isn't. That is not the reality of unemployment today. Social realism is not realist in the way it pretends to be ... what we've got at the moment is a language which has become deformed by being attached to the circus appearance of the past – the cloth cap, a working class which looks like an Engels lithograph and which doesn't exist.[9]

Throughout the seventies and eighties Staeck continued to attack German social democracy with wit and pathos. His photomontage 'counter-adverts' effect to distance the claims of the post-war settlement from their class realities.

Kruger's accusatory 'guerilla semiology' has generated a compelling set of resources for a women's poster-work that sets out to rupture the pact between advertising and male pleasure and desire which dominates Western city streets. She does this though in a highly ambiguous way by addressing both men and women simultaneously by the use of the linguistic device of the 'shifter', the oscillation between personal and impersonal forms of address. 'We won't play nature to your culture' reads one caption. 'Shifters' allow the speaker to cross from the individual to the collective, from the particular to the general, from self to other. Mimicking the 'ideological work' of modern advertising she in fact foregrounds its mechanisms of control. As Craig Owens has argued:

> Kruger produces neither social commentary nor ideological critique – the traditional activities of political artists (consciousness raising); her art has no moralistic or didactic ambition. Rather, she *stages*

for the viewer the techniques whereby the stereotype produces subjection, interpolates her/him.[10]

I wouldn't want to make such a sharp distinction between conscious-ness raising, morality and didacticism and this process, but never-theless Kruger's images are clearly, on the whole, more concerned with disturbing the stable mechanisms of ideological interpellation than lining up with any direct critique of the mass media as an external system of control. They are not iconic then in the way Kennard and Staeck's posters are, and the way the May 1968 posters' attack on the French state and broadcasting system were, even if they seek a legibility of their own: large striking captions, with mysterious figures or body fragments.

Pete Dunn and Lorraine Leeson on the contrary have used the poster as a means of intervening in, and recording, a long-term community struggle: the resistance of the Docklands community to the Tory Docklands Development scheme. From the early eighties, when the scheme was set up, they have utilised the energies and ideas of the local working-class community as the basis for a series of large-scale poster-hoardings. Unconcerned with the problems of producing strongly iconic imagery for immediate campaign work, their posters (combining photomontage, drawing and captions) have a complexity and conventional narrative structure (the posters are installed panel by panel over a period of time) that makes few concessions to 'instant reading'. Their readability lies very much in their symbolic value as visual interruptions in the area.

Nevertheless, a British artist who no longer works on a large-scale campaigning basis, an American artist who does poster-work intermittently, a German artist who has found the current political climate in the Federal Republic decidedly unconducive to street work, and two British artists who are winding up their recent community work, does not amount to much of a dialogic poster-culture in practice. Clearly there are a number of other artists working in similar areas, particularly in Mexico and South America where the tradition of counter-public poster-work (if not derived from the Heartfield tradition) remains strong, but all the same as far as the West goes, we should not overestimate the impact of these artists' work. Kennard, Staeck, Kruger, Dunn and Leeson hardly represent a vital part of a new street culture. In reality the direct consequence of the collapse of a political culture of the poster has been to cede the street as an area of cultural struggle to capitalist representation. The street

is perhaps the only public arena where counter-public imagery and messages can be displayed without any direct and immediate control over the means of production – in short posters can go up quickly in a multitude of sensitive or embarrassing places. This in many ways is what Staeck meant by 'irritation'. The poster on the street participates in a battle – fought everyday, consciously or unconsciously – for the 'ownership of "reality"'.[11] In the final analysis that is the basic function of the poster be it propagandist, community-based or non-agitative: to assert through its powers of negation that the claims of the bourgeoisie to reflect reality and speak for us are provisional and mystificatory.

This combatancy appears to take us back to the KPD and the SPD at their height, when the commitment to an alternative visualisation of the world stood locked in critical conflict with an emergent propagandising mass media. This scenario though couldn't be further from the point I want to make. Present conditions are nothing like they were in Germany in the 1920s and 1930s; the post-war capitalisation of the communications industry has functioned in order to prevent counter-public messages competing directly, let alone finding a hegemonic voice. We need to be particularly clear then about the public sphere as structurally determined place of intervention. The public sphere is a place for the exchange of commodities, and not a place freely open to counter-hegemonic intervention. This much is obvious; the Tories' dismantling of the GLC was based largely on the fact that the administration was able to propagandise effectively for socialist ideas on the street. All talk of the struggle over the ownership of reality cannot avoid the powerful class limits on public work. However despite this there always exist real opportunities for poster-artists; critics of the productivist tradition have given away too much to the difficulties, particularly in Britain. It is extraordinary how *visually unpoliticised* London is in contrast to say, Barcelona, Paris, Madrid, Berlin.

A realistic dialogism then needs to be based on the fundamentally *contradictory* nature of the poster. On the one hand their duration is short (through contemporaneity, vandalism, weather, over-posting), they are likely to be prohibited if public access has to be negotiated by some state agency or funding body, and they can obviously be misread; on the other hand though their temporal and serendipitous qualities provide a potentially rich and mobile source of counter-public dialogue, in so far as posters create a visual environment – a mnemonic no less – for political issues. A substantive defence of the political poster therefore should not be based on the estimation of their

direct political effects (though the idea that they *can't* mobilise large numbers of people is obviously spurious) but that they can offer in quantity and multiplicity a visual *corrective* to the dominant visual culture of the street. In reality the poster, with its multivalent forms of dialogism, stands to contribute to the regeneration of the city space as a site of democratic exchange and heterogeneity, which under late capitalism and the weight of statist legislation has, particularly in Britain, sought to erode.

Thus although John Heartfield seems a long way away, and although our concept of cultural politics is far more sophisticated, non-eschatological, 'unburdened' by so-called 'workerism', the interaction between artist and the street remains potentially unfulfilled. This is why, deep as we are in the crisis of productivism this 'interventionism' at least offers us the means to remap the combative side of our cultural politics, a process which the 1970s, for all its righteous volunteering, took for granted.

Notes

1. S Tretiakoff quoted in John Willett *The New Sobriety: Art and Politics in the Weimar Period 1917–1933* (Thames & Hudson 1978) p 107
2. Walter Benjamin 'The Author as Producer' reprinted in ed. Victor Burgin *Thinking Photography* (Macmillan 1982)
3. Ibid pp 26–7
4. V Voloshinov *Marxism and the Philosophy of Language* (Harvard University Press 1973)
5. Ibid p 21
6. *Studio International* 'Art and Social Purpose' issue no. 980 (March/April 1976)
7. Jonathan Miles 'Statement' *Studio International* no. 980 (March/April 1976) p 161
8. Klaus Staeck interviewed by Georg Jappe, *Studio International* no. 980 (March/April 1976) p 138. 'The irritational effect is an ideal instrument of communication. It's been pointed out that through irritation one can very, very easily get into discussion.'
9. 'Left in Sight' Stuart Hall interviewed by Kathy Myers *Camerawork* no. 29 (Winter 1983/4) p 18
10. Craig Owens 'The Medusa Effect, or The Spectacular Ruse' in *We Won't Play Nature To Your Culture* (Institute of Contemporary Arts 1983) p 11
11. Jill Montgomery 'Défense d'afficher: loi du 29 juillet 1881 … Paris May 1968' *Art & Text* no. 16 (1984) p 42

9

INTERVIEW WITH
BARBARA KRUGER

JR The fashionable designation 'post-feminism' has been applied
to your work. How do you react to that?

BK The 'post-feminist' thing is the most superficial, unthought
kind of journalism. It's like a *New York Times* fluff piece. There was
an article in the *Times* magazine section in 1981 on 'post-feminism',
which was just a secular extension of Clare Sterlingism; it's crazy, it's
stupid. The idea first of all that there is a singular *feminism* is indicative
of that very phallic univocality that the *Times* and the *Time Magazine*
and *Newsweek* want to put feminism in. I hope for the idea that there
are *feminisms*, that there are a multiplicity of readings of what
constitutes feminism. And I think we have barely begun to enter it.
The whole idea of a 'post' is to say that we have 'done that'; it's soiled
and full of women in denims and ponchos; we've been through that,
we're 'post-feminist' now. It's just air-head. The real change has not
even begun to start.

JR Do you think the reason that the term has gained currency is that
despite the feminism of your work, the spectator that you address is
not gender-specific?

BK Let's just say that I'm interested in ruining certain representa-
tions and welcoming the female spectator into the audience of men,
which doesn't mean a female audience, it means mixing that audience.
I think that the interesting thing that I would hope for is that a
spectator chooses to decline or accept the address. In many cases there
are specific gender proclivities that I would say I engage in terms of
the viewer. But it's really a free field. The last thing I want to be is
correct in terms of a reading of my work; that last thing I want is a
singular reading.

10. Barbara Kruger, *Untitled*, 1983.

JR You are currently having a show with Robert Mapplethorpe at the ICA.[1] Mapplethorpe's ironic use of the stereotype and your sharp displacement of it is quite a productive conjunction. Do you relish that difference?

BK Why do you think it's productive? I am not interested in binary oppositions. I really like the idea of a free field. I would say, without wanting to get involved in that opposition that Robert's work is more about desire and mine's more about pleasure. Desire only exists where there's absence. And I'm not interested in the desire of the image.

JR But like Mapplethorpe you are interested in challenging gender-images.

BK I'm basically interested in *suggesting* that we needn't destroy difference.

JR Jane Weinstock has called you a 'guerilla semiologist'. That has strong overtones of Situationism. Does Situationism play a part in your thinking?

BK I think there's something to be said for the resuscitation of that writing now. I think some of it is quite interesting, in that it acknowledges a broad field of spectatorship for all of us; how what we see dictates so much of what we look at and what we do. But I think that like similar and much more ambitious writing such as Art & Language's work, there's an incredible mean didacticism to it all, an incredible disallowance of difference. There was a film I wrote about called *Call it Sleep*. Basically it was a film about spectacle, a collage film of found footage, combined with shot narrative. Over this footage was this insistent, unrelenting male voice *dictating* our histories to us, *dictating* the specific directions for change. Now I found that unbearable and I feel that in much of that – very similar to Art & Language again – is a total absence of women, if not *contempt* towards any analysis of gender. So I'm not interested in Situationist theory on that level because it doesn't allow for me as a subject. Don't worry girls, when the dictatorship of the proletariat comes we'll get you washing machines.

JR So you don't see your works as strictly interventionist?

BK I see them as such, but I think that there are some situations where they function more powerfully than others. Again, I see my work as a series of *attempts*.

JR In an odd way I was reminded of Daniel Buren in your work; there's the same assertiveness through repetition.

BK Perhaps. I think that you can say something a million times before you can actually intervene. Or you can intervene stultifyingly once and it's forgotten. So in many ways I agree with that. And also the notion of originality is one that is strained and ridiculous, just like the notion of the authentic and genuine.

JR Like Buren do you see yourself ostensibly as a poster-artist?

BK Sure.

JR Are you involved in any poster-campaigns at the moment?

BK It's interesting because with the gentrification of Soho and Tribeca there are fewer and fewer buildings that you can post. Last year when I was here I went to the Cockpit Gallery and saw a show by the Poster Collective and was really impressed. And the fact that they were used as *teaching* aids in schools as well as posters would just be unheard of in the States. We're just 25 years out of McCarthy. Our tradition of political posters, art posters, is very small. In Los Angeles there was a mural tradition in the sixties and seventies that is much less active now. In New York, rather than a community effort to say something about a particular topic, to engage in a view or a particular issue, what we have is the reduction of writing to one's name. The call has been diminished to a yelp. I put my name on a piece of property, that's what becomes of poster-work. There's little, almost none. I wish there was more. I did some posters in Europe last year and I'd like to do more in New York. I'm doing the specta-colour sign in Times Square. It's really important for me to do work which concretely addresses the issues of my social life. I don't see politics as something out there. It's all one cloth. As far as making films for instance, it takes two years to make enough money to make a film. So while I'm doing that I can try and get teaching jobs – that's a politic, to be able to address a room full of people as a *woman* writing criticism. I don't consider myself a theorist though, I'm writing

journalism; I want to make myself accessible to people. Which doesn't mean I'm against theory, I totally support theoretical writing; it's been very important to me. That's part of my work too. Because the artworld is a cottage industry I can still borrow enough money to make work that can be shown in a white room and thus enter the discourse of the much benighted and exalted male art historians. They talk about you because you have entered the market to some degree.

JR The market is still important for you then?

BK Sure. I don't know how it's going to last though, it's so cyclical. Unlike most men I know, recently it's been very good for me in New York getting a lot of press. The *Voice* did this Power of Art / Art Power thing, so I was on the cover and did a full page. Never under any situation would I consider myself a phenomenon. The phenomenon is the structure that needs phenomenon. I think people get so easily deluded about their own elevation for 60 seconds or 15 minutes as Andy Warhol would say. And to me it's that system which needs that celebratory mystique. And I will *use* it, if that gets a particular message across.

JR Do you see your work as ever becoming issue specific?

BK I did a number of pieces, in particular one – *Your Manias become Science* – which was in an anti-nuclear show going across America. Certainly my appearance on panels has been issue-specific – The Artists Call for Central America. I certainly haven't fudged that, that's very important to me.

JR Is it worse for women artists now than it has ever been?

BK Yes, I think it's pretty bad. My wish is that more women and men did work which addressed social issues. Now of course there are a lot of women who are going to get into galleries who are doing colour-field painting. I will support the effort of any woman to define herself through her production because I know how much more difficult it is. But I cannot support all work because a woman did it. People say to me there aren't any more big star women artists. If I had a choice – and most women in the artworld are appalled when I say this – between having three more women art stars who spend all their money at Georgette Clinger and Bloomingdales, and health

care for 400 women in the South Bronx, I would pick the latter. What's appalling to me is the idea of women getting an audience within the artworld, entering the market, doing work, and not concerned with what we are, and how we have had to struggle. I don't care about these people. That's reprehensible to me. What has given me some pleasure is when women do get some audience, and do make certain inroads. I'm not interested in buying a beautiful loft, in buying a beautiful man, in buying a beautiful car, all the things that most men I know are engaged with. And I can name a few women in similar situations who would agree. I'm not trying to pass for white. That's what puts me off here. America's certainly not a classless society, but compared to here – at least our traditions are not carved in the great oaks of history.

JR So there's still room for struggle *within* the artworld?

BK Of course. I am working with representations, with pictures, pictures we have all grown up with in some ways, pictures that have dictated our desires, that have dictated our appearances. If one of the extensions of my work is within this white room, I hope that seeing the work and its reproduction – it's very important that the work be *reproduced* – can change things a little bit perhaps. I'm not interested in any of this complicit subversion trip that people talk about. The critique in my work is fairly explicit; you don't have to have read three essays by Doug Crimp to understand what my work is saying. I'm not interested in an implicit critique that's available to ten people who go into a gallery and know what the line of the gallery is. I really want to reach more people. You don't have to have an understanding of the meandering phantasms of the resonance of graphite on paper to understand my work. I want to make it more secular.

JR There's a negativity to your work, a stripping away, a disabling of categories, do you think this puts the idea of other kinds of imagery into jeopardy?

BK When I say I'm interested in coupling the ingratiation of wishful thinking with the criticality of knowing better, I think that there's this kind of flux that's part of the seduction. I am making something to be looked at; there's a retinal address. You make something people want to look at and then you deliver a message. There is a negativity

involved but I think that negativity is balanced, hopefully, by the construction of another kind of subject. For one spectator the work is negative but perhaps for another it's very positive.

JR Where are your images appropriated from? Film stills, magazines?

BK Many different places. I'll see an image and I'll know right away whether I can use it. Again there's a lot of radical cropping going on. What I'll do is find an image first. Almost none of these are film stills though. I don't like the idea of nostalgia. I try to make them as generic as possible.

JR What were you doing at Condé Nast?

BK I was a designer, laying out pages exactly the size of the pages that I use to blow up to this size.

JR What kind of projects were you working on?

BK I worked at *Mademoiselle* for four years, I worked at *Vogue* and *House and Gardens* as a designer and picture editor.

JR Were you politicised through this world?

BK See your notion of a politics here is so different from that in America, especially as regards somebody like me who was out of college by the time she was 19; there wasn't any women's movement, there was nothing, I was on my own. I was totally in limbo really. I didn't belong to the hippy movement, I wasn't a masochist. I don't know one woman who can think back to that movement today and not think it was the most oppressive experience of her life. I believe that any discourse, any political movement, which doesn't take considerations of gender into account, is complicit, that's all.

JR It is interesting – though not surprising – that there should be a so-called explosion of political work in the States given the current climate.

BK What? Where's this explosion?

JR Your work, Dara Birnbaum, Martha Rosler ...

BK Three people who have been peripheral for years – hardly an explosion. One must see it within the picture of the American art market, which would define Dara, Martha and myself as an explosion.

JR But there's a sense of things being taken into account. Politics is suddenly an issue again. It's there in the pages of *Artforum*, it's there in *Art in America*.

BK Most people who write art criticism are air-heads, all they want to do is lick the arse of some artist who is parading up and down West Broadway. What can you say? Most artists who the Brits might construe as doing media-conscious work see their role as being the guardians of culture. They're not taking a critical position, the critique is implicit, 'get it'?

JR So you don't think things have changed?

BK There have been cycles of work which have pushed towards a more secular reading which connects more concretely with one's life, sure, sure. I can't see it in terms of progress though. We have to define the notion of progress too. I think that there are certain works – mine included along with Sherrie's and Jenny's and Dara's and Martha's. I wish I could name some men – Michael Glier's work. Mike is somebody who thinks about these things also.

JR Do you sense that the energy and excitement that has taken hold of the New York artworld in the late seventies and early eighties is now dissipated with the strengthening of the market? Or was it all a myth anyway?

BK I never felt any energy and excitement because I can't get excited about the artworld. I think things are better now in some ways. They're certainly better for me; they're certainly better for Jenny and Martha. If I feel excited about something it's very seldom it's going to be in the artworld; it will be in film. That's why I don't write about art I write about film. But I'm not saying that the artworld is ours to cede to the great expressionists because it's not even ours to cede. But do we give up one venue? I say it's silly to. If those pictures can make an intervention into the seamlessness of representations in

that space, why not? But then there is an insistence to just look at my work as an example of montage theory, and never think about gender, never think about a reception or response or a spectator, because he feels that doesn't constitute a political view; Haacke agrees. They see it as frivolous and trivial.

JR In the article Benjamin Buchloh wrote on allegory in *Artforum* he mentioned your name at the beginning and then failed to discuss the work.

BK That's right because he was afraid to come out against feminist art; he was afraid he would be attacked. Jonathan Caplan, the American director who did *Heart Like a Wheel*, made this statement that most Hollywood films with a feminist slant are about women deciding which town house to live in in New York, and I totally support that view. Because I think the problem with so much American bootstrap *Ms* magazine feminism – and with French theoretical feminism which has meant a lot to me – is that it is always discussed in some Café de Bourgeoisie. Class just does not become an issue. And I think that's something that bothers Benjamin. But if he had troubled to talk to me about it, it bothers me also. I am not concerned with issues if they are not going to be anchored by some kind of analysis or consideration of class. Any questioning or displacement of the subject within patriarchy that is going to change the strictures of that construction is going to be an attack on class. To change the dominant position of the subject is to change class.

Note

1. 4 November – 11 December 1983

10

ELEVEN THESES ON THE SITUATIONIST INTERNATIONAL

With the exhibition in 1989 of Situationist literature and artefacts at the Pompidou Centre and the ICA in London, and the recent publication of a number of essays on the group, the Situationist International (SI) (1957–72) has found itself the inevitable object of academic scrutiny. Denounced and marginalised in its day by the European left, and largely depoliticised by its would-be popularisers during the 1970s, the SI has, in the main, come to be seen in a jaundiced way as a bunch of counter-cultural misfits. Idealist, megalomaniacal, and at times just sheer daft, the group nevertheless represents an extraordinarily prescient moment in the development of socialist theory in Europe post the 1950s. It also provides rich insight into the continuing troubled relationship between art and politics, mass culture and modernism. As Peter Wollen has said: 'There has not been such a fruitful interchange between art, theory and politics since the 1920s'[1] – and since for French culture for that matter. The SI represents perhaps the most influential French cultural phenomenon since the School of Paris. Moreover it became a home and a set of reference points for a whole number of French intellectuals and writers disaffected from both official Gaullist and Communist party-dominated left culture. Post-structuralism owes many of its themes and political retreats to the group.

The influence of SI in the contemporary artworld has come and gone depending upon what aspects of the group's work has fitted current theoretical preoccupations. In the early seventies it was the carnivalesque and agitational side of its post-object aesthetics, in the eighties it has been an emphasis upon an art of the commodity. For many commentators though this work on commodification has little to do with the SI, in as much as the actual use or replication of mass-consumed objects or images in this work (as for example in Jeff Koons's sculpture) is grounded *in* the object; the productivism of

the group (though it was a very aestheticised productivism) was travestied.

I don't intend to enter into these current artworld disputes. What I want to concentrate on is the political and cultural legacy of the group. Below I focus on the key critical themes and categories of the group in terms of either its false intellectual trails (codified to a large degree in post-structuralism) or its continuing critical productiveness (for example, its advocacy of an ideologically combative 'art of the everyday'). For general histories of the SI, I refer the reader to the recent literature;[2] all quotations from SI authors are from *Leaving the 20th Century: The Incomplete Work of the Situationist International* (1974).[3]

THE REVOLUTIONARY PARTY

To understand the vehemence of the SI's attack on the prevailing left and bourgeois cultures of the advanced capitalist countries we need to be clear about the repressive nature of French culture and politics in the 1950s. A year after the SI was formed General de Gaulle came to power. De Gaulle inherited and defended a wholly authoritarian system: there were few structures of mediation between the government and the working class; television and radio were subject to direct political control; and the police were used regularly and openly to break up industrial disputes. The French Communist Party however – the main focus of radical opposition – did little to combat this state of affairs, subjugating the interests of independent working-class action to making parliamentary inroads through alliances with progressive sections of the bourgeoisie. A familiar historical story.

Sickened by the final moral and political collapse of the French CP over Hungary in 1956, and the all-pervading crisis of de Gaulle's modernisation of the French state, the French theorists of the SI sought to reconvene what they saw as a lost revolutionary tradition. In this they were influenced by the *Socialisme ou Barbarie* group's defence of council communism and the political spontaneism of the working class. Bypassing orthodox Trotskyism and Maoism as politics, they argued, grounded in forms of Stalinist-type authoritarianism and elitism, they looked to the anti-vanguardism of the 'anarchists of the First International, Blanquism, Luxemburgism,

the Council movement in Germany and Spain, Kronstadt, the Maknovists, etc, etc.'[4]

Despite the anti-orthodox Trotskyism and anti-Stalinism the target was largely Leninism – which it tended to associate, through implication, with Stalinism – and the revolutionary party. Lenin and the Bolsheviks created an 'authoritarian ideological radicalism',[5] to quote Guy Debord, which through the 'greatest voluntaristic effort',[6] managed a 'reality which reject(ed) it.'[7] The result, given the backwardness of Russia – which pulled such a type of organisation forward – was an inevitable counter-revolution in the form of Stalinism and the lethal 'absolute management of society'.[8] For the Situationist International a revolutionary organisation then should not 'reproduce within itself the conditions of rupture and hierarchy which are those of the dominant society.'[9] On the contrary it must be the 'Minimum Definition of a Revolutionary Organisation' to create an organisation in which the 'only limit of participation in its total democracy is the recognition and self-appropriation of each of its members of the coherence of its critique.'[10]

This elision of Stalinism with Leninism and the critique of organised collective political strategy of course found its extended intellectual home in post-structuralism's attacks on Marxism and the universal claims of science. Although it remained committed to workers' power the SI's critique of workers' organisation opened up the flood gates of the assault on reason-as-domination from the left that was to overwhelm French intellectual life in the 1970s. The anarchist themes that are to be found in Michel Foucault's anti-historicism, Felix Guattari's anti-psychiatry and Jean Baudrillard's political spontaneism all owe something to the SI's voluntarist cry of 'liberation now'. 'The actualisation of desire', to quote Baudrillard, is to be 'demanded here, immediately'.[11]

Essentially whereas the SI attacked the instrumentalisation of reason from a libertarian-proletarian position, post-structuralists such as Baudrillard and Foucault attacked reason, from a Nietzschean position, *as such*. Nietzsche's critique of reason as a will to power makes an appearance in early SI writing, but Nietzsche was in no sense a key figure for the group; the critique of reason had to wait for the Nouveaux Philosophes and post-structuralism's break with Marxism for that.

THE SOCIETY OF THE SPECTACLE

In contradiction to their spontaneism the group developed a highly deterministic view of commodity capitalism. Guy Debord's influential *The Society of the Spectacle* (1967) was central to this. An extension of the critical categories of Western Marxism (reification, alienation) Debord conceptualised commodity capitalism as an all-encompassing system of ideological domination. The 'ruling spectacle' reduced everyone to isolated consumers. Echoing this, Raoul Vaneigem, the SI's other leading theorist, talked of the individual as being assigned a 'particular-*role*-in-the-spectacle'.[12] The result was a tendency in the group to swing from defences of the spontaneous working out of class resistance to reification, to the need for concerted SI-led intervention to lift the 'veil' of ideology. Furthermore, beginning from a theory of reification led them to expand the boundaries of the proletariat to 'almost everybody'.[13] In fact defences of the self-emancipation of the working class stand confusingly side by side in SI literature with defences of the revolutionary potential of the non-worker (the unemployed, the black lumpenproletariat) – a theme that was to find egregious continuation in the Situationist-influenced writings of André Gorz in the 1970s and 1980s, and in the New Movement, 'autonomist' politics of much of the radical left today. The consequence of all this was an emphasis upon ideology and dismissal or marginalisation of economic struggles as acts which simply continued the logic of the system (a major theme of Baudrillard and Gorz). The attack on commodity production capsized into a full-blown idealism. 'The coming society will not be based on industrial production at all. It will be a world of art made real.'[14] As with other forms of what amounts to proletarian-anarchism, Situationism had little time for the idea of socialism distilled in the womb of industrial culture and in the routine trade union activity of workers at the workplace. A world won from necessity could be won without the messy intercessions of long-term struggle. This utopianism is characteristic of Gorz's technocratic, agent-less vision of social transformation. Given that the working class was called into being by capitalism it still retains a vested economic interest in its continuation; transformation of capitalist relations will come about through a non-class of non-workers who have no interest in maintaining the system, and therefore want to change dominant work / leisure relations. As Gorz argued in 1985, echoing the SI: 'Future socialism will be post-industrial and anti-productivist or it will not be.'[15]

A CRITIQUE OF THE EVERYDAY

The SI's return to Marx and the question of ideology was nonetheless timely and important. Taking its cue from Henri Lefebvre's critique of Stalinism and economism in the 1930s and his *Critique of Everyday Life* (1947) the SI extended Marxism as a research programme to the orbit of popular culture and art. In this it echoed Gramsci's and Benjamin's insights into capitalist culture as a sphere where the meanings of the dominating might be contested and transformed at the level of signs, rather than simply opposed from a fixed proletarian position. This was approached on a fairly crude level – the oppression of women was not on this agenda – but nevertheless it clearly opened up a passage to that semiotics of the everyday, that post-Roland Barthes, that the left now takes for granted as cultural studies. In fact in the same year the SI was founded Barthes published his *Mythologies*.

The Situationist injunction to transform everyday life though was more than an academic exercise. In essence it remained the key focus through which the group's politics and cultural politics fused. The debt to Lefebvre was also a debt to André Breton and Surrealism's insistence on politics as a matter of 'aestheticising' life. In this it recovered, via the cultural politics of Surrealism rather than any advocacy of surrealist techniques, the central aestheticising impulse of Marx's vision and writing: that the struggle for communism may be born of a struggle for truth and knowledge, but its end result was a pleasuring of the body and development of the senses free from necessity. As such the productivist and combative side of Benjamin's commitment to an art of the everyday, was held in tension with an anarchic, aestheticising side. Productivism in its revolutionary form was too rooted in forms of pedagogic transmission, too rooted in forms of organisation that instrumentalised the potential liberating relationship between artist and spectator. Aestheticising life meant, as it did for the Surrealists, discharging the unfamiliar and unpredictable into the daily and mundane as a means of lifting the senses, of linking, in intense moments of pleasure, revolutionary struggle with aesthetics. The term Situationist comes from the group's emphasis upon the need for the revolutionary to construct situations (acts of disruption and play, performances, events) that would imaginatively 'break' the lure and routine of commodity relations.

UNITARY URBANISM

This was a central concept for the SI's projected total transformation of everyday life. Faced with the 'New France' of dormitory towns, high-rise flats and traffic jams, the SI attacked the architectural rationalism of modernist-metropolitan living. It called for new forms of human association and the construction of new environments and living quarters that would release and stimulate the imagination. Unitary urbanism represented a

> living criticism fed by all the tensions of the whole of everyday life, of this manipulation of cities and their inhabitants: living criticism means the setting up of bases for an experiential life: the coming together of those who want to create their own lives in areas equipped to this end.[16]

This had a modicum of intellectual influence in critical architectural circles in the 1960s, in particular Alison and Peter Smithson and the 'Mutual Aid' theorists. It had far greater and more practical impact on a cultural level. The SI's urban utopianism has spawned a whole legacy of counter-cultural life-styles and aspirations: from Hippies, Yippies, Alternative People, feminist separatists, down to the current New Age vegetarian–animal rights nexus. In this respect secreted at the very heart of the SI's proletarianism is a romantic anti-capitalism; which is why in many ways its cultural slogans, rather than other aspects of the group's work, have remained so enduring for so many people on the left over the years.

DESIRE

For the SI desire was what the rule of the spectacle suppressed, and what the revolutionary had consciously to empower. Central to this was a theory of the poetic which pitted the 'free' language of creativity against the 'exterior of organisation of life'.[17] 'Fundamentally we are only concerned with the moments when life shatters the glaciation of survival.'[18] Unconstrained then by any sense of the practical limits of 'art led' politics, the SI's aestheticisation of everyday life dovetailed with the group's general voluntarism into a theory of resistance as subjective refusal. The poetic became as in the Romantic tradition a synonym for art's resistance to the instrumentalisation of reality. 'It

is no longer a question of putting poetry at the service of the revolution but rather of putting the revolution at the service of poetry.'[19] This evocation of modernist techniques as politics is the key to the SI's final dissolution as an organisation, in so far as it reflected the inability of the group to theorise adequately agency and structure under capitalism. The dialectical tension between the real and feasible agencies of social change and the structures that contained such change, was, as in the manner of all modernist avant-gardism, frozen into a conflict between free particularity and oppressive totality. Because reason was concretised in the state, in urban planning, in production, in political parties, in vanguardism, emancipation lay in an intensification of everything bourgeois reason suppressed: disinterested play, indeterminacy, free sexuality, those things, in short, that remained the privileged province of the aesthetic. Struggle for workers' power was meaningless if it did not find a form of expression that was adequate to an abandonment of all forms of hierarchy and control.

This was also to characterise post-structuralist conceptions of resistance – though without the proletarianism – which adopted Nietzsche's self-aestheticisation as a new politics of the body. For Jean-Francois Lyotard (an ex-member of *Socialisme ou Barbarie*) and Gilles Deleuze and Félix Guattari, the joint authors of *Anti-Oedipus*, faced with capitalism as an all encompassing system of social control, resistance could not name itself directly as ideological critique for fear of rendering itself instrumentalised, of speaking in the language of domination. It had terroristically to cancel and disturb reason as such. Thus, as an unnameable spirit of creative violation, desire negated the dominant order of speech and vision by continually calling into question, or transgressing, all claims to truth be they from the left or right. Desire as a negation of all identities became a positive escape from all forms of stable representation. The Situationist theory of desire clearly prefigures this closely. The SI's subversion of public events, semiotic transgression of popular images and texts, celebration of spontaneity, are defended as acts that are *positively* negative. However, if both the SI and post-structuralism looks to the modernist avant-garde as a model for reason's cultural subversion, there is little sense of the SI's collective political vision in Lyotard, Guattari and Deleuze. Desire is a highly parcellised and privatised concept in these writers; a view in keeping with their notion, particularly in Lyotard, that the break-up and fragmentation of identities under commodity capitalism should be *affirmed* as a new bodily experience.

At least the SI took the intensification of bodily experience under commodification as something that far from prefiguring the aestheticisation of everyday life, actually distorted it. Aestheticisation of everyday life for the SI, as for Marx, remained an interactive and *non-alienated* shared experience.

THE CARNIVALESQUE / FESTIVITY

Concomitant with the idea of the situation as taking art / desire into rationalised life, was the 'poetry' of the public or political act of sabotage or transgression. After the Watts uprising in 1965 the SI wrote a celebration of the riot as the political carnival of the oppressed. The SI then could not believe its good fortune when it was thrown into the centre of revolutionary struggle in May 1968. May 1968 gave the group the perfect opportunity to establish its spontaneist credentials as the French working class and students took to the streets. The SI slogans, actions and posters, gave a carnivalesque form to the mass demonstrations, marches and meetings. For a brief moment workers' power and the modernist avant-garde collided in a way that had not been since 1917 in Russia.

POPULAR ART / HIGH CULTURE

The split between popular art and high culture, between art's would-be reduction to entertainment or propaganda, and its 'relative autonomy', has been a fundamental concern of the Marxist tradition on art this century. This debate was central to the SI. As an artist-based organisation, the group in fact was formed largely to confront this split under capitalist culture. The notions of the situation and unitary urbanism were essentially attempts to link aesthetics and politics directly to lived social relations. The SI's critique of socialist realism, modernist abstraction and Surrealism (as a movement) was principally a productivist critique, if a highly aestheticised one: that the commodity form of the artwork, irrespective of its imputed political content, prevented art finding an active place in working-class life. There was a split though over this question, resulting in the artist and leading art theorist in the group, Asger Jorn, leaving in 1961. It was Debord's break with modernism and socialist realism on the grounds of 'going beyond' the object to art's final 'suppression' that won the

day. Jorn still believed in the critical possibilities and aesthetic necessity of the art object. The art object should ally itself with critical theory in order to generate experiments on everyday life.[20] In these terms Jorn's position is closer to the classical Marxist position that the art object will be 'realised', free of fetishisation, under socialism. It was with this loss of conflict between the aesthetic object and the critique of everyday life that the SI turned increasingly to the situation and propagandist ephemera as a kind of 'transitional' art; which is why the group produced so few artefacts of any lasting visual interest.

Nevertheless what remains important about these debates is that the group tried to theorise a 'third way' for art beyond the closures of socialist realism and modernist abstraction. Despite their differences, both Debord and Jorn agreed that the critical spirit of the early avant-garde needed to return to its political home: the everyday.

DÉTOURNEMENT

Détournement (semantic shift) was principally an extension of the techniques of 1930s photomontage as an act of ideological interruption and subversion. However, because of the dominant anti-object premisses of the SI these acts of subversion were made purely as additions to appropriated popular and mass-circulation imagery. Despite the radical claims of these acts though, because of the absence of any specific concept of women's liberation in their politics of desire, the group had a weak understanding of many of the visual codes they were *détourn*ing. Thus René Vienet could argue: 'The subversion of "photo-comics". Also of so-called pornographic photos.'[21] The use of pornographic images of women overlaid with proletarian slogans in the SI literature was one of the more embarrassing hiatuses of the group.

All the same the art of *détournement* as the revitalisation of dead objects,[22] to paraphrase Jorn, has been massively important not just in terms of the rise of the new urban, media-based art over the last ten to 15 years, but as a general strategy of interruption within popular capitalist culture and on the street. Feminist *détourn*ing of adverts owes a lot to the SI, along with the more familiar extension of such strategies in the punk culture of the late 1970s. Punk fashion was in many ways a *détourn*ing of boutique fashion.

DÉRIVE

Dérive or the notion of drifting, became another key concept in the SI liberationist pantheon. Related to the experience of the alienated individual in the 'closed'[23] spaces of the metropolis, it celebrated the idea of wandering through varied ambiences as a utopian reaction to the conformities of town planning. 'Development of the urban environment is the capitalist education of space.'[24] Drifting was its revolutionary antidote. This reworking of Baudelaire's theme of *flânerie*, the pleasures of disorientation, was to be one of the sources of post-structuralism's wholly hedonistic and submissive celebration of the 'nomadic': Lyotard's 'joys' of the self abandoned to the ephemeral desires of the commodity.

THE POTLATCH

If revolution means the immediate realisation of freedom, and exercising desire is its libidinal agency, the potlatch (the gift) is its conceptual form. The idea of the situation – the action or manifestation – was taken in the manner of the gift, to represent the opposite of the workings of the market economy. 'Real needs are expressed in carnival, playful affirmation and the *potlatch* of destruction.'[25]

THE AVANT-GARDE

'Power must be totally destroyed by means of *fragmentary acts*.'[26] In many ways the SI was the last of the great avant-gardes in which artistic proclamation and polemic fused with, and directed, political utopianism. As such this was both its strength and its crippling weakness. For in theorising the spontaneous creative act as the spark that would ignite a revolution it pushed politics into cultural politics and wrested cultural politics from any sense of practical limits. The result was the all too familiar and depressing belief that simply ideas or changes in lifestyle can change the world. Nevertheless as a group the SI sought, against the grain of French Stalinism, to offer an alternative revolutionary tradition, one that didn't hold to 'stages' and 'gradualism', that tried to connect cultural activity with revolutionary politics, the aestheticisation of the everyday with the real meaning of socialism. That project still remains on the historical agenda.

The political highpoint of the period is still the inspired telegram sent from the occupied Sorbonne to the Chinese Politbureau by SI-influenced students, as the May 1968 events were at their height. Its pathos is made even more striking today after the massacre in Tiananmen Square and the revolutions in Eastern Europe; its optimism is no less vivid:

> The international power of the workers councils will soon wipe you out. Humanity will only be happy the day that the last bureaucrat is strung up by the guts of the last capitalist. Long live the factory operations. Long live the great proletarian Chinese revolution of 1927 betrayed by the Stalinists. Long live the proletariat of Canton and elsewhere who took up arms against the so-called popular army. Long live the workers and students of China who attacked the so-called cultural revolution and the bureaucratic revolution and the bureaucratic order. Long live revolutionary Marxism. Down with the State.[27]

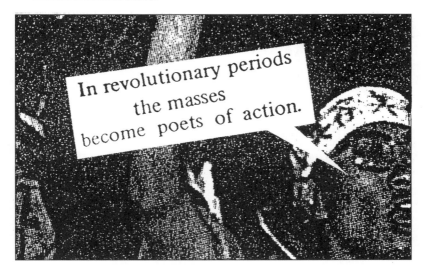

11. John Roberts / David Evans, *Tiananmen Square*, 1989.

Notes

1. Peter Wollen 'Bitter Victory: The Situationist International' in ed. Iwona Blazwick *An endless adventure ... an endless passion ... an endless banquet* A Situationist Scrapbook (ICA/Verso 1989) p 16

2. Peter Wollen 'The Situationist International' *New Left Review* no. 174 (March/April 1989). George Robertson 'The Situationist International: Its penetration into British culture' *Block* no. 14 (1989)

3. Christopher Gray ed. and trans. *Leaving the 20th Century: The Incomplete Work of the Situationist International* (Free Fall publications 1974)

4. 'The Bad Old Days Will End' in ed. Gray *Leaving* p 118

5. 'The Proletariat as Subject and Representation' in ed Gray *Leaving* p 118

6. Ibid p 120

7. Ibid p 120

8. Ibid p 118

9. Ibid p 126

10. Ibid p 126

11. J Baudrillard *The Mirror of Production* (Telos Press 1975) p 165

12. 'The Totality for Kids' in ed. Gray *Leaving* p 64

13. 'Bad Old Days' p 43

14. Ibid p 45

15. A Gorz *Paths to Paradise: On The Liberation of Work* (Pluto Press 1985) p 3

16. 'Unitary Urbanism' in ed. Gray *Leaving*

17. 'Totality for Kids' p 60

18. Ibid p 59

19. 'All the King's Men' in ed. Gray *Leaving* p 77

20. See A Jorn *Modifications* (Paris 1959). As Wollen says in 'The Situationist International': 'Jorn wanted to get beyond the distinction between "high" and "low" art. While his sympathies were always on the side of the "low" in its struggle against the high, Jorn always wanted to unite the two dialectically and supersede the split between the two, which deformed all human subjectivity.' p 91

21. 'The Situationists and the New Forms of Struggle Against Politics and Art' in ed. Gray *Leaving* p 103

22. See Wollen 'The Situationist International' p 91

23. 'Formula for a New City' in ed. Gray *Leaving* p 18

24. 'Unitary Urbanism' p 28

25. 'Watts 1965: The Decline and Fall of the "spectacular" Commodity Economy' in ed. Gray *Leaving* p 95

26. 'Self-Realisation, Communication and Participation' in ed. Gray *Leaving* p 149

27. Ed. Gray *Leaving* p 83

11

THE PERFORMANCE OF
STUART BRISLEY

The use of the artist's own body as a medium of expression has been well championed in the 1970s. Photography subjected it to taxonomic scrutiny (Klaus Rinke); video examined and re-examined the self's mirror-image (Joan Jonas); performance with the wind in its sails diversified into 'opera' (Robert Wilson), 'horror' entertainment (Chris Burden), shamanism (Joseph Beuys), or returned to its Romantic origins in artistic lifestyle (Gilbert and George). All are symptomatic of the same desire: to create a closer relationship between art and life and hence a would-be more self-fulfilling public space for the artist.

In a climate of cultural stagnation in the mid-1960s the freedom attached to working live or directly with one's own body was very attractive. Political and artistic demands have changed though, and artists who once talked of deconstructing the object now talk of deconstructing performance or have given up live work altogether and returned to painting. In fact, breaking through the narcissism barrier has been *the* test case in the late seventies for so many artists working directly with their bodies. (For all the self-aggrandisement of their recent work Gilbert and George have at least shaken off their old solipsism). Stuart Brisley has been careful to avoid the pitfalls of such a *self*-centred approach, in as much as his art has been motivated by a strong socially interactive perspective. As he says, art is always 'to do with others'.[1] I emphasise this not in order to claim that Brisley is the only performance artist whose work has been consistently dialogic, or that his work is in no way 'psychological', but to dissociate his approach from those who would see it as individualistic and self-obsessed. 'The work is never seriously about one's own problems.'[2]

The world of 'dark-things' that Brisley's art inhabits then is not the projection of a troubled consciousness, but the imaginative trans-

formation of the conflictual relationship between the self and those apparatuses of power – the state, the family, public institutions – that inscribe and regulate lives in their myriad, ubiquitous ways. Many artists have used the subject of power (Goya for instance, who has been an influence on Brisley) and many artists have used their own bodies to express this (Dennis Oppenheim, Gina Pane) but Brisley is one of the few artists to place power-relations in an *active* context by subjecting the body to social tasks and rituals. By using his own body on his own or with collaborators he creates an imaginary landscape of the subject in struggle against structure.

Brisley's own response to what he saw as cultural stagnation, like many other artists of his generation who came to artistic maturity in the late sixties (Brisley was born in 1933), was conditioned by the libertarian, counter-cultural politics of the time. Optimism about ends went hand in hand with an iconoclasm about means; everyone was 'extending' their medium; audience participation became a measure of critical value. Theatrical values in fact were offered as a source of freedom for those who sought collaborative forms of activity outside of object-making and the gallery system. Jean Jacques Lebel, John Cage, Michael Kirby, the Situationists (Debord and Vaneigem), Jerzy Grotowski, Hans Magnus Enzenberger, Herbert Marcuse and many others in their various ways attacked the notion of fine art and its 'authoritarian' voice in the individual producer of discrete, consumable objects. Paris May 1968 was the symbolic and active affirmation of the new aesthetics. Embodied in the street theatre, poster-collectives and graffiti was a combative art of the future that had learnt from the revolutionary past: Russian Productivism and Constructivism, Dada, Surrealism.

One of the specific influences on Brisley at the time was a catalogue of an exhibition at the Stockholm Museum of Modern Art in 1969, *Poesin maste göras av alla! Förändra världen!* (Transform the world! Poetry must be made by all!), Marx and Lautréamont; praxis and imagination, the twin spirits of revolution, systematised by Marcuse in his *Essay on Liberation* (1969) and transformed into verse and event by the Situationists on the street of Paris in May 1968. The exhibition, organised by Ronald Hunt, was a survey of Constructivism, Dada and Surrealism. Filled with the intoxicating optimism of the times, Hunt's introductory essay contains much brave idealism and the then current vogue for primitivism. (It is worth noting that Lévi-Strauss's *The Savage Mind* had appeared in English in 1966; primitive cultures, indexed to ideas of anti-authoritarianism, had become idealised

models of artistic and social harmony). Following on from Hunt's essay in fact is an extract from Gregory Bateson's 1932 account of the Naven Ceremonies of the Iatmul People in Sepik, New Guinea. The introduction of straight anthropological material into an art-catalogue after lengthy discussions of Constructivism, Dada and Surrealism, (there was even a Solomon Islander on the cover) was clearly a direct attempt at finding a pre-historical status for those pioneer modernist arts which proposed participatory forms of activity. Whatever these words and pictures confirmed in Brisley it was not simply a matter of transposing the look of primitive rituals into contemporary form, but understanding how rituals have functioned in society. The consensual function of the ritual was what attracted Brisley to its form. The mandate was to find an art that reached out to an audience without the intermediary classifications and fetishisms of high culture and professionalism. In Brisley's public works that productivist mandate still stands today even if the political optimism of the late sixties has receded.

In the late sixties and early seventies because of the performance-based nature of this mandate Brisley's work was invariably presented and reviewed in a new-theatre context. Reviewing *Celebration for Due Process* at the Royal Court in 1970 for the *New Statesman*, Benedict Nightingale said: 'But Brisley hasn't identified a properly evil correlative; he's raging at a symbol, and comes to resemble an inarticulate overwrought child, vomiting from sheer temper.' Nightingale is judging Brisley's gestures *dramatically.* The actions, he is saying, lack psychological truth. However, although conventional psychological elements have played a large part in Brisley's work the concern with dramatic naturalism to which Nightingale addresses himself is antipathetic to the way Brisley (and most performance art) works. 'We were much concerned with *doing things.*'[3] The collaborative value of the work was where any 'psychological truth' lay; the interaction of people working and learning together. 'Doing things' for Brisley was essentially a matter of incorporating real-time action into organised sequences of actions; and not *acting.* Michael Kirby in his well-known analysis of the Happening in the mid-sixties described this crucially as nonmatrixed live-art:

If a nonmatrixed performer in a Happening does not have to function in an imaginary time and place created primarily in his own mind, if he does not have to respond to often-imaginary stimuli in terms of an alien and artificial personality, if he is not

expected either to project the subrational and unconscious elements in the character he is playing or to inflect and color the ideas implicit in his words and action, what is required of him? Only the execution of a generally simple and undemanding act. He walks with boxes on his feet, rides a bicycle, empties a suspended bucket of his milk on his head. If the action is to sweep, it does not matter whether the performer begins over there and sweeps around here or begins here and works over there, variations and differences simply do not matter – within, of course, the limits of the particular action and omitting additional action. The choices are up to him, but he does not work to create anything. The creation was done by the artist when he formulated the idea of the action. The performer merely embodies and makes concrete the idea.[4]

As such Brisley's formal debt was closer to current debates in sculpture than extending the boundaries of theatre. The foregrounding of process, of the artist's guiding hand, in the work of Richard Serra, Barry Le Va and Robert Morris, was where the commitment to doing things lay; however instead of simply leaving evidence of the artist's presence, Brisley stepped into the process of production, claiming for the temporal, as the early modernist performers did, the status of an aesthetic experience itself.

In the mid-sixties Brisley was making fairly conventional constructivist sculpture. Politicisation though blew away their preciousness; Brisley increased their scale and used them as environments: enormous geometric units, that were clambered over and perched on. Physically entering the domain of sculpture and claiming it as a public space was a natural step in the face of Brisley's increasing commitment to seeing the studio / private gallery nexus of Western art as moribund. Environmental art offered 'new relationships' between audience and artist. As Brisley wrote in 1969: 'In environmental work the public is confronted by potential experiences which in evading known forms in art may not be recognisable as art and may be exposed to totally and uncatered for responses.'[5]

In the spirit of the anti-illusion of the new sculpture, materials in the early environments were roughed up, 'messed' about, incorporated into the work for their maximum *material* value. Messiness in Brisley's case more often than not signifies disgust. On occasions paint was used to disfigure and obliterate form. On other occasions natural processes, specifically the decay of food, were incorporated into the work, which Brisley has consistently used since 1968. The

incorporation of organic material though involved a different approach to live-work. The early constructivist-based environments tended to be unstructured; expressionist in their non-matrixed detail. Allowing organic processes to take their natural course demanded an extended linear structure; actions *unfolded* as in a ritual. Although Brisley had made *White Meal* in 1968 (a one-day performance at Middle Earth) it wasn't until *You Know it Makes Sense 2* at the Serpentine in 1972 that this linear ritual structure was used in any coherent fashion. The earlier work, like *Celebration for Due Process*, tended to adopt ritual elements ad hoc.

Rituals provide an index or register of social relations. The ritual 'demarcates, emphasizes, solemnizes, and also smoothes over critical change in social relationships.'[6] The original sacred meaning of the term however has obviously diminished. The word is more frequently used as an expression of stylisation, repetition and emptiness – it has become secularised. In these terms Brisley's performances are not strictly rituals, although at times they do make visual reference to their original sacred function. Brisley's performances incorporate the *rules* of ritual: obedience, obligation, duty; those forms of ideological subjugation that the ritual symbolically demarcates. Brisley is not interested in the historical, mythical or primitive aspects of the ritual (there is no nostalgic search for the 'authentic'; there are no primitive props); what concerns him is how their structure as a social force, as 'socially accepted repetitive acts',[7] can produce intelligible insights into the way society operates – the way power is made manifest between individuals (class) and between individuals and institutions. Brisley's art is nothing short of a politicisation of the body. It is not surprising to note therefore that Brisley has referred to a 1980 piece as 'cruelty learning'.[8] Just as demonstrations, marches and picket lines attempt to disengage the authority of their opponents, Brisley's rituals are performed to convey dissent against those power-relations which have a hold on the body. This may take a fairly direct and highly demonstrative form as in *Measurement and Division* at the 'Hayward Annual' exhibition in 1977 in which, covered in paint, he hung himself upside down by the ankles inside a wooden cage, or a reflective form as in the Christmas dinner piece *10 Days* in 1978.

Brisley's use of the rules of ritual can be divided into two types: the purification ritual or *rite de passage* (which Brisley used in both an active and passive form) and the contest-ritual (an active power-model). Elements of the former are incorporated in the latter. The contest-ritual is a quite recent development. In this type of performance Brisley

engages physically with a collaborator / opponent. In the purification-ritual Brisley puts himself through solitary self-imposed situations of constraint. In the early work this took the form of 'live-situations', tableaux in which Brisley was estranged from the viewer, creating a strongly voyeuristic viewing relationship between viewer and work. In later performances such as *10 Days* the audience became directly involved; talking to the audience 'broke the skin' of the work. In the early 'life-situations' a fixed image (Brisley would remain still for set periods of time) carried the meaning; communication was monologic. In the later work talking to the audience allowed the meanings of the work to be extended and challenged. 'The earlier work was to do with presenting images and the later work was about opening up and articulating the arguments that were represented by those images.'[9]

12. Stuart Brisley, *And for Today ... Nothing*, 1972.

One of the early image-pieces or tableaux was *And for today ... nothing* (1972). Over a period of two weeks, for two hours a day, Brisley sat in a bath of cold water and rotting meat in a tiny upstairs room at Gallery House. In the most repellent of ways the piece metaphored an inescapable feeling of social decay. Brisley's intentions were unashamedly cathartic, to capture the emotions of the viewer briefly, excitingly, through physical repulsion. Such explicitness was considered strong at the time; the English artworld has never been

noted for being friendly towards those who cut sharply against the grain. Inevitably the shock value of the work landed Brisley on television (Joe Melia's *Second House*). Asked by a member of the audience after he had performed a much shortened version of the piece (without the meat) 'what did he feel?' during the piece, Brisley answered: 'It's not an emotional state I'm in, it's a professional state.' This may not be wholly true but it is worth re-emphasising the basic anti-illusionism of Brisley's rituals. Brisley's performances are diagnostic, a critical method, real-time metaphors or allegories if you like, and not dramatic projections of inner states. 'The point at which the artist entertains is usually the stage at which his intuition, response and memory cease to be focused.'[10] The emotional disengagement is a way of focusing visual impact.

Putting the body into self-imposed situations of constraint is an act of faith, a belief that by lowering the bounds of personal comfort one is putting one's self on the line. *And for today ... nothing* was relatively undemanding for Brisley in this respect. A piece in which he did put himself on the line to a much greater degree and hence which could be classified as a *rite de passage* was *10 Days*. The work in fact had the classic regenerative form of the fertility ritual. First performed in Berlin in 1972 and then at the Acme Gallery in London in 1978, *10 Days* is one of Brisley's most successful reflective ritual pieces, a rich confluence of his preoccupations on power. For ten days over the Christmas period Brisley starved himself. Silent and austere, he was seated at the end of a long bare table. Each meal time food was served to him which he refused. The food was prepared and served by a professional chef. Uneaten food was left on the table to rot. At selected times food was served to the public. People came and went but on the whole there was little change in the action. Brisley would explain the work or answer questions when required. On the tenth day Brisley crawled along the table through the decayed food. The piece ended in the evening with a banquet for friends to celebrate the 'new' self. In such low-key circumstances the emergence of a 'new' self for the casual visitor can only be felt distantly. It is what Brisley's endurance promises on an imaginative level that counts. As such it is in Brisley's translation of process into allegory that the meaning lies. Although he is an artist working in a gallery and not a prison inmate, his refusal of food *is* a political act. The action, for all its literalness, sets in motion a powerful set of responses not only to questions of consumption, but to human agency and social transformation. We can read the piece specifically as a seasonal corrective to commodification, or more

generally and pointedly, as a meta-journey (as in a sense fertility rituals are), as the *necessary* production of a set of new values out of a surrounding world of decay and stasis. There is a striking immobility and silence at the heart of Brisley's work where the past and its living dead capitulate.

In *180 Hours – Work for 2 People* (Acme Gallery 1978) a 'new-order' wasn't governed by the fulfillment of a specific task but by the convergence of two figments of Brisley's imagination. In contest-rituals such as *Between* (De Appel, Amsterdam 1979) the tendency was to enact power conflicts in the most basic and aggressive of ways with a partner – in *Between* Brisley and Iain Robertson (who has worked with Brisley on a number of occasions) spent a set number of periods over 48 hours struggling with each other on a steep ramp. In *180 Hours – Work for 2 People* the territorial struggle was imaginary – enacted as much in the mind of Brisley as the spectator. Brisley took on the persona / actions of two opposed 'roles': A, an 'anarchist' who lived in the downstairs gallery, and B, a bureaucrat or functionary who lived in the upstairs gallery. The schizophrenic tug between their respective 'mind-sets' (A was messy, B was obsessionally tidy) became the basis for a live-in work lasting 180 hours and the nearest we get in Brisley's punitive anti-theatre to actual descriptive action. In the imaginative transaction between these two selves he produced the strongest simulacrum of authoritarian power-relations he has yet created.

> Part of the idea for the work was from reading a small section of Marx which makes an analysis of bureaucracy. It was also that which I experience all the time which set the work in motion. At the back of it was a power struggle, a class struggle, where people in positions of power assume superiority over the majority. I saw A not only as the artist, but the private individual, the civil person. The individual who walks freely down the street. B was a figure of authority corrupted by his own power. I gave to B the simplistic idea of being opposed to anything organic, because I was making that relation between the free, private individual who suppresses all that in himself and others.[11]

However, despite Brisley's description we are not too sure where we are and what the figures represent. What is inescapable though is how they actually behave, how B treats A. Discipline (B's own) and its corollary surveillance (B's 'monitoring' of A's space) are functions of

B's will to power throughout the work. He is the dominant one, he is the one who remains silent and unaccountable. Brisley became either A or B by walking into either of the galleries which were connected by a stairway. The action was written up each evening by Brisley and displayed each day in the gallery in what became a kind of accompanying narrative. In a way the notes were the performance's outlet to the outside world; the notes conferred a meaning on the action that the viewer could only grasp in a shadowy way.

On the first day, 5 September 1978, Brisley wrote: 'If A manages to escape his unpleasant condition he can do so only by becoming like B. Then he experiences power.'[12] On the last day, 12 September Brisley wrote: 'B has gone. Yesterday he was adamant that he would outlast his time. But that was the last posture. In the course of the day he experienced the most invidious assault upon his consciousness by his unseen self. It forced the realisation that he was a preservationist and a deteriorationist.'[13] What had become obvious to B was that throwing rubbish into A's space did not actually remove the presence of its smell. His ascetic order was incapable of controlling nature. Or more precisely he was incapable of accepting the course of nature. Realising the ultimate impossibility of such a refusal he eventually chose 'non-existence'.[14]

As a concept, B was that authoritarian part of Brisley, that part of himself which adopted the language and behaviour of institutionalised power. A was the creative, 'more feminine'[15] side of his work. 'In a way it was an interpenetration of me as an artist conceiving the work – that was A's role – and me as a wage earner – B's role.'[16] B was the visually stronger of the two because it was through his actions (swinging from the 'catatonic' to the 'manic') that the contradictions of his order could be felt. The fact that he wore dark glasses and was therefore unable to return the viewer's gaze increased his position of isolation.

Looking takes on a political dimension in Brisley's work. In many of the pieces the impression is that Brisley is incarcerated in a cell or some other place of detention (*And for today ... nothing*, and *ZL 65 63 95 C* in which he sat in a wheelchair covered in paint and debris). Immobile, silent, his body is subject to the constant visibility of an observing gaze – a process of surveillance. There are echoes of Foucault here. In Foucault's writing this image of constant surveillance is offered as a metaphor for all social relations under 'Western reason'. We live, he argues, in an unseen and perfected world of coercive and consensual power relations. Thus for Foucault

knowledge is always inscribed by power relations and therefore in some way the domination of others. Truth / freedom is not a possible state beyond the effects of power it is coexistent with it. Much of Brisley's imaginary world would seem to confirm this pessimism. However Foucault's abstract and trans-historical model couldn't be further from Brisley's intentions. Brisley's metaphors of confinement are not terminal or *fin de siècle*, but a response to the prevailing conditions of a given *mode of production*: capitalism. Brisley's images of stasis and decay are the product of a determinate historical epoch: the post-war world of social democracy and Stalinism. In this sense his work has always been embedded in a Gramscian reflex: that the subject matter of the radical artist in the bourgeois Western democracies must be produced in the light of a sense of historic limits. This is not to say that Brisley works out of some pre-determined ideological model but that the question of representation and resistance is inseparable from acknowledging the containments under which they may take place.

The early tableaux for all their vividness were unsuccessful at representing the dynamics of power relations. Brisley's response in *180 Hours – Work for 2 People* (and to a lesser extent *10 Days*) was to create a sequence of images which combined with action and discussion. *180 Hours – Work for 2 People* moved between 'making pictures', breaking those pictures up and commenting on those pictures. The analogy to film is pertinent. Both the improvised work such as *Between* and those works which incorporate fixed images or elements of regulation in the action, use space as a framing device, be it the gallery itself or some form of construction. (Like the 'poor theatre' of Jerzy Grotowski Brisley's performance uses very few technical resources relying on the sharp or 'raw' delineation of the body in space to compel our attention and excite the imagination.) In *Approaches to Learning*, a contest-ritual performed with Iain Robertson in the darkened basement of the Ikon Gallery in Birmingham in 1980, the framing device was a lift-shaft which carried the action into and away from the space, releasing light and blocking it out. 'It's like watching a film. There are a series of sequences which take place in time where the conjunction of one sequence in relation to another begins to operate beyond the sum of its parts.'[17] Brisley's sequences though are in no sense narrative but allegorical. Allegorical meaning resides in the whole and any of its constituent parts. Although we may get a clearer picture of the whole if we follow the action through to the end it is not necessary in order to understand

Brisley's work or be affected by its power. We can 'see' the whole through the single image of action or sequences of images or action. The sustained uneventfulness of much of the action (or highly repetitive action) confirms this. We may return to the work without having 'missed' anything. What is important is how the work comes across at a structural level, whether the central image or images of the work suggest and sustain a number of different readings. Thus it is important to counter the view that Brisley is a fetishist of process. On the contrary the structuring of action and detail always centres on the creation of a core poetic image or images.

For political artists it is a matter of course that what one is doing is peeking behind appearances, peeling away the onion of representation; political art in the seventies whether it has followed a structuralist or agitational bent has been a confrontation with common sense. Its strongest base has been in photography, a medium perfectly suited to examine the politics of classification. Recent performance has tended to examine roles and behaviour; the attraction of performance for women artists has been its critical function as a theatre of subjectivity. For Brisley performance is ideally suited to making *gestures*. 'My activity exists as a kind of gesture which is in recognition of the possibility of change.'[18] The way in which Brisley works – the collaboration, the refusal to play the market – is where the politics lie; what the work 'says', what specific political sights it sets and metaphors it creates, are governed by this. As such, performance has no privileged position in Brisley's work as a whole; there is no Brisleyian performance model to adopt; performance is simply the most direct and flexible way of moving between art contexts and non-art contexts. What Brisley has pursued along with a number of other artists who came to political consciousness in the late sixties is a new status for the artist, a status tentatively outlined by Hans Magnus Enzenberger in 1970, looking back to the productivist debates of the 1920s, in his essay 'Constituents of a theory of the Media'.[19] The artist 'must see it as his goal to make himself redundant as a specialist in much the same way as a teacher of literacy only fulfils his task when he is no longer necessary.'[20] Unfashionable words today, but a principle which guided Brisley's art throughout the seventies. Brisley is a protean artist whose suspicion of style and his pursuit of collaborative forms of work has pushed his art into many diverse areas. One activity that underpins all his live work is his involvement with film. His collaboration with the film maker Ken McMullen who 'documents' his works has been of

primary importance. Retrospectively the performance could be seen as the precondition for film making. In fact just at that point when Brisley is coming to be known as the doyen of British performance – a view that the 1981 ICA retrospective exhibition to a large extent confirmed – he may well make himself redundant from that position altogether. In the same year Brisley said: 'I need to find something which allows me to conceive of performance in relation to film. If I could do that the necessity to work live would probably diminish. Then again maybe not.'[21]

Notes

1. Stuart Brisley 'Anti Performance Art' *Arte Inglese Oggi 1960–76* (British Council 1976) p 417
2. Conversation with Brisley, January 1981
3. 'Stuart Brisley' interviewed by John Roberts *Art Monthly* no. 46 (May 1981) p 5
4. Michael Kirby *Happenings* (Dutton 1966) p 17
5. S Brisley 'Environments' *Studio International* (June 1969) p 268
6. I M Lewis *Social Anthropology in Perspective* (Penguin 1976) p 136
7. G S Kirk *The Nature of Greek Myths* (Penguin 1974) p 248
8. Unpublished notes to *Approaches to Learning* performed at the Ikon Gallery Birmingham June 1980.
9. 'Brisley' interview by Roberts p 8
10. Brisley 'Environments' p 268
11. 'Brisley' interview by Roberts pp 8–9
12. S Brisley unpublished notes to *180 Hours – Work for 2 People*, performed at the Acme Gallery September 1978
13. Ibid
14. Ibid
15. 'Brisley' interview by Roberts, p 8
16. Ibid p 8
17. Ibid p 7
18. Ibid p 6
19. Hans Magnus Enzenberger *Raids and Reconstructions: Essays in Politics, Crime & Culture* (Pluto Press 1976)
20. Ibid p 53
21. 'Brisley' interview by Roberts p 9

13. Jo Spence / Terry Dennett, from *Beyond the Family Album*, 1979.

12

INTERVIEW WITH JO SPENCE

JR Like a number of photographers at the moment, you are working in the area of what loosely might be called post-naturalist photography. Central to this area is the notion of the staged or studio photograph. However, if your work is close in spirit to this type of photography – in particular those photographers associated with Victor Burgin at the Polytechnic of Central London – your critical aims and mode of address are very different. Your work has purposively avoided rooting itself in recent academic post-structuralist debates about deconstruction or in sectarian proselytising for photography against other media. On the contrary you have at all times been concerned to generate a practice and a discourse around that practice that would enable photography to enter constituencies outside of the university / fine art axis. You have recently called yourself an 'educational photographer'. Could you talk about these areas?

JS The term 'educational photographer' comes straight out of Brecht. My understanding of Brecht's work is that it could be educational and entertaining at the same time, and not mere dogma. You should be able both to enter the work and yet stand back while you're watching your emotions in play. That's one reading of Brecht; and certainly that's how it has worked on me. My work is also for use within education itself in a formal and informal sense, in so far as my work tends to get circulated around a network of connections in higher education and in adult education. It seems to be studiously ignored within formal higher education except when I am asked on a personal basis to go and give a lecture, usually to what are seen as 'difficult' students. I think my work is seen as the 'underbelly of theory' in some colleges where they are struggling to teach theory. I was told long before I studied theory that my work was theoretical, which I found quite extraordinary. So in that sense I can't say how

my work does relate to theory, I've just been told that it does. I think the educational aspect also comes out of performance art; Rose English was very influential; and, on another level, John Heartfield, although I don't like his sloppy love-the-communists type stuff. Rather, I like the way he foregrounds contradiction and his use of irony and vulgarity; sometimes strategically the more vulgar it is the better it is. I think it is good that people laugh when they are being stabbed in the brain, by something, I hope, that they hadn't thought about until they laughed about it. So in that sense my work allies itself to theatre and joke telling and the music hall. These are my roots as are those of the Photography Workshop. And my roots are also in working-class ways of dealing with adversity through telling extraordinarily funny stories all the time about the conditions you're living under. This *can* be very politicising but very often isn't, it is often just a way of reinforcing the status quo by turning everything into a joke. However, sometimes radical humour can work against the grain of dominant forms of humour. But it is very difficult to be funny in photography, because you either have to echo *Private Eye* cover type images (which I like, though I'm not particularly keen on the content) or seaside postcards. I'm interested in striking at the same kind of mythologies as the post-structuralists are but coming at it from a completely different direction. So the virgin, the bride, the madonna, Hollywood, are target areas of mine, but ultimately my work is concerned with saying to people 'you can do this unpicking for yourself', because until you have experienced a conflict of being *caught* up in a set of structures that are set in motion by the images, that one desires to become but can't become, those desires cannot be challenged.

JR Do you think there has been a decisive critical shift in photography, that it's no longer possible to produce a naturalistic documentary photograph with any degree of intellectual conviction? Is the staged photograph the dominant area photography now has to deal with?

JS Not to dodge the question, I think actually that there is still a role for what we call naturalistic photography. I think by and large the professionals – by that I mean people who make a living out of naturalistic and documentary photography – create a problem for the viewer because the camera is seen to be 'telling the truth'. I'm very interested in theories of literacy from people like Paolo Freire where

images are used as the basis for vocabulary building and the images will be grounded in people's everyday experience, though they wouldn't necessarily be taken by them. So let's say a picture taken on the street of people standing around the Labour Exchange would be the basis for *talking* before one teaches reading to adults. The vocabulary that comes out to the discussion of the photograph would be grounded in their own experience of oppression, which would overthrow the idea of naturalism as we know it by bringing up contradictory readings. In that context, which is an educational context, a context in which people want to learn to read and write, people actually have a point of view worth stating and which is validated. In that situation therefore naturalistic images can be extraordinarily useful. Similarly in dealing with one's own experience, for example my illness, in trying to show something that actually hasn't got a currency or has hardly been seen before (whilst making clear that it is one truth among many because it is my perception of the events I pass through) if I had tried only to stage photographs of what was happening I would have missed the point: that no one had ever seen those images before in the first place. You can't deconstruct something until you've already seen it and it has a currency. There are some experiences that have never been given any credibility because they are continually suppressed in the image-making process. So the making of images that engage with those things at a natural-istic level could be quite useful. On the other hand there is a crossover between naturalism and staging very often. For instance, I have been working continuously on amateurism as a discourse in photography and I try to deal with domestic power-relations and the way they are held at bay in the Family Album. As one of a couple, I can at any moment in the day say to the guy I live with 'can I photograph this?' I would literally stop the 'film' so to speak, go and get my camera, and come back and photograph it preparatory to later on putting a text with it. In a sense it is staged at that point, it ceases to be naturalistic because I've lifted it out of the flux of events. And so let's say the question of male sexuality and the male body – an area that I have become increasingly interested in both theoretically and from the point of view of my own desires – has allowed me to produce a range of images which crossover between naturalism and staging. Depending where you put them I would say they were naturalistic or not. So a photograph of a man bending over the bath is something personally I see everyday, but actually it does look like a piece of theatre when lifted out of the flow of domestic life.

JR Would you agree then that photography is in crisis because of the thing that it does so well: describe the world (or some part of it) naturalistically? In *Camera Lucida* Barthes talked about the essential banality of photography in this respect. Is this what you are battling against in your attempt to create a wider set of parameters for the amateur tradition? Are you saying that photography need not necessarily be banal?

JS It's not photography that's banal, it's the people who have had control over photography as an amateur discourse who have used it banally. This in fact ties in very closely to psychoanalytic theory in that most of that which we would probably want to photograph we daren't because we actually prohibit ourselves from photographing it or from even 'seeing it', or looking at it. An extreme instance of that would be sex between one's parents or physical violence between family members, both of which are held at bay in memory as much as possible. Certainly they wouldn't be seen as subjects fit for photography. It is only if one has a notion of therapy, or being able to dredge up or re-work what happened to you in the past, that one can merge other techniques with photography, such as psychodrama, in order to create a personal theatre in which you can create photographs as a kind of memory trace. In that sense it is all a complete fantasy because there is no direct 'going back' in memory. But what one is using as the building blocks to recreate visually our memory traces would be people who stand in for family members, or we can re-enact all the parts in the scenario for ourself. However, if you think of it in relation to the post-structuralist work that has been going on around Hollywood icons, or particular themes from Freud, I think to represent what is not normally represented in the private sphere has a validity in the wider sphere. It is not about attacking one's family or blaming one's parents, but a means of putting on to the agenda for discussion those 'problems' we can't talk about in personal life, and how they relate to ways in which we are positioned in society.

JR Do you see this as ever being conceivable in a democratic sense without there being some fundamental change in primary and secondary education?

JS No I don't. But on the other hand sexuality is the big time bomb in secondary education. Wilhelm Reich said that if you want to

engage with the hearts of youth politically, you have to talk to them about their sexuality; and you have not to moralise as others have done. Well that's what goes on in individual therapy but it isn't seen as a political act. It is only when you go into therapy as someone *already politicised* that you begin to make this connection. Which is what I think I'm doing. It just so happens that I can't be in therapy without dragging with me Marxism and all the other isms I have read. Of course as a photographer whatever I do I think to myself: 'how could I represent this?' because we have such a total paucity of images about most things that I think are important politically. Sexuality can only be talked about in the most abstract terms, but if you can imagine putting a picture down in front of an adult (or child) of its father's genitals, you're going to encourage a totally different conversation, because the permissions are there. As in any form of education the agenda is set usually by the person doing the educating. A narrow set of prescriptions is set up, and higher education is absolutely no exception to that. Beyond that in therapy I've picked therapists who I know are themselves politicised, because then they will provide a framework which will allow me to talk about class and gender and sexuality together. If I went to a bourgeois psychoanalyst I wouldn't be able to do that. I would be blocked up. So, the photography comes after the therapy as a form of visual history making. What I do is add photographs to my therapy which would relate to my own class experience and experience as a woman that would hopefully relate to other people's concerns who share the same cultural base as me. There's no universal audience; there may be universal signs but our reading of them is very different. However, a lot of the post-structuralist photography ignores that and assumes that we are caught up in psychic structures that *are* totally universal. Maybe this is so in terms of structures, but in terms of content and reception these are very different from person to person or group to group. Certainly from being in therapy, and wandering around the country teaching the stuff that Rosy Martin and I are producing, our work was ringing bells – very, very noisy bells – in a way that images, say, on fetishisation accompanied by abstract analysis intimidate the audience into saying nothing at all. When we have put our images up the whole group erupts into discussion. That is where the democratisation comes in, in a sense. Because we are not going to remain behind to be the theory teachers, we are hoping to shift the agenda of what students ask for. A lot of people are now beginning to see that you can't teach theory without having some work in the

first year on your own history; you just can't leap over the head of your own history. The problem is how to do that without going into straightforward reminiscence or people inserting themselves into abstract texts without engaging with what is happening in their own lives. Of course in adult education, where one's life experience is the basis for teaching, they often have a problem with theory because they cannot move beyond the anecdotal and immediate needs of the students, or beyond questions of bias. Phototherapy therefore attempts to work across the polarity of those two things: theory and experience.

JR The central component of your desire to combine the political and the personal, theory and experience, is an attempt to produce a body of work that represents the relationship between the subject and the social world (dominant medical discourses, institutions, the state, etc) as a struggle for some systemic understanding of the self and other. If capitalism fragments consciousness into specialised and mutually exclusive categories of knowledge and competence, then the body under science, particularly orthodox medicine, is paradigmatic of this fragmentation. In your recent work on your own cancer, by documenting your treatment at the hands of the medical profession and your switch to alternative medicine (traditional Chinese medicine), you have attempted to produce a set of images that explains and resists this fragmentation. Could you talk about this?

JS I don't think the *images* resist fragmentation; in a sense it is endemic to photography to fragment. The thing I am trying to raise is the question: how does one experience oneself in a fragmented way? And in that sense I don't think photographing traditional Chinese medicine is any different from orthodox medicine because you actually do experience the treatment on a moment to moment basis as fragmented. On the other hand within any session I am also being counselled, so the mind and the body are being worked on at the same time. Now I can't represent that in one photograph. So what I have tried to do is use phototherapy as a way of re-enacting what my psychic states were whilst undergoing orthodox medicine – and that is a very political question, because the question came up at the very beginning, how come I at 48 years old, an intelligent, articulate woman – can give my body to a doctor that I've never seen before in order for the doctor to carry out highly contentious treatment in an area that they have little competence in: breast cancer? There are

more areas of dissent over breast cancer than there are agreements. Patients are ongoing guinea pigs.

JR A conventional 'deconstructive' approach to the discourses of orthodox medicine would invariably involve a distancing from the material. In your work though, given you are yourself a cancer patient, your attempt to gain another type of knowledge about cancer has sought deliberately to break down that distancing by being present in the text.

JS I am present in the text – and naturalism here again rears its head – in the sense that when I was being processed within an industrial institution – which is what I see state medicine as, good or bad – I decided to document it from the patient's point of view. So in that sense I'm subjectively present, literally in terms of how I 'see the world' through my eyes. I discovered while I was doing it the incredible limitations of trying to show what was happening to me, and as I say in the work the limits of naturalism become very clear in this type of work because you can't show what the dominant discourse of medicine itself is about. In order to find out I had to go and do an awful lot of research; and that means of course researching the history of the medical institution and the illness I have. Then you immediately begin to understand that truth is produced within the discourse of medicine itself. There is no truth about cancer: they are continually arguing about the definitions of the disease. That led into other fields like the drug industry, health education, food. So that's where the personal becomes political: how is it we don't question what is happening to us? But then as soon as I moved to non-orthodox medicine – which is dealing with whole body medicine, and by that I mean no illness can be located to part of the body – then you move into the really big questions of photography: how do you show the structures of society? In other words if I'm in a bad relationship and I don't have a job and I'm having a bad deal with my landlords and all these things are relevant to my illness, how do I represent this to myself? How do I show my relationship to the rest of my family's health? These are really big questions, and they are posed *really simply* when you come at it this way. And the next level in representing my illness was, 'how did I *feel*: terror, anger, despair?' And that's where the staging of images with myself as the main actor begins to throw up new images for me. It's a form of assertiveness training really. Where the debates on positive imagery fall down is

in the fact that the dominant group wants to offer idealised images of itself, as well as images for us to aspire to – images over which most of us have little or no control. Alternative medical theories of illness assume that you can't hope to get better unless you have an image of what *being better* is about, because it is totally abstract. In these terms the point of my images is that they show me acting rather than being acted upon. When you are in a defiant position, when you are opposing what is being done to you, the fact that you have a record of it (and again this is a naturalistic thing) is a confirmation for yourself that you have done it, because it is very easy to be so undermined that you can forget that you have found out new things. In that sense it ties into family and class history absolutely: if every time there is a problem you have to reinvent the wheel then you are going to be stuck with the bicycle. And so in the Family Album for instance, I've come to the conclusion more and more that very tiny details could be kept that could be incredibly useful in the history of any family. For example that it might be worth writing down the contents of the medical cupboard and what each thing is for, as an ongoing process. I don't expect people to do this, it is just a way of being polemical really. So instead of saying that's a cupboard for medicine one says *why* is that cupboard full of medicine? In fact when I went to photograph a family for television a couple of years ago the family said to me 'you can photograph anything in the house'. So the first thing I did was open the medicine cabinet and the first thing they did was take the Librium out, which I found very, very instructive as a photographer. In other words they want to hide the evidence of what it is in the family they are taking that allows them to stay in the position they're in, without doing anything about it. So to come back to the question of the holistic or systemic. What I understand by holistic medicine is that you treat the whole patient in relation to their life history and circumstances. What I understand by systemic therefore is that the whole body is involved. So in breast cancer the breast is not removed unless it is life threatening. However, the fact remains that it is cheaper to have the breast cut off than not. Thus even if medical 'knowledge' has moved on, economically it is still cheaper to do what they used to do. In a recent staged image which Terry Dennett and I did, we have combined a prosthesis and a medical journal with a note implying that somebody has the power to make these decisions. My hope is that it might be used to shock women into thinking about how they come to believe what is told to them. This is a non-naturalistic photography.

JR You mention the word 'shock'. However 'putting into view' as an act of political shaming or 'transgression' is becoming an increasingly attenuated area for representation under late capitalism, in so far as there are few taboos, or acts that 'dare not speak their name' left to be colonised. The exception is perhaps disability, which remains the real and unpalatable other, because it respects no one. How do you see this in relation to your work on cancer?

JS I am already coming from the women's movement; I'm into raising consciousness. But as a person who had studied psychoanalysis I am also into 'unconsciousness raising' as a question. However, not in the abstract ways it is usually raised. If cancer is the big taboo – except under certain prescribed newsworthy forms like Reagan's nose job – then I felt if one could raise cancer as a metaphor for that which seems impossible to change or come to terms with, one could also begin to raise wider questions about power that are specific and diffused. I think that if you engage with something like health – which nobody can say is not their concern – and relate it as a political question to debates going on in representation it can be very useful. And cancer, if you like, is a metaphor for that struggle in my work to bring those two discourses together. This is why I have gone to the cancer journals in America to quote, to make it quite clear that orthodox medicine is trying to destroy the signs and symptoms of the body rather than heal it. And that then allows the question of cancer treatment to engage with other areas of struggle such as disarmament and the nuclear industry. In my work I am trying to use material from other discourses, again metaphorically. By doing this you can then say one struggle is not disconnected from another struggle. It wasn't until the Chernobyl cloud passed over Britain that I realised that the food chain is on the verge of being destroyed. If you understand the politics of nourishment, the fact that the food is under direct threat immediately leads you to totally different conclusions, rather than saying 'I won't eat lettuce for a week'. I'm beginning to make different connections now to my health work.

JR The work on health though is not simply about making the abuses around the treatment of cancer visible but in showing and celebrating the female body in process. There is a purposiveful and shameless display of your 'wound'. In Renaissance devotional painting this display of wounds was called *ostentatio vulnerum* (the showing forth of wounds). There are echoes of this in your work. The

wound becomes the mark of redemption. However in this instance of course, the wound does not mark the proof of Christ's corporeality – a reiteration of the Word, of Holy Scripture – but serves as a subversion of dominant texts around the female body: women with a mastectomy have no right to a visible sexuality; the passivity of the female cancer patient under orthodox medicine; the 'good' feminine self-portrait. This is a very compelling work because it addresses both female and male simultaneously, in so far as it is an image of female triumph, and a provocative transgression of capitalism's infantilisation of the female body. Would you agree with this?

JS I can only answer this by saying I have no religion. However I have read Audre Lorde's *The Cancer Journals* where she talks about wearing our scars with pride – and I thought 'what crap' when I read it. I don't have any pride in my scars at all. I actually wanted to show what had been done *to* me, plus the crossover between sexual avail- ability and sexual glamour and the impossibility of that for an aging, mutilated woman.

 Secondly it was a validation of not disavowing what had been done to me, because the only way I can begin to come to terms with it and take control of my own life was being able to look at what *had been done to me.* And the prosthesis syndrome is a complete denial for women of what has been done to them. That image has been used a lot on its own and I'm not too sure whether it says I'm a victim or not. The effect was to liken cancer treatment to warfare; it was based more on a notion of our culture as systematically trying to root out and destroy what it sees as the 'trouble' or the 'dissenter' rather than go to the complex causes of something. As for the question of redemption: redemption implies that I have committed a crime, on the contrary, I feel as if a crime has been committed on me. I am beginning to see the way the medical profession treats women's bodies as tantamount to war crimes. I would say all my work has been concerned to subvert dominant images of women; however, the real problem for me has been how to represent the class connotations of this, which is why I am entering the sphere of debates around power. It becomes easier to discuss things metaphorically in those terms rather than being class based. Talking about power relations gives you a wider canvas in a sense because you can begin with the mother and child, or father and child, relationship as one of the main structures of all authority relations. Class, and of course race, would then enter according to the socialisation of the child. And certainly in the work

Rosy and I are doing now (Rosy and I are two working-class kids-made-good, so to speak) this is something which is central. As soon as you start unpacking the bland universalised images of the school child; and working within a tradition of oral history into phototherapy, the questions of class begin to come up immediately. You can begin to make your own experience visible to yourself in a way that you can't if you are working with a universalised icon of femininity and gendering, because they are all classless in any real sense. They are coded so that class doesn't cross your mind. Women's magazines are about 'how to leave the class you belong to'. My politics are informed by Marxism but I am finding it increasingly difficult to know how to talk about class in relation to images of women. Which is why in using myself as subject matter, and going back historically, at last I have been able to draw upon what I know rather than being stuck with the agendas of higher education which endlessly deconstruct images that are not about class, in the sense that they are a displacement of class. Anything from Hollywood which addresses sexuality only is a complete displacement of class, but unless you *say* it is a displacement of class it is not going to cross your mind. Worrying about androgyny at the height of the greatest economic and unemployment problems yet seen by the world might seem a very strange proposal from somebody with my background. But as a feminist who is interested in people rather than gendering, androgyny, the idea that we can all choose to manifest a range of masculine and feminine aspects, is very important. Within my family I can dredge up and replay images of parents that are totally androgynous: e.g. my mother went out to work in trousers all the time; my father looked after me as a child. Those things are not addressed in mainstream discussions on deconstruction. In fact as soon as you move into your own history many people would be able to see a different spectrum of images in their own past, and a range of identities emerge distinct and separate from the mere deconstruction of dominant images. The question of class for me is becoming more and more foregrounded; I feel I have been pulled sideways by a great gust of wind by going into higher education in which the main credibility is going to people doing work on masculinity and femininity, whereas other artists doing work on class have been relegated. It is the crossover between gender and class that I'm interested in, because the dominant myth is that as a woman who has no real power, you can *pass* as middle class. That is the myth that is handed out to women, not the myth of the madonna. The myth of the madonna obscures the realities of being a parent. I have a very

practical approach to images really. I spent so much time in 'lower' education where you are dealing with adults who haven't had a so-called education, that in my own work I've been forced to find ways to address both the realm of the universalised image and the realm of the self and one's own experience. And that is why I'm very pleased with the helmet shot as an icon but only in the context of the whole work, which is about power relations. The fact is that by virtue of their anatomy – their reproductive ability – women spend far more time in the hands of doctors than men do. In that sense health is a much bigger question for women – in terms of an ongoing process – than for men. Men have more industrial diseases, but they tend to be towards the end of their working life. Then they are as equally infantilised as women; they just hand their bodies over to the medical profession.

JR This takes me on to the subject of phototherapy itself. In the work you have done in this area of identity with Rosy Martin you have talked about using photography in a similar way to using psychotherapy, as a means of creating 'different images of ourselves'. You talk about each of us having sets of 'personalised archetypal images, "in memory", images which have been produced through various photo-practices.' I am not too sure what you mean by this. Are you saying that we carry around the harmful residue of images of former selves? Where do these archetypal images come from?

JS The archetypal images are the ones we keep in the family album: the school photograph, the wedding photograph, the holiday photograph, etc.

JR But why should these images present a psychic problem?

JS Because every image in the family album is a disavowal of everything else that *could be* in the family album. In this sense such images feed into the mythology of universal experience.

JR Why should I want to reclaim these mythologised images?

JS We are not saying you should reclaim them, we are saying you should reinvent them. The point is they are a way of screening the past from you. In psychoanalysis you discover screen memories, memories that you obsessively come up with. You can't think about

anything else because these memories are in the way. Well, there are photographs which are screens in that sense, they screen the past from you. And every time one's history is recounted over these photographs that screening process is reinforced, because you get further and further away from the possibility of discussing anything else; just a series of safe anecdotes are exchanged. This is my experience and this is the experience of all the people I have interviewed on this matter. What we are saying is that if you had a different type of, say, high-street photographer (because this is the position I originally came from) who had the therapeutic abilities and could work with you in order to unpick these screens there could develop a parallel or interpenetrating analytic situation to that of psychoanalysis but through the use of images. The narrative visual fragments of one's past would then help you to understand a lot about why you are the way you are, and who you are now. The image of, or its reconstruction, therefore becomes part of the psychoanalytic dredging. Sitting in front of a photographer in the studio, as one would do in therapy, or psychodrama, is not about simply giving an account of what has happened to you, but a process in which you literally go back in time and reinhabit your old memories. It's like entering a film. A lot of feelings come up that in therapy you are then able to deal with rather than block. The mechanisms of dealing with the world on a day to day basis are that when something happens that you unconsciously don't want to deal with, then you don't. Your psychic structures have been set up in such a way as to allow you to go on blocking that which you feel unable to deal with or to look at, because it's too painful. What psychotherapy can do is allow you the space to see that it isn't that painful, that actually there is nothing to be afraid of and nothing to be ashamed of. Life doesn't have to be represented and attempted to be lived in fantasy only in an idealised form. What phototherapy does is to provide a visual 'map' of aspects of our psychic processes.

JR So this dredging up of older image repertoires in order that they might be reconstructed in our own interests is therapeutic. But in what ways is it therapeutic? As a means of dealing with the aging process, the loss of the child in us, the suppression of other forms of sexuality, or to debunk the idealised picture we have of ourselves?

JS All those things and more. As a woman I have been told from birth that I must have complete control over the shape of my body;

I have to show as little aging process as possible; I have to be as beautiful as possible. That continues right through life more or less; the dominant image repertoire supports that. We live in a world where people aren't very old, they're not ill, they're not disabled, etc. The point is unless you can accept that you are aging from the minute you are born and thus in a *process of change*, what such image repertoires force you to do is think statically. I have worked with a lot of women who are afraid of being seen to 'be their age'. When I point to them when they look through their family photographs that they have been aging since they were nought, then they begin to say 'oh, I didn't realise that'. It's extraordinary that one gets a 'peak' in one's teens and then tries to keep at it for the rest of one's life. Now when you start breaking down physically or mentally and become ill you really do go into a crisis because you have to hide that as well. As such this is another aspect of the helmet photograph: why should I, on top of everything else, worry about trying to *hide* what is going on in my life? Because that has been the pattern of my whole life. Everything that didn't fit into the norms I had to hide, to be ashamed of. So I was never able to draw on any real strengths from people in my family because our knowledge as class members was never validated, because nothing was ever viewed politically. Thus struggle and the expression of rebellion did not exist as part of the image repertoire of my family. So, to come back to the school photograph as a good example, the assumption is that everyone is blandly processed through schooling and comes out the other end as an ideal citizen. The reality is not that, as we know. School is a sieve for sorting out and reinforcing various social stratas: manual workers from mental workers, the 'unemployable' from the barely employable, black from white, male from female, and so on. What unpacking that is about is that if you actually re-run your school days the first thing you come up with is your sexuality, not the power relationship with the teacher interestingly enough, which is a paradigm for every other power relationship you are ever likely to get caught up on. It's actually for a woman about what you *looked like* at school. Well I find that quite extraordinary because it gives a notion of the hierarchy of needs, that even in phototherapy you can't leapfrog over into abstract notions of power. On the contrary you are stuck with 'oh I was an ugly schoolgirl and I wanted to be a beautiful adult'. This is the reality for me as a teacher when I go into schools. It's not 'how can I change the schooling system?' but 'how can I get rid of these spots, how can I

lose weight?'. I can only talk as a woman, I can't begin to talk about what boys express to me.

JR Given this do you see your work moving more into the area of institutions?

JS Well the work is moving in two directions. Firstly, the phototherapy has moved into narrative fragments. What we have done is taken the 'decisive moment' or snapshot and tried to open out the 'before' and 'after' of the static image. Secondly, with the medical work, I've begun to visit hospitals and attend medical conferences and health groups. As such I have had to adopt a completely different strategy in addressing doctors and administrators. I am now involved in a power confrontation which requires me to use every bit of guile I have in order for them to even listen to me. For instance I went into University College Hospital recently to speak to medical students and I took a slide show on advertising and pornographic images of women's bodies. I said that I was coming from one set of discourses around the body in higher education and they were coming from another and it was about time these spheres met and had a dialogue. I said I wasn't there to petition but to talk about power relations. Thus I said the infantilisation of patients within Western medicine was counter-productive. What was needed was for patients to have some control over their own lives, even if it meant the medical profession losing power, because it would give more credibility to medicine. The point is though, if one wants to open up a dialogue, I can go in to such institutions as a 'naive' disingenuous patient. I can say, as I did, that I have my own reputation in higher education, but as soon as I enter the sphere of medicine I become a gibbering idiot. In this sense the aim of my work is to demystify where knowledges come from and who possesses them, because I think to intimidate people by what you know is not a very good ploy in teaching, on the other hand you can't deny what you do know. The point is to make it seem as if there are different ways into it, that there are different ways to challenge it and query it. The more people can begin to see people with specialist knowledge as like anybody else – individuals who happen to know more about one thing than another – the better it will be. This is why I'm not an artist in any real sense, because that is where the democracy comes in: for if you find something out, then as a socialist or feminist you try and share it with other people.

JR If we can no longer talk about images as a 'window on the world', then under what conditions can we claim that practices are realist? Brecht saw realism as something that was determined by the conditions of reception, i.e. that the critical effects of works couldn't be guaranteed by 'correct content' or by political contemporaneity. Essentially Brecht saw the critical effects of works of art as lying in their long-term use value. Does this concur with your democratic view of photography, that the realism of your work lies in its accumulative effect within diverse constituencies?

JS Yes, I agree with that. Ever since I have been creating images I've tried to get them used in different contexts so that it becomes clear that they don't have a fixed meaning. I don't like repetition basically, I don't like doing the same thing over and over again. I am coming from a position in film theory which is Vertov's work. One is working to produce a series of 'facts' and these are building blocks, so to speak, of what one wants to do. It means nothing is sacred and you can make your images mean what you want them to mean depending on where you place them. He talks about a 'factory of facts'; and that is how Terry Dennett and I have always worked. We might produce a discrete block of work but then it goes back into the archive or the 'factory'. These works therefore are tools to be used; there are no essential meanings to be dredged up from them. *The Picture of Health* is the epitome of that because it contains material that has been used in other places. Moreover, it has different modes of address as a means of undermining any univocal notion of truth. Thus I re-stage things that happened to me in the real, i.e. the marking up of the breast for amputation. The latter image is about the ongoing flow of the powerlessness of experience, the former image is about dealing with that powerlessness. So in this sense, yes, my understanding of realism is based on a sense of myself as an agency and as a subject in struggle. I have all these different pieces of work that can be used in many ways. I want to construct images that cause a rift in how people perceive 'the real' but I don't want to leave the real behind. Thus when I say I am dealing with fantasy I am simply dealing with that which is suppressed in visual representation, that which is not normally shown. What I want to do is create images that people can see in galleries or books that will stay in their minds as seeds so that when they look at their own photographs they will think 'my God! I never thought of that before'. By letting loose these seeding ideas into the world one hopes that other people will see that the dark side of

their lives has a validity in coming to understand who they are. And not be afraid to show it and discuss it. New activity can then flow from that.

JR It seems to me your defence of a productivist model of photography – everyone has the potential to be, in quotes, an artist – you are laying claim to what photography and art might be under socialism. Is this how you see your role in a broad sense?

JS I think art should be a living process, the point is to put it into a socialist context. We have at the moment a situation in which all oppressed groups are throwing up different histories of themselves which draw on every medium available; and it seems to me that the use of photography is completely under-theorised in that struggle because it is by and large the documentary mode that is used. The real democratisation could be that we encourage from school onwards the writing of stories and the making of images about our lives for ourselves in a complex range of ways, modes of address, so that we are in a continual process of self-reflection, a questioning process. Thus the conditions would then be available for the representation or making visible within the family of opposing views of different histories. Essentially the kind of photography I am interested in moves on from the worker photography of the thirties in Germany where people at work and in neighbourhoods documented their own lives. In this sense I think the function of photography under socialism could be one in which it becomes a tool for discussing what is happening around one and to one. As such a primary concern for me is for socialists to make their own, perhaps contradictory, reading materials. Why children learn to read from picture books about Cinderella is beyond my comprehension. There are plenty of good folk stories that could be translated into images that are not about this magical, commodity-fetishised society that the dominant fairy stories are about. You have a whole scenario of heroes and victims and some outside agency which comes along and transforms your life. Folk stories are not about that, they are about the struggle of individuals in communities to change their own lives. So right away you can see how photography might be used differently from a socialist perspective. Secondly, the way Terry Dennett teaches photography is by teaching low-technology photography so that you learn that a camera is a box with a hole in it, with a piece of sensitised material at the back. And so you don't fetishise the camera,

you actually use it as a metaphor for the cannibalisation of anything else that happens to be lying around, to solve the problem you have to solve. It's not that one is negating the fact that we live in a high-technology society but that such a process resists the easy infantili-sation of the self in the face of commodification. And photography could be such an easy way not to be infantilised, to use the camera to ask questions instead of making statements.

ART AND THE 'MARGINS': REPRESENTING IRELAND

14. Locky Morris, *Creggan Nightlife*, 1985.

13
'DIRECTIONS OUT':
A CRITIQUE

Bill McCormack in his book *The Battle of the Books* outlines how entrenched Irish culture and criticism remains within a theologia of binary opposites: the language of 'tribes' and 'communities', 'barbarians' and 'civilians'.[1] The absence of any consistent base 'for the scientific study of the interaction of religion and economics, class and culture, regional and metropolitan forces'[2] in Ireland, he argues, is 'felt daily like an amputation'.[3] This 'apartheid'[4] between politics and the philosophy of culture can equally be applied to the context of the Northern Irish show 'Directions Out', a survey of work from Derry and Belfast, on the war in the North since 1969.[5] The accommodation to denomination rather than class and economics as a focus for political and cultural analysis is all too familiar. However, the irony is that here is a show of work – the first 'comprehensive' show of art from the North to travel to the South – that supposedly offers another view of the cultural life of the North to a politically inured South, that moves beyond the received image of the old antinomies and allegiances. The catalogue text written by Brian McAvera, however, and a good deal of the work, actually belies this.

Questions of subjectivity aside, it is revealing that McAvera should be chosen to select representative work from the North. Even if one can resist the temptation to call his line the SDLP approach to art criticism, his constant recourse to sectarian oppositions and the emphasis on art as somehow redemptive and above such 'warring factions',[6] falls comfortably and securely into that literary humanist world of 'civilians' and 'barbarians'. As McAvera says in his best felicitous Eliotian voice: 'What optimism I possess (a minute but precious seepage) is distilled from the arts.'[7] Tell that to the people of the Bogside. Platitudinous, evasive and full of category mistakes, McAvera's 'sensitivity' is a monument to intellectual indigestion. Take

this for example: the artists 'ignore the traditional sectional viewpoints which are seen clearly in murals of both traditions'[8] (as if dealing with the political in art is equivalent to reproducing the agit-prop of a wall mural), or this: 'the backward looking fundamentalism (on both sides)'[9] (despite the historical problems of Irish nationalism I see no comparison between the progressive secularism of socialist Sinn Fein under its new Northern leadership and the *laagerism* of the Unionists), or this, one of the most insouciant excuses for not including women in a survey show I have read: 'Women do not seem to be working in the areas considered by the show'[10] (so the masculinised political culture of the North, dealt with in the work of a number of Belfast women artists, is not common territory?). But maybe this is just as well, for the absence of women points to that world of critical difference that unconsciously haunts the show's retroactive celebration of a Symbolist aesthetic. McAvera sets up a contrast between the positivism (my word) of the documentarist approach to Northern Ireland (the 'atrocity'[11] image) and the 'oblique' and 'layered'[12] response of the artists. No doubt an important point is being addressed here – artists don't want to be seen to be identified with a narrow range of options – but such is the confusion of terms and premisses that a break with positivism is identified simply with a kind of upgrading of the poetic[13] (that slippery and ideologically inflected category). The result, as in most of the painting and the etchings of Diarmuid Delargy, is a sub-Orwellian world of animals as human analogues. (I counted a swan, seagulls, a panda, pigs, monkeys, dogs and horses.)

Clearly an aesthetic of inference and metaphor is the product of a politically charged public sphere (as has been the case in the art and literature of Poland and Latin America), but what we are being given here is not so much convincing allegory as good old-fashioned mythopoeic aggrandising, in which the Human Condition and Alienation play leading roles. In this world, 'symbolically'[14] contrasted images 'explore'[15] the social as part of a 'modern morality play'.[16] 'Intellect is married with expression',[17] resulting in 'direct, passionate images'[18] in 'vibrant colour'.[19] The only thing missing from this *mélange* of clichés is a 'Beckett-like loneliness' and a 'terrible beauty'.

In essence McAvera's text exhibits one of the dominant and recurring tendencies in liberal writing on Ireland this century and last: the creation of an interpellative agency that would culturally transcend the religious divide and the imperialist legacy. For writers of the Protestant Ascendancy it was Gaelicism and the landscape – forms

of identification that could both incorporate the national sentiment of the subject Irish people and marginalise Catholicism as a non-Irish imposition at the same time – that was looked to in order to provide the source for a new Irish social identity. For the protestant Thomas Davies, writing in the early nineteenth century, cross-sectarianism was to be achieved by the creation of a new nationalism based upon a secular, popular education and literature. For W B Yeats it was likewise a national literature – albeit for Yeats rooted in Irish mysticism – that would transcend political factions and establish a new national Irish identity.[20]

The idea of sectarian reconciliation without political and social transformation is a structurally repetitive liberal myth in Irish culture and literature. However, cross-sectarian forms of interpellation cannot be reduced simply to cultural categories. This of course was the basis of James Connolly's defence of class. Thus we can argue that there are idealist, mystificatory forms of cross-sectarian interpellation and progressive ones. Despite McAvera's wish to move beyond the old oppositions he falls back into the former. In many ways this is a problem rooted, as it was for the writers of the Protestant Ascendancy, in his own Protestant identity. The force of the language and culture of a subjugated people is levelled out in the spirit of a 'greater' cultural unity. The problem with this of course is that it actually fails to take account of the enduring imperialist and economic realities upon which the otherness of the native culture is built and reinforced. It is revealing that McAvera shows such a strong antipathy to the culture of nationalism, because for him this represents not the long-suppressed and contradictory voice of a subjugated people, but the bulwark of cultural anti-modernism. In certain respects this may be true, but a subject language and culture has on the whole its myths, monuments and collective identities chosen for it. In fact despite the presentiments of even-handedness in his liberal distaste for the antediluvian reflexes of both official cultures, McAvera's defence of the poetic as a cross-sectarian move is a faintly disguised anti-Republicanism. His text then does more than reinvent the cross-sectarian discourse of the Protestant Ascendancy for a modern liberal cultural politics, it actually seeks to place Irish nationalism back into a kind of barbarian aesthetic space, only this time in the company of the hyper-barbarians, the Unionists. The bypassing of the complexities of identity, nationality and politics in favour of the safe home-ground of the poetic is not so much a means, as McAvera contends, of uniting politics and aesthetics in Ireland within a de-sectarianised,

modernist space, but a means of distancing nationalism from any legitimate claims to be part of such a space. The poetic, in its historically constructed bourgeois role as the voice of enlightened reason, becomes the very antithesis of 'demagoguery' and political conflict, that very beacon of 'optimism' through art he claims to see.

In one sense it is unfair to criticise work on the strength of its contextualisation; but the work itself does little to ameliorate this. For if the show attempts to present a more complex, differentiated view of the political situation in the North, its complexity and differentiation are derived not so much from critical practice, from the extension of content space, as from the mapping out of outmoded rhetorical devices on to exhausted critical categories. Despite McAvera's assertions to the contrary the majority of the works' commitment to a symbolist aesthetic actually militates against the possibility of complexity and differentiation and cultural renewal. There are, however, exceptions to this rule, and these exceptions in some sense 'save' the show. In reality this work can be seen as the nascent part of that 'structural' and materialist agenda that McCormack and others have called for. What characterises the work of Willie Doherty (Derry), Locky Morris (Derry) and Victor Sloan (Dungannon) is a specificity of place and incident. They have resisted both the sentiment of the 'atrocity' image and the overheated imaginings of mythopoeic typification. In short there is an intrusion of history as a space of ideological conflict and struggle (an empire of signs so to speak) rather than as farce or inflated tragedy, in which the artist's *concern* is flaunted. (It is a condition of realism in art today – philosophically speaking – that the artist displace himself/herself from the position of universalising humanist commentator.) But each artist works with very different cognitive and aesthetic resources. As a photo-text 'demythologiser' Doherty's two large black and white images of the banks of the River Foyle (one of the Republican west bank and one of the Unionist east bank) printed over with the slogan 'Stone by Stone' and the respective phrases 'Tiocfaidh Ar La' ('Our Day Will Come') and 'This We Will Maintain', sharply juxtaposes the deep-ranging historical commitments behind Republican and Unionist political discourse. But this isn't simply a meeting, à la McAvera, of their respective intransigence. Encoded in the passage from one to the other is a sense of two very different political spaces. The distinction between projection and *maintenance* needs to be read as a distinction in political perspective.

If Doherty fixes on the Irish landscape in order to wrest it away from the picturesque emollients of traditional landscape art (in order to mark it with the traces of ideology) Locky Morris's sculpture focuses on the coralled spaces of urban Derry. His effects, by turns robustly or playfully anomalous, have much to do with scale. Thus in contrast to *Derry Air* (a large plume of smoke made out of steel) *Creggan Nightlife* (*see* page 158) has the miniature scale of a toyscape. The blades of the British helicopters (attached to the rooftops by wooden beams of light) even look like lollipop sticks. Like Doherty, Morris is committed in his work to a qualitatively different type of Irish locale than is usually associated with Irish landscape art; one that is certainly ideologically familiar, and cut across by desuetude, but one that is resolutely anti-Romantic. Doherty achieves this through a heightened (and unfashionable) implacability (as if to say the afflatus of Irish Romanticism stops here – now) and Morris by a kind of ironic, nervous inversion: the transformation of the places and monuments of Derry into a world of 'strange sightings'. The use of the anomalous and discrepant as a means of moving beyond the conventionalised reflexes of both Reflectionism and Symbolism is also characteristic of Victor Sloan's work. Here, though, the effect is one of dread. Sloan's adulterated photographs (he scratches the negative and then paints over the top) of the Unionist marching season in Portadown – figures glimpsed through 'broody' swirls of black, browns and purples – pinpoints exactly that sense of costiveness that is the Unionist political mandate.

In effect the exhibition shows not so much 'directions out' as 'directions sideways', and as such is a failed opportunity to address the culture of the North (and South) as something of more than internal possession ('The Troubles'). A show based around the initiatives of Doherty, Morris and Sloan, would have been far more cogent and apposite. But the question of theoretical parochialism should not be dumped unceremoniously at the feet of the organisers of such exhibitions and the artists concerned. Cultural under-development has been structurally endemic in both statelet and Free State. The effects of imperialism's containments (poor economic growth, mass emigration, fragmentation of the left, nationalism itself) have fractured the growth of an indigenous modernist intelligentsia, immuring Irish art criticism in particular, in a regressive search for the Irishness of Irish art. Yet, despite McCormack's pessimism about this, things *are* changing. The importance of the Belfast magazine *Circa* (founded in 1981) in raising the level of artistic

debate in both the North and the South has been inestimable. Its concerted editorial attacks on the Irishness question have provided an ideological space for the discussion of Irish identity in art without recourse to Romantic and Symbolist nostrums. This to a large extent was underpinned by the development in the 1970s of a materialist Irish film criticism and literary criticism. With the erosion of the rural dominance of politics and culture in the early seventies in Ireland a new generation of Irish writers and intellectuals began to excavate and critique the dominant cultural identities. In essence what was being put in place, tentatively, fragmentarily, was a post-Yeatsian, post-Pearsian, post-Gaelic, cultural politics. A new cultural politics based not on Irishness as other, but on a critical reading of Irish history, in which Irish identity is subject to displacement *and* assertion. This is why in the final analysis 'Directions Out' is such a frustrating exhibition; because artists like Doherty and Morris are very much committed to, and are products of, this new agenda. However, they are 'secreted' in a show that does little to make clear what the real stakes are. Of course there is nothing to say that a show 'showing what the real stakes are' was ever a possibility. McAvera's liberalism clearly is conducive to those ruling interests that want a modernised discourse for contemporary Irish art but from a resolutely anti-nationalist position. Nevertheless we should be undinting in our criticism of the weaknesses of such an exhibition, because it reinforces a parochialism of critique at the point where it thinks it has broken through the parochial.[21]

Notes

1.	Bill McCormack *The Battle of the Books* (Dublin: Lilliput Press 1986) p 39
2.	Ibid p 46
3.	Ibid p 46
4.	Ibid p 50
5.	'Directions Out: An investigation into a selection of artists whose work has been formed by the post-1969 situation in Northern Ireland' Douglas Hyde Gallery Dublin 1987
6.	Brian McAvera *Directions Out* (Dublin: Douglas Hyde Gallery 1987) p 11
7.	Ibid p 6
8.	Ibid p 6
9.	Ibid p 23
10.	Ibid p 12
11.	Ibid p 49
12.	Ibid p 49

13. Ibid p 45
14. Ibid p 29
15. Ibid p 30
16. Ibid p 45
17. Ibid p 30
18. Ibid p 30
19. Ibid p 30
20. See David Cairns and Shaun Richards *Writing Ireland: Colonialism, Nationalism and Culture* (Manchester University Press 1988)
21. McAvera replied to my criticisms. See 'Reply to John Roberts' and my reply, *Artscribe International* no. 68 (March/April 1988) p 11

14

THREE IRISH ARTISTS

The struggle for a place from which to speak outside of the dominant centres of metropolitan power has become one of the most important aspects of radical post-late-modernist culture in the West. In Britain for example, geographical place as a corollary of an independent cultural identity has become the basis of a continuing attack on the link between cultural power and geography. In his 1988 William Townsend memorial lecture, Declan McGonagle emphasised the importance of his remaining as a curator in Derry, where he was born, and building an independent power base for Irish artists. Likewise, the increased regional production of the visual arts in Britain (ironically in concert with the Arts Council's new arts policy), has served to decentre the myth that the artist is somehow at his or her best where the central institutions of cultural patronage are. This radical regionalism has brought with it a sense of optimism that the unequal exchange between the centre and the peripheries has changed. To a certain extent it has; the work of McGonagle in Derry has been important in disturbing those familiar circuits of cultural exchange in which the peripheries *receive* cultural largesse from the centre. Scotland's would-be renaissance in the visual arts has certainly, in a number of sectors at least, sought to continue to politicise the relationship between North and South that has been at the heart of post-war Scottish culture. On the whole however, there has been a tendency to overemphasise the breakdown of unequal exchange, as if the peripheries were in some way in control of the terms under which they enter into relationship with the centre. There has been a tendency, therefore, to assert national identity as the cornerstone of an independent cultural identity. Thus it tends to be forgotten that because Irish artists are seen to be dealing with the war and the effects of imperialism, that space is given to Irish art, that a transference of value from the periphery to the centre is created. The

problems that ensue from this are the problems that ensue from all aspects of the relationship between politics and identity: communities, group loyalties and geographical place, are both sustaining *and* containing.

These issues were writ large in a show at Battersea Arts Centre of work by three Irish artists, Dorothy Cross, Willie Doherty and Kathy Prendergast, all of whom deal with the issue of Irish location and dislocation.[1] The exhibition threw up the difficult question of how long can the artist give him/herself over to a critical regional identity without being subsumed or derailed by it?

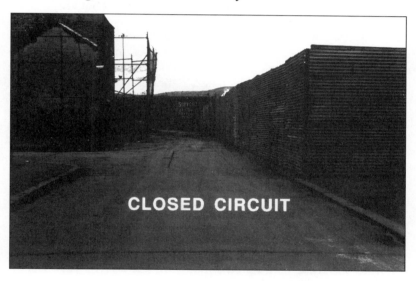

15. Willie Doherty, *Closed Circuit*, 1989.

Born in Derry and currently living there, Willie Doherty represents a case of the classic organic artist/intellectual in that his work is located *in* and is a direct product *of* a Republican working-class community. Moreover, given that he is working in a situation where images are liable to deliberate misinterpretation, although his work is a product of Republicanism, it clearly seeks to address the Loyalist community as well. The ambivalences of his black and white photographs, with their panoramic sense of historical mourning, allow a space of entry for identifying with the losses of both working-class communities. If this reveals the realities of producing work under war conditions, it also reveals, on Doherty's part, the agitational

uselessness of linking such mourning to any explicit set of nationalist references. In this respect there is an obvious distancing in the depiction of Derry as a place of political fracturing in these works; local detail does not outweigh a generalised sense of the area as a divided landscape. As Doherty has said:

> In general the sentiments within my work would be more weighted towards the idea of colonialism rather than factionalism within the North. The work is more about Derry and Ireland as a whole, rather than the six counties and the rest of Ireland, so the particular issue of colonialism is one that is pertinent throughout my work.[2]

Consequently, in avoiding the representation of the machinery of war, he uses landscape (the River Foyle, the border, areas of dereliction) as a series of melancholic vantage points; sites of memory and desire and longing; 'undramatic elements'[3] that create an uncanny and ironic sense of normalisation. In a mimicking of official photography of the North – the historically drained images of the army, big business and the tourist board – he produces the obverse effect of normalisation: an everyday image that in its very banality is far from the everyday.

This ironising of normalisation leads on to the question of closure in relation to identity. Doherty has now produced a sizeable body of photo-text pieces within this same aesthetic framework. (An aesthetic in fact that not only ironises official state photography but the photo-text Conceptualism of the seventies.) But how long is it before such a framework becomes a cognitive imposition, a series of moves made in order simply to continue the mournful self-image? This is not a cynical or underhand question. It is a recognition rather, of how artists might continue to practise when access to a language and to cultural power is determined by the continual need to replenish a given cultural identity (in this instance the artist as anti-Romantic ally of the Irish struggle), since to give up this identity would be to give up cultural specificity and therefore cultural power. The central paradox for those who speak from the 'margins' then is that coming to speech and power becomes double-edged: a mark of autonomy and subordination *and* otherness. This is why in the struggle for an independent voice and an independent place from which to speak we need to recognise how capitalism, as a system which regulates cultural difference in its own interests, sets the terms of the debate. In his 'Field Day' pamphlet *Nationalism: Irony and Commitment* Terry

Eagleton outlines succinctly the problems involved in the paradox of identity:

> to attempt to by-pass the specificity of one's identity in the name of freedom will always be perilously abstract, even once one has recognised that such an identity is as much a construct of the oppressor as one's 'authentic' sense of oneself. Any emancipatory politics must begin with the specific, then, but must in the same gesture leave it behind. For the freedom in question is not the freedom to 'be Irish' or 'be a woman', whatever that might mean, but simply the freedom now enjoyed by certain other groups to determine their identity as they may wish.[4]

To recognise this then is not to advocate the abandonment of struggles over cultural identity, but to acknowledge that there are powerful structural determinants and constraints which give shape to the pursuit of such struggles. Autonomy is not so easily won.

These issues, to a certain extent, are reflected in the work of the other two artists in the exhibition, Dorothy Cross and Kathy Prendergast. Neither has lived – at least permanently – in Ireland (the South) since studying there a number of years ago. They are the familiar emigré Irish artists who are haunted by Ireland as a place, if not of the unfinished revolution, then at least of civil and political containment. In this sense they are as 'inorganic' in relation to their resources as Doherty is organic. Although obviously not a direct result of geographical distance, their work lacks that specificity of place evident in Doherty's case. Prendergast's floor piece, composed of imitation shells/stones made out of plaster, calls upon an imagined sense of Ireland as an island; her piece encapsulates the history of the country as a history of forced departures. Dorothy Cross, on the other hand, produces a combinatory wood-based sculpture out of a series of sexualised, masculine architectural forms, the connection presumably being between the dominance of clerical architecture in the South and the hegemony of the values of a male priesthood within Southern civilian society. There is an emphasis on spikes and sharp surfaces as traps.

The problems with this work are exactly the obverse of Doherty's: in calling on memory to do the work of self-definition there is an inevitable separation between place and the cognitive demands placed on art by its contingent political conditions of production. For it is one thing to mourn from within a community or political struggle,

it is another to mourn at a sympathetic and poeticised distance. The work of both Cross and Prendergast looked slightly lost and winsome, pointing, though from the opposite direction to that of Doherty, to what remains at the basis of all questions around the relationship between geographical place or identity and politics: the need for cultural identities to be negotiated in a continual process of learning *out of* the political situation that has created such desires. To argue this though is not to advocate that artists have to live out such relationships. I am not arguing that Irish artists *can only* produce interesting work on questions of Irish identity and politics living in Ireland. Viconism has no place in any progressive cultural politics or art criticism. However, in this instance, a cultural struggle against colonialism, the importance of building a culture centred on, and *part* of a sense of place, is an absolute imperative in the struggle for autonomy. Doherty is one of a younger generation of artists who have chosen to remain in Ireland for these very reasons. If the history of modern Irish culture has been a history of emigration and exile Irish art has certainly not escaped these pressures. It has suffered in practical terms – the continual emigration of artists – and intellectually; the history of Irish art from the 1950s is of an ideological struggle over possession of the landscape, and little else. Modernism, late and de-politicised, was an essentially pastoral experience, a means of revivifying the pre-modernist landscape tradition, modernising it for the New Ireland and the foyers of banks. The war in the North, for all its human cost, actually propelled the crisis of this comprador modernist culture. Questions of cultural identity, of art and politics, could be put on the agenda again in a way that linked the present not only with the revolutionary nationalist and socialist past but with a critical modernism that had its emotional and intellectual roots in Ireland, if not its physical production: the writing of Joyce. Joyce's irony was an important weapon in countering the bathos of the prevailing pastoralism; it was difficult to attest to visions of the Irish sublime in a world of plastic bullets and barbed wire. However, to say Irish artists were suddenly politicised is to say only the half of it. Rather, the war opened up Irish culture to the realities of political and cultural uneven development. For artists at least, new concepts, new categories adequate to the contradictions of the situation had to be put in place, concepts and categories that to a large extent were common international artworld discourse, but that had been marginalised or considered irrelevant under the pastoral modernists. As such the whole question of imperialism and colonialism as systems

of control which produce subject identities entered Irish art. Art, in effect, began to contribute to a general rehistoricisation and critique of Irish identity within the culture. The old liberal modernist pieties began to appear even more complicit with a colonialist mentality. This in short is the reason why younger artists such as Doherty remain in Ireland: there is something to fight for and *build* – an Irish visual culture that has a critical sense of its own history and a future sense of its critical development. To do this as part of a collective project means, in the end, staying on.

Notes

1. 'Three artists from Ireland' Battersea Arts Centre June–July 1988
2. *Willie Doherty: A Conversation with Declan McGonagle* (Dublin: Oliver Dowling Gallery 1988) p 3
3. Ibid p 1
4. Terry Eagleton *Nationalism: Irony and Commitment* Field Day pamphlet no. 13 (Derry 1988) p 10

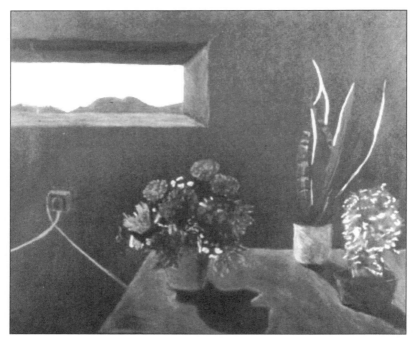

16. Terry Atkinson, *Bunker in Armagh, Nature Morte – Booby Trap*, 1985.

15

REPRESENTING IRELAND: AN INTERVIEW WITH TERRY ATKINSON

JR If Northern Ireland remains, to use an imperialist metaphor, the 'dark continent' of British socialist politics, it is also very much a 'no go' area for British artists. Although a number of artists have attempted over the last few years to deal with the British occupation the quality and consistency of the majority of the work has been markedly weak, the possible exception being Richard Hamilton's painting *The Citizen* (1983), a portrait of a Republican prisoner on the blanket in the Maze. Could you talk about why you think there has been such an absence?

TA Well I think what we might call the structural mythology and historical marshalling of the notion of 'terrorist' has probably got a lot to do with it. What the propaganda effort is in relation to 'terrorism' is to suggest that if you in any way, not simply sympathise, but meddle with the notion of 'terrorism', you will dirty your hands. I think that has an effect on a whole range of cultural workers, but particularly artists. The theatre hasn't been so cautious; there have been lots of determined attempts to deal with the issue there. But I think also that there may be many artists we don't know, who are working on the problem. We are just talking here about the public platform we know. Moreover the whole idea of terrorism and violence for a practice that was quite heavily involved in the sixties in pacifism and anti-war gestures (which was tied up very much with the rock-orientated culture of the period) is a problematic base for what we might call the liberal reflexes of art training. So I think Northern Ireland is simply too bloody in many ways for artists.

The ruling class antidote against 'terrorism' is 'decency'. In their vocabulary there can scarcely be a pair of words with a more

overloaded manipulative function unless it be 'strike' and 'the right to work'. In one very direct sense it is impossible to avoid considering violence as a subject of work. This is because violence is one of the main staple fuels upon which the 'civilised' world runs. It would be absurd to admire violence, but this is not to say that given acts of violence are not linked to acts of courage. The 'terrorist' is defined by the people to whom she or he is opposed as gratuitously violent. It's all very precarious semantics. I am always reminded when questions like this are raised of the accusation recurrently made against some of Ted Hughes's work. A good deal of the work (*Crow* for example) against which this accusation is levelled I find exactingly damning of the structural, institutional violence of the world we live in. In respect then of the work that I have made on the subject of Ireland–Britain I think it is worth making an argument for this work of Hughes's. He has, I think, in this work created a powerful recoil from the complacent and repressed responses to the institutional violence of the societies we make and live. Some of his early poetry dealing with World War One was perhaps a first pointer to the momentum of some of the work which followed. It is directed at stripping away the layers of 'civilised' insulation allowing our societies their bureaucratised space in which they can make their comfortable slogans and euphemisms on the violent acts they carry out. Right at the centre of this work is Hughes's fierce criticism of the complacent assumption that civilisation not only will continue, but that it is worth continuing. Hughes, it seems to me, converts the ideas of being civilised into an accusation – he accuses the civilised world of being just that, 'civilised' – as containing an institutional, repressed, habitual and structural violence.

I did not invent violence, no more than I invented the world we live in, so I'm damned if I'm going to be bullied and hurried out of a considered view of the causes and historical character of this violence, by people whose every interest rests on the implied, constant use of the most terrible violence. The hypocrisy of these administrations is structurally endemic.

Another kind of wilful abstracting process goes on too. The 'mainland' British have always abstracted the Irish as 'other'. The Loyalists as much as the Republicans. I did modern British History at A Level in the mid-fifties. Needless to say Northern Ireland never got a mention, although Cyprus did. The idea of it ever being mentioned that a significant section of the alleged citizens of Britain and Ulster were deprived of basic civil rights was quite beyond

comprehension. Ulster was a drawn veil in respect of the British 'mainland' education system. The history and politics of the province was simply erased, the British simply forgot – until 1969! As for there ever being the slightest conjecture that any police force in the British Isles was historically and institutionally corrupt – this was a point of national anomie. In my own case, it came as a shock in 1969 watching on New York television, the 'B' Specials in action in the August of that year. The context of New York certainly broke the insulation protecting the British state from any supposition that it was violent. I saw the Burntollet Bridge on New York television for example. At that time the IRA had not surfaced; what was attacked was a civil rights march. To a Brit brought up on the post-war diet of British justice and freedom to consume rock 'n' roll culture the Burntollet spectacle, to say the least, was a bit of a shock. Put it this way, it caused me at least to prick up my historical ears. Since then I think I have learned over the years that Ireland remains historically abstract to the British. Only, it seems, the most violent scenarios will provoke any response from them, and I suppose, in some respect, that's better from the Republican view than the anomie which settled over the British pre-1969 view of Ireland, if that could be called a view.

Then there is also the grim history and events of the situation itself in Northern Ireland. Though it has never been sanctioned as a war by any official declaration of war by the British themselves, the IRA have more or less declared open war since the twenties. There is an increasing tendency in Britain though, on what we might call a kind of semi-official level, to view the conflict as a war. I heard, for example, John Stalker say just this at a talk that he gave in Leamington Spa. Obviously, it would be out of the question that Britain should recognise Republican 'terrorists' as POWs – we remember the hunger strikers' quest for political status. And even a guerilla outfit as well organised as the Provisional IRA would have an impossible job running POW camps – they are after all illegal in the Republic. The technical structures (Geneva Convention etc) which a declaration of war brings into play simply won't fit, not that official wars have ever been conducted according to the rules either. But if we can say that here is something like a 'war condition' in Northern Ireland, and matters of securing surveillance can be widely seen to be in operation, this itself might be forbidding to an artist wishing to be critical in some way, that is wishing to make work which raises questions of historical legitimacy, say. All this is pretty forbidding terrain. But perhaps most forbidding of all is the plain fact of what happens in Northern

Ireland. If we ask, what do 'terrorists' do under war conditions, then the answer is that sometimes, maybe often, they kill civilians and often by accident. This is a pretty forbidding prospect for any of us, the idea of, whether by accident or design, the indiscriminate killing of civilians. This I think is the most forbidding prospect of all.

So far then I have advanced guesses that are to do with the moral issues. But there is probably one equally serious obstacle to doing work on Northern Ireland and this is under the delicate matter of a resourcing of modern history painting. How far are resources developed which will make a modern history painting? The matters of technical and cognitive competence. There might well be a tendency, for example, for artists who are prepared to tackle a subject such as Northern Ireland, to substitute or mistake the contentious subject itself for contentious and formally affronting resources. This is not at all uncommon – politically contentious but cognitively mundane, this is in the final analysis not politically challenging at all. Resources of illustration (which cannot be dismissed since they also might be aberrant or anomalous resources vis-à-vis the canons of a modernist and transatlantic orthodoxy) are often used to do just that – illustrate the subject. This latter point is a central weakness of the entire category 'Political Art'. Thus I think there are a number of difficulties which make Northern Ireland problematic to work upon.

JR How do you see Richard Hamilton's treatment of the issue in relation to what you have just said? Is he posturing?

TA I assume not, I assume anyone who takes on a subject like a Republican prisoner on a blanket is taking it on seriously perhaps with some sense of irony in relation to the historical complexities. But for me there is a problem with it in terms of the complexities of that particular tradition of form of struggle. There is nothing new about the hunger strike. The Irish Republican movement has a long history of hunger strike. The apocryphal aspects of the present-day blanket protests are at least partially because they got the media coverage they did. So individual struggles became newsworthy stories. With Hamilton's own history (the Kent State killings piece for example) one wonders whether he is handling this aspect here. The formal means are illustrative and apparently without irony. Its illustrativeness is perhaps a kind of political protest that the media eats up such events. But the problem for me is it is not clear. There seems a kind of stand off in the picture between the 'subject' and the technical development

of the picture as 'subject'. My problem therefore with Hamilton's picture – and it is an interesting picture – is that its illustrativeness doesn't clear that ground. The picture doesn't seem to me to sort out what is a very rich area.

JR One of the reasons in fact that I mentioned Hamilton's picture was that here was a work on Northern Ireland by a British artist *with* a degree of complexity, in so far as it relates the centrality of the tradition of the political stereotype within working-class struggle – the martyr – to the stereotyping functions of the media itself.

TA Those two areas are raised: one, the misrepresentations of the media, and two, martyrdom as a necessary but not sufficient condition of Republicanism. But in establishing a relationship between those two things certain competences are critical. Adequacy to historical complexity is a real problem for history painting. Whether we have actually got the established allegorical and metaphorical depth, let's say that David had in his time, is the problem. Thus it is not just a problem for Hamilton in any narrow sense, it is a problem for all of us; how is it possible for a history painting to generate an adequate allegorical and metaphoric terrain? My own view is that there isn't much evidence that this is happening.

JR This leads on to the question of *how* and *what* does one represent in relation to Irish politics without falling into sloganeering. In some of the large drawings you have attempted to generalise the terrain of Irish politics as seen from Britain as an ideological bunker. Within this metaphoric black cabinet-space you introduce various still lifes and incidents that dramatise the agents and contradictions of the conflict. I'm thinking in particular here of *Daughter having returned from an armed mission being greeted by her mother near a Christmas wreath* (1985) which obviously plays on the emotional ambiguities of armed revolutionary struggle. In other large drawings you adopt the conventions of landscape painting – the dominant genre we tend to associate with Irish visual culture – as the picturesque backdrop for the machinery and combatants of war. Could you talk about your use of these resources?

TA Well let's deal with the picture you mentioned. That is a straight-up attempt to say something about the myth of terrorism, in so far as actions that are held to be terroristic are far from being abnormal.

Under given situations people will throw bricks and stones and take up guns. I hope I'm not being disingenuous, but it seems to me that the Irish have in many ways been provoked. And people when they're provoked will do certain things. So that's the first level of that picture: terrorists do have mothers, and mothers and their terrorist offspring do have conventional relationships. The attempt was to display some kind of tenderness, but to underlay it with the irony of what the promotion of terrorism is. Clearly the term terrorism is that promoted by its enemies, not by people who are characterised as terrorists. Obviously it would be perverse for a terrorist to say 'I am a terrorist' and fill in the meaning of the term with the meanings of a Reagan or a Thatcher. So there again there is an attempt to demonstrate the ideological complexity of the subject. On top of that, that specific drawing also attempts to map out a key problem in Irish Catholic politics: the question of gender (for example divorce). Many of the fighters – or terrorists, depending on how you define it – in the modern IRA are women. Evelyn Glenholmes is only the most current example. So I was raising in a kind of nod and a wink way – again I hope there is some leaven of irony in it – that under certain historical circumstances, perhaps remote ones, there is a possibility of our two daughters becoming terrorists. So there was a range of things at work in that picture.

In relation to the metaphor of the bunker, it's perhaps worth remembering that 'The Art for the Bunker' show was set up in halves. The first involved a set of anti-nuclear political positions. The logic of that set of positions – if it is strictly taken – is pacifism. If you go down that road, then you can't use nuclear weapons. At some point you are also going to be forced into a position where you say you can't use force at all. The other half of the show was about Ireland. Now if the IRA had potential for a nuclear strike, the IRA would not be the IRA we know, they'd be in power, because as yet we know only of governments having the capability of a nuclear strike. The first 'terrorist' movement that gets one sets up a diabolical logic. This is very dicey ground; nations may, quite soon, be defined as terrorist. The USA administration is increasingly trying to characterise the Libyans in this way. But the IRA as yet has shown no signs of striking Manchester with a one megaton. So I was planning to raise this set of problems. And the contradiction comes when the first half leads, hypothetically to pacifism, and the second half leads hypothetically at least – providing one is not pussyfooting – to some kind of support for violence, for the violent armed struggle. So the black of the Irish

drawings and the white of the anti-nuclear paintings, was set up with that in mind. It was never picked up in any review of the show. But it was quite a purposive strategy to try and point out what it is to live in a number of silent contradictions. There is a contradictory response there: if you follow the line of beliefs that are organised by governments in power that people who strike against them are terrorists (vis-à-vis the tabloid press's coverage of the miners' strike) you are bound at some point to come up against the 'contradiction' of asking for what reason the terrorists are doing it. So the idea behind the use of what you call the cabinet-spaces was to set that into a fairly conventional pictorialism. The use of black and white, of two halves of the show, was quite deliberate in that sense – on the one hand the white side of pacifism, on the other hand the black side of terrorism – the supporter of violence; and how in many ways we are all unavoidably caught up in this. Anybody who is going to take on the question seriously can't honestly say that the Provisional IRA is a blind mechanism of terror. You have only to look at Sinn Fein to realise that; their political programme has certainly built into it the idea of armed struggle but it is a political struggle. I honestly thought that this might be picked up. Obviously it had crossed my mind it might not, so I had rehearsed in my mind some possible scenarios that might ensue should it not be picked up and should I then decide to point it out. I figured the first one would be that the pictures didn't make it clear enough in this respect. I thought this might be kind of fun to engage in, but I quickly thought it would be a bore – after all they were black and white, dark and light sides of the show so to speak. It struck me as pretty obvious and corny. Corny enough to be anomalous, perhaps, but sailing very close to being pedestrian and formally prosaic. Nevertheless 'black and white' is the currency of the popular discussion on violence. In the end I thought what the hell and went right on and fixed it up.

JR Do you think people's inability to read that contradiction when the show was travelling around Britain has a lot to do with the fact that there is no popular memory around insurrectionary struggle in Britain?

TA That raises another line. The idea of Republicanism per se is something I'm interested in. The first picture I did on the subject was the *Banana Republic* (1981) where I tried to raise the issue in the context of the way the First World consumes the Third World. To say

I support Republicanism today is a pretty trite statement. In Britain it sounds like an empty piety. Today Republicanism is … blah, blah, blah. If you look at French or American Republicanism you are looking at mature capitalist societies. So, don't get me wrong, I'm obviously not seeing Republicanism as mutually exclusive of capitalism. Nevertheless in terms of the Anglo-Irish struggle particularly, there are historical resonances around Republicanism that interest me a lot. They are something like this. In 1685, for example, when Monmouth landed in Lyme Regis to claim the monarchy the whole area that responded to him – the West Country through Somerset up to Bristol – was – and we have to remember that the time was 40 years after the Civil War – a noted Republican area. This area came out to support him – ironically yet again given he was trying to claim the kingdom – the rebels wore their symbolic Leveller green sprigs. Nat Wade and people like him were by then redoubtable veterans of old Civil War Republicanism – the 'Good Old Cause'. To hear the British responding in public venues today you would think that they had no tradition of Republicanism, let alone that they had been significant actors in its modern inception. If I said today I would support a British Republic – which I would – it's laughable; it's so much swimming against the tide. The monarchy is so constitutionalised inside a modern ideology of Western democracy, the idea of a British Republic is bathetic. Nevertheless, the historical currents are there. And there is no party in Britain which even resonates that. The idea is apparently not even practical but I find it a more interesting politics than any conventional party position.

JR This seems to be very close to E P Thompson's argument, in so far as there is this potential, this attenuated Republican continuity that needs reclaiming, or can be reclaimed, by the organised left.

TA Well I don't know if it can. I'm not saying it can. It depends what you mean by 'reclaim' and the 'organised left'. If we are talking of reclaiming in terms of *activating for* a republic in Britain, I don't know if that can be done. As I said I think now the instruments of so-called modern democracy are so highly developed and hegemonic, that the only thing that would turn over the control of economic power in Britain would be something like a catastrophe like a nuclear war. And then we are not sure what all the consequences of this would be – monarchies or republics seem pretty insignificant in the face of the catastrophe. These would be fine ideological points that would

belong to a seemingly previous history. We are then talking about simply whether we could survive. Reclamation might seem funny. The USA and the Soviet Union are republics; so is South Africa. But I am suggesting that there are a set of historical comparisons between Britain and Ireland in relation to trying to say something about British Republicanism and Monarchism that are worth dealing with. Thus Cromwell, one of the original British authoritarian Republicans, has a record in Ireland of butchery and persecution that is second to none. And before he went to Ireland he cleared up his own forces, the fracas with the Levellers at Burford Church in Oxfordshire, for example. And one of the primary bones of contention between the Levellers and Cromwell was that of the political substance of Cromwell's intended campaign in Ireland. So I hope I'm not idealising Monmouth's landing in 1685. I don't know if Thompson is idealising the subject of British Republicanism. There is therefore an element of pessimism in the work of Republicanism as well. The idea of using the black was also a metaphor of that pessimism. The Irish struggle is one of the most pessimistic aspects of what we might call national British behaviour. It seems almost blinding.

JR It seems that these options are getting narrower and narrower. It is interesting – though of course not surprising – that Neil Kinnock should recently defend the Queen as a defender of the Commonwealth.

TA There's a whole range of associations there between Republicanism and the idea of a commonwealth. In terms of British history it is full of resonance. So when I say that the monarchy is constitutionalised within Western democracy, I meant something like that; the monarchy is very malleable in the way it is built into the constitutional structure of the state; and of course the Labour Party will defend it. There are a number of other details about that issue of which I'm trying to make drawings and paintings. You mentioned the use of landscape. That area comes from a concatenation of references. It is no more or less than a kind of list. First, one of the dominant British views of Ireland is that of an angler's paradise, a pastoral idyll. So you get this green landscape, more or less wet, more or less peaceful, which is paradoxically populated by whole sections of the population which are Machiavellian. These days we call them 'terrorists', when our racism was less discriminating and more straightforwardly imperialist, we called them Irishmen. So when

Britain consumes Ireland you have this paradox between land and people. Perhaps the most contentious, and in terms of British reception the most horrific, incident in relation to this was the INLA assassination of Mountbatten. I remember being advised not to say anything about it on TV, it was so contentious. What you have got there is Mountbatten taking up a certain position in relation to Ireland. The Mountbattens established affectionate and close relations with the local community; he was swanning about in his boat and generally doing things that the British have done in Ireland for centuries. No matter what anybody says it is not impossible to see that it might enrage the blindest and most savage of Republican reflexes. The Ireland that Mountbatten could occupy and would consume is the ruling-class version of the way the British usually see the Irish landscape. So all the attempts to deal with the Irish landscape had something of that behind them. Another aspect was the terrain in Armagh. Belfast and Derry are one thing – that's urban, in Armagh it is something different, the British soldier is literally patrolling the pastoral idyll, the rolling hills. I've heard from a number of ex British soldiers who have been on tour in Armagh that you tread the sod at your own risk and of course it is literally the green border. So in some of the drawings, for example, those indicating robot bomb disposal, I used a formalised set of hills; also the use of flowers, particularly lilies, was an attempt to include things that belonged to the ideology of Ireland as a pastoral and domestic family idyll. I also tried to play on the literal metaphor of still life. I usually translate still life as *nature morte* – dead life. The booby trap is a kind of classic 'terrifier'; in this sense it literally is a still trap to take life – trembling perpetually as 'nature morte'. Thus by using the genre of still life, I wanted to draw in these associations.

JR A number of the works, in particular those which refer to the early history of Republicanism (the Republican Protestant Henry Joy MacCracken) use the unifying metaphor of the ghost to signify the ideological contradictions of Republicanism. The suggestion being that modern Republicanism is as haunted by its half-hidden radical nonconformist heritage as it is by the continuing spectre of rural Catholic conservatism.

TA The fact is that the aspirations of early Republicanism were held and demanded, maintained and fought for by Protestants as much as Catholics – Wolfe Tone himself was a Protestant. So there is in this

instance a kind of 'straight' complexity – if that is not a contradiction in terms that the British do not again perceive. Moreover, Irish Republicanism used as its model as much the New Republic founded by the American Revolution, which was dominated by Puritan sentiments – as it did the French version of Republicanism. These connections also I find interesting. Using Henry Joy MacCracken therefore is only one aspect. One has to look at the general contradiction within Irish Republicanism itself. Although I have never done a drawing on it, one of the clearest illustrations of that problem is the way the IRA responded to the Spanish Civil War, the fact that the right fought for Franco and the left fought for the Republican side. This is a good example of the complexity I'm talking about. But that is the complexity the IRA has lived with. So basically we can say that the devout Catholic right of the IRA are not that interested in political programmes; in their view, the IRA was formed simply to get the British, through armed struggle, out of Ireland and unify the country. The left wing has certainly kept that nationalism in its sights; Connolly is a good example. But it has also never been frightened to get into political programmes, economic issues, tenants' rights, etc etc. This tension at given moments generates outright contradictions. I find this seems to be an historical resource for my pictures. The recent *An Phoblacht* editorial line on the divorce referendum illustrated the complexity again. Obviously Sinn Fein are in favour of divorce and describe it in the editorial as a civil right. Again their socialist aspirations clash directly with the doctrine of the Irish Catholic Church.

JR There are a number of drawings which try, it seems, to reflect the changing face of Irish Republicanism, its current international socialist profile. In one drawing you depict a fiddler playing a lament near a cactus sent in solidarity from Angola. The emphasis being that despite the deep ideological contradictions within the Republican movement, Sinn Fein under the new Northern leadership has shifted to the left. For some Irish socialists though the socialist transformation of Sinn Fein is skin deep. How would you react to Michael Higgins's view that Sinn Fein's recent advance is simply clientalist, 'short-term opportunism, that is neither republican nor socialist'?

TA I'd want to know in far more depth what Michael Higgins has in mind.

JR Higgins argues that Sinn Fein (particularly in Dublin) are holding in socialist politics around short-term local issues, such as the drug problem, against broader questions of women's liberation, the state and the Church, in order to catch votes.

TA I guess I don't know in detail the policies which catch votes in the Republic. But that problem could apply to any political situation. If you like let's say there is a left-wing group that has an agenda that is concerned solely with long-term socialist objectives; it gets no votes. In fact it has gone for so long without getting votes it no longer puts candidates up. It then says the idea of voting has nothing to do with socialist objectives anyway – we know those arguments. So I can understand the pragmatics of Sinn Fein. I think every serious left-wing party is faced with that dilemma. It has two choices, *the* revolutionary struggle, or the struggle to get to where the revolutionary struggle takes place. And of course, politics invariably means adapting to the second perspective. So it seems to be that the kinds of campaigns one is forced into are the very ones that you say Michael Higgins describes Sinn Fein as being involved in. But in these terms I also guess he calls the hunger strikers clientalist: you gain votes simply because you have been on the blanket. I think there's a lesson to be learned here from somebody as old fashioned these days as Trotsky. You really have to sort out which strategies are or are not realistic propositions. Again Michael Higgins might turn around to me and say what an alternative party in Ireland may or should be doing in terms of long-term socialist perspectives. I guess I'd agree with him.

JR Finally was one of the reasons behind your recent work the need to raise consciousness about Northern Ireland, and to place it on the political agenda for the visual arts?

TA Yes. As I said it seems to be an issue of such historical importance because of its brutalisations of the political reflexes of Britain, that it is unavoidable. So I don't think I'm indulging in any moral earnestness – I hope it won't appear that I think I'm a 'good person' by doing work on Northern Ireland.

16

SINN FEIN AND VIDEO:
NOTES ON A POLITICAL PEDAGOGY

Over the last few years the Education Departments of Sinn Fein North and South have become increasingly involved in the pedagogic possibilities of video. Their aims are threefold: the development of internal structures of Republican socialist education within the party; the circumvention, in the South, of the censorship powers of the notorious Section 31 of the Broadcast (Amendment) Act, 1976; and paradoxically the development of 'media skills' that will allow the party to enter more fully the competitive consumerist politics of the bourgeois political process. In broad terms such moves represent deep and long-range transformations within the party post-abstentionism and the clandestine nature of the organisation. Sinn Fein in a sense are having to change those illicit reflexes of mind that have been borne of long-term isolation. It's a shift that spokesman Danny Morrison has described as a movement from a party selling newspapers and raising money for the Provisionals on the street and in the home, to an 'open political organisation'[1] that seeks to *capture* traditional Republican support lost to Fianna Fail and the Social Democratic Labour Party.

The development of socialist political skills to compete with bourgeois political ones is a process subject not only to the organisational strengths of the working class and its leadership. It also obviously depends upon the hegemonic nature of the bourgeois democratic process itself. The 'exceptional' political conditions of Ireland and Northern Ireland – the implicit censorship of the North and the explicit censorship of the South – make any real short-term advances for Sinn Fein fraught with difficulties; all the more so in the wake of bombing tragedies such as Enniskillen in 1987. Enniskillen was very much a watershed within the Republican movement. The 'unmitigated disaster'[2] of Enniskillen, to quote Morrison, licensed the crown forces in the North and the Free State government to 'de-humanise' further

the Republican struggle and 'expedite', to quote Sinn Fein President Gerry Adams, 'increased repression'.[3] The immediate legislative consequences of the bombing are now clear: ratification of the Extradition Act and renewal of Section 31 (which, with a great deal of cross-class support for its repeal, had looked like being amended) in the Republic; the permanent establishment of the 'draconian powers' of the Prevention of Terrorism Act in the UK; and a general increase in a British-sponsored anti-Sinn Fein campaign North and South under the auspices of 'security'. This was borne out recently when a Cork Sinn Fein organiser was jailed for five years, under the Offences Against the State Act, for selling as an 'incriminating document' an IRA poster captioned 'The IRA Calls the Shots'.

Sinn Fein in the South has no illusions about the limitations of video in the face of Section 31.[4] Despite the development of production techniques within the organisation and the building up of video libraries, the audience for such work remains on the whole the membership itself and its supporters. This, notwithstanding the 'exceptional' circumstances of the Irish struggle, says nothing new about restrictions on the distribution of political videos. But in the UK there is at least a potential production link-up between independent video and film and mainstream broadcasting – albeit now highly attenuated – in the shape of Channel Four's 'open' structure policy. There is no comparative access to RTE (Radio Telefis Eireann) for the Republican left. In these terms we are talking about a very different political and cultural climate; progressive alliances based on the commitments of a left intelligentsia well-placed within the media are just not available. In fact it is the historical absence of conditions for the growth of a modern and combative left intelligentsia (through the long-range effects of migration, the long history of Catholic censorship in the South, and the splitting off of Republican aspiration from socialist analysis and activism which James Connolly fought so hard to oppose) that accounts in part for the degree of legitimation Section 31 finds in the Free State.[5]

Although it may seem an inflated comparison, Sinn Fein's use of video in the South resembles the anti-colonialist struggles of Third World countries, as part of an ideological war of position fought *on the ground* with very few resources. If this says something about the global nature of anti-imperialist struggle, even under the exceptional circumstances of mass consumerist economies, it also points to the particular demands on such struggles today to build up educational work through media technology as an inseparable part of articulating

and carrying those struggles forward. As a direct response to state censorship within the politics of a neo-colonialist situation, Sinn Fein's use of low-level technology has a progressive role to play in both establishing self-identity and disseminating information efficiently and providing the necessary conditions whereby members and supporters can raise political consciousness in pedagogic exchange. If it is wrong, in the absence of political advance, to over-estimate the socially dynamic role of such a process – as has been argued for the democratic potentiality of video in a number of Third World situations[6] – it would be equally wrong to assume Sinn Fein are simply *using* videos. Videos have become one of the means by which a predominantly working-class organisation can develop its political skills.

Paolo Freire's notion of 'learning situations' based on dialogical relations is perhaps the best way of describing these initiatives.[7] (Freire's defence of dialogism was in fact the direct product of an anti-colonialist politics.) As Jim Monaghan, an Education Officer for Sinn Fein in Dublin has said:

> The main point we feel is that videos provide an easy and useful way to hold educationals at *cummann* [group] level which everyone should gain from, and which require very little input from an educational officer, who might feel otherwise inadequate or unable to run educationals or give satisfactory papers. And that videos should also be thought of as something individual members can borrow, watch in their own time, or watch with friends, and thus disseminate the nature of our struggle and of Sinn Fein with a view in the longer run to recruitment and generating new *cummann* in areas where we have supporters but no organisation.[8]

The recognition of pedagogy as practice here clearly points to an organisation that is building out of a Republican tradition where not only cultural politics but politics itself has taken a back seat in the face of the 'physical force' traditionalists. With the rise of the right in the IRA in the 1940s and 1950s (after the defeat of the socialist policies of Saor Eire in the 1930s) the legacy of Connolly, Liam Mellows and Frank Ryan was subjugated to the armed struggle.[9] In short, what Sinn Fein's use of video represents is the emergence within the Republican socialist movement – after the civil rights marches of the late sixties, the rise of the new Northern leadership and the recent influx of feminists and activists with Trotskyist backgrounds into the

organisation – of a modern cultural politics. Through it the *development* of Republicanism as a broad-based movement has displaced the old-style exhortative and rural forms of nationalism that dominated the socialist down-turn in the 1950s. Moreover despite the historical weakness of the left in Ireland, there has been a 'quiet' revolution in academic life, as a new generation of intellectuals have sought to establish a materialist critique of Irish culture grounded in the realities of the new urban Ireland. This clearly has had a contributory influence on the left of the Republican movement. (This is why a number of commentators have been quick to interpret – erroneously – tragedies like the Enniskillen bombing as a spoiling attack by rural nationalist elements in the IRA leadership on the re-politicisation of the struggle in the new Sinn Fein, and its generally slow results.) As Gerry Adams himself has described these political changes:

> Republicanism is a very potent force in Irish politics but the vehicle of organised republicanism is still weak organisationally and our underdevelopment in this respect is something which we recognise and which we are constantly addressing ... There is nothing which concentrates the mind of a political party as much as an electoral campaign and while we do not restrict ourselves to electoralism – indeed we see it merely as one facet in a many-faceted struggle of campaigns, street, agitation, cultural resistance, publicity work and education – our electoral successes have played a major role in changing the nature of Sinn Fein.[10]

The production of videos can be divided into four categories: material made on community issues, videos of speeches at the Ard Fheis (the annual party conference) and internal policy discussion groups, election videos and 'training videos', in which prospective Sinn Fein councillors, or TDs (MPs) are asked hostile questions in controlled situations. The second and fourth categories are obviously for internal consumption only. The community issue titles are aimed predominantly at the Republican community itself (pubs, clubs, meeting halls and homes) and the video for the Westminster election (scripted by Danny Morrison) was shown on the BBC under their equality of political representation clause. The technical quality of these naturally varies greatly, the election video being the most sophisticated or 'professional' in structure, given the demands of mainstream broadcasting. Still, as Sea.nas Keenan, Publicity Officer for Derry Sinn Fein has said, Sinn Fein has no 'policy'[11] on video.

Given the lack of resources, and the political demands on activists from other areas (the Sinn Fein paper *An Phoblacht/Republican News* is still sold on the streets), things remain uncoordinated, reflected in the fact that the party does not have the capacity to copy and distribute material on a wide basis, and videos are not extensively available for individual consumption. Nevertheless, both Keenan and Monaghan see the need now for autonomous groups to be set up, North and South, that will provide the basis for a broad cultural and educational programme. Moreover, it will also allow Sinn Fein to take over some of the propaganda functions that have been provided by independent video and film makers sympathetic to the Republican cause.

Sinn Fein's use of low-level technology is largely about establishing the necessary conditions through which transformative forms of knowledge production and exchange can take place. As a result there is a sense that traditional literary forms of Republican pedagogy – the Romantic, conservative organicism of Patrick Pearse and the legacy of the Irish Republican brotherhood – with its emphasis upon the marshalling of an 'essential' Irish identity grounded in rural lore and Catholic martyrology – are up for scrutiny. The concessions Connolly had to make to this tradition no longer loom so imponderably large for the Republican left. However, this is not to say that Sinn Fein are no less committed to the Gaelic language. As Adams has said: 'the Irish language is the reconquest of Ireland and the reconquest of Ireland is the Irish language.'[12] Nor is it the case that there still doesn't exist, in certain sections of the leadership, a conservative desire to restore the place of a pan-Gaelic culture after a break with Britain. But, rather, the question of traditional notions of Irishness, which have played such a large part in constructing cross-class forms of interpellation within the Republican movement, are shifting. The links between culture and politics, nationalism and socialism, as *productive* and *dialogic* sites of meaning (rather than the fixed repositories of myth and allegiance) are moving hesitantly and informally into place. This is reflected particularly in the work of women members who have had nothing to gain from the way traditional forms of nationalism have lined up with Catholic hegemony to police working-class women's identity and sexuality in the South. The women's movement has been an important contributory influence on the new agenda.

In the absence of effective means of self-representation through access to the media, and in the face of administrations North and South that seek to de-politicise and de-historicise Irish history and

Republican struggle as 'atavistic', the necessity for a post-Romantic, combative cultural politics has become paramount. The mobilisation of a popular Republican socialist cultural politics will increasingly take up the foreground of ideological debate within the party. Faced with the hegemony of Anglo-American popular culture, the working class, the unemployed and youth will not be won over to a socialist united Ireland on visions of Irish dancing and Gaelic football. Which is why, despite everything I have said so far, one of the weakest chapters in Gerry Adams's *The Politics of Irish Freedom* and one of the weaker sections of the Sinn Fein manifesto are actually the ones on culture, which both assume a wholly unproblematic, morally empowered, notion of traditional culture within a united Ireland. The new leadership may seek to distance the Republican movement from rural and Pearsian forms of conservatism, but it certainly, at national level at least, cannot afford to break with all forms of Irish traditionalism. Sinn Fein remains essentially a *nationalist* party. The struggle for a new Republican cultural politics then is not a struggle against the interpellations of nationalist sentiment, but, if you like, their restructuring, for there can be no Republican struggle without such identifications. This of course is the weakness and strength of all nationalist movements.

Sinn Fein's use of video as part of a 'modernisation' programme sits at the very centre of this conflict between the need for the mobilisation of nationalist forms of identification and a critique of their conservative appropriation – in short the conflict between nationalism and socialism in any anti-colonialist situation. In fact it has to do a number of jobs at once. Thus at the same time as it promises a pedagogy that takes on conservative forms of Gaelicism (what we might call those organicist prefigurations of cultural 'oneness'),[13] in its attack on governing cultural forms of Anglo-American imperialism and the general de-politicisation of the Republican struggle within the culture, it is also forced to construct new forms of nationalist interpellation that in some sense rely on Gaelic or traditional nationalist sentiment. The productive and dialogic relationship I earlier referred to is clearly structurally determined at all times by nationhood. The argument then is not to use the emergence of a new cultural politics within the Republican movement to unhook the link between the reconquest of Ireland with the reconquest of the Irish language and traditional culture, but to see them in inescapable critical tension.

I therefore do not want to overemphasise the critical socialist role of the use of video; just as I don't want to overplay its dialogic

powers. Nevertheless the use of video reflects quite clearly a party that is now undergoing a transformation of identity and strategy as it confronts the harsh realities of *political* organisation.

Notes

1. *The Tasks Ahead – Danny Morrison and John McCluskey* video of two addresses to a Sinn Fein meeting in Longford November 1986.
2. Interview with Danny Morrison *New Statesman* (20 November 1987) p 19
3. Interview with Gerry Adams *An Phoblacht/Republican News* (19 November 1987) p 3
4. The difficulties that Sinn Fein face under the powers of Section 31 were given an absurd twist recently when a song from Christy Moore's album *Unfinished Revolution* was banned by Radio Telefis Eireann because Moore's sister, who is in Sinn Fein, was singing in the chorus! This is a fairly trivial example, but it gives an indication of the extent to which Conor Cruise O'Brien's revamped bill will find its targets. For recent information on Section 31 see the International Federation of Journalists report *Censoring 'The Troubles': An Irish Solution to an Irish Problem?* (Brussels May 1987)
5. For an historical discussion of the weaknesses of left intellectual culture see McCormack *Battle of the Books* (Dublin: Lilliput Press 1986)
6. See Dee Dee Halleck 'Nicaraguan Video: Live from the Revolution' in *Making Waves: The Politics of Communication, Radical Science 16* (Free Association Books 1985)
7. Paolo Freire *Pedagogy of the Oppressed* (Penguin 1972). For a good (if strangely unacknowledged) update of Freirian-type pedagogy see David Lusted 'Why Pedagogy?' *Screen* vol. 27 no. 5 (September–October 1986).
8. 'Notes on Use of Videos' Sinn Fein internal memo
9. Saor Eire was a left reformist movement within the IRA in the 1930s. See Sean Cronin *Frank Ryan: The Search for the Republic* (Repsol 1980) for a discussion of the ideological struggles within the IRA through the 1920s, 30s and 40s.
10. Gerry Adams *The Politics of Irish Freedom* (Brandon Publishers 1986) p 151
11. Seamas Keenan in conversation with John Roberts, Derry, July 1987
12. Adams *Irish Freedom* p 148
13. See Peter Beresford Ellis *The Celtic Revolution: A Study in Anti-Imperialism* (Talybone, Ceredigion, Y Lolfa Cyf, 1985). Ellis's Republicanism is defined principally in Third-Worldist terms as a struggle between little nations and large multinational states. With its independence, the author argues on p 209, Ireland will regain its identity and 'feel oneness with its past and confidence in its future'.

RECLAIMING THE REAL

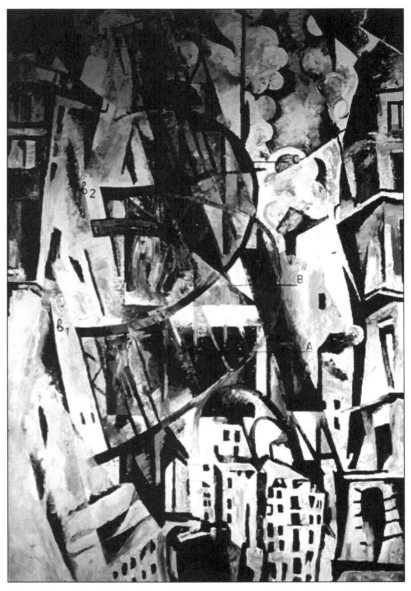

17. David Mabb, *Elegy to the Third International VIII*, 1988.

17

APPROACHES TO REALISM

Realists argue for an understanding of the relationship between social structures and human agency that is based on a transformational *conception of social reality, and which avoids both voluntarism and reification. At the same time they advance an understanding of the social as essentially consisting in or depending upon* relations. *This view is in opposition to both atomistic individualism and undifferentiated collectivism.*

ROY BHASKAR[1]

If works of art are to survive in the context of extremity and darkness, which is social reality, and if they are to avoid being sold as mere comfort, they have to assimilate themselves to that reality. Radical art today is the same as dark art: its background colour is black.

THEODOR ADORNO[2]

What is realism? Definitions of realism in art have been subject to so much conflicting and reductive interpretation that it is no surprise that the term today is met by either indifference or confusion. Yet, claims over its validity won't go away. During the 1980s in Britain alone there have been repeated attempts at rewriting its critical aims. A number of shows and texts have been produced defining realism as a kind of 'hold out' against the onslaught of would-be conservative forms of postmodernism.[3] In my view though these attempts have been too programmatic or simplistic, stemming from basic philosophical errors about how representation works and art's relationship to knowledge. On the whole realism has been linked too closely with a theory of resemblance. By this I mean that realism, be it social realist painting or documentary photography in its conventional forms, is defended on the grounds that art is at its most 'truthful', and

progressive, when it is showing recognisable people, doing recognisable things in recognisable settings. This thinking runs very deep throughout the whole debate on realism and art this century. Thus the socialist realist and Popular Front artists of the 1930s, the New Realist artists in Britain in the 1950s (fronted by John Berger), the muralists of the 1970s, and the so-called Critical Realists of Scotland in the 1980s, have all professed, in their various ways, that showing people doing recognisable things in recognisable settings is somehow more 'accessible' and politically accountable than other forms; that is, abstraction and recently conceptual art and its legacy (texts, sound-tape work, performance, etc). In fact a moral imperative is attached to these claims. By producing figurative content, 'realist' painting is held to offer a far better chance of entering living social relations than other forms.

The arguments espoused by the exhibition *Approaches to Realism*[4] oppose such a view. This is based, however, not on the rejection of figurative content per se – the inclusion or exclusion of figures is not a critical issue – but on the rejection of the insidious assumption, so thoroughly ingrained in the empiricist thinking of conventional realist practices as a whole, of the conflation between realism in art and the naturalistic rendering of the world of appearances.

BACKGROUND

The confusion between the *realistic* and real*ism* has its roots in the modernist revolution at the beginning of this century. Its roots lie therefore not just in questions of art's formal self-definition, but in the political and ideological struggles upon which those questions were predicated. The eventual suppression of the modernist revolution in the Soviet Union in the wake of the Stalinist counter-revolution and the rise of fascism in Europe, created a left visual culture which tore the dialectical heart out of the realist–modernist debate. With the consolidation of Stalin's rule and the codification of socialist realism as a 'progressive' international force, realism was placed back within its traditional naturalistic orbit, leaving modernism stranded and vilified as an ideological 'other'. Socialist realism's instrumentalisation of art created a massive historical cleavage around the realist debate. To be honest, however, this had less to do with the intellectual prestige of the arguments, than the political prestige in the 1930s of the Soviet Union. The defence of a Popular

Front cultural politics was also held to be a defence of the Soviet Union. This exerted an enormous emotional pull for artists; modernism for all its achievements up until the thirties, was held to be incapable of mobilising against the threat of Fascism. Essentially, the realist debate in the late twenties and early thirties was used by the Stalinists to marginalise the left and pull sympathetic artists behind the notion of 'socialism in one country'; the threat of fascism was simply the most powerful and direct way of doing this. With the decimation of the modernist left by Stalinism and Fascism, the arrival of the remnants of the modernist avant-garde in America during and after the war, the realist debate was to achieve its completed degeneration into opposing camps as the Cold War got under way. By identifying realism with the instrumentalisation of content and the suppression of individuality, modernism became the crucible of everything progressive, humane and visually interesting. Those who defended realism, even those who had no truck with Stalinism, were held to be involved in the very bureaucratisation of human expression. Realism was once again irredeemably linked to academicism.

This polarisation of realism and modernism of course had its opponents. In fact at the same time the Popular Front and socialist realism were being mobilised their claims were being theoretically demolished by a formidable array of anti-Stalinist modernist intellectuals and writers (Brecht, Benjamin, Adorno, Trotsky, Breton and Aragon – though Aragon tended to switch position when political circumstances dictated). In their respective ways, whilst retaining a commitment to the critical and disaffirming powers of art, they all argued for its relative autonomy. They in effect sought a unity of modernist self-reflexiveness – a sensitivity to the materiality of art – and realist critique of prevailing social relations. The terms of this encounter may have been very different from writer to writer – Adorno always saw residues of instrumentalisation in Brecht and Benjamin's commitment to photography – but they all lined up behind the view that realism was in no sense 'correct' content inserted into traditional forms. Thus if Popular Frontism and crude defences of socialist realism were the political enemy on the ground, it was the theoretically powerful presence of Georg Lukács that was the immediate target. The well-known debates on art and politics in the thirties were essentially the result of Lukács versus the rest. After the Soviet Writers Congress in 1934, which was convened largely to push the Popular Front / conventional socialist realist line, Lukács in many ways became the leading spokesman for socialist realism.

As such it was his prestige as a theorist that did much to reinforce the modernist–realist split. Seeing modernist technique as a reflection of fragmentation and political retreat, he argued that traditional forms of exposition in literature and painting were a far more progressive and adequate way of the artist creating an insightful overview of social relations. The job of socialist realism was not to reproduce the anomie and cynicism of capitalist relations but to create a picture of human relationships in all their roundedness. '[T]he object of proletarian humanism is to reconstruct the complete human personality and free it from the distortion and dismemberment to which it has been subjected in class society.'[5] This roundedness was to be achieved through *typification*, the construction of characters and situations which organically bound together the particular and the general. Although Lukács was writing principally about literature the implications for the visual arts were clear enough from this: art was at its strongest by employing and reworking traditional representational forms.

Lukács though was no unthinking defender of art's politicisation. Rather what concerned him was a kind of moral commitment to a set of formal values that he felt best represented the interests of realism. Modernist techniques were incapable of generating a 'satisfactory wholeness'[6] from reality because the artist was unable to grasp reality from the inside. Traditional forms enabled this because they allowed artists to show human beings and classes in conflicting *progress*. For Brecht, Benjamin and Adorno then the problem with Lukács's writing was less its commitment to thirties-style Soviet 'Heroic Realism' than its general grounding in bourgeois organicist aesthetics. Thus central to their critiques of his realism was his surface commitment to the representation of social contradiction; social contradiction was, as far as literature goes, always presented and resolved within the closed form of the classic picaresque bourgeois text. Likewise contradiction in painting was identified simply with the historically significant moment – the emotive panderings of the traditional history painting. As such, although Lukács was a sharp critic of what he called illustrative socialist realism, his moral commitment to the representation of recognisable humans in purposiveful action led him to defend a set of skills that would be adequate to this content. The question of different skills doing different kinds of jobs never entered his conception of what might be progressive; and it was this that Benjamin, Brecht and Adorno objected to. Lukács's socialist realism *closed down* the possible

representation of social contradiction by not so much instrumental-ising content but by instrumentalising form. Lacking a critical sense that artworks are made *out of* the very social contradictions they seek to represent, Lukács had an undertheorised conception of art's *means* of representation. As Terry Eagleton has argued: 'Brecht's rejection of Lukács nostalgic organicism, his traditionalist preference for closed, symmetrical totalities, is made in the name of an allegiance to open, multiple forms which bear in their torsions the very imprint of the contradictions they lay bare.'[7]

What Lukács's realism lacked then for Brecht, Benjamin and Adorno was any sense that realism was a self-reflexive and necessarily unstable category. The development of skills was not about the honing of a set of predetermined competencies, but learning *through* the development of skills. Realism as the critique/representation of social contradiction was to make and remake itself contingently; to do otherwise was to substitute itself politically and aesthetically for a given set of interests or achieved condition. Thus if this was so, the privilege given to traditional forms of narrative exposition and organisation was not the result of their greater aesthetic worth or candour, but their construction ideologically for political ends: their use as a critique of art's containment under bourgeois culture by func-tionalist appeals to the popular and the accessible. Lukács's defence of the superiority of his socialist realism therefore cannot be separated from the Stalinist cultural politics he was prepared to endorse in his denunciations of modernism as decadent and elitist. His critique of modernism was also a critique of what he saw as ultra-leftism; the undermining of popular forms of socialist identification. Lukács though was not a hack, or rather, he was more canny as a Stalinist than his critics give him credit for. After the full revelations of the Stalinist horrors and the invasion of Hungary Lukács committed himself to the re-presentation of his position in which he dissociated himself from what he acknowledged as the Stalinist distortions of socialist realism. It 'ceased to reflect the dynamic contradictions of social life; it became the illustration of an abstract "truth".'[8] In a certain sense these writings were a response to his modernist anti-Stalinist critics. 'Socialist realism is a possibility rather than an actuality.'[9] However, in no sense did this represent a concession to the modernist position; rather, the de-Stalinisation was an attempt to reclaim traditional organicist aesthetics for the construction of a new popular state art in the newly formed 'socialist' (state capitalist) countries. It was the powerful influence of Lukács in East Germany

in the late fifties that did much to marginalise the realist legacy of John Heartfield for example.

Specifically for Brecht, Benjamin and Adorno, Lukács represented the failure of conventional reflectionist forms of realism to deal adequately with the complex relationship between representation and knowledge. Lukács wanted a realism of imaginary resolution, a realism of symbolic totality in which the contradictions of bourgeois society are aesthetically divined and overcome. Brecht, Benjamin and Adorno wanted the complete opposite. It wasn't the imaginary totality that would lead the artist to realism, but the fragment, that which in fact resists the resolutions of the symbolic. For if the artist was truly to inhabit the contradictions of the bourgeois order, bourgeois reality had to be made available in a form that actually *embodied* those contradictions. Hence the centrality of montage and collage to the modernist–realist opposition. Montage and collage lighted on the semiotic fragment as the means to estrange familiar objects and identities by drawing the disparate and disconnected phenomena of social relations together. Furthermore, the semiotic fragment was not merely the building block of a greater aesthetic totality, but something with an aesthetic and cognitive value of its own. For Benjamin, the fragment allegorised bourgeois relations by a process of non-mimetic correspondence; the fragment in a sense 'stood in' for another set of meanings. Specificity of detail was imprinted with the very context from which it was torn. The fragment and the collision of unfamiliars then problematised the very epistemological basis upon which Lukács and defenders of the resemblance theory of realism based their aesthetics. By defending montage and an aesthetic of the fragment they opened up the realist debate to the modernist insistence that the post-Renaissance perspectival space had no privileged relationship to truth; the truth-content or realist claims of an image lay in their cognitive status as produced significations and not as reflected approximations of external objects or state of affairs. This is why in Brecht and Benjamin what is of principal concern for their theory of a new realism is the very production of the real itself; realism as a problem grounded *in* the representation of knowledge. How is it possible to talk of things being realistic, Brecht argues, when pictures invariably show us only a small part of the world? How is it possible, in fact, to talk of picturing the world realistically, when so much of the world is hidden to human view? In effect Brecht and Benjamin (the Benjamin of 'The Author as Producer'[10]) were claiming to connect realistic aesthetics to a Marxist

theory of knowledge that owed nothing to its class reductionist, economistic and organicist distortions under both Stalinism and the legacy of the Second International. In this they also looked to the scientific advances of Freud and the Copenhagen school of physics for support.

Central to Marx, Freud and the Copenhagen school of physics was the view that underlying observable phenomena were enduring structures and generative mechanisms. Events were not the product of contingent affairs but of 'deep' and hidden structures. Phenomena were bound together not mechanically and atomistically but as the product of *coherent relations*. The issue for the artist or photographer committed to retaining some belief in art's powers of 'truth-telling' was how to visualise such relations, in short, how to visualise the invisible? For instance Brecht asked: how was it possible to show the extensive economic power of Krupp's armament business? A photograph of Krupp's factory wasn't enough. We might also add, how is it possible to show the economic function of the nuclear family? Or the capitalist value–form? Which is why Brecht and Benjamin not only stressed the constructive powers of montage and collage but the power of the caption. The use of captions, of the direct contextualisation of the image, allowed the artist, without ambiguity, to invest the image or images with a knowledge beyond surface appearances.

Understandably it was the work of John Heartfield that became the key focus for the modernist–realist opposition in the thirties. His anti-Nazi montages fulfilled all the right criteria: engaged, self-reflexive, ironic and discontinuous in aesthetic effect, his work represented, for Benjamin in particular, an actual paradigm shift for realist practice. Photomontage allowed political images for the first time to have an organising function; distributed widely, in their process of reception they created a political *culture* of reception. For Benjamin then the problem with Lukács's traditional defence of history painting – Lukács in fact had little time for Heartfield, accusing him, strangely, of naturalism – was that it failed to acknowledge one of the fundamental issues of realism: effectivity. How can works claim to have realist effects if they are not seen, or do not enter those constituencies they are destined for? In these terms Benjamin's realism looked back to the productivist debates in the Soviet Union in the twenties, in particular the October Group. The October Group in many ways represents the point of greatest sophistication for the modernist–realist debate. Attacking the growing

dominance of 'Heroic Realism', supported by the Association of Artists of the Revolution (AKhRR), it defended a realism which intervened *in* life, 'a dynamic realism that reveals life in movement in action.'[11] The artisanal individualism of socialist realism merely reinforced the opposite: passivity and ideological exhortation. Moreover, they argued strikingly that the avant-garde debate was a debate first and foremost about *realisms*. (This in fact was in no sense a marginal position within avant-garde discourse; emboldened by the revolution Russian modernists such as Malevich saw themselves as engaging in an extension of the realist debate.)[12] Benjamin's adoption of October Group type productivism was thus a strategic move: to reclaim the complexities of the modernist–realist debate in the face of Stalinist reaction.

In the light of this it is interesting to note the intervention of Louis Aragon in these debates. A Stalinist and a modernist, Aragon cut sharply against the grain in the thirties by defending Heartfield *as* a socialist realist. After participating in the Soviet Writers Congress in 1934, in 1935 he published a collection of speeches and essays entitled *Pour un Réalisme Socialiste*,[13] which included his well-known essay on Heartfield, 'John Heartfield et la beauté révolutionnaire'.[14] Providing a French intervention into what was a predominantly German–Russian debate on the Popular Front / realism he defended Heartfield as a *modernist* socialist realist. Moreover he defended him as a *painter*. Although critical of Lukács's organicism, he nevertheless saw aesthetic continuity with older forms as part of the renewal and extension of realism. Arguing that Heartfield's use of photography was essentially painterly, Aragon saw Heartfield's successful use of photomontage as opening up possibilities for artists to work as realist painters but without recourse to traditional resemblance / narrative models. As David Evans has said, Heartfield became 'the potential saviour of realist painting, replenishing exhausted artistic traditions with audacious uses of press photographs'.[15] Realism for Aragon was bound up with three criteria: political commitment, extension of subject matter (the 'burden of the modern')[16] and stylistic innovation – expressly the incorporation of the non-artistic/non-literary into art. This is why he could describe the Surrealists as realists, because they gave form to realities that had no previous place within art. All Aragon's criteria were applied to Heartfield. Heartfield had 'created a new technique more consistent with contemporary life'.[17] 'His art is art in Lenin's sense because it is a weapon in the revolutionary struggle of the Proletariat.'[18]

However, 'meaning hasn't disfigured beauty'.[19] What is interesting about this writing is how it negotiated Stalinist / Lukácsian orthodoxy. Although he fails to register the real radicality of Heartfield's practice – the fact that it stood to transform the *relations* of art's production – relies too closely on a formal historicist model, and recants his modernism in the fifties, he is one of the few contributors to the art and politics debates of the thirties to open up painting to modernist–realist intervention. Unfamiliar with the Soviet avant-garde literature on painting from the twenties, he nonetheless offers a route back to those earlier modernist discussions of realist painting. Unlike Brecht and Benjamin he touches directly upon questions that concern the materiality of painting.

It could be argued of course that Lukács's position was similarly concerned with giving form to the invisible. Lukács was in no sense an atomist. However, what Brecht and Benjamin make clear is that realism is a *relational* concept, not an aesthetic or ontological category. Their emphasis upon the real as site of ideological production, determined by context and by conditions of reception, has nothing to do with Lukács's metaphysical view of successful realism involving the reclamation of the *essence* of reality. For Lukács the hidden world of bourgeois relations was simply lying in wait to be recovered by the artist applying the 'correct aesthetic understanding of social and historical reality'.[20] For Brecht and Benjamin the 'truth' of realism is not the recovery of an essence, but the production of a *practice* caught up in the ideological and historical production of the real itself. The recovery of the real is in a sense also its production, in so far as the 'truth-effect' of realist representations are also to be measured against the claims of other representations. Thus for example the Krupp's factory photograph with caption is held to sustain a greater realism than a photograph of the Krupp's factory without caption. Works may reveal an identity with an historical real but the work of signification is not commensurate with that real. Now this is not to say that a moment of correspondence is not at play within representations that claim realist status,[21] but that realist meanings are also the product of discursive articulation. Representations do not signify simply through a process of identity, but also through non-identity. Far then from signifying the essence of reality, the artwork is marked by certain determinate absences which pull its significations into contradiction with the world. The condition of the work's realism is read according to what it fails to signify or what it externalises. An

aesthetics of the fragment therefore is absolutely central to the possibilities of realism, for in its very heterogeneity it acknowledges how partial all claims to realism must be. In actuality what Benjamin and Brecht clarified in their pursuit of a new realism was the very limits of representation.

Brecht, Benjamin, Adorno and Aragon could all be said to be involved in a critique of reflectionism and Romantic organicism. Yet in no sense did this represent a united front. As I have just mentioned Aragon's commitment to realism was principally through painting. Although he was a relatively minor influence in these debates, his interest in, and defence of, the traditional aestheticised object introduces us to what might be called a counter-realist tradition: a realism that recognised the critique of reflectionism and Romantic organicism but was not prepared to situate that critique within the boundaries of productivism and the prioritisation of mechanised reproduction. The traditional aesthetic object – in short, painting – was not so easily remaindered by productivist critique. This is why Adorno was in fact as much opposed to the implications of Brecht's and Benjamin's photography-based pedagogy as to Lukács and conventional realism. For Adorno, Brecht and Benjamin's realist appropriation of photography was no less instrumentalised aesthetically than conventionalist realist practices, in so far as a politicised photography weakened the fictive and illusionistic base of art. Crucially Adorno's work looks back to the 'culture of materials' of the early Soviet avant-garde (Malevich, Rodchenko, Tatlin) to establish a realist defence of the aesthetic. Principally this is a realism which accords a central place to the materiality of art; that the realism of works cannot be judged solely in terms of their philosophical predicates or the effectivity of their conditions of reception, but in terms of their material status as *objects*; or rather more precisely, how they place and define themselves against other works of art, as well as the world. The Marxist notion of art as a process of learning in front of the real is defended as one in which cognitive development (the intellectual apprehension of the world) and aesthetic interest are defined as inseparable. Realism in art – the foregrounding of social contradiction – can only be assessed in terms of how such contradictions are embedded *formally*. As Adorno argues in *Aesthetic Theory* 'The unresolved antagonisms of reality reappear in art in the guise of immanent problems of artistic form. This, and not the deliberate injection of objective moments of social content, defines art's relation to society.'[22] 'Form is the key to understanding social content.'[23]

It is in the inner logic of the development of art therefore where art's critical autonomy is to be found. For Adorno the new, or formal novelty, was not a symptom of modernity but a necessary extension of the object itself. Without this dialectic art was incapable of defining itself and remaining independent of its use for instrumental ends. Hence Adorno's objection to Brecht and Benjamin's productivist defence of the need for art to intervene directly into reality, was that they overdetermined the use-value of the art object. Art's 'promesse du bonheur'[24] was not so much its manifest content but its material otherness; the artwork's critical or realist status is derived from the grounds of its aesthetic intractability. For Adorno then the very fetishism of the artwork carries a redemptive content in so far as its illusionistic powers provide an affirmation of freedom from the instrumentalities of mass culture. First and foremost Adorno's defence of the formal autonomy of art was a critique of the way the development of the means of reproduction under mass culture subordinated culture to either the commercial dictates of entertainment or bourgeois propaganda. Art, in its very otherness, retained the promise of forms of human self-realisation, of the development of human faculties, free of such social interests. In this respect Adorno saw Brecht and Benjamin's leftist defence of mechanised reproduction as ushering in a new and progressive set of production relations for art as mistaken; its commitment to art's direct intervention into reality could only distort and contain that process of human realisation. Brecht and Benjamin were seen to line up too closely with the dominant technological interests of mass culture.

In many ways it could be argued that Benjamin's defence of mechanised reproduction in 'The Work of Art in the Age of Mechanical Reproduction'[25] was not prescriptive, but diagnostic. The capitalisation of technology placed art in a relationship to its audience and art's history that, irrespective of the cultural implications of such a process, profoundly broke with the past. Adorno never denied this; rather he saw a conflict in Benjamin's aesthetics that Benjamin's commitment to productivism compromised. By committing himself to productivism, Benjamin's revolutionising of the relationship between part and whole as a defence of the artwork as the necessary product of a divided social world was weakened. The problems of aesthetics as rooted in such divisions could not be solved, particularly with the rise of Stalinism, by advancing photography against painting, no matter how provisional that might actually be. That is why Adorno sought firmly to place Benjamin's

aesthetics of the fragment within the sphere of high culture, because the aesthetic as grounded in painting for example had a privileged access to such fragmentation, distorted as it was by dominant cultural relations. Realism then for Adorno was a matter of utilising the inner development of art to place such contradictions in the open.

Adorno's constant vigilance about artistic method was also central to the contributions Trotsky made to the debate in the thirties. Trotsky of course established his modernist credentials in the mid-twenties in *Literature and Revolution*,[26] a major contribution to realist–modernist Soviet avant-garde debates. In exile and confronted with the rise of Popular Frontism he restated his views. In his 'Manifesto for an independent revolutionary art' (written with André Breton), the Popular Front artist and socialist realist (though not expressly mentioned) provide a continuing instance of the crude politicisation of art. Echoing his insistence in 'Class and Art' (1924) that art must be judged by its own law, the 'law of art',[27] he and Breton argue that 'the imagination must escape from all constraint and must under no pretext allow itself to be placed under bonds.'[28] Always the severest critic of those who would confuse political content in art with political transformation, he saw that without art grounding itself in critical practice, content would inevitably end up as routine and spectacularised – learning would have stopped. We should not fail, he urges in the manifesto, 'to pay all respect to those particular laws which govern intellectual creation.'[29] In short like Adorno he was highly critical of those who would substitute the predicates of politics for the work of aesthetic self-definition. Moreover like Adorno he saw the social contradictions inherent in the artistic object as something not to be vaunted over but acknowledged as the very condition of art's marginalisation under class relations; Trotsky's attack on the 'Lef' theorists and artists in *Literature and Revolution* was that they presumed they could close down this distance by simply privileging the photographic 'fact'.

To pair off Trotsky and Adorno neatly as part of a counter-realist tradition however would be a mistake. Unlike Trotsky (and Brecht and Benjamin) Adorno had a poor sense of audience; in his writing intimations of the popular were invariably castigated as leaving the door open to the sins of entertainment and sentiment. His defence of the need for a constant revolution in the languages of art as a realist (moral) hold-out against the conformities of mass culture became impaled on the logic of his own avant-gardism: perpetual novelty. Trotsky for all his strengths had a weak grasp of representation

and ideology. Nevertheless, what remains important about their writing is that in defining the generation of critical content in art as linked of necessity to problems of formal self-definition, art's relationship to realism can be more profitably linked to the notion of 'research programmes', rather than to simplistic notions of realism as 'political figuration' or a 'style'. In Adorno in particular, knowledge in art is put on the same footing as realism in science: as a hypothetic–deductive process. Art 'progresses' precisely through its mistakes and anomalies, and not inductively through a gradual process of accumulation of skills and knowledge or the implementation of a fixed method.

Essentially, it is this tension between the Brecht–Benjamin commitment to ideological intervention in art, and the Trotsky–Adorno insistence on the necessity of art's formal self-definition, or self-monitoring, that lies at the heart of *Approaches to Realism*. Which is why I have selected a wholly *painting* show (though some of the work includes photographically reproduced material). For I believe that it is within painting where this conflict between aesthetic autonomy and use-value is currently of necessity being played out. Thus the realist claims of the paintings in this exhibition should be seen as both products of, and responses to, this split. Which brings us back to my earlier argument about realism not being confused with a theory of resemblance. All the work in the exhibition treats the problems of pictorial organisation in painting today as bound up with a critique of this correspondence. This is not to say that some of the paintings don't employ traditional figurative or reportorial conventions, but that they do so in an explicit 'second-order' way. By 'second-order' I mean that such conventions are treated as one set of possible representational resources amongst many. That is they are treated as *symbols* which stand to be manipulated in various ways in order to put in place certain critical contrasts between people and things.

'SEEING-AS'

Let us be clear therefore about what is important here by looking at how the paintings in the show reject the conventional realist legacy.

One of the principal weaknesses of the conventional realist legacy is its failure to acknowledge, in any explicit fashion, the connection between pictorial competence and 'seeing-as'. That is, that it is not essential for resemblance or imitation for denotation (the reclamation

of meaning) in art to be possible. Thus I may paint a number of flag poles which stand for famous post-war American artists. Each flag *denotes* each artist without actually iconically representing them. Such an admittedly extreme example covers a general law: that the meanings we reclaim from art are in part *achieved*, are the product of understanding rather than simply recognition. Now this is not to say our recognitional abilities do not come into play; our interpretative capacities are in a sense grounded in our recognitional abilities: I do not need to open a reference book on animals to understand that I am looking at a picture of a dog; but I may need that reference book in order to find out what breed of dog I am looking at.

Principally this issue of 'seeing-as' deepens the claims of realism as a theory of representation concerned with revealing 'hidden' relations and orders. For if one thing might stand in for another thing, then the production and reading of content becomes open to the complexities of *indexicality*. By this I mean that the process of one thing being able to denote another thing allows the artist to represent relations abstractly *across* time and space. Indexicality then can be related to the earlier discussion of an aesthetics of the fragment; a sign or combination of signs may denote a set of social relations beyond their own surface identity. Consequently, from this perspective the political claims of realism as an art of social critique undergo a qualitative transformation, in so far as the relations between people and things do not have to be *described* in order to achieve realistic status. Good examples of this in the show are Rasheed Araeen's *Green Painting* and Terry Atkinson's work on Northern Ireland. In *Green Painting* Araeen constructs a cruciform of photographs of the Muslim festival of Eid-ul-Azha, framed at each corner by a painted green panel. By organising the signs of the 'primitive' (bloody ritual) within the framework of Western modernity (the minimalist art grid) he establishes a set of critical relations and contrasts between cultural imperialism and cultural autonomy, modernism and tradition that dialecticises the relationship between East and West. The minimalist grid is at the same time both restored to its traditional culture of origin (Islam) and subverted from a modernist vantage point. By including the green panels (green is the Islamic holy colour and beyond permissible use in representation in Muslim countries) Araeen asserts his independent right as a modern Pakistani artist to criticise his culture of origin. Thus by including photographs of a supposed barbaric ritual in a modern work of art he restores the traditional culture of the margins to the centre. The realism of the work

therefore lies in its capacity to reveal contradiction and invert identities through the artist's and our shared capacity to read one thing as another. In effect what *Green Painting* reveals vividly is the particular abstract spatialising qualities of indexicality.

In Terry Atkinson's painting the release of political content from the descriptive is also based on a sensitivity to the indexical possibilities of the sign. In his *Goya* series, the history of late modernist abstraction as a history – in crude terms – of pictures 'failing to signify', is indexed to the aspect-blindness of the British ruling class on the war in Ireland. The Irish question is in a sense, following Adorno, *embedded* formally in the work. However, what perhaps distinguishes the realist claims of Atkinson's work from most of the other painting in the show is his extended use of captions. More than any of the other artists in the exhibition he follows Benjamin's insistence on the need for the caption – in this instance an ironic mixture of jokes, stories and historical data – to anchor the image historically. This is not in order to substitute caption for picture, but to contextualise the picture, bring it under some provisional control.[31]

The issue of content being embedded formally in the work is also the central concern of Art & Language, David Batchelor, Dave Mabb and Sue Atkinson. In Art & Language's painting the question of political content is not separable from the general conditions under which art is able to find the resources to 'go on'. As they have argued in an interview:

> These days one can argue fairly succinctly that the characteristics of the culture which are most capable of being scrutinised, dislocated or displaced by something like art, are not the manifest, concrete political inequities, but, rather, its more insidious barbarities This culture has been refined (or has degenerated) into a theatre of coercion. And to have any critical aim (or claim), one has got to have that culture very much in focus.[32]

This is not a recipe for opaque self-reflexiveness, or for that matter a rejection of manifest political content as such, but a recognition of *limits*, of what is possible and what is not possible in order to continue to practice with a degree of critical autonomy under class society. Hence we should not mistake Art & Language's continued quotation of their own past works in their painting for inwardness. On the contrary, the self-presentation of their own intellectual history and interests functions as the very material out of which they make their

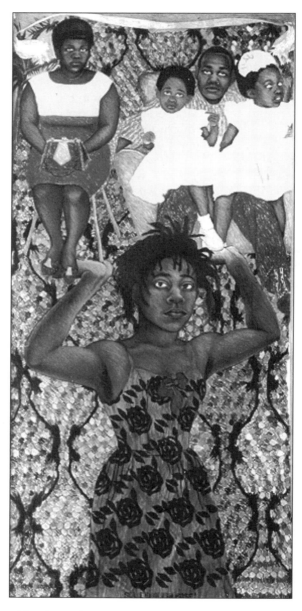

18. Sonia Boyce, *She Ain't Holding Them Up, She's Holding On (Some English Rose)*, 1986.

critique of the misrepresentations of our culture. They use themselves to expose what is done to art and its meanings as the basis for working on the institutions (recently the modern museum)[33] and artistic categories of modern capitalist culture.

This self-conscious monitoring of the historical possibilities and limits of art's social role, as a means of generating some critical autonomy, is also characteristic of the paintings of David Batchelor, Dave Mabb and Sue Atkinson. All are concerned with extracting meaning for painting after the debris of late modernism (theories of self-expression; defences of originality) and conventional realism. Which introduces us to another area of symbolic manipulation central to the show: parody. Parody in many ways works close in hand with indexicality in a number of the paintings in the exhibition. Thus Terry Atkinson's use of the conventions of modernist abstraction as an index of ruling class 'blindness' is also a parody of the would-be expressive 'freedoms' of modern culture. Likewise Araeen's use of images of bloody ritual as an index of so-called Islamic barbarity, is also a parody of one of the symbols of such 'freedoms': Abstract Expressionism.

Batchelor, Mabb and Sue Atkinson use parody in a similar fashion to establish a set of ideological contrasts or inversions. Batchelor parodies Minimalism and expressionism as a means of exposing the false opposition between 'individual' expression and abstract system at the base of the modernist / realist split; Mabb parodies Robert Delaunay and Tatlin's designs for his Third International monument as a means of opening up a 'lost' revolutionary past to the present; and Sue Atkinson parodies, in the form of a section of Greenham Common topography embedded with 'unfeminine' materials and manipulated in 'unfeminine' ways, the stereotypically feminine sewing-sampler, as the basis for upending a certain kind of complacent radical feminist female-centred politics and aesthetics. As with Terry Atkinson, Araeen and Art & Language, the use of parody in these artists' work is a further means of asserting the priority of reading out realist content from the formal manipulations of the work itself.

Finally, Sonia Boyce in many ways bridges this kind of self-consciousness with the more traditional concerns of realism: the recording of events and experiences that have been suppressed and marginalised within dominant pictorial experience, in this instance black female experience. However, this is not to say that this process of 'putting into view' does not play a part in the work of the other

artists (Terry Atkinson's work on Ireland and Araeen's on Islam are obvious examples), but that the need for historical self-representation here carries a very different political emphasis and notion of realism given the recent history of black people in Britain. Moreover, Boyce's use of painterly mark, xerox, drawing and collage, perhaps represents the most extreme version of one of the key notes of the show: that painting's continued intellectual mobility is dependent upon its aesthetic mobility *across* media.

Approaches to Realism does not attempt to unite all these artists in one jolly family of realists. There are clear differences or orientations that need to be recognised as responses to different conceptual and aesthetic questions – questions that are the product of different intellectual histories and subjectivities. Nevertheless, what does unite the work is a singular commitment to the view that art's critical recovery of the external world needs to be linked to an understanding of that world as both structured and differentiated and characterised by emergence and change. The issue of the painting in this show formally embedding its critique of the social world therefore, is no more or less a recognition that art's capacity to understand the world is also a continual act of self-definition and self-criticism. There can be no realism in art without recognising that realist claims will of necessity be subject to change in the face of social transformation. Thus if the work in the exhibition seems strangely 'unrealistic' this is a contingent consequence of these demands. Or, as Paul Wood has succinctly put it, 'it may well be that one paradoxical condition of the adequacy of a contemporary realism is that it be unrecognisable as such to its forbears'.[34]

Notes

1. Roy Bhaskar *Reclaiming Reality: A Critical Introduction to Contemporary Philosphy* (Verso) p 3
2. T Adorno *Aesthetic Theory* (RKP 1984) p 58
3. See in particular 'The Forgotten Fifties' Graves Gallery Sheffield 1984 and 'Critical Realism' Castle Museum Nottingham 1987
4. Organised by the Bluecoat Gallery, Liverpool, April–May 1990. Travelled to Oldham Art Gallery June–August; Darlington Arts Centre November–December and Goldsmiths' Gallery London January–February 1991
5. Georg Lukács 'Preface' (1948) in *Studies in European Realism* (Merlin Press 1972) p 5

6. G Lukács 'Critical Realism and Socialist Realism' in *The Meaning of Contemporary Realism* (Merlin Press 1963) p 99
7. Terry Eagleton *Criticism and Ideology* (Verso 1976) p 161
8. Lukács 'Critical Realism' p 119
9. Ibid p 96
10. Walter Benjamin 'The Author as Producer' in Victor Burgin ed. *Thinking Photography* (MacMillan 1982)
11. Quoted in John E. Bowlt *Russian Art of the Avant-garde: Theory and Criticism 1902–1934* (Thames & Hudson 1990)
12. See Paul Wood 'Realisms and Realities' in *Modern Art Practice and Debates* (Yale University Press 1992) for an excellent overview of these debates.
13. Louis Aragon *Pour un Réalisme Socialiste* (Paris: Denöel et Steele 1935)
14. Louis Aragon 'John Heartfield et la beauté Révolutionnaire', first published in *Commune* no. 21 (May 1935). Published in English as 'John Heartfield and Revolutionary Beauty' in *Praxis* 4 (1978)
15. David Evans *John Heartfield Photomontages 1930–1938* (Kent Fine Art 1992)
16. Aragon *Pour un Réalisme Socialiste* p 76
17. Aragon 'John Heartfield and Revolutionary Beauty' p 4
18. Ibid p 7
19. Ibid p 7
20. Lukács 'Critical Realism' p 97
21. See Flint Schier *Deeper into Pictures: An Essay on Pictorial Representation* (Cambridge 1988)
22. Adorno *Aesthetic Theory* p 8
23. Ibid p 327
24. Ibid p 17
25. Walter Benjamin 'The Work of Art in the Age of Mechanical Reproduction' in *Illuminations* (Fontana 1973)
26. First published 1924, in English in 1925.
27. L Trotsky 'Class and Art' collected in Paul N Siegel ed. *Leon Trotsky on Literature and Art* (Pathfinder Press 1970)
28. André Breton and L Trotsky 'Manifesto for an Independent Revolutionary Art', collected in Franklin Rosemount ed. *What is Surrealism? Selected writings of André Breton* (Pluto 1974) p 185
29. Ibid p 183
30. See Bhaskar *Reclaiming Reality* and Imre Lakatos 'The methodology of scientific research programmes' in John Worrall and Gregory Currie eds *Philosophical Papers Volume 1* (Cambridge 1978) for a discussion of scientific method from this perspective.
31. See my *Postmodernism, Politics and Art* (Manchester University Press 1990) for a full discussion of these artists' work.

32. David Batchelor 'Interview with Art & Language' *Journal of Contemporary Art* vol. 2 no. 1 (Spring 1989). Quotation taken from manuscript.
33. For a discussion of their museum series see 'Realism, Painting, Dialectics: Art & Language's museum series' in my *Postmodernism*
34. Paul Wood 'Realism Contested' in the proceedings of the 28th Congresse Internationale de l'Histoire de l'Art (Strasbourg 1990)

18

REALISM AND PICTORIAL
COMPETENCE: NELSON GOODMAN
AND FLINT SCHIER

We can identify three principal kinds of referential relationship or forms of of-ness: one, representational of-ness (a picture can be a picture of someone or something without it being a picture *of* that person or thing); two, pictorial of-ness (iconicity or literal resemblance); and three, denotational of-ness (non-iconic representation, flag poles for example denoting different post-war American artists). Debates within the philosophy of representation have tended to use points one, and three, to infer that the business of looking at pictures is wholly conventionalised. In so far as looking is to a large extent knowledge-determined this claim would appear to be uncontentious. What the above clarifies is the need to discriminate between pictures *of* things and thing-pictures or person-pictures. However, despite the importance of 'seeing-as' for any adequate theory of pictorial competence, the tendency inherent in conventionalism is to assume that *all* acts of spectatorship are interpretive. Interpretation, it is argued, always precedes our recognitional abilities. The result of this is not only to weaken the distinctions between iconic and non-iconic forms of representation, but to construct a wholly idealist view of human beings' capacity to understand the world they move about in. If all pictures were determined by convention, we would need to learn which pictorial marks were being used to stand in for various features of the world before we could begin to interpret them. This is plainly not the case for a large number of representations we experience on a daily basis.

The respective claims of 'seeing-as' and 'no-decoding' furnish a number of key issues for the realist debate then. Below, I want to look at the work of Nelson Goodman and Flint Schier, who have been at the centre of this debate, Schier's premature death robbing us of an extraordinarily perceptive critic of conventionalism. Before I embark

on this though, we need to have a clearer picture of the kind of images that fall into the above categories.

REPRESENTATIONAL OF-NESS

19. Veronese *The Resurrection of Christ*
 (circa late 1560s/early 1570s)

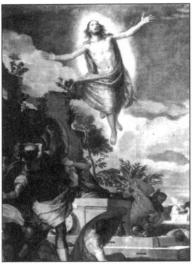

This is a Christ-picture and not a picture *of* Christ. Accepting the historical reality of Christ, there are no verifiable, extant portraits of him.

20. A picture of a unicorn
 (derivation unknown)

This fictional picture represents a unicorn but it is not *of* a unicorn. Unicorns do not exist and therefore images of unicorns have null-denotation.

21. Art & Language *Portrait of V I Lenin in 1917
Disguised by a wig and working man's clothes
in the Style of Jackson Pollock* 1980

From our pictorial experience of Lenin as non-Lenin specialists this is not recognisably a picture of Lenin. Yet it is a picture *of* Lenin, just as photographs taken by a British secret service agent of Lenin and Trotsky seated on the top deck of a London omnibus surrounded by fog in 1903 are *of* Lenin and Trotsky.

22. Robert Wilson *I was sitting on my patio ...*
Royal Court 1978

We clearly cannot recognise Wilson here, but nevertheless it remains a picture *of* him. As with the above examples this picture does not iconify the person it depicts in any basic fashion.

PICTORIAL OF-NESS

23. A portrait of Karl Marx
(derivation unknown)

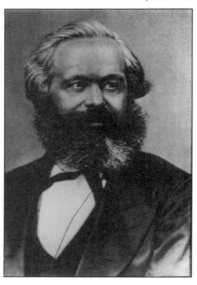

This is a picture *of* Karl Marx.

24. A portrait of Elisée Reclus
(from the *Geographical Journal*, 26, 1905)

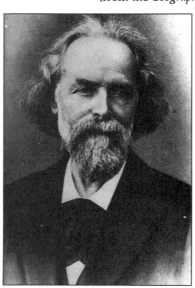

This is a picture *of* Elisée Reclus. Both portraits iconify the people they depict in a basic fashion.

25. Martin Johnson Heade *Magnolia Flower* circa 1885–95

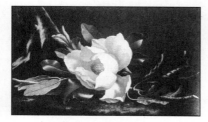

This is a picture *of* a magnolia. The picture iconifies the flower it depicts in a basic fashion.

DENOTATIONAL OF-NESS

26. Palm trees – *Homage to the ANC* 1989

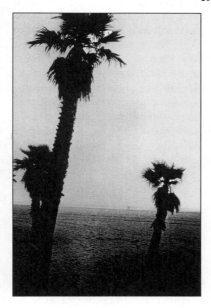

This is a piece from my recent imaginary series of photo-text works at the Golden Eye Gallery in Los Angeles, a gallery devoted to the furtherance of 'semiotic art'. I have 'purloined' a number of images of trees from Sunday supplement magazines to stand in for leading ANC members; this *denotes* Winnie Mandela without iconifying her.

27. Mark Wallinger *Lost Horizon* 1986

Here, likewise, Wallinger is using one icon (or set of icons in this instance) to stand in for another. The lesson is that almost anything may stand for anything else, depending upon the conceptual heading under which it is displayed. The point is that conceptualising X as Y does not involve us in believing X *is* Y.

28. Susan Hiller *Self-Portrait* 1983

The absence of iconic content in this self-portrait involves us in a similar process. The use of automatic marks *denotes* a gendered subjectivity, in as much as it functions as an index – an indicator – of the status of women from a feminist perspective. Automatic writing's conventional identity as 'incoherent' expression is used to signify both the subordination of women's voices and the fact that women are in a process of shaping their identity free of previous representations. This is not a portrait *of* Susan Hiller.

In discriminating between pictures *of* people and things and thing-pictures or person-pictures we are forced to clarify the complex relationship between seeing and knowing. To what extent are our recognitional abilities bound up with our interpretive skills? How are we to characterise these skills and on what grounds might there be a case for arguing that interpretation in some instances might be secondary to our recognitional abilities?

For writers such as Nelson Goodman and Ernst Gombrich we *acquire* the ability to read pictures, even pictorial icons like the one

of Marx above.[1] Thus Goodman argues that denotation is at the heart of representation. As he says in *The Languages of Art*, 'reception and interpretation are not separable operations; they are thoroughly interdependent.'[2] Goodman's law states: a picture must denote a person to represent him or her, but need not denote anything to be a person-picture. The history of art includes innumerable representations of non-existent persons. What Goodman is rightly attacking here is the careless conflation, so deeply ingrained in conventional descriptive accounts of realism, between representation and *resemblance*. Thus looking at pictures always involves two kinds of questions: what does it represent and what *sort* of representation is it? Consequently we need to pick out what class of objects the picture represents and what class of *picture* such a picture belongs to. The above examples to a large extent sort out these distinctions. The problem though with Goodman is that he advances the latter over the former to the point where he argues that we can only understand a picture by knowing what kinds of pictorial system or conventions are being used. Moving from the convincing argument that resemblance is not *sufficient* for representation, he argues that resemblance has no determining place at all in representation. For Goodman the shared properties between a symbol and a referent are always disguised forms of denotation. A picture may resemble an object or person but this always stands in asymmetrical relation to its status as a representation of that object or person. The referential relationship then is determined solely by the picture's participation in a given symbol system. Thus he argues: 'A Constable painting of Marlborough Castle is more like any other picture than it is like the Castle.'[3] However, as one of his critics Douglas Arrell says, this surely depends 'on the context whether we notice the properties of the painting which make it similar to the Castle or similar to another picture.'[4] The fact that the Constable painting may reference other paintings does not alter our noticing a number of shared properties between symbol and referent. Hence it is on the basis of *certain* shared properties that we say the painting resembles what it represents.

What Goodman doesn't acknowledge therefore, and what is implicit in our recognition of pictorial icons, is the question of how it is we know how to recognise objects and people on a *consistent* basis without recourse to learning a given symbol system, or decoding a depiction as an image. This is a question that Flint Schier takes up

extensively in *Deeper into Pictures*. Concentrating on the category of pictorial of-ness he sets out to clarify some of the confusions around the question of the relationship between recognition and interpretation.

Schier disagrees with the Goodmanesque view that in looking at iconic pictures we have to put in place a knowledge of conventions. 'It does not seem right to suggest that we generate pictorial interpretations ... by our first imbibing (or coining) make-believe satisfaction conditions for "peach", "round" and so on and then cranking out such make-believe statements as "This is a round peach".'[5] He also disagrees with the related phenomenological argument that in looking at iconic picture we have a double experience, that is we experience the object as a picture and as an object itself. For example we experience both the painting of the magnolia – the distribution of marks – and the image of the magnolia in a kind of push and pull fashion. As Richard Wollheim puts it: in 'seeing a picture of a peach I have an experience as of a peach which blends with my experience of the picture so that one and the same experience is both an experience as of a peach and an experience as of the picture'.[6] Advocates of these two positions, Schier argues, '[miss] out the heart of pictorial experience'.[7] For Schier the point about iconic pictures is that they can be understood without stipulations of any kind. An icon 'naturally' elicits its interpretation from the viewer. 'An icon is something which it is possible for someone to understand without calling upon information garnered from past episodes of iconic interpretation.'[8] Schier calls this process provocatively 'natural generativity'.

Is Schier arguing therefore that we don't need to decode icons in order to understand them? No. Rather he is stressing the need for a clearer understanding of the limits of the role of convention in pictorial experience. Central to this is his argument that once the observer has been schooled in pictorial interpretation he or she will be able to recognise an infinite number of novel icons without recourse to remembering or putting in place any received model of *how* one should read such icons. Let us go back to the Marx / Reclus icons. Now that you have learnt to recognised Reclus, that is, those of you who did not know what Elisée Reclus looked like beforehand, memory withstanding, you will be able to recognise an infinite number of pictures of Reclus. We are involved in this kind of process all the time. But how can we defend this in a non-circular way? How can we avoid the complaint that 'natural generativity' is only

a fancy way of saying that recognition is knowing what you see? Isn't this simply trivially true?

For Schier pictorial interpretation is not anterior to recognitional ability, but is caused by, or brought about by, recognitional ability. Recognitional abilities are certainly learnt – we learn to recognise Reclus – but they are not put in place as a system from one picture to another. Our understanding therefore is engaged *through* our recognitional abilities and not the other way around. We do not understand a picture in order to put in *place* our recognitional abilities. Goodman, however, argues that this in fact is what we do. Consequently he fails to answer how it is we can understand a novel icon without ever having encountered it before. As Schier says, 'Once you have succeeded in an initial pictorial interpretation, perchance as the result of some tuition, you should then be able to interpret novel icons without being privy to additional stipulations given only that you can recognise the object or state of affairs depicted.'[9]

Schier's natural generativity thesis is based on the argument that our capacity for interpretation is a natural non-context-determined ability. Recognitional capacity leads 'spontaneously to an ability to ascribe content correctly to a picture.'[10] This turns centrally on a rejection of the conventionalist notion that we acquire an iconic vocabulary in the way we learn a language or a specialist discourse. In order to understand pictures we do not first have to collect images of things as a lexical resource that we employ from one situation to another. 'Interpretative competence in natural languages is acquired piecemeal (as stressed by Davidson 1968 – 9) but interpretative competence in pictorial systems is acquired in one go.'[11] Which is not to say that the recognitional competences which underlie pictorial competence are not themselves required piecemeal, but that our ability to put those capacities into interpretive operation is generated naturally. Linguistic communication involves a common knowledge of vocabulary; pictorial communication, on the other hand, is characterised by an absence of any common knowledge of artistic technique. The producer's stock of techniques then does not amount to a vocabulary. In linguistic communication:

> there is a prearranged significance for the whole which both speaker and hearer know. They know that each other knows it and so on. In the case of an icon, however, what co-ordinates maker and beholder as far as the specific content of S is concerned is not a convention at all. It is the fact that they both naturally generate

a certain interpretation *p* and they believe that they both naturally generate a certain interpretation *p* and they believe that the other believes he will generate the *p*-interpretation and so on.[12]

Thus by saying that pictorial competence does not involve the generation and application of a lexical resource, Schier is not arguing that artistic techniques are irrelevant to the retrieval of meaning from pictures, but that the understanding of the iconic content of such pictures does not *presuppose* them. Because pictorial representation does not possess a grammar 'specifying how to generate novel statements by certain combinations of symbolic elements',[13] there can be no question of pictorial interpretation being ultimately constrained by an understanding of those techniques. So, our recognitional abilities may be learnt in a fragmentary fashion, but our natural competence to interpret what we recognise remains the basis for understanding. 'It is a matter of convention whether a symbol is an icon at all. But given that it is, the specific interpretation is natural and not conventional.'[14]

The place of understanding the intentions of producers in the retrieval of meaning of pictures is subject therefore to a very different account from that in conventionalism. For conventionalism we need to know the intentions of producers *before* we can interpret pictures. For Schier, however, causal analysis is a consequence of our recognitional abilities. If this is not so we will not be able to grasp why it is that the producer's intentions and the interpreter's understanding can coincide without the interpreter being aware of the producer's intention at all.

> In general, knowing that an interpretation which I generate is the correct one may require me to know something about the causal origin of S. But I would claim that this knowledge can be a consequence of my interpretation rather than a cause of it. It may be *because* I naturally generate the interpretation that S depicts O that I surmise that S was produced or used with the intention of representing O. The interpretation comes first. Then, on the basis of a naturally generated interpretation, I explain the interpretation in terms of a plausible hypothesis: I naturally generate the interpretation that S is of O *because* someone intended that I should generate this interpretation.[15]

For Schier then the fact that our ability to recognise a depicted object explains our ability to interpret it and not the other way round, requires pictorial competence to be grounded in a process that acknowledges some shared experience between producer and spectator. To reiterate it is the fact that both producer and spectator 'both naturally generate a certain interpretation p and they believe that they both naturally generate a certain interpretation p and they believe that the other believes he will generate the p-interpretation and so on',[16] that is at the heart of pictorial interpretation. The fixing of iconic meaning then follows Convention C: 'given that S is of O, the artist intends that those able to recognise O should be able to interpret S as being of O.'[17] It is because the producer can naturally generate the interpretation of S that he or she expects other spectators to do so.

Thus in interpreting icons or iconic parts of pictures, no convention is needed to be learnt in order to *start* the process of interpretation and causal analysis. That is all in a sense Schier is saying; not that we can interpret icons automatically without any recognitional abilities. As such Schier's argument does not occlude that our recognitional abilities are socially constrained and limited by class, race, gender, but that when interpretation of iconic material does take place it is not prompted by the learning of convention. I do not have to learn the intricacies of medieval theology and lore, before I can *begin* to interpret the moral point Bosch is making in *Ship of Fools*. All I need to know is that a drifting boat full of strange figures, is replete with significance about 'lost souls'. We have a natural propensity therefore for interpretation on the basis that both producer and interpreter share the same powers of recognitional ability (*pace* the dictates of Convention C). And these competences can, and do cross other cultures and historical epochs.

Let us return to the question of realism and resemblance. The upshot of Schier's argument is that we need to make a firm distinction between iconic and non-iconic (denotative) symbols, for otherwise we are led to improbable accounts of resemblance playing *no* part in representation. It is not Schier's intention then to defend a theory of resemblance at the cost of denotation. There is no value judgement attached to his defence of resemblance theory, as if he were advocating some return to conventional realism for painting. 'The question of what value if any should attach to realistic depiction should be kept quite distinct from the question of whether it is possible meaningfully to assert that one mode of depiction is more realistic than another.'[18]

Rather the issue is: without a theory of resemblance our retrieval of iconic content in art is rendered opaque to our natural capacities as viewers. Without a theory of resemblance for iconic content we would need to know the different sign systems of pictures employing iconic parts before we could enter into their meaning. As has been explained this is plainly absurd. However, if resemblances require a theory of correspondence to make them resemblances, Schier's defence of resemblance is not based on any crude assertion that the recognition of shared properties between depiction and object is *only* operable when depiction and object match each other 'exactly'. In Schier's theory it is not required that a picture should look like its depictum in any phenomenologically similar fashion for the recognition of resemblance to be true. Rather 'S and its depictum O are alike to the extent that they trigger or bring into play some of the same recognitional capacities.'[19] Thus Goodman is right to argue that resemblance is not sufficient for representation, but wrong to suggest that in *no* sense do certain pictures resemble their depicta.

What are the implications for contemporary practice from this? I think they are twofold and relate to the attack on realism (in all its forms) within the recent orbit of cultural studies. On the one hand, a defence of natural generativity as an attack on conventionalism weakens the claims of specialist and professional discourses to speak *for* people (even if people on the whole are not listening), and on the other, by defending iconic pictures as the product of a common knowledge between producer and spectator, the tradition of documentation can be saved from its recent ignominious dismissal. Post-structuralist and conventionalist attacks on documentary photography have monologised iconic content. Schier's defence of the link between iconic pictures and an *external* world opens it out, dialogises it again. Now this is not to prioritise such functions, or to talk about iconic content letting art speak for itself, but a recognition that iconic images of everyday working-class life for example are subject to a two-way process of interpretation. Such images may, in the parlance of post-structuralism, objectify people as 'other', but they also operate as 'reported speech'. The 'look of things' becomes a source of empirical knowledge. As Steve Edwards has said such knowledge is 'the answering word of those who are imaged.'[20]

Schier's book may be concerned to make no value judgements about art, but clearly it cannot avoid it. By providing a much-needed account of the distinction between iconic and non-iconic symbols he

opens up contemporary realist practice to the *full* diversity of representational resources.

Notes

1. Gombrich, however, diverges from the strict conventionalism of *Art and Illusion* (Phaidon 1956) in his later writing. See in particular 'Image and Code: Scope and Limits of Conventionalism in Pictorial Representation', in *Image and Code*, ed. Wendy Steiner (Ann Arbor: University of Michigan 1981)

2. Nelson Goodman *The Languages of Art* (Oxford University Press 1968) p 8

3. Ibid p 5

4. Douglas Arrell 'What Goodman Should Have Said About Representation' *The Journal of Aesthetics and Art Criticism* (1987) p 43. For a defence of Goodman see WJT Mitchell, *Iconology: Image, Text, Ideology* (University of Chicago 1986)

5. Schier *Deeper Into Pictures: An Essay on Pictorial Representation* (Cambridge University Press 1988) p 23

6. Quoted in Schier *Deeper into Pictures* p 24

7. Ibid p 25

8. Ibid p 53

9. Ibid p 43. Schier's defence of 'natural generativity' is largely indebted to Wittgenstein's notion of understanding signs as an habitual intellectual process, and not one in which meaning is the result of abstract application. For Wittgenstein understanding is not akin to translating 'raw data', but coterminous with the act of interpretation, *with* seeing-as. Recognition is the result of knowledge and this over time is unreflective and automatic. Understanding then is closer to rule-following than any individualistic 'mental' apprehension of the world. (*Philosophical Investigations*, Blackwell 1974). As Colin McGinn says 'One accordingly does not *choose* to understand a sign in a certain way, as one does not choose to see something as such-and-such. Use of the notion of interpretation imparts an overly "intellectualist" conception of the phenomena of seeing and understanding' (*Wittgenstein on Meaning*, Blackwell 1984) p 16

10. *Deeper Into Pictures* p 61

11. Ibid p 84

12. Ibid p 138

13. Ibid p 159

14. Ibid p 156

15. Ibid p 97

16. Ibid p 138

17. Ibid p 137

18. Ibid p 143
19. Ibid p 189
20. Steve Edwards 'The Machine's Dialogue' *Oxford Art Journal* vol. 13 1
 (1990) p 74

19

ZONES OF EXCLUSION:
LEON GOLUB'S 'OTHER AMERICA'

Leon Golub was in his late fifties before he began producing his most widely known work. It was therefore at a point when most artists have given up on the possibility of pushing through to something new in their art, or have fallen into the routines of market success, that Golub began to produce the large-scale history paintings that his reputation now rests on. That is a long 'apprenticeship'; thirty years in fact. Moreover, just after he painted the *Assassin* series, which prefigured the *Mercenaries*, he even considered giving up painting altogether. Times were bad.

I mention all this not in order to romanticise the vicissitudes of artistic production, but on the contrary to make a general historical point: there is no predetermining the place from which artistic success and value might emerge. Who would have thought that the artist who produced the *Gigantomachies* of the early 1970s would have produced the *Mercenaries* and *Interrogations* of the late 1970s and early 1980s? Golub's development from a generalised, humanistic figuration to the iconographic complexities of the new paintings, is one of the most impressive achievements of post-war American painting. This is not idle eulogy or to deny that Golub's development in part rests on the recent high visibility given to painting within the market, but rather a recognition of what successful paintings today might be made *of*. For the value of Golub's work lies not in any commitment to painting *figures* or a 'return to content' as if references alone can secure interest or worth, but in the process by which the resources available to him as a painter have been decisively transformed into a politicised practice. And this is what I mean by the historical accidents of value. For the gigantism of his Roman wall painting-inspired early figures paradoxically provided the necessary expressive resources upon which to build a painting that could deal with the historical image without falling into an academic descriptive

realism. Golub's introduction of photographic source material into a modernist / Romanised space produced a fusion of resources that 'broke open' the closures of both late Modernism and descriptive realism.[1] Clearly for Golub this wasn't a 'blind' process. As Trotsky once said, intuitions are *made*. Golub saw as he introduced a greater variety of historical detail into his flat Romanised space, that he was producing the basis for a contemporary history painting that met the cognitive demands of our distorted and distorting culture. The meeting between a realist specificity of detail and an adulterated, modernist surface and space is thus the key to Golub's narrative dramas. For what these scraped canvases with their awkward, clumsy figures do, is *embody* the injuries and dislocations of modernity.

Golub paints 'class positions' in all their contradictoriness. This is a big claim and a profoundly unusual one for an artist living in the USA, let alone a painter.[2] What does it mean though to say he paints class? On what grounds and with what cognitive materials and with what end in view? Since the late 1970s Golub has been producing a large-scale history painting which addresses, or rather dramatises, the agencies and agents of the late imperialist USA.[3] The words 'agencies' and 'agents' are important here, because in a key sense Golub's paintings of mercenaries, contras, 'professional' torturers, working-class black men and women, invoke, or place in view, a world of structures, of ideological apparatuses and economic structures, that determine the modern capitalist state. In effect by dramatising the actions of these individuals and groups he clearly makes capitalism visible as a contradictory formation, a formation determined by fundamental asymmetries and exclusions in power and resources. This would seem conventionally to make Golub some kind of social realist. Drawing into view the dispossessed and those who do the dirty work of capital, he 'shows things as they really are'. In a trivial sense this is true, but in another deeper, more methodological sense, Golub's principal interest is demonstrating the *how* rather than just the *what* of social relations. He is not concerned simply with *protesting* the pathologies of modernity, but with *locating* the place of the agents he depicts within an intelligible set of social relations, with establishing, in the words of T J Clark from another context, the body as a 'determinate [fact within] a particular class formation.'[4] This implies a very different critical base to his practice than that normally associated with the social realist tradition. What is this base? To answer this it is necessary to analyse what we might

mean by the social realist tradition and whether it continues to have any validity today.

Broadly speaking social realism refers to those forms of pre-modernist painting that are based on a descriptive narrative aesthetic. Figures are rendered with a high degree of verisimilitude in convincing, naturalistic settings. The politicisation of this form this century – 1930s Popular Front realism and the work done around John Berger in Britain in the 1950s – sought to extend this verisimilitude and plausibility of action and situation to the depiction of political protest and the occupations and pleasures of the working class and the petty bourgeoisie. Following Courbet of the 1850s (the Courbet of the *Burial at Ornans*) this type of work extended painting's franchise outside the meanings of the dominant classes. Moreover some of the work extended this franchise to the languages of propaganda itself. The debate between social and socialist realism was as much a feature of the cultural life of art as it was in literary circles in the 1950s. Under the influence of Lukács a concern for *typification* of action and situation became the means of distinguishing particular socialist educative concerns from simply socially anecdotal ones. The problems of typification in painting need not detain us here, nonetheless we might say that such a position, predicated as it was upon conven-tionalised types that would provide conditions of easy recognition and identification, degenerated into the repetitive manipulation of stereotypes. Furthermore in the interests of securing the 'right political effect' the rhetorical power of the stereotype was inflated to heroic heights. Largely, this tradition in its assumption that the right epis-temology could secure aesthetic and cognitive value, valorised the abstractions of commitment before *learning* in the face of the real. In this sense this partisan type of work failed to take on the historical lesson *of* the Courbet of the 1850s: that if art was not to convention-alise its critique of ideology then its resources had to be aesthetically and cognitively mobile. Its aesthetic predicates had to be ones of anomaly, discrepancy and displacement. It is no surprise therefore that in the 1960s there was a massive shift away within 'political practice' from conventional descriptive and narrative painting to the 'new media'. The social realist tradition was seen to have decayed, to have become aesthetically and cognitively *immobile*.

The part American-type Modernism played in securing this shift is of course central. For what American abstraction showed, to the first power in an artist like Pollock, was what Courbet had uncon-sciously adumbrated: that there was no *necessary* relationship between

critical content, aesthetic value and the world of appearances; critical value was not to be secured simply *in* references but in the means employed (in the vividness of those tropes, displacements and inversions that secure the fictiveness of painting).[5] However, if for Courbet this was a dialectical process – in so far as the fictiveness of painting was secured *through* the world of appearances – for American abstraction the retreat from representation became a critical *fait accompli*. It was American Modernism's final dissociation of means from ends that eventually secured the exhaustion of its resources.

It is in the late sixties and early seventies though that the lesson of modernism – that meaning in art can only be won and generated in transformational *practice* – was brought into clear political view. The key intellectual figure in this of course was Brecht whose critical reclamation in tandem with the work of Walter Benjamin by a generation of 'structuralist' photographers promised a politicised practice that linked the means of representation to an ideological intervention *into* the real. Knowledge in art had to foreground the contradictions and asymmetries of bourgeois conceptions of reality, those undisclosed relations and interests that determined the way things looked the way they did. However, it was Louis Althusser, whose 'Letter on Art'[6] formalised Brecht's 'dialectical practice', that did much to lay out the terms of this type of modernism in the 1970s, much as Clement Greenberg's 'Avant-garde and Kitsch' had done for a nascent American-type modernism in the 1930s. For it was Althusser's defence of Brecht's aesthetic of absence, discontinuity and montage that powerfully discredited – as part of a general critique by his followers of the 'auratic' object – the sentimental and propagandist closures of the social realist tradition. The social realist tradition, with its 'humanism of the face' and stereotypical virtues and miseries, may have offered us recognition of our unfreedom but not the *knowledge* of its laws. The troublesome fictiveness of painting had a hard time picturing those 'complex relations' which lie beyond appearances. The unities of time, action and place in the conventional social realist tradition were thus pursued relentlessly (in Britain in the 1970s principally through *Screen* journal)[7] for their inability to generate visual information at the level of structural contradiction, that is, in particular, the unproblematic insertion of the male into social realism's world of social and political action as the 'universal signifier'. Women, when they actually made it on to the political representational agenda, were either presented as domestic drudges or victims of damaged femininity, or as allegorical socialist cyphers. In most

respects these criticisms have been borne out to be true: post-war representational painting has looked unable to handle the complex demands of the representation of knowledge across the questions of class, gender and race. (It is no wonder then that in the wake of the 'new media' and its theoretical revolution that the social realist tradition should attract so few women artists.) Yet, were these closures the fault of painting *tout court* (as the post-Althusserian theorists of the post-auratic on a journal such as *October* would say) or the fact that painting, as a medium still deeply institutionalised within the Romanticist / Expressionist aesthetic, has lagged behind theory? Looking at the achievements of Golub the 'post-painting' critiques of the technologist-inclined left look glib and premature. For what Golub has done, based as his painting is on the specificities of the photographic message (which I will elaborate on later), is position the 'photographic–modernist–structuralist' critique of the unities of conventional descriptive painting *within* the narrative spaces of the social realist tradition, creating a new and richly particularised juncture for the political in contemporary painting. Thus we might say that Golub's paintings combine a 'modernist–structuralist' understanding of the image as a source of knowledge marked by a passage from presence to absence (by the play of difference) and an almost Lukácsian respect for the verities of narrative, in so far as it is through the social interaction of human beings that the social world is made manifest. As Golub has said himself: 'There is a necessary ambiguity in my work between direct intention (to make domination explicit) and the complexity of events and "modernist" knowledge which blocks straightforward one-to-one explanation.'[8] However, this is not to say that Golub's paintings are made out *of* Althusser's formalisation of Brecht and the verities of narrative art, as if in an act of theoretical union he had sired them together, but the sentimentalised–humanist crisis of social realism which Brecht foregrounded, and that a generation of artist-theorists in the seventies elaborated, provided the critical and aesthetic space for Golub to make his move between photography and painting.

But doesn't such a move, the anti-painting argument goes, simply re-animate the culture of the dominant classes? Isn't Golub just keeping alive an old culture: the public history painting? Journals such as *October* would concur, and in fact have said as much. However, the problem with all anti-painting arguments (irrespective of their economism – the holding of artworks accountable to capitalist relations) is that painting is seen to be reducible to its inherited

contents; that the failings of painting are secured by the constant (market) repetition of its binary-opposed myths: expressionism and reflectionism. Clearly what marks out Golub's painting is a vivid theoretical rejection of this, in so far as his emphasis upon the particularities of gesture and action across the questions of class, gender and race *thinks* signification as a socially inscribed process. This places on the agenda a view of cultural tradition and 'going on' in art that is very different to the ruptural logics of both American modernist theory and recent technologist accounts of postmodernism.[9] Painting becomes not so much a *tabula rasa* for the 'fall out' from the meeting between 'self-expression' and 'subject matter', but the practised, critical and self-reflexive reworking of extant and shared aesthetic and cognitive materials (signs, symbols, etc). This of course is to say something very familiar: that art is made out of bits of other art and bits of the world. In another sense though it is to say something unfamiliar or half-forgotten, that painting – successful, aesthetically vivid, ideologically 'responsive' painting – *is* the product of a continual turning or troping of aesthetic and cognitive materials at work in the culture. T J Clark put this very well in his book on Courbet. Describing Courbet's use of nineteenth-century French popular culture's amalgam of iconographic material from different ages and ideologies as disjunctive, he talks about Courbet animating and reorganising the repetitive forms of popular art. Popular culture imagery was put to new disruptive, textual uses. Here he is describing Courbet's 'The Meeting' (1854):

> by the middle of the nineteenth century, popular art was a strange amalgam of different ages and ideologies. Napoleon rubbed shoulders with St James; a Book of Dreams with a tract about Cabet or Fourier; farming hints with Tom Jones. Strangest of all, popular art began to catch up with the imagery of bourgeois Paris. With lithography, mass production began in earnest; and the peasant of Ornans could see the latest Paris fashions or have crude drawings of the marvels in the Exposition Universelle, the very same year they were worn or put on show. In 1854, a bourgeois popular art existed alongside one which still used the imagery of feudalism.
>
> It was this disjunction that Courbet exploited in his usual instinctive fashion. Popular imagery had always developed – in other words, carried new information – by a series of transformations, reversals of terms, exaggeration and distortion of detail

... He tried to use this system of changes and inversions, and stay within the understanding of a mass audience – to forge images with a dual public, and a double meaning. In *The Meeting* he took a detail of legend (*The Wandering Jew*) and retained very faithfully the visual form of the original; he retained the bourgeois, but gave their presence a new significance; retained the landscape, outside town, outside time; transformed the outcast and his attitude towards the people he meets.[10]

Golub's transformation of the scale and flatness of Roman wall painting into a modernised 'no space',[11] as he calls it, and the building up of monumentalised figures from mass cultural photographic fragments, exhibits a comparable disjunctive 'intertextuality'. Disparate resources are yoked together and transformed in the process. Now, this is not to gloss over the cultural differences of Courbet's and Golub's respective 'system of changes and inversions', as if both artists' understanding of, and political response to, mass culture were similar; but nonetheless what Clark's exposition clearly points out is painting's primary modern, if marginalised, status as a critical parodic activity, that is an activity that is *simultaneously* a process of appropriation from shared cultural materials, and an individual act of supercession.[12] In these terms the use of a critical theory of parody to defend painting could be said to 'come into its own' as a specifically post-late-modernist concept. For by focusing on all art as divided and appropriative in relation to its resources and materials (art reclaims and conserves at the same time as it disrupts and transforms) the question of art's critical renewal is divested of the spectres of historicism and technological determinism. Essentially, as a theory of the decentred artistic subject, parody allows us to acknowledge the exhaustion of originality in painting (the radically novel image) without capitulating to the equally specious views that painting is dead, that it should return to a traditional naturalism, or that it should become ironic pastiche. As a theory of meaning in art grounded in the transformation, recasting and inversion of antecedent symbolic materials, parody offers a view of painting as formally determined and limited in its powers of signification, yet socially open to new content spaces. (Which of course is not to say that there are also structural limits on the critically feasible or adequate range of contents within a given social formation.)

Golub then is an artist whose reworking of a decayed social realism and a decayed late modernism has shifted the arguments for

painting not so much into a logically *higher* category than social realism and late modernism, but into a space where painting's 'traditional' and 'deep' resources can be refocused or most ably performed: the narrative representation of subjects as historical agents. Narrative for Golub then is less a set of stylistic attributes than the overarching framework that links the 'deep' conventions of painting (the illusionistic relationship between spectator and painting, the recasting of historical and cultural material, the theatrical scale) to the fictive requirements of our existence as political subjects. Human actions and speech acts testify to the fact that human behaviour (and hence politics) is unintelligible without some narrative understanding. To talk of human behaviour is immediately to presuppose the motility of beliefs, intentions and settings, just as human conversation itself is structured around beginnings, middles and ends. As Terry Eagleton has said: 'We cannot think, act or desire except in narratives, it is by narrative that the subject forges the "sutured" chain of signifiers that grants its real condition of division sufficient imaginary cohesion to act.'[13] To accept this of course is not to assume that *history* is a narrative with a beginning, middle and end, as is fashionable at the moment amongst those followers of Jean-François Lyotard, who in rushing to denounce Marx, would reduce historical materialism to historicism and the unilinear, but that narrative thinking is essential to the projection of subjects and structures through time. Thus narrativisation is not a mode of thinking which asks us to *predict* the future, rather it is that unfolding space into which politics projects itself.

It is in this larger 'neo-classical' concept of the political space of narrative that we should situate Leon Golub's work. For as an artist who narrativises fragments of social relations and conflicts in order to disclose the larger narrative of American interests (neo-colonialism), Golub's interest is in the discontinuous, fractured and violent nature of the historical process, and not in imbuing the historical image with any futurist resonance. What emerges from this is a 'doubling' of narrative exposition; on the one hand a narrativisation of the injuries of class, gender and race as moments within a larger oppressive totality (capital) and on the other a narrativisation of power-relations between individuals, groups and classes as ideologically motivated and intelligible acts. We are talking therefore about a very different sense of morality and utility than is commonly associated with the historical, painted image.

History painting as the premier genre was required in the seventeenth, eighteenth and nineteenth centuries to deal with heroic or religious themes; literary or historical events were treated in a dramatic and elevated manner. As with the work of Jacques-Louis David and Thomas Couture the past was recast in a more heroic mode in order to provide uplifting commentary on the present; to transform opinion or remind the spectator of his or her civic duties. David and Couture's work was patriotic in this sense; the events of the 1792 revolution were commemorated for the glory of the common good.[14] However, we see the contradictions of this 'Public State Art' breaking down by the late 1840s. Couture's celebration of the Second Republic in his *Enrolment of the Volunteers of 1792* (1847–51), an allegorical synthesis of all social classes led by the figure of Liberty, was dismissed by the incoming Minister of the Interior after Louis Napoleon's *coup d'Etat* in 1851, as being too subversive, a 'tableau des demagogues',[15] and was never shown. What Couture thought to be a carefully balanced representation of politics and cultural interests was, with a change of political administration, out in the cold. In effect Couture's attempt to save history painting as a form of heroic *grand peinture* collapsed under the weight of class contradictions. With the failure of the 1848 revolution and the ensuing Napoleonic reaction, the cross-class intimacies of a Couture became both an embarrassment to a victorious bourgeoisie, and an historical irrelevance to those fighting the bourgeoisie. History painting was never to be the same again (though in a comparable form of state patronage Soviet socialist realism came close) as the bathos and adventitiousness of synthesising opposed class and cultural interests under the celebration of *patrie* or fraternal ideals, became apparent. It was Courbet of course in the years that followed the *coup d'etat* that focused and foregrounded these contradictions. Courbet's move away from the literary and classicised to the synthesis of popular imagery and peasant experience, opened up history painting – albeit short lived – to a set of interests that were directly opposed to the historical self-understanding of the bourgeois state.

History therefore, as many commentators on Courbet have pointed out, is disclosed for the first time as a *problem*, as a space of conflicting class interests, and not as a sealed and eternally recurring diorama of Great Events. Golub's modernity lies in continuing to secure this space of conflicting interests for painting. But as an American artist working in New York in the latter part of the twentieth century there is of course a fundamental difference between his exposure of

class and that of a rural-based Courbet. Golub has no organic link to his material as Courbet had (in so far as Courbet's peasantry were his peasantry); on the contrary Golub is the familiar *déclassé* politically disenfranchised modern (male) artist. Golub's political constituency rests on what he *chooses* to represent. Now this is not to bewail the breakdown of a stable critical constituency for artists; this breakdown can in fact be seen as one of the achievements of modernity (the separation of art from the state, increased class mobility) but that such an uprooting places a heightened theoretical and practical responsibility on artists to make their autonomy work in the interests of bridging this gap, of producing new constituencies. This is why we might talk of Golub's history painting as both informed by, and the product of, the massive historical reality of the mass media. For in the face of both the uprooting of any stable mass base for the artist, *and* the problem of history, the exigencies of history painting – its utility and affectivity – have become constitutively linked to the reality of mass culture's binding logic. To ask what Golub's paintings are made *of* therefore is not simply to say in the positive – class, power-relations, etc – but in the negative – the hegemony of a media culture that consigns the realities of class, power-relations, etc, to the far margins of political consciousness. This is why it is necessary to see the cinematic scale and vividness of Golub's images as products of, and responses to, a highly spectacularised political culture and its attendant imperialist reflexes – the USA's saturation by confidence-speak and rhetoric about the 'pacifying' of aliens. As Golub has said:

> We're up against simultaneous bombardments from a range of media sources. I try to make some of these palpable in painting ...[16] These kinds of figures in a strange way reflect American power and confidence. This is an American presence, the projects of a very powerful society which intends to stay Number One. The implications of confidence and the use of force is implicated by these figures.[17]

Scale, action and candour of detail create a 'forcible contact'[18] between the spectator and the symptomatic agencies of American capital. And perhaps this is why Golub has become so successful in a New York artworld that has long essentialised history painting as nostalgic and *retardataire*. Golub depicts that which is unseen and rarely read about by the metropolitan middle class and magnifies it as if to shame. In many respects Golub is *the* artist of Reagan's America, post-

Watergate and post-Vietnam: the America of domestic abandonment, of the ideal of urban reform (the Second Reconstruction) and of nefarious and neurotic intrigue: a government which supports the most mendacious and oppressive regimes around the globe.

In these terms it can be argued that the very class violence and power that Golub depicts on a pan-national scale, narrates the actual foreclosure of a particular era of American imperialism: the progressive expansion, under the economic supremacy of America, of bourgeois democracy and mass consumption – otherwise known as Fordism. What the 1980s saw was the gradual exhaustion of the sources of productivity and profitability in the old system of capital accumulation, in so far as America's guaranteed geographical expansion was relatively curtailed with the defeat of reformist capitalism in Latin America. The direct result of this was the massive increase in military spending in the area in the eighties to regain ideological and economic ground. As the *New York Times* noted in 1987 military spending by the USA in Latin America – military articles and services purchased with cash, credit, grants or aid – rose from a few million dollars in 1979 to 212 million a year by the mid-1980s.[19] Defeat in Latin America has inverted the classical ideological relations of American hegemony. Instead of the penetration of capitalist 'democracy', we have witnessed a violent *cancellation* of democracy.[20] Reagan's revival of a pre-emptive counter-insurgent foreign policy in the 1980s continued the traditional (Democratic) American practice of transferring aid directly to local armies and police forces, with almost no influence from civilian officials. The result as in El Salvador has been an almost complete militarisation of civilian life and the unleashing of residual fascist groups (though the fascist White Squads Golub depicts are now supposedly under 'constraint'). But this was merely a 'diplomatic' problem for Reaganism. For American foreign policy retrenched itself once again within the ideology of the 'World Anti-Communist League', which places, as in the post-war years under John Foster Dulles, a premium on alliances with the far right and fascists as those 'spearheading' the resistance to communism. As Alain Lipietz has pointed out, the economic conditions in such militaristic circumstances are based on the transfer of advanced technological conditions of exploitation *without* mass consumption or bourgeois democracy.[21] In effect, the extension of democratic capitalism to the semi-industrial periphery of Latin America has become highly problematic. There is a crisis of 'core-Fordism'. The domestic symptoms of this are represented by the

halting of the Second Reconstruction (inner city reform, black democracy) in favour of a regime of accumulation that subsidises the middle class, that is Yuppification, or to quote Mike Davis, 'over-consumption'.[22] As Davis has said:

> the increasing political subsidization [Reagan's 1981 tax 'reforms' in favour of upward income distribution] of a sub-bourgeois *mass* layer of managers, professionals, new entrepreneurs and rentiers who, faced with rapidly declining organization among the working poor and minorities during the 1970s, have been overwhelmingly successful in profiting from both inflation and state expenditure.[23]

This is the world – domestic and foreign – that Golub's painting is cognitively and aesthetically a product of, and response to. But, to return to the specific questions of representation (of class, gender and race). How does he actually *deal* with this world? And in establishing this how and where do we attribute value?

Golub's inscription of a framework of social relations and structures outside of the figures he depicts is the result, essentially, of a commitment to history painting as a psychically charged theatre of interaction between spectator and artwork. Just as Manet's *Olympia*, to quote T J Clark, allows us to 'imagine a whole fabric of society in which [her] look might make sense and include [the male viewer]',[24] Golub's painting (particularly the *Mercenaries* and *Interrogations* series and *Two Black Women and a White Man* (1986)) uses eye contact or failure of eye contact between those depicted and the spectator as a palpable, intrusive visualisation of power relations. In this respect Golub's paintings take us back to the psychic spaces of eighteenth century French history painting for their critical effects: the dissociation between seeing and being 'seen' by a painting, between looking in on a scene and being looked back at by its participants.[25] The reason for this was that as objects to be beheld paintings had first and foremost to fascinate or, to borrow the terms of the anti-Rococoists of that period, to attract, then arrest, and finally enthral the spectator. One of the powerful effects of this spectator–painting eye-contact, as Clark notes in his treatment of *Olympia*, is a 'troubled' or 'inconsistent' response to that which invites the easy pleasures of consumption. The same ambiguity is at play in Golub. Thus in *Interrogation II* (1981), in which the two soldiers on the left are shown in the act of torture, the two figures on the right are staring good-humouredly out of the picture at us, as if they have turned around to say, 'we're

29. Leon Golub, *Interrogation II*, 1981.

enjoying this, it's our job, can you appreciate that?'. The illusion of
the scene (its distanced iniquity) is broken down, and becomes an act
committed by men with specific histories and positions in a chain of
command. As both voyeurs and acknowledged respondents the
pleasure we take from being physically distanced from these realities,
the pleasures we take from the glorious patterning of blue on crimson,
is problematised. To acknowledge Brecht's modernist legacy again,
Golub's attempt to produce a configured but 'naturalistic' scene is
simultaneously adopted and broken down, in so far as the spectator's
view of the painting may begin in enthralment (voyeurism) but ends
in 'alienation' (knowledge): the fact that the pleasures we are
implicated in here are oppressive ones. As such, given that these
paintings magnify these pleasures as masculine ones, our imaginative
entry into this world is not only an entry into the relations between
men but between men and women. The anonymous, silent cellars
where these acts of subjugation and sadism are perpetrated echo with
the concealed and hidden violence of the home; clearly these paintings
are not only public interventions into the 'hidden' reality of state
terrorism – its ubiquitous furtiveness so to speak – but into the
masculine fantasies that govern this world. And it is this collision
between our subjective position as voyeurs and our objective moral

condemnation of such acts that gives this series its instrumental power, for the work doesn't simply condemn, it explains by foregrounding a chain of inclusions and exclusions across subject positions. Thus if these paintings problematise the power of men in power by 'excluding' the female viewer (in order to privilege her position as a political critic of such acts) Golub also problematises the easy assumptions about the world of mercenaries being a wholly *white* lumpen proletariat/petty bourgeois one. Golub's inclusion of blacks in the paintings as agents of state oppression is a clear example of what I mean by Golub representing contradictory class locations. Doubly subjugated as blacks and working class their position is massively one of bad faith. The recent recruitment in South Africa of immiserated black youth from the townships into the security forces is a comparable example. Golub, however, doesn't moralise here, he acknowledges it as an inevitable contradiction of the political process itself. Moreover, the contradictory class locations of these black mercenaries are dealt with from within the sphere of relations between the mercenaries themselves. In *Mercenaries IV* (1980) we are shown racial and sexual tension between a black and white soldier.

In these terms, if classes designate objective positions within the social division of labour independent of the will of the agents, then Golub's paintings dramatise the conflicts between class agents and class positions. To talk about contradictory class locations is in effect to talk about the conflict between objective designated class positions (working class, petty bourgeois, etc) and the relations of domination and subordination which determine the agent's ideological place within such positions.[26] For example supervisors (the new petty bourgeoisie) politically dominate the working class at the point of production, but are also dominated by capital itself. They therefore have an ambiguous relation to the interests of capital. And this is in a sense what Golub is compelled by: those specific and contradictory relations of domination and subordination that define class positions. Thus in the case of the mercenaries and interrogators (elements of the lumpenproletariat, working class, petty bourgeoisie) they occupy a position within the political and ideological apparatuses of the state, but do not *create* the ideologies they defend and carry out. They execute it (literally). Consequently a residual conflict exists between their illusion of autonomy (of being beyond the law) and their subordination to the interests of the ruling class. It is this 'dialectical knowledge', distributed across bodies and actions, that Golub wants us to see.

The political content of Golub's paintings lies specifically in the designation of attributes across this chain of inclusions and exclusions. The body – its gestures, posture, gender, race – is not an unmediated abstract term, but something that takes its place within a particular class and social formation. Golub's bridging of the 'photographic message' (in the case of the mercenaries and interrogations, material borrowed from mercenary magazines and S & M magazines) with an adulterated, awkward figuration, could be said to essay class as something read *on* the body.[27] However, this is not to fetishise the cognitive details of Golub's work (as if he were mapping out class positions along some predetermined path); what makes the references in Golub's art worth talking about is their fictive power as parts of a dramatised world. Adorno saw success in art (the 'figurative' arts of painting and the novel) as lying in the dialectic between the aesthetic (convention) and what he called 'the heterogeneous moment'.[28] Something similar is happening in Golub's art. The tense, awkward, anomalous treatment of gesture, posture and the gaze, become the chain of signifiers through which we identify an *imagined* world of class relations; the awkwardness of the figures, the 'bleached' and scraped surfaces *embody* the dislocations of class society. To acknowledge this is to once again acknowledge that 'modernist knowledge' which Golub refers to and which remains at that centre of critically adequate painting today: the link between awkwardness and adulteration and the claims of 'authenticity', 'expressiveness', etc. The theoretical idealism underpinning such terms may have decayed, but the necessity for distortion and uglification as qualities that not only avoid the pitfalls of illustration but secure a range of aesthetic effects that are adequate to the reality of our ideologically distorted and distorting culture are still – vividly – determining. Modernist *gaucherie* is still our resource.[29]

Perhaps this link between class and aesthetic adulteration is at its most stark in some of Golub's recent paintings of working-class black men and women. Here Golub's techniques of colour bleeding (to the point of etiolation), distortion and gigantism (*Threnody* (1986), *4 Black Men* (1985), *Two Black Women and a White Man*) are employed to show a class and a race in a state of fragmentation and disorganisation. There is no heroicisation or valorisation. As such, criticism could be made that he 'objectifies' his figures as victims, in order to gain political mileage. On the contrary Golub again, in the interests of political candour, shows the contradictory position of a class grouping. The structural capacity of the working class is not

determined only within the productive process. It is also based in community links and ethnic solidarity. In Reagan's America, however, there has been a weakening of the non-productive base of this capacity, through suburbanisation, geographical mobility, increased home ownership.[30] The effects of this have been a rise in racial tension between the black, hispanic and white working classes as Reagan's redistribution of wealth bites home. In essence the black working class Golub depicts is a community whose central structural capacity for transforming the political process in America is currently divided and under attack (despite the success of Jesse Jackson's Rainbow Coalition). Golub's black men and women are the indices of the retreat from the Second Reconstruction and the politics of 'overconsumption'. In this respect we might say here is a good example of that play between absence and presence, or that 'double narrative' interest, that is integral to Golub's art. By showing the breakdown of a class and a race he also shows their latent structural capacity for resistance, in so far as it is a subjugated black working class in America (and South Africa) that stands to change the current political economy of capitalism. These are pictures of a slumbering giant.

This of course sounds terribly virtuous, as if Golub's critique of American imperialism was directly aligned politically. On the contrary there is a deep scepticism to Golub's work, an intractable sense of human *failure*. We cannot overlook the voice of the tragedarian in his choice of material. But nonetheless through his strong commitment to specificity of detail, there is a concern with the complexities of the political process that flies in the face of the way Golub has usually been interpreted (favourably) or dismissed. Thus the notion that Golub's images of 'extreme violence' force us into a 'classless' society in which there are 'no individuals but warring groups',[31] to quote Donald Kuspit, or that 'it's not political ideology but a "swamp of feeling" about men and violence they inflict on each other that lies behind these paintings'[32] (to quote the editors of *Art News* from a profile on Golub) seems to be exactly opposite to the truth. For by placing his figures in the *Mercenaries* and *Interrogations*, the *Contra* series, and the recent black paintings in 'recognisable' settings (Latin America, the de-industrialised North of America) and by foregrounding their psychological interaction as gendered, class positioned individuals, he depicts men and women at work in, and on, the real world. The result is that Golub clearly wants us to understand and *contextualise* the actions of these figures as historical agents, to see them as both effects of American capital in the age of

its imperialist decline and as the evidence of the brutalisation of a masculinised, racist culture.

Now that is a knowledge to be used and balanced against any pessimistic hermeneutic which characterises the work simply as focusing on violence and desuetude as evidence of our 'premonition and discontent'[33] as a culture. Consequently any adequate reading of these paintings will need to emphasise that their privileging of a multiplicity of readings across the questions of class, gender, race and the power of the state, is not based upon any arbitrary 'readings-in' but on the procedural methods of the work itself: the fact that through the intertextual reworking of the photographic antecedent a high degree of particularised detail can enter the painting as a means of anchoring reference. Golub's vividness as the 'modernist-documentor' of the 'Other America' lies exactly in that.

Notes

1. Golub begins his work by projecting – with an opaque projector – drawings or parts of photographs on to the canvas. The figures are then shaded in black. A coat of white is subsequently applied to give the figures three-dimensionality and to mark out highlights. After local colour is applied the canvas is placed on the floor and scraped, or as Golub says 'eroded', with a meat cleaver. (This process has now been taken over in part by assistants.) The result is a rough, porous surface. During the process the figures are reconstructed and facial features and gestures are 'worked up'. Little paint in fact remains on the canvas; the colour is manipulated into the canvas leaving a kind of stain.

2. A profoundly unusual position for a US artist because of the specific nature of class politics in the USA: the lack of any collective self-formed working-class agencies and institutions independent (or relatively independent) of the state.

3. There is a constant tension in Golub's interviews and public statements between a recognition of the Americanisation of his figures and a certain distance from this Americanisation. This may be the pragmatism of the artist concerned to keep his 'options open'. However, Golub has always been at pains to emphasise his work as being the product of the USA's cultural and political power. In this respect we should stick with the spirit of this work.

4. T J Clark *The Painting of Modern Life: Paris in the Art of Manet and his Followers* (Thames & Hudson 1985) p 118

5. To call on Roger Fry to articulate the importance of such knowledge may seem a little perverse, but what Fry recognised and recorded as a necessary modernist truth was that it was an agitated surface that

secured anti-academicism in painting. This modernist truth still holds. However, we need to make a distinction between the epistemological base upon which Fry's understanding of this was secured, and the implications of this truth today. As Fry said in his essay with Desmond McCarthy for the 1910 Grafton Galleries 'Post-Impressionism' exhibition:

> Like the work of the primitive artist, the pictures children draw are often extraordinarily expressive. But what delights them is to find they are acquiring more and more skill in producing a deceptive likeness of the object itself. Give them a year of drawing lessons and they will probably produce results which will give the greatest satisfaction to them and their relations; but to the critical eye the original expressiveness will have vanished completely from their work ... there comes a point when the accumulations of an increasing skill in mere representation begins to destroy the expressiveness of the design. (Quoted in Richard Shiff, *Cézanne and the End of Impressionism: A Study of the Theory, Technique and Critical Evaluation of Modern Art* (University of Chicago Press 1984) p 157)

Associated with notions of the 'authentic' and 'intuitive', the expressive mark became a sign of visual scrupulousness and honesty. It was a short step of course from this to the conflation of modernism with the 'truth of the gesture' as such; modernist abstraction's general devaluation, or occlusion, of the question of descriptive and cognitive skills, clearly lies in such 'expressionist' ideology. Yet what modernism theorised, from Fry through to Greenberg, was that there was no going back to pre-modernist defences of value in art as lying solely in its references.

6. Louis Althusser 'A Letter on Art in Reply to André Daspré' in *Lenin and Philosophy and Other Essays* (NLB 1971)
7. For a summation of this position see Mary Kelly's 'Re-viewing Modernist Criticism' *Screen* vol. 23 no. 3 (1981). In the face of the 'ambiguities' of painting for women Kelly calls for the production of 'statements'.
8. Matthew Baigell 'The Mercenaries: an interview with Leon Golub' *Arts Magazine* vol. 55 no. 9 (May 1981) p 169
9. See Hal Foster *Recodings: Art, Spectacle, Cultural Politics* (BayPress 1985)
10. T J Clark *Image of the People: Gustave Courbet and the 1848 Revolution* (Thames & Hudson 1973) p 158. See also Thomas Crow *Painters and Public Life in Eighteenth-Century Paris* (Yale 1985) for a discussion of Jacques-Louis David from a similar perspective
11. See L Golub 'Three Essays' *Sulfur* 17 (1986) pp 62–8
12. See Linda Hutcheon *A Theory of Parody* (Methuen 1985)
13. Terry Eagleton *Walter Benjamin or Towards a Revolutionary Criticism* (Verso 1981)

14. See *Enrolment of the Volunteers: Thomas Couture and the Painting of History,* catalogue for Museum of Fine Arts, Springfield, Massachusetts, April–June 1980

15. Quoted in Robert J Bezucha 'The French Revolutionary Tradition and the Painting of History in *Enrolment of the Volunteers* (Museum of Fine Arts, Springfield 1980) p 2

16. L Golub interview with Michael Newman in *Leon Golub: Mercenaries and Interrogations* (ICA 1982) p 6

17. Quoted in Matthew Baigell 'The Mercenaries' p 168

18. Interview with Michael Newman p 4

19. James LeMoyne 'Central America's Arms Buildup: The Risks of Guns without Butter' *New York Times* (19 April 1987)

20. See Mike Davis's excellent and indispensable *Prisoners of the American Dream* (Verso 1986)

21. Ibid p 205

22. Ibid. See section on the rise of overconsumption, Chapter 5

23. Ibid p 201

24. Clark *Painting of Modern Life* p 133

25. See Michael Fried *Absorption and Theatricality: Painting & Beholder in the Age of Diderot* (University of California 1980)

26. See Erik Olin Wright *Class, Crisis and The State* (NLB 1978) for an analysis of class positions and class agents

27. A phrase of Clark's. See *Painting of Modern Life* p 118

28. T Adorno *Aesthetic Theory* (RKP 1984)

29. For a discussion of *gaucherie* or awkwardness in relation to modernism see Richard Shiff *Cézanne*

30. See Davis *Prisoners*

31. Donald Kuspit *Leon Golub: Existential/Activist Painter* (Rutgers University Press 1985) p 26

32. 'Leon Golub's Mean Streets' *Art News* (1985) p 74

33. Kuspit *Leon Golub* p 76

20

ART AND VALUE:
A PHILOSOPHICAL DIALOGUE

A Hilary Putnam has argued that *all* our acts are ultimately instrumental, that is, are involved in adopting a means to achieve an end. If we accept this then the question of art as an intentional human activity becomes inseparable from the discussion of validity claims.

B By this are you saying that artworks should satisfy some notion of 'cognitive significance'? That they must be rationally accountable in some way?

A In a certain sense yes.

B But artworks are not rationally falsifiable.

A Obviously not; artworks cannot be proved to be 'incorrect'. However, if we take seriously the notion that all human actions presuppose a set of validity claims then we need to question the basis of those claims.

B So, are you saying that value judgments on art should be framed as questions around criteria of adequacy?

A In a sense yes: I think it's perfectly legitimate to refer to works of art as intellectually incompetent, inauthentic, cynical.

B So, do 'good intentions' – technical and theoretical competence – produce good artworks?

A No of course not, but if technical and theoretical *in*competence can be said as a general rule to lead to the production of work that *is* incompetent then we can legitimately assume that some level of

technical and theoretical competence will lead to the *possibility* of the opposite.

B But how do we define technical and theoretical competence? Aren't these wholly relative criteria? And if so, aren't we then immediately caught up in a circular argument?

A Well, if we are to remain within the domain of the rational as being in the interests of the good, in so far as a theory of rationality presupposes the raising and verification of truth claims about the world, then the question of technical and theoretical competence in art must be judged according to criteria that are meaningful in a non-subjective way. Thus if all works of art infer validity claims then we need to ask what values might stand in the best interests of technical and theoretical competence in art. Which means of course addressing the social and political circumstances under which a question is to be significantly posed. In short, if all acts are ultimately instrumental then what moral and political values should the instrumentalities of art endorse or work with?

B You mean socialism.

A Yes.

B But how might art be attached to the interests of socialism without falling into functionalism? For just as scientists do not pursue science simply in order to produce better machines, artists do not produce art simply in order to 'win over' people to socialism or raise consciousness amongst the working class. If this was so they would chose a medium which was far more 'efficient' in the means which it adopts to achieve its ends, such as radical journalism.

A You confuse the instrumentality of all facts and acts with a reductivist view of the means adopted to achieve an end. It is not a question of defining the success or validity of artworks produced in the interests of a critique of capitalist culture and representation in terms of what teachers of ethics call Majoritarianism – getting across, in the simplest terms, to a lot of people all the time – but of establishing and building on the fact that art participates in a culture where opposing values over moral, political and aesthetic questions are in continual struggle. To talk of 'cognitive significance' in art therefore

is to talk about a set of interests that enable some purposeful critical discussion to take place on the work in relation to the culture and the society of which it is the product.

B But doesn't this contradict your acknowledgement of the non-necessary relationship between technical and theoretical competence and aesthetic quality in art? You may have no time for the populist crudities of what you call Majoritarianism, but none the less your view of what is acceptable is still predicated upon a strict adherence to the primacy of ideological goals.

A No, there is nothing in what I've said that disallows the possibility of us, as rational subjects, rejecting works on aesthetic grounds. This much is obvious. Yet, if we are not to fall into relativism then we must proceed from some normative set of standards where questions of *relevance* hold, that is given the nature of capitalist society and Western modernity – its splitting of the social world, *pace* Kant, into three distinct domains: the moral–practical (the educative), the scientific (the theoretical) and the aesthetic (the pleasurable) – then the questions of the good in relation to art could be said to be best served by their attempted interaction. We might say therefore that questions of relevance and adequacy in relation to art under capitalism cannot be separated from discussion of the good as attendant upon the *maximalisation* of art's aesthetic and critical resources. Much contemporary art and criticism exhibits a retreat from this complexity into the reification or celebration of one of these domains; thus to take one recent example the 1986 'Falls the Shadow' exhibition at the Hayward Gallery, which abrogated the educative and critical functions of art in favour of a disinterested, neo-Romantic view of aesthetic experience. The show idly transcended or rather disavowed the massive historical reality of Kant's three-sphere split.

B But isn't the future interaction and unification of these separate spheres of modernity a complete leftist fantasy?

A In terms of a post-capitalist holistic unification of the subject with nature yes, I would agree. There can be no retreat from the specialised and differentiated knowledge of modernity into the belief in some transparent unity of interests and understanding. But this doesn't obviate the need in the interests of the good – the increased democratic communication between subjects – in pursuing the

production of works of art and changes in institutional structures that would link the moral-practical, theoretical and aesthetic components of art to the everyday.

B You refer to both the production of critical works and changes in institutional structures. But isn't the real issue simply institutional–capitalist relations? Political or critical content is purely secondary in advancing this re-linking of art with the everyday. For under any real democratisation of our culture there will be no need for critical practices. Haven't we just agreed that the good of art cannot be reduced simply to *practical* goals?

A Yes, but we don't live under socialism, consequently practical goals will continue to remain central to an adequate definition of the good. To reiterate, this does not contradict our rational capacity to reject work on the grounds of aesthetic inadequacy, it simply indicates that if art is to signify in any meaningful public sense – if it is to enter the culture so to speak – then we cannot separate the question of what from how and where, intention from the conditions and necessities of communicativeness.

B But isn't this desire for *grounding* art in democratic communication highly suspect as the basis for art's place within human flourishing? As Richard Rorty has said, by seeing Kant's three-sphere split as the fundamental problem of Western modernity (that is, our democratic future lies in its reunification) our politics, art and philosophy are the product of a continual to-ing and fro-ing between reductionism and anti-reductionism, in as much as more escapes the notion of reunification (in the interests of emancipation) than can be contained by it. In effect, why does art have to be grounded in a paradigm of communication when art's qualities (its interpretative instability) continually overstep or defy such rationalisation?

A Because it is only through such a grounding that any form of collective and generalisable communicative function for art might take place in which that interpretive instability might be openly and freely debated. Defending this therefore does not mean, *pace* Lyotard, that an emphasis on the means and ends of communication in art leads to 'correct content', 'correct narratives', etc. Rather, if we are to take seriously that art is severed from any real communicative function within collective life in our culture then those political and aesthetic

resources that stand to change that are more *rationally* defensible. As Habermas has said: 'If aesthetic experience is incorporated into the context of individual life-histories, if it is utilized to illuminate a situation and to throw light on individual life-problems – if it at all communicates its impulses to a collective form of life – then art enters a language game which is no longer that of aesthetic criticism, but belongs, rather, to everyday communicative practice.'[1] This seems not just reasonable but a necessity.

B But once again you seem to be saying that art's function is principally a form of social problem solving.

A No, but if we are to recognise that all acts of human creativity have to take into account the means which they adopt to achieve their ends, then it seems legitimate to acknowledge that the kind of value in art I'm arguing for will issue from some engagement with those knowledges, resources, forms of life that are at work in opposition to capitalist cultural relations. Thus we might say the 'work is good' or in the interests of the 'good' when a conjunction of the aesthetic, moral and political claims of the art produces the *necessity* for critical discussion; the 'good' artwork therefore demands communicative interaction and discourse, rather than simply idle chatter or opinion.

B But how are we to draw a consensus around the question of necessity when the verification of aesthetic quality is so unstable and necessarily so?

A Well in the end there are no guarantees in that sense, there is only the belief that the culture of art we inhabit now is a profoundly undemocratic and misrepresentative one and that therefore certain critical practices stand in the interests of its transformation. Which in turn of course means seeing the 'good' of art as being inseparable from the 'good' of the future collective emancipation of human beings.

Note

1. J Habermas 'Questions and Counterquestions' in ed. and intro. Richard J Bernstein *Habermas and Modernity* (Polity Press 1985) p 202

21

MASCULINITY, POLITICS
AND ART

Masculinity – the last 'dark continent', the last great unsaid. Over the last few years the 'crisis of masculinity' has become increasingly visible on the cultural politics agenda. As the women's movement's insights into the specific oppressions of women have become dispersed within Western culture and politics, certain sections of men influenced by these ideas have gradually moved forward into the critical light to cast a self-scrutinising eye on their own identity and sexuality. This process to a large extent got under way in Britain in the late seventies and early eighties with the formation of men's groups and the production of the magazine *Achilles Heel*. Supportive in particular at this time of the need for men to talk about themselves was the *Leveller* magazine, which is now defunct. Of a more theoretical nature the work of Stephen Heath also helped to underpin the need for a shift in men's self-understanding. His book *The Sexual Fix* published in 1982 sought to unpack the 'terrorism of sexuality',[1] in which heterosexual and homosexual were posed against each other.

Urged on then by the political imperatives of the women's movement, men – or rather white middle-class heterosexual men – began to scrutinise their sexual and political relationships not just with women but with other men. What emerged from this was a very strong *anti*-masculine perspective. I remember at the time the political requirement posed on heterosexual men to kiss male friends and acquaintances in public. The early work to a large extent was drawn together in the anthology *The Sexuality of Men*[2] published in 1985, with contributions from a number of the men who had been instrumental in setting up the early men's groups. The two key thematics that run through the anthology are men's fear of intimacy and their confusion between power and responsibility.

This shift from women addressing masculinity as a problem, to men facing up to the problem themselves, has taken on even greater

powers of self-definition over the last few years. Anthologies such as *Men in Feminism* (1987)[3] and *Male Order: Unwrapping Masculinity* (1988),[4] the exhibition *Behold the Man* (1988),[5] and the general rise of a popular discourse of the New Man have secured, quite clearly, a new critical agenda. However, what distinguishes the sharper contributions to this debate recently, such as *Male Order*, is a clear distance from the individualistic, psychologistic and Eurocentric definitions of masculinity reflected in an anthology like *The Sexuality of Men*. Essentially there has been an explicit attempt to refigure the question of masculinity through the determinations of class and race as part of a new sexual politics. Criticising the 'old' left in general (Labourist and extra-parliamentary alike), and the anthology *The Sexuality of Men* in particular, *Male Order* presents a political critique of white male heterosexuality as an unproblematically centred discourse. Politics from this position, it is argued, are always about other people and their problems, never about the problems of being white, male and heterosexual as a consequence of the power of such a subject position. As Jonathan Rutherford, one of the editors of *Male Order* says, such a lack of self-understanding reinforces the myth that:

> men are neither a problem nor have problems. We perpetrate forms of organisation and practice that exclude people's needs and feelings. The physical space we occupy, our language and the organisational forms it produces perpetuate masculine presence. The subsequent hierarchies often exclude working-class and black men as well. Those who are angered and oppressed and marginalized by a politics that will not acknowledge there is a problem, and that it belongs to the institutions that have been created in the image of a specific white masculinity.[6]

Thus, for Rutherford what the earlier work by men on masculinity failed to do was open out the specific subject position of white male heterosexuality to a wider political analysis. The tendency towards the purgation of masculinity as an unsightly problem, and the fetishistic celebration of supposed feminine virtues – compassion, non-aggression, caring, etc – simply disabled men from participating with women in any projective and shared way in a new sexual politics. For the contributors to *Male Order* then, the crisis of masculinity needs to be sited within a framework of power relations that are cut across by class, race and sexuality, if men are both to understand masculinity as constructed, and to avoid the pitfalls of

moralism and self-doubt. For without a sense of political responsi-
bility in learning about the place from where men speak as men, the
prospect of men 'working on themselves' can easily slip into a
spiralling regress of self-criticism in which being seen to be compas-
sionate, non-aggressive, caring, etc, is held to be yet another device
of male power seeking. The penitent tone of a 'more-self-critical-
confessional-than-the-next-man', as a bid to avoid resituating a
traditional masculinity from a more 'attractive' position is something
that mars *Men in Feminism* – particularly, ironically, Stephen Heath's
essay.[7] It is interesting to note that Alice Jardine in response to Heath
says: 'his complication becomes passive'.[8] 'Shut up man! and get on
with it', she could almost be saying in another voice.

Male Order in contrast, derives its character from a complication
made active. By centring on masculinity as constructed across the
divisions of class, race and sexuality it seeks to situate the crisis of
masculinity as something that can contribute positively to a new
sexual politics – a sexual politics in which heterosexual white men
unlearn their centredness without guilt or demoralisation and the
worshipping of women.

Where then does *The Invisible Man*[9] and the visual arts as a whole
fit into this? Clearly the visual arts have not escaped the crisis of
masculinity. If the crisis of masculinity is something that has generally
been disavowed within socialist politics, it has been equally invisible
within the visual arts, even within its so-called progressive sectors.
When heterosexual men have addressed the question of sexual
politics they have invariably addressed their relationship to women
as objects of sexual objectification and/or desire. With the exception
of a number of gay artists, Robert Mapplethorpe being the most
obvious, heterosexual artists have largely avoided representing their
own bodies as other.[10] The women's movement provided the
permission for men to work on representations of the *female* body.
Recently, in response to this, I have argued about the need for
creating a greater sense of permissibility amongst male heterosexual
artists to engage with their own masculine self-image and sexuality.[11]
This is not to call, however, for a new confessional aesthetic, or to
categorise masculinity as a new subject of artistic exploitation
(problems that have befallen the construction of the category 'feminist'
art), but an attempt to open up a space, or spaces, for a new order of
imagery in which male subjectivity is rendered an object of analysis.
For we only have to look at the international artworld to realise how
powerful a centred, white male subjectivity remains, grounded as it

is in the economic determinations of artistic individualism. In this respect *The Invisible Man*, organised by Kate Love and Kate Smith, represents the first tentative steps (in Britain at least) to open up this analysis in a generalisable way. (*Behold the Man* was less an engagement with the politics of masculinity than an affirmation of men in *all their diversity* in representation.) Consequently the intention of *The Invisible Man* is to establish a space for dialogue around the crisis of masculinity from a number of subject positions. In fact the show is dialogic at its core; work by heterosexual men on masculinity is brought up against work by gay men on masculinity and against heterosexual and lesbian women on masculinity, a cumulative argument that emphasises that the issue is one of *masculinities* rather than the identification of masculinity in any fixed and pre-ordered way. Thus it would be wrong to assume that the work in the show was simply *deconstructing* masculinity, as if an alternative definition of masculinity was waiting to be released and codified. On the contrary, each work participates in various (and sometimes antago-nistic) ways towards a sense that at root, masculinity is primordially a fiction. This is not to say that men and women do not experience masculinity in real and damaging ways, but that masculinity is something that is historically determined and therefore open to transformation.

In these terms the recent growth of work on masculinity needs to be placed in the context of how capitalism continually polices identity and sexuality in order that social reproduction can take place with as few disruptions as possible. This is why we need to look at the current restructuring of capital and the division of labour to be clear about what is actually underpinning the current shift of focus on to masculinity. With the expansion of the white-collar sector under the aegis of the implementation of new technology and the increased entry of women into the labour market, many of the old jobs dominated by men have disappeared or become deskilled. The material bases that have underpinned traditional masculine identities have been eroded, weakening male certainty in the inviolability of men as the major wage-earners. Moreover, with the strengthening of the market economy men's interest and sense of identity have become increas-ingly shaped at the point of consumption. It is interesting that one of the biggest growth areas for merchandising in the late eighties is that of products aimed specifically at men as *men*. A space has been created, out of capitalism's relentless capacity to commodify all social relations, for men to be addressed narcissistically as individuals

with special personal needs and as domestic participants, without either the associations of homoeroticism (though this is not to deny those disavowed pleasures that men may take from looking at other men) or effeminacy. The conventional sexual divide between women as home-based and fashion-conscious and men as active and indifferent to personal consumption has certainly shifted.

To talk of the crisis of masculinity therefore is not to talk of something that is occurring in the abstract. By identifying new transformations in subjectivity – the product themselves of struggles against capitalist relations of exploitation – capitalism has exploited the crisis of masculinity as a potential new market for goods and services. As such the new critical work on masculinity, be it within the framework of the visual arts or academia, has to be seen as both a response to these struggles, and a part of this general process of commodification. *The Invisible Man, Male Order* and *Behold the Man* would not be possible as interventions in the way that they are, without the economic pressures currently being exerted upon definitions of masculinity at the point of production and consumption providing a popular space for critical analysis and discussion.

Are these changes progressive though, and if so, how deep do they go? How far do they cross class boundaries? Well, first we need to make a distinction between how the image of masculinity is received and defined and changes in social relations. Clearly these two areas do not overlap. Thus the *market* may be shifting an image of masculinity in 'tandem' with the critiques of the women's movement and 'new men', but obviously this does not necessarily mean any popular transformation of values and attitudes. Far from it in fact. (Don't let us forget that the crisis of masculinity has been accompanied in the late eighties by vociferous attacks on gay identity and lifestyle, with the spread of AIDS.) The idea then, espoused by certain sections of the left, that the expansion of consumer identities reflects a widening fluidity of social identity needs to be treated with a great deal of scepticism. Contrary to current leftist wisdom nobody actually *learns* from consumerism; political consciousness is not a product of identification but of *practice*. Frank Mort though, one of the contributors to *Male Order*, would seem to think differently.[12] The new codes of masculinity being employed by fashion and advertising, he says, are fracturing traditional forms of masculinity. Although he acknowledges the market has not *created* these codes, he sees the market's interest in the New Man, nevertheless, as making a new diversity of identities available to men and women. 'Marketing

imagery enters the realm of sexual politics.'[13] However, as Rowena Chapman has argued in her contribution to *Male Order*, such sanguinity singularly fails to address the terms under which this new sexual settlement is being pursued. The fudging of the boundaries of masculinity hasn't so much loosened men from their traditional roles as created a 'hybrid masculinity which is better able and more suited to retain control.'[14] The crisis of masculinity becomes a means of renegotiating and revivifying the traditional sexual roles. '[Men's] acceptance of feminine qualities substantiates their personalities, makes them more rational, more sane, not less. They are valorised by virtue of their gender, affirmed in whatever course of action they choose. Their behaviour changes, but their affirmation remains the same.'[15] Chapman in fact points to one of the problems of dealing with masculinity and representation in the absence of real social transformation. For she rightly acknowledges that talk of changing masculine identity without a commitment to fundamental change in the social and economic relations between men and women, will tend to be on men's terms, in so far as in the short term it is in the interests of men to 'co-opt femininity'.[16] Unlike Mort, Chapman is quick to point to how the would-be proliferation of multiple identities for men and women under late capitalism serve familiar ideological ends. Yet, like Mort, class doesn't get much of a look-in in her analysis. As a patriarchy theorist the crisis of masculinity is acknowledged by men 'only in order to hold on to power, not relinquish it.'[17] Implicit in this is the argument that working class men have no vested interest in the liberation of women and therefore all renegotiations of the image of masculinity by men are suspect, the result of middle-class heterosexual men reclaiming some autonomy lost to the women's movement. This is reflected in her dubious political conclusions – the need for a female-centred post-industrialism. This conspiracy-type account of male–female relations does little to put the genuine fear Chapman feels about co-option on to a materialist footing. It also weakens the claims of *Male Order*, for all its insight, to be putting the masculinity debate on firmer critical ground.

One of the problems with Mort's essay and a number of other essays in the collection, in fact, is their political substitutionalism. The fact that there is a tendency in their writing, under the heading of a new radical democratic politics, to see the politics of representation and lifestyle as the cutting edge of socialist transformation. This rests largely on a confused notion of the relationship between

masculinity and class. In Mort, Chapman, Rutherford and Kobena Mercer, class struggle is identified predominantly with a white working-class male heterosexual perspective. It is the job of a new radical democratic politics to decentre the view that white working-class heterosexual men are the bearers of socialism by emphasising the autonomy of other struggles not contained by such a subject position. However, the problem with this perspective is that class is not so much problematised *across* subject positions but abandoned altogether as an objective category. Or rather, class becomes one identity amongst many, and not the focus through which other oppressions are grounded. 'Is it possible for a socialist discourse to articulate the concern for difference without reducing any one element of society to the privileged role of the singular agent of democratic revolution?'[18] ask Mercer and Isaac Julien. This argument is currently very influential on the left. You'll find it in the pages of *Marxism Today*, in certain sections of the left in the Labour Party, in the recent writings of Stuart Hall, Ernesto Laclau's and Chantal Mouffe's *Hegemony and Socialist Strategy* and among those socialists generally who have been influenced by the post-Marxist writings of André Gorz and post-structuralism as a whole.

Now, this is not to subjugate women's oppression, gay and lesbian oppression, racial oppression and the crisis of masculinity itself, to some *anteriorised* notion of class, as if class was out there in the world bobbing along hand in hand with white, male working-class heterosexuals, but a recognition that it is the experience of class exploitation that these oppressions are rooted and continue to be *reproduced*. This is why without looking at the distortions of masculinity as a question of class we will not be able to understand why the New Man as image has touched the white and black working class, but certainly not framed its politics. Thus for example, without establishing the link between traditional forms of masculinity and capitalism's unwillingness/incapacity to provide socialised childcare for working-class families, we will not be able to grasp why it is that working-class men are under greater pressure than other men to conform to the old behaviour. Reframing masculinity, men talking about being men is important, as Rutherford says, in shifting political focus on to men irrespective of class. But in the final analysis it is only through understanding the non-discursive effects of class on the construction of masculinity that we will be in a position to ask the far-reaching socialist questions.

The upshot of this is that much of the writing on masculinity in *Male Order* reveals clearly just how capitalism separates the economic and political as a means of disguising the basis of capitalist exploitation. In pre-capitalist societies the expropriation of the primary producers was based directly on the exercise of juridical privilege and political power. In capitalist societies the economic and the political are separated; capitalist exploitation is not based upon political power. If one of the consequences of this is to create a purely economic category of class, capitalism also creates the impression that class is *simply* an economic category. It seems that there is a world of relations and identities beyond the economic where class interests hold no sway. The development of extra-economic goods then (the struggle for women's rights, gay rights, the rights of black people) produces the appearance of enhancing the extra-economic domain by denying or marginalising class inequalities. This is why social identities outside of production today seem more 'fluid' than before. However, if we look at the economic development of late capitalism it has actually narrowed the extra-economic sphere as a place of autonomous human exchange. Capital has established private control over activities and resources that were once in the public domain. Paradoxically therefore capitalism's structural indifference to the social identities of the people it exploits – the fact that formal equality is guaranteed for all under the law – allows it to concede the development of the extra-economic domain. As Ellen Meiksens Wood has argued:

> If capital derives advantages from racism and sexism, it is not because of any structural tendency in capitalism toward racial inequality or gender oppression, but on the contrary because they *disguise* the structural realities of the capitalist system and because they divide the working class. At any rate, capitalist exploitation can in principle be conducted without any consideration for colour, race, creed, gender, any dependence upon extra-economic inequality or difference ...[19] [This means that whereas] in pre-capitalist societies extra-economic identities were likely to highlight relations of exploitation, in capitalism they typically serve to obscure the principal mode of oppression to it.[20]

Late capitalism's 'Pandora's box of diversity'[21] (to quote Rutherford and Chapman), its would-be world of proliferating social identities and shifting sexualities, suddenly appears less to be the work of

political liberation than effective ideological cover. This was revealed all too clearly in a discussion Frank Mort had at the Institute of Contemporary Arts with the editor of *Sky* magazine and an advertising executive as part of the launch of *Male Order*.[22] Both the editor and the executive had no problem about advertising and the world of fashion addressing racism, women's oppression and ecological issues. All this was grist to the mill of selling *difference*.

When we look at recent critical work on identity then, we see a contradiction. On the one hand we see the development of an extra-economic sphere that is committed to the possibility of a new politics sensitive to the diversity of human identity, and on the other we see an extra-economic sphere whose development functions to deny the structural realities of capitalism as a mode of production. The problem with the cultural politics of *Male Order* is that it jumps over this contradiction. Consequently the issue is not about denying the importance of struggles over representation, but of countering the view that such struggles, as a matter of political organisation, can be achieved autonomously outside of forms of working-class organi-sation in which a multiplicity of subject positions *participate*. It could be said of course, *pace* Rutherford, that this simply recentres the problem of political representation on my terms – white, male, heterosexual. However this misses the fundamental point. For the reality is not whether white, male middle-class heterosexuals in alliance with gay middle-class men and women might be able to secure the conditions for socialism, but whether the working class as a class made up of white men and women, black men and women, gay men and women as the *creators of surplus value* can.

What has all this got to do with masculinity and the visual arts, and in particular *The Invisible Man*? Well, I think an enormous amount. Because one of the basic problems with *Male Order*'s conflation between work on the politics of representation and political transformation is that it legitimatises art's engagement with masculinity as part of some counter-hegemonic struggle. What was done for feminism and art in the late seventies and early eighties is now being done for masculinity: art becomes an interventionist force against a 'hegemonic repertoire of dominant images'. The 'new politics'' severance of material interests from the construction of identity has left the door wide open for idealist defences of cultural-led politics. Thus, as far as my own reading of *The Invisible Man* goes, we need to keep conceptually distinct what *can* be and what *needs* to be done in imaging other masculinities, without assuming

in the face of the problem of masculinity as a class issue that the critical representations of dominant forms of masculinity, be they in an art gallery or in the market place, can secure structural changes in social relations. What such an exhibition as *The Invisible Man* can, and hopefully will, do therefore, is *identify* the crisis of masculinity and provide the resources, for male heterosexual artists in particular, to address their own self-image without self-censorship and self-doubt.

Notes

1. Stephen Heath *The Sexual Fix* (Macmillan 1982) p 157
2. Eds Andy Metcalf and Martin Humphries *The Sexuality of Men* (Pluto Press 1985)
3. Eds Alice Jardine and Paul Smith *Men in Feminism* (Methuen 1987)
4. Eds Rowena Chapman and Jonathan Rutherford *Male Order: Unwrapping Masculinity* (Lawrence and Wishart 1988)
5. 'Behold the Man: The Male Nude in Photography' organised by Alasdair Foster, Stills Gallery Edinburgh 1988
6. Jonathan Rutherford 'Who's that Man?' in eds Chapman and Rutherford *Male Order* p 44
7. Stephen Heath 'Male Feminism: Men and Feminist Theory' in eds Jardine and Smith *Men in Feminism*
8. 'A Conversation: Alice Jardine and Paul Smith' in eds Jardine and Smith *Men in Feminism* p 248
9. 'The Invisible Man: An installation of work which deals with the construction of "male" identity', Goldsmiths' Gallery, University of London. Part I: 12 October – 2 November 1988; Part II: 9 November – 30 November 1988. The first half of the exhibition was involved in a censorship furore soon after it opened. The organisers Kate Love and Kate Smith were asked to take down one of the exhibits before Princess Anne was due to make a visit to the University. The offending painting by Rebecca Scott entitled *Porsche Cabriolet* showed a naked young man with a large erection posing in front of a photograph of a Porsche. The work was taken down and a censorship row broke out in the press. The story even made the front page of the *Sun*.
10. There are a number of male heterosexual artists who have taken on the issue of women-as-image, but this has been at a considerable distance from any questioning of masculine self-representation. For example, it is very much through women as receivers of the male gaze that Victor Burgin and John Hilliard address the question of men's identity (though Burgin has given us an image of himself reflected in the mirror of a women's toilet). To point this out though is not to moralise, but rather to acknowledge how relatively easy it is for men to exhibit

their commitment to the women's movement. It is quite feasible to read Burgin and Hilliard's work as a variant on the theme of fetishism; the women's movement for men becomes yet another form of admiration for women, another way of abrogating men's responsibility *within* the sexual relation.

11. See 'Speaking Without Ruses' *Performance Magazine* no. 53 (April–May 1988)

12. Frank Mort 'Boy's Own? Masculinity, Style and Popular Culture' in eds.Chapman and Rutherford *Male Order*

13. Ibid p 201

14. Rowena Chapman 'The Great Pretender: Variations on the New Man Theme' in eds Chapman and Rutherford *Male Order* p 235

15. Ibid p 247

16. Ibid p 248

17. Ibid p 235

18. Kobena Mercer and Isaac Julien 'Race, Sexual Politics and Black Masculinity: A Dossier' in eds Chapman and Rutherford *Male Order* p 102

19. Ellen Meiksens Wood 'Capitalism and Human Emancipation' *New Left Review* no. 167 (January–February 1987) p 6

20. Ibid p 20

21. Chapman and Rutherford 'The Forward March of Men Halted' in *Male Order* p 17

22. July 1988

22

BLINDNESS AND LIGHT: SCIENCE AND NATURE IN THE PAINTING OF IAN McKEEVER

HOT AND COLD

Around 10,000 million years ago the 'big bang' occurred. Five hundred and fifty million years ago multicellular animals first made their appearance. One hundred and twenty to two hundred million years ago Pangaea began to separate, scrunch and drift apart into the continents we now know. Forty thousand years ago human beings in their present biological form first developed. Ten thousand years ago all the large ice caps melted with the exception of those in Antarctica and Greenland. Four to five thousand years ago humans in south-western Asia had domesticated all except a few of the crops and livestock central to Old World neolithic civilization and to agriculture now. Three thousand years ago humans migrated from the Old World to the New World (America, Australasia). There to a certain extent neolithic culture stops. Radical innovation does not occur for another 1,500 years, when the Iberian *marinheiros* circumnavigate the globe and rediscover America and Australia and their neolithic peoples. Why did it take so long for this expansion to occur? Hadn't the Scandinavians crossed the Atlantic and settled in America in the tenth century? The absence of Old World people beyond the Mid-Atlantic ridge is simple: economic underdevelopment and demographic paucity. The Norse colonies in America could not sustain themselves because of their weak home economy, small population and lack of agricultural expertise. Norway unquestionably was not Byzantium. It could not produce an agricultural surplus to sustain any expansionist ambitions. It was even unable to profit from its colonisation of Greenland. Grain would rarely grow there and there were very few trees. Moreover, the Scandinavians'

encounter with the Amerindians inverted the usual pattern of biological interchange. Because the Norse in Greenland and Iceland and Norway were so remote from the metropolitan centres of Europe they hardly ever came into contact with infectious diseases. They were thus unable to build up generational immunity. When smallpox returned to decimate the population of Iceland in 1707, 18,000 people died.[1]

Climate, disease and a weak economy then prevented the Nordic peoples from becoming the vanguard of global economic development. This reveals an enormous amount not just about the necessary conditions for economic development, but about the nature of the subsequent development of early capitalism and the global market. For it was not fortuitous that the *marinheiros* of Spain and Portugal became the agents of Old World expansion. An expanding population, fertile lands in the South, a developing trade with the East, and more important an equitable climate and a portmanteau biota that worked for them on their trips, provided the conditions for sustaining expansion. Moreover they had the Canaries, Azores and Madeiras on their doorstep, a set of fertile imperialist staging posts, that were just not available to the Norse. In fact these islands were more than staging posts; they became, with the introduction of sugar and a slave economy, the very crucible of imperialist expansion. As Alfred Crosby has argued:

These three archipelagos of the Eastern Atlantic were the laboratories, the pilot programs, for the New European Imperialism, and the lessons learned there would crucially influence world history for centuries to come. The most important lesson was that Europeans and their plants and animals could do quite well in lands where they had never existed before, a lesson that the Norse experience had never made completely clear and that the Iberians had never had the opportunity to learn from them, anyway.[2]

In essence Europeans were not very good at adapting to alien lands and climates. Prospective colonies had to be in lands that were favourable to the animals and plants of Europeans. In effect they had to be *neo*-Europes. The development of European imperialism from the sixteenth century onwards is fundamentally of this pattern. The Iberian archipelagos, America, the central lands of South America, Australia and New Zealand all have climates where European animals and plants have flourished. Unlike lands in the Northern

hemisphere and the tropics they all possess large areas of high photo-
synthesis potential.

The cold lands of the North therefore to a large extent escaped
imperialist adventurism. Too barren, too uninviting, too sparsely
populated they could not sustain the animals and plants of the early
European colonisers. Consequently it is no surprise that these lands
have entered the Western European imagination as places where the
very limits of human endurance in front of nature might be put on
trial. The almost obsessional character of Arctic exploration this
century and last are testament to what Barry Lopez has called the
'single-minded belief in something beyond the self.'[3] But whatever
the power of the far North and the Arctic circle to attract explorers,
ethnologists, paleontologists and geologists to its sublime reaches, its
place in the imaginations of artists has been more or less fragmentary.
Whenever artists have gone in search of 'sanctuary imagery' this
century or last, Greenland, Lapland, Iceland and the Arctic circle have
not generally been favoured. Their very inhospitableness has rendered
them unavailable to the peripatetic Western artist. Ian McKeever's
continued involvement with these lands as a cold harbour of the
imagination, then, goes somewhat against the grain. Cryophiles
have not been that common within the Western modernist tradition.

> In the simplest terms I go north because my body seems to like the
> cold, I work better, and I can get hold of things. For instance,
> cold air seems to come in chunks and has holes in it, it's graspable
> in a way that warm air isn't. My nerve ends seem to open up in
> the cold – things are often physically excruciatingly close up
> against the skin. I need that proximity. I tried to talk about this to
> some extent in the tape–slide work (Swedish Lapland) I made for
> the Whitechapel Gallery in 1988. On another level I'm very strongly
> rooted, culturally, in the Northern tradition. I feel my Celtic roots
> increasingly strongly, not in any overtly tangible sense, but as an
> under-current.[4]

* * *

Dear Ian

The idea of the artist *in* the landscape as the mark of artistic-
hood has its roots in the Romantic tradition. Immediate experience of
the landscape constituted both a commitment to the powers of learning
in front of nature, and a purgative break with the conventionalised

routine of metropolitan life and the instrumentalism of the growing market economy. At regular intervals this century (for example the inter-war period in Britain)[5] and last, this 'return to nature' has reconstituted the political implications of this early Romanticism. Nature, as untainted other or threatened resource, has become intimately linked with creative individualism and the possessive free spirit. Rousseau's *The Confessions* is a good example of the early codification of this. Speaking from the depths of his country retreat in 1751–52 he says: 'I could no longer see any greatness or beauty except in being free and virtuous, superior to fortune and man's opinion, and independent of all external circumstances.'[6] Rousseau's *philosophie naturelle* has continued to exert an influence and fascination long after its driven asociality has withered, because, quite simply, of its utopianism. One of the most common fantasies of bourgeois life is the escape into the countryside, or the vision of rural self-sufficiency. These remain powerful myths because they are based on real but unfulfilled needs. Likewise the image of the amateur artist convening with nature 'away from work and modern life' carries conviction for millions of people because of its actual or imagined sense of physical release from the habitual. It is one thing therefore to say that such Romanticism as a critical artistic project is exhausted, it is another to say that it does not retain strong popular identifications under bourgeois culture. Furthermore, it is one thing to say that artists such as yourself have directly sought to excise the ghosts of this history, it is another to say that you have entirely escaped its grasp. For, however you might justify your trips into the North, and now Tasmania, as 'field work' or 'breaks from studio routine' etc, they continue in practice and imagination that very culture of exile and return that is at the heart of Romantic *philosophie naturelle*. Living in harsh conditions, travelling over uncharted territory, suffering from extremes of cold, getting lost, you embrace the perils of nature as the trials of human authenticity. However, don't get me wrong here, I'm not moralising or claiming that you cannot profess one thing and do another. Rather, I'm asking why is it you should feel the desire to travel in the places that you do, and under the conditions you do, if not on the grounds articulated above. It seems, paradoxically, that one cannot be a landscape artist, or an artist working from nature today, without this special and intimate involvement with nature's extremes. Because essentially we are talking about the production of works about the natural world that have no ready context of cultural appropriation as in the nineteenth century. As nature has been 'driven out'

of modern art as a site of authenticity, the modern artist seeking to reinvest a human reciprocity between it and humans is forced in a sense to *re-experience* its harshness. Which leads me to the nub of what I'm getting at. On occasions you have argued that your experience of the landscape in no strict sense determines what gets into your pictures. You are not trying to 'find yourself' through your experience of the landscape. But doesn't this actually remove the very experiential bond between your presence in the landscape and the final work, that makes the work a record of a life? In other words trips into the landscape and the work itself figure as a whole *in* the way Romanticism sought to embrace. Nevertheless, the political implications of this have changed enormously for any modern artist who seeks the pleasures of such excursions. To experience consciously and systematically extreme landscapes is to notice and foreground a world of geographical divisions post the imperialist climax and the advance of commodity capitalism. Your visited landscapes interestingly are those few 'virgin' areas that remain relatively untouched by imperialism: Lapland, Greenland. The South Sea islands served a similar function for Gauguin. But the South Sea islands were on the imperialist temperate routes. By the time Gauguin left, the colonising process was advanced, which of course he contributed to. The cold lands of the Northern Hemisphere escaped the routes of imperialism because of climate and geography. These lands still remain in many ways untouched by American–Nato culture (though as oil exploration continues in the Arctic regions these lands are in retreat as well). You said as a Celt that you are attracted to these countries. But is that enough? Isn't it rather more a case of reconnecting with that *philosophie naturelle*, albeit at its most extreme edges? As the metropolitan world groans in agony, don't we need to re-imagine other borders, other spaces? Isn't this necessity rather than caprice? Politics rather than tourism?[7]

Dear John

With Gauguin there is a sense that the artist is living *it*, he goes there and *stays* there. For me it is much more to do with the other side of things, with removing myself from what I have to work with, to live with, on a daily basis, in order to effect some kind of critical balance between opposites. It is much more to do with duality, with tension, and not the celebration of the other. In fact this sense of dualism has been fundamental to my work. I work with diptychs, I produced a painting for a hole in the ground, I work with painting

and photography. What is important is polarity. The metropolis is one place, the landscape another. I get lost when the situation is 'grey', when the landscape is inhabited and cultivated. The presence of arable land and hedges somehow encroaches, becomes an emblem and extension of the metropolis.[8]

* * *

It is easy to see what attracts the cryophile. The coldness, the isolation, the 'emptiness', provide a feeling of intimacy through distance that is virtually unavailable anywhere else in the world. But what might be made of such experience for *art*? What might be won for modern practice from the landscape that both negotiates a lost reciprocity between humans and nature, and yet at the same time acknowledges the deep crisis of those traditions that have sought to 'heal' such a split: Romanticism, pastoralism and luminism?

For the Romantic artist to invoke the sublime was an easy matter of homage in front of nature. To capture the wonders of nature was to divine it as a source of power over and above that of humankind. No wonder the torrents, cascades, caverns and burnished skies of the tradition are so often rendered without human witness; they seek to captivate and educate through awe. That awe may have found much of its reasoning in religious belief, but as industrial capitalism began to transform the landscape, redemption found a secular voice: sublimity was turned into a black art of mourning. The landscape was transformed from a place of spiritual beauty into a site of remorse and longing for what had vanished within living memory. As capital increased its symbolic hold over the landscape and the market economy transformed social relations within the countryside, the 'aesthetic landscape' as a place of human surrender to the beauties of nature could no longer escape a sense of bathos. Human beings were subduing and transforming nature through unprecedented acts of collective labour. Nature as a repository of affective and spiritual values could no longer convince in the same way. Which is why in the late nineteenth century landscape art in Europe and America became heavily inscribed by a nostalgic politics. We can of course point to exceptions to this rule, to those works that showed the land being worked on and used by the peasantry and working class, but this is very much a marginal – and rarely politically conscious – tradition.[9] Just as we can talk in general terms about landscape art as a whole being marked by a sublated Utopianism.

Nevertheless landscape art at this time served a particular nostalgically corrective, hegemonising role until its final crisis with the rise of modernism and the need for images of *metropolitan* modernity.

One of the unifying characteristics of pre-modernist landscape art was the contemplative vantage point, a position we tend to associate with both the picturesque and anti-picturesque in painting and landscape gardening.[10] The tension between these positions in the eighteenth and nineteenth centuries is very much a problem about what kind of contemplative position might be adopted. The classical picturesque scene (after Capability Brown), with its geometries of space, was criticised for reinforcing social division.[11] The anti-picturesque picture space was favoured either for its comforting cross-class intimacies, or on occasions, as the anti-picturesque mutated into Romanticism, a bohemian wildness and dynamism. Whether picturesque or anti-picturesque, the 'long view' or the sylvan scene, the pre-modernist landscape embraced an honorific sense of place. The anti-picturesque tradition may have embraced it at the expense of conventionalised beauty, but nevertheless both traditions took the function of landscape to be one of *location*. In these terms the crisis of landscape art in the nineteenth century in the face of the advance of industrial capital and the emergence of modernism also needs to be seen as a crisis in the process of surveying. As the anti-picturesque moved towards the urban landscape, the picturesque landscape, increasingly distanced from how people actually experienced a rapidly transforming environment, reinforced landscape painting's traditional aspect as a site of repose and nostalgic longing. Furthermore the development of modernism as an ideology of free critical interpretation further weakened the empirical basis of this tradition. Since Cézanne at least, the modern landscape artist has been forced to 'obliterate' stable pictorial relations of space, for fear of not being able to render the landscape as an object of *individual* aesthetic transformation.

This is the legacy McKeever has worked out of, and against. From the early work *Painting for a Hole in the Ground* (1976–77) to the recent series *A History of Rocks* (1987–88) and the *Diptychs* (1988–89) McKeever has consciously sought to ruin the unities of pictorialism and Romanticism. There has been a specific absence of concern for the details of place, as if the explicit identification of location would anecdotalise the landscape, transform it into a modernised version of Romanticism's memorialism and longing: the ecological.

I think landscape itself is far too much cared about, cossetted like a library book that's taken off the shelf, browsed through and then put back. We are in the precarious position of treating it as something quite special, when I think it is something that has to be participated in, which has to be violated and abused.[12]

Darwin's Metaphor

Out in the cold fields
where the air blasts the stone
and the earth barely breaths
each step is like a step across millennia
crushing the unfathomably slow
and delicate accretion of life.
Such patience though is not wasted,
for waste is not a word nature knows.
Where the lichen is disturbed,
where the earth is broken,
things transform themselves without worry.
The movement of humans, plants and animals
is the continuous work of adaptation.
As in Darwin's metaphor one pie slice
has to fall off the plate
before another can take its place.
The rightful despair we feel about
the boot, the hoe and the digger's claw
is too often the righteous call of those
who would speak for nature against human life,
and confuse the expiation of 'lusts'
with the meeting of needs.

However, McKeever is not morally indifferent to the landscape – far from it – but is clear that the predicates of 'environmentalism' should not end up substituting for the problems that currently face painting. For even if we may talk about the need for a new reciprocity between art and nature, we cannot separate this from the crisis of modern picturing itself:

If working with landscape is problematic now, then it is more a problem endemic to working with images generally, of how to shift the ground between a sense of self and a notion of 'out there'.

Certainly in the late seventies and eighties I think that too many
tacit assumptions were made in the area of painting, and there is
now a problem of how to open up the space again (not to fill it with
images) but to really open up the space as a prerequisite to a
sense of imagery. We now know the space of gesture too intimately;
too many have, and still are, occupying it with 'secrets'; but its
familiarity, one could say almost, its sentimentality, is embar-
rassing. But how to make it unfamiliar, another space? I think on
that level photography and other means of imaging perhaps hold
clues.[13]

How to make it unfamiliar? If for McKeever in the early to late
eighties this meant various strategies of obliteration and adulteration,
as for example the *Traditional Landscape* series (1984), and work post
A History of Rocks has sought not so much to displace Romanticism
and pictorialism, but to construct a new language/s for the repre-
sentation of nature. A language, if you like, of contrasting scaling and
gigantism. Working mainly in black oil and white acrylic on stretched
canvases laid out on the floor, McKeever primes the canvas with the
acrylic. When the final coat is still wet he pours the black paint on in
vaguely predetermined areas. Water is then added which causes
the oil and acrylic to separate. Manipulating the canvas when
necessary by hand he creates a vivid topographical effect. In fact what
is generated is a kind of monstrous natural imagery, which strangely
and emphatically reconnects a modern vision of landscape and its
powers of reciprocity with all those 'lost' sensations of the sublime.
McKeever's strategies of disruption between object and subject takes
on a bastardised beauty.

Dear Ian
 The idea of the sublime has become so devalued as to become
a bathetic aesthetic category. Seekers of the sublime today invariably
turn to the metropolitan experience. A good example of an artist of
the metropolitan sublime is Jack Goldstein. In many ways his spray-
gun canvases of urban night sky-lines attempt to replicate the same
sense of awe in the face of external, impersonal forces as the
nineteenth-century sublimists did. However, if they had a retributive
nature, Goldstein has the nuclear state and the hyperreality of late
capitalism. Essentially the experience of awe in the face of the sublime
is about passivity, about the pleasures taken in knowing things are
'beyond your control'. Which is why the sublime as a state of

penitence became so central to the religious urgings of the American luminists. And which is also why this embracing of passivity can be traced through the luminists to Jack Goldstein. Goldstein, fed by theories of simulation and technological catastrophe, is the Frederic Church of our generation.

There is however another experience of the sublime that takes its sense of wonder in front of nature not so much as signs of powerlessness but as a space of connection and repose between human scale and the scales of nature, between the large and small. Good examples of this are the work of Barnett Newman and Clyfford Still. Here the geometries and 'voids' of nature, denuded as they are of retributive power, place the spectator in a greater reciprocal contact with the landscape. The domination of the spectator by size is not based on a desire to distance but to envelop, to encompass. Hence the flavour of much Abstract Expressionist rhetoric about 'spiritual' values as spatial values. The would-be benignity of this aesthetic should not blind us though to the darker movings, darker edges so to speak, of its workings, particularly in Still. In Still the sublime is not wholly 'secularised', in so far as the ragged edges, fissures, sheer faces of paint, mark out a nature that still terrifies, still dominates the achievements of human labour. In many ways Still looks to the sublime as a counter to the domestication of the landscape in the same way as the nineteenth-century Romantics, as a 'resistance' to the pacification of our spontaneous relationship to the natural world by capitalist rationality. Still's paintings still look nervous and broody, slightly malefic, in their attempts at a new reciprocity.

If the sublime then offers us penitence or recompense, where does it leave your recent work? Maybe sublime is the wrong word altogether. Your use of divergent and ambiguous scales, the absence of colour, the sheer monstrousness of many of the images, would seem to belie this. As in Still there is a paradox at work. On the one hand, you want the monstrousness of your images to carry, as in the traditional sense of the sublime, feelings of awe, but on the other hand you want such feelings to tap into a sense that such monstrousness has actually become absent from much of our experience of nature and thereby weakened our *imaginative* life in all its possible heterogeneity.

The monstrousness of the sublime serves to revivify our depleted relationship to the sheer vastness of nature across its macro and micro scales.

A footnote, however, needs to be added here. This sense of monstrousness is not a monologic process, it is always relativised and

humanised by the contrasts in scales across the images and internally (the ambiguity in whether we read some images as scaled down entities or scaled up entities). The monstrousness of the images becomes powerful or not powerful, imposing or not imposing, relative to our reading, to that constant oscillation between near and far.[14]

MICRO/MACRO

Throughout McKeever's work there has been a tension between order and disorder, perception and imperception. His writing on photography and drawing (*Field Series*) is first and foremost a commentary on the gap between the scientific status of photography as reportage and the metaphoric, motile status of drawing. This sense of two qualitatively different operations – one momentary and mechanical, the other accretive and autographic – underlies all McKeever's work: the tension between art as record and symbolic transposition, between art as 'ordinary' in Raymond Williams' sense and art as 'other' as non-particular. There is a clear understanding then in McKeever's work of the divided powers of representation. However this is not simply the familiar opposition between the ideographic (the particular) and the nomothetic (the general) but a sensitivity to the very limits of representation as such. As a landscape artist, or rather, an artist working from nature, McKeever has been acutely aware of the gap between the mutable, ever-changing patterns of nature, and limitations of drawings and photography in ever recording its diversities. Crucially the problem is one of aesthetic priorities and options post the breakdown of a classical sense of order in nature. The breakdown of a mechanistic view of the natural world and the adoption of various theories of the dynamic structuring of nature in the wake of quantum and post-quantum physics (chaos theory) and the new whole-earth sciences, has contributed profoundly to the general crisis of the pictorial landscape tradition. Central to this of course has been the question of the 'threshold of perceptibility'.[15] Now this is not to say that artists have not been more than aware over the centuries of this threshold – modernism in some sense could be seen as a response to the impossibly relativist claims of conventional realist practices: 'the object before me is a man, a swarm of atoms, a complex of cells, a fiddler, a friend, a fool, and much more ... I cannot copy all these at once' (Nelson Goodman).[16] Nevertheless with the rise of the new sciences, the 'threshold of perceptibility' becomes

linked to an actual *world view*. That is to say objects are no longer taken as discrete, interacting entities, but as abstractions, as events and processes in themselves. 'The classical idea of the separability of the world into distinct but interacting parts is no longer valid or relevant. Rather, we have to regard the universe as an *undivided and unbroken whole'* (David Bohm).[17] As McKeever has himself said in the *Field Series* essay:

> Robert Smithson wrote of the 'vanishing, vanishing horizon', that far and always so elusive horizon of landscape. As you move towards it, it recedes, and disappears, to reveal a new horizon. Never to be stood on or firmly located, it has to be continually relocated and redefined. To zoom in closer, in an attempt to find it, is only to change the problem. As fields disappear, furrows appear; as furrows are walked into, clods of earth are isolated.[18]

What does the artist do then in the move from 'horizon to grain', what can be retrieved from beyond the 'threshold of perceptibility'? The question in actuality is a false one, for art cannot do anything, in so far as it cannot add scientifically to our perception of micro-events and hidden processes. Rather the issue is cognitive and aesthetic: what metonymic and metaphoric resources might be adequate to a fundamentally changed sense of the relations between subject and object, between the artist and the natural world. In these terms art – or at least significant art – does not mimic or incorporate the technical insights of important scientific change; it internalises such insights as a possible new conceptual framework for new kinds or sets of critical and aesthetic contrast. Thus in breaking with the stable perspectivalism of the pictorial landscape tradition, McKeever has been concerned in general terms to secure a stronger sense of the spatial complexities of the natural world. From *Painting for a Hole in the Ground*, through the *Waterfall* series (1979) and the *Traditional Landscapes*, to the recent *The History of Rocks* and the *Diptychs*, what has been prioritised has been the notion that photographs or drawings are in a sense, as outlined above, *abstractions*.

We should not confuse this then with any failure of representation to register movement. The crisis over the 'threshold of perceptibility' for McKeever is not one of verisimilitude. Rather it is how one operates as an artist with nature given such limits. Regarding this McKeever's dialectic between order and disorder, perception and imperception, the micro and the macro, is about establishing a set of

coordinates that will allow a research programme to go on, with all the creative anomalies and discrepancies that entails. Thus what matters first and foremost is his view that the landscape and natural forms are material to be worked *on*, to be manipulated and transformed in the same way the natural world is undergoing constant and subtle change. The question of McKeever's post-classical 'scientific' status as an artist therefore is more to do with finding an adequate set of formal resources that will at least allow this natural mutability to be recognised intuitively.

Dear Ian

If chaos theory and advances in the hard sciences generally have played a part in establishing the cognitive framework of the new work, in what *specific* ways has this been so? Would you say that recognition of the patterns and repetitions of the microworld allowed you to create a set of generic forms that metonymically denoted that world, or some part of it? Or is this all after the event, given that the forms in the pictures are the result of a predetermined (if unstable) process? Maybe then we need to phrase the question somewhat differently. Given that the pouring and mixing of paint on a flat canvas results in forms that interestingly denote the microforms of the natural world, are you drawing attention to that process of similarity across scales, for example, which has been a key morphological aspect of fractal geometry? Geometry, in fact, seems to be a key work here. I know this sounds a bit grand, but are you trying to create a new landscape painting out of the geometries of the new post-classical sciences?

Dear John

This is too grand, too specific; and perhaps we are getting a little too hooked on this word landscape and need to jettison it for a while in order to come back to it afresh. Certainly ideas around chaos theory and physics have been increasingly creeping into the work. They seem to have superceded, or to be running in front of, my interest in the earth sciences at the moment. I see all of these areas as being interrelated, so perhaps really its just a change of emphasis. I'm not looking for geometries, they may come through as a consequence of how the pieces are made, and perhaps even as a result of working with the diptychs; but the works are not formulated, not that programmatic. I have no understanding of how the pieces would work in any strict geometric sense. The works start out a little like the 'butterfly

effect', with just an intuition and it snowballs into something much bigger. I'm starting with vague ideas of qualities, properties, entities, domains, levels, etc; and the sense of an image being in there somewhere. I then have to work it out or push it back, until it feels clearly articulated. It has a lot to do with the possible scale and dimensions of things. In terms of the new sciences it's the ideas around them, rather than their imagery – which is invariably schematic – which excites me. Illustrations of fractals don't do much for me, but some of the ideas are really engaging. There is a passage in James Glieck's *Chaos*[19] where he talks about Mandelbrot's exploration of scaling and suggests that scaling may be a signature. That idea to me as an artist is far more provocative than most paintings I see.[20]

Dear Ian

In many ways what is at stake here is a familiar discussion about the 'internal' and 'external' determinations of art. In the hard sciences, to echo Imre Lakatos, research programmes either degenerate or they continue to provide (through anomalies, discrepancies) the basis for further enquiry.[21] The idea of scientific development, *pace* Karl Popper, as a continuing series of 'quick kills' or refutations is actually contrary to the fairly ad hoc 'hands on' approach of discovery and analysis. Future developments may occur through materials/theories that were at one stage considered to be unproven or just highly adventitious, for example some of the mathematics of the new superstring theories.[22] Sciences progress then through the *suggestiveness* of various theories which compete in terms of the questions they provide for the status of truth up to the best argument available. Although there are clearly sharp differences between art and science in terms of the questions that get asked, I think the idea of art developing through research programmes is a good way of looking at the internal developments of artistic practices and their relationship to the outside world. For essentially here we are talking about the success or failure of the internal problems of the artist's practice as resting on the development of a cognitively adequate engagement with the world *within* the specific area of artistic enterprise adopted. This sounds terribly intellectual and assumes that art in some sense *follows* the natural and social sciences. Maybe, if pushed for an answer, we might have to concede that it does (in a non-linear fashion). However, there is, in a basic way, a sense that art is reliant on knowledges outside of its own inherited domain (by that we might mean – in relation to painting at least – the technologies of paint,

perspective, etc). Art is intimately bound up with knowledge claims. If this is so the notion of the artist creating, and working within, research programmes, sounds less 'scientistic' on first hearing.

Anyway, if we take the crisis of the post-Renaissance and Romantic / pictorial landscape traditions as read, your work offers a research programme into the feasibility of another language/ languages of the natural world. In these terms I believe that all the anti-expressionist strategies (*Painting for a Hole in the Ground*, the *Night Flak* (1980) series) have served heuristically as a means of achieving this. Through the self-conscious negation of the expressing subject you create a relationship between the image and the natural world that avoids, or holds off, the anthropomorphic investments of traditional pictorialising approaches to nature. This could be said to be, echoing Lakatos again, the heuristic core of your work; the critical ground-base. All the moves that have been made subsequently stem from this. I also believe, evinced by the mid-period work (*Traditional Landscapes*) that these strategies entered a crisis period of their own given that their aesthetic commitments were based principally on acts of negation. Which leads us to the new work post a *History of Rocks*. In my view this is Ian McKeever the artist coming to terms with this crisis by actually switching the *terms of encounter*, but within the same cognitive framework, that is there can be no transcending of an anti-expressionist stance, or a retreat to pictorialism, for serious modern painting. Rather, there has to be a continuing commitment to a sense of the outside world that the artist *learns* in front of. The question of the causality of the recent work therefore needs to be treated in a way that gives space to the internal demands of the adopted research programme as such. Which does not mean that the moves prior to the *History of Rocks* were not 'influenced' by a developing understanding or awareness of the new post-classical scientific geometries, but that we can't register the attractiveness of these new geometries separate from the need to overcome certain anomalies and problems established internally within the practice. All this might sound dreadfully rationalist and artificial, but I think it touches on an important point about your work and how we might talk about the painting in ways that avoid all the pitfalls of reading-in 'scientific' data that you are rightly worried about. By locating an internal crisis and its attempted resolution, we can see that the ad hoc procedures of research programmes in art are grounded in a continuous play *off* between form, knowledge and the outside world.[23]

Dear John

I have always tried to place myself outside of the picture, to in a sense appear not to be the maker. Even in the gestural works I did through the early eighties I wanted not to own the gestures. This was probably impossible, the gesture is too loaded, but I had to try. I think getting outside of the gesture has become a stumbling block for painting; Artists like de Kooning or Vedova, asserted its individual primacy, beyond Pollock's grasp. Then artists like Baselitz and Richter turned things upside down and back to front in an attempt to shake it loose, but somehow its primacy has stuck. As a mediator of the subject–object relation those strategies of displacement only worked so far. The gesture was still giving a certain sense of narrative. The question I asked myself was how to get beyond it? In the new works I have been trying to step outside of the gesture completely, to move outside of its space and time, but at the same time staying with something which is not mechanical. In a sense I am looking for prototypes, not in terms of style but in terms of a space/image, subject/object differentials beyond the norms of current painting. I am trying to find what I can only call a kind of proto-abstraction. Until now painting has essentially been a process of 'towards' abstraction; abstraction came after, as a condition, as an end. Richter's abstract painting intimated an alternative, but they are still wedded to the narrative gesture and its problematic. It seems to me the problem now is how to move 'in front' of Richter's abstraction inversion, beyond pure formalism, to a position where possible prototypes can reinvest the subject/object dichotomy with new meanings.[24]

Accordingly McKeever's dualistic artistic strategies invariably operate across the space between necessity and chance. By leaving a painting in an open field during the winter he subjects it to the effects of snow, wind and rain; by painting it in the dark mark making becomes an impossible act of memory; by pouring paint and manipulating it on flattened canvases, the boundaries between 'created' beauty or vividness and a revealed beauty or vividness are blurred. McKeever in effect seeks to give due space to the work of indeterminacy, for it is through such processes where the possible metaphoric and metonymic links with the natural world might be forged. It is a risky process, because without the constant controlling interventions of the artist, such aleatory techniques collapse into mere subjectivity.

Essentially McKeever's work addresses the crisis of painting's cognitive function post late-modernism (theories of self-expression) and social realism (reflectionist theories). This crisis is in many ways at the centre of a critical and materialist reading of *post*modernism. By breaking with both expressionist and descriptive realist aesthetics, McKeever destabilises the conventional contrast between figuration / pictorialism and abstraction upon which the entrenched opposition between modernism and social realism has been based. Now this is not something peculiar to McKeever's work, or work that deals with the natural world as such, but rather is fundamental to a whole range of recent practices. What is specific to these practices and McKeever's is a reclamation of the *indexical* functions of representation. By this I mean that resemblance is not necessary for the work of denotation. One thing may represent another given the conceptual heading under which it operates. Thus I may paint a series of different varieties of apples which stand for different First World War German gun placements. Consequently the whole notion of realism as a theory of direct resemblance in which recognition precedes and determines understanding of the function of a picture is undermined. One thing might stand for another thing given the tacit understanding between artist and spectator that this is so. A good example of this basic representational operation is Michael Craig-Martin's infamous *Oak Tree* (a glass of water on a shelf). Now, with my earlier example, what these admittedly extreme versions of the necessary gap between depiction and denotation demonstrate is that the work of representation is the work of understanding signs. As a result 'seeing-as' becomes a stipulation of pictorial competence. However, this is not to say that we can only begin to understand pictures once we know what the artist is doing (pictorial competence does not *precede* our recognitional abilities) but that our recognitional abilities are causally linked to our conceptual abilities.[25]

Anyway by forcing home the gap between depiction and denotation the relationship between the painter and the world (or some part of it) becomes open to a very different set of orders and relations. For once representation is understood as a question of *symbolisation*, the metonymic, metaphoric and allegorical functions of picture making can be foregrounded. In short picture making becomes open to a different set of scalings, in which iconic content operates across space and time. The modernist photographers latched on to this, particularly the Surrealists (Man Ray). By singling out a discrete object they located a set of external relations which the

object denoted. Breton called this process *magique-circonstancielle*. Now this is not to argue that only singular objects possess this sign-value – conventional perspectival scenes can just as easily function in this way as well (see the point above) – but that iconic content can quite easily function at a quotational, metonymic level. Obviously historically all artists have had to make selective choices over *what* they represent; but it is perhaps only with the early modernists that the radical – formal – implications of this were pushed to an extreme; the iconic fragment stood in for the 'whole' so to speak.

The crisis of late modernism and social realism rests on their failure to incorporate this insight: in effect a failure to appreciate that utilising iconic fragments of the world is not a question of losing or fragmenting meaning. Which brings me back to my original point about *post*modernism allowing us to synthesise this insight into a position. In a certain sense this is what Fredric Jameson attempts in his much cited essay on postmodernism,[26] when he refers to the need for a complex representational dialectic that will be adequate to our positioning as subjects within a global perspective. The 'more traditional and reassuring perspectival or mimetic enclaves'[27] are incapable of achieving this.

When all the debate about McKeever's use of the new sciences dies down, this is where, I believe, his commitment to the 'prototype' will be found. However, perhaps a note of warning needs to be struck here. Central to many other critical postmodernist realist practices working in this area is the idea of ideological exposure. By placing one icon (one sign-system) next to another, an ideological contrast is established. Or, *pace* the Surrealists, by singling out a given object, that object is read in its relations to the external world as a symptom. In McKeever's work the juxtapositions across scales, the indexing rather than the description of the natural world, is not about 'decoding' prevailing representations of the natural world. Rather, McKeever uses the iconic fragment to extend our cognitive and imaginative understanding of nature's 'hidden' internal and external relations.

BLINDNESS AND LIGHT

Paths, holes, traces, contours in cold climes give corporeal shape to McKeever's world. Blindness and light are its conceptual coordinates. It takes time to see the outline of an artist's practice. It's only in the

unfolding overview that the dialogic base of a practice becomes visible. Ten years after the *Field Series* it is only now we can see the importance of these coordinates.

With only the moonlight as guide each mark loses its anchor in the world and lodges itself in memory. Painting out of a corner the notional sense of an external landscape transmutes into an index of an internal one. To lose sight is to lose site; with the powers of discrimination lost to darkness, darkness brings a sudden sensitivity to bodily movement. To move is to be aware of the body's vulnerability, of its loss to reason. Maybe McKeever's decision to paint blind (*Night Flak*) was a 'crisis of light', a crisis of visibility; in much the same way virtue might only be recovered by embracing sin, vision might only be recovered through darkening the studio. Darkness however does not become a place of residence for painting, but a heuristic, a state of anomaly, where the discriminations light brings can be relived with increased strength on its other side. McKeever cannot seem to escape this dichotomy; he plunges into holes and thickets, into forests and ravines, as if to blind or thwart the discriminations that light brings. McKeever's work unfolds as a history of adulterations, obliterations and palimpsests, the marks and acts of an artist continually forced to the edge of two opposing worlds. But maybe this blindness and light uncovers a deeper register, maybe the dichotomy between blindness and light figures not just the insubstantiality of paint in face of the world, but of the troubled relationship between science and art itself. The artist cannot plunge into the light without losing hold of those anomalies that give shape to critical development and that lie at the heart of darkness, just as to plunge forever and unseeing into darkness is to lose sight of those powers of discrimination that give darkness's hidden anomalies their force.

In the early eighties Art & Language painted by mouth as if blind, in a similar act of recognition about how penitent painting is in our culture, as an expressive human act. It is as if painting must know blindness (the expressive mark) in order to know light (theory); it must know stupidity, idleness, ugliness, incoherence, before it can claim knowledge and interpose itself between the subject and the world. Isn't this though just another way of stating the modernist claim that painting can only avoid academicism through the negation of the world of appearances, through the rupturing of the link between truth and a theory of resemblance? Maybe, but blindness is not just an aesthetic category it is a critical one, one that is couched in the view

that the penitence of painting is marked by forces beyond what it
might or might not think it is doing under the 'good offices' of
Western culture. Art & Language have talked about not avoiding what
we cannot choose.[28] McKeever's plunge into painting's darkness
embraces these constraints; for it is only by embracing such acts of
blindness that one can begin to see where the light of theory actually
is.

30. Ian McKeever, *Them Breathing*, 1984–8.

The tension between the photograph and the painterly mark is the
concrete expression of these limits; the blindness of the mark, of its
indeterminacy, against the light of the photograph's indexicality.
The early paintings are not easy paintings, they hinder and refuse both
the pleasures of the aesthetic (blindness) and the powers of recognition
(light). They exhibit their identity through negation. And negation
of course is the master of blindness in its prevention of identification.
These paintings in a sense 'blind us'. Which is why we might talk of
modernism as a history of 'blindings', a history of anomalies. The
blindness of these works is that in their wresting of an image from
the light of pictorialism, luminism and descriptive realism respec-
tively, they recognise a certain confederacy with the still determining
effects of modernist history.

Blindness of course is also the work of mis-seeing and inatten-
tiveness; the purblind and the aspect-blind; blindness as the product
of 'ways of seeing'; the foreigner in an alien land; the metropolitan
in a barren landscape. In *A History of Rocks* and the *Diptychs* McKeever

traverses these meanings to lead us to the point where blindness shades into light, to the point where blindness becomes relative to position. Travelling through cold and deserted landscapes the very measure of perception is transformed; space is transposed across scales as sensitivity to diversity in 'sameness' becomes a requisite of taking pleasure from the natural world. The 'threshold of perceptibility' is extended:

> much of the tundra ... appears to be treeless, when in many places, it is actually covered with trees – a thick matting of short, ancient willows and birches. You realize suddenly that you are wandering around on *top* of a forest. (Barry Lopez)[29]

The blindness of the panorama gives way to the luminosity of the non-linear.

<div align="center">

A history of rocks
a record of a life
forty works
forty years.
Like the Romantic's ruins
the earth gives up its mortalised remains
to the distillations of reading.

</div>

Notes

1. See Alfred W Crosby *Ecological Imperialism: The Biological Expansion of Europe 900–1900* (Cambridge University Press 1986). I am indebted to Crosby for the information contained in the opening section.
2. Ibid p 100
3. Barry Lopez *Arctic Dreams* (Picador 1986) p 354
4. Extract from correspondence between the author and Ian McKeever, question no. 2. The correspondence was conducted between 10 December 1989 and 2 February 1990.
5. See in particular Ian Jeffrey *The British Landscape: 1920–1950* (Thames & Hudson 1984)
6. J-J Rousseau *The Confessions* first published 1781 (Penguin 1953) p 332
7. Question 14
8. Ibid
9. See for example Hugh Prince 'Art and agrarian change 1710–1815' in eds Denis Cosgrove and Stephen Daniels *The Iconography of Landscape* (Cambridge University Press 1988) pp 98–118

10. See Simon Pugh *Garden, Nature, Language* (Manchester University Press 1988)

11. See in particular Stephen Daniels 'The political iconography of woodland in later Georgian England' in eds Cosgrove and Daniels *Iconography of Landscape* pp 43–82

12. Interview with Ian McKeever by Tony Godfrey, *Fields, Waterfalls and Birds* (Bristol: Arnolfini Gallery 1980) not paginated.

13. Question 1

14. Question 9

15. David Bohm *Wholeness and the Implicate Order* (Ark 1980) p 180. For a discussion of this question in relation to the earth-sciences see Robert Muir Wood *The Dark Side of the Earth* (Allen & Unwin 1985)

16. Goodman *Languages of Art* p 6

17. Bohm *Wholeness* p 125

18. Ian McKeever *Field Series* (London: Nigel Greenwood Gallery 1978)

19. James Glieck *Chaos* (Sphere 1987). As difference proliferates in a given sequence of events or movements we don't experience 'disorder' but rather, according to chaos theory, an order which is of an infinitely high degree. Embedding data from experiments – one of the early key ones was a dripping tap – into a computerised phase space of large enough dimensions, chaos begins to disappear and patterns emerge pulling the data into repeated shapes.

20. Question 5

21. Imre Lakatos *The methodology of scientific research programmes*, Philosophical Papers Volume 1 eds by John Worrall and Gregory Currie (Cambridge University Press 1978)

22. For an overview of the debates see P C W Davies and J Brown *Superstrings: A Theory of Everything?* (Cambridge University Press 1988)

23. Question 6

24. Question 3

25. See Flint Schier *Deeper into Pictures*

26. Fredric Jameson 'Postmodernism, or the cultural logic of late capitalism' *New Left Review* no. 146 (July/August 1984)

27. Ibid p 92

28. 'You must not hide what you cannot choose' from an unpublished interview with Art & Language by Mike Archer and John Roberts, quoted in Roberts *Postmodernism, Politics and Art* (Manchester University Press 1990) p 162

29. Lopez *Arctic Dreams* p 29

INDEX